POP IMPRESSIONS EUROPE/USA

PRINTS AND MULTIPLES FROM THE MUSEUM OF MODERN ART

Wendy Weitman

The Museum of Modern Art, New York

Distributed by Harry N. Abrams, Inc., New York

Published on the occasion of the exhibition *Pop Impressions Europe/USA: Prints and Multiples from The Museum of Modern Art*, organized by Wendy Weitman, Associate Curator in the Department of Prints and Illustrated Books, The Museum of Modern Art, New York, February 18–May 18, 1999.

This publication is made possible by the Contemporary Exhibition Fund of The Museum of Modern Art, established with gifts from Lily Auchincloss, Agnes Gund and Daniel Shapiro, and Jo Carole and Ronald S. Lauder.

Produced by the Department of Publications, The Museum of Modern Art, New York
Edited by Jasmine Moorhead
Designed by Santiago Piedrafita
Production by Marc Sapir and Heather DeRonck
Printed by Passavia Druckservice, Passau, Germany

Library of Congress Catalog Card Number: 98-068389
ISBN (MoMA): 0-87070-077-8
ISBN (Abrams): 0-8109-6195-4
Second printing, 1999

Published by The Museum of Modern Art, 11 West 53 Street, New York, New York 10019. www.moma.org
Distributed in the United States and Canada by Harry N. Abrams, Inc. New York. www.abramsbooks.com
Distributed outside the United States and Canada by Thames and Hudson, Ltd., London

Printed in Germany

Front and Back Cover: Martial Raysse. Detail of Untitled from the illustrated book *Das Grosze Buch* by various authors. (1963, published 1964). Screenprint and feather powder puff collage. Linda Barth Goldstein Fund, 1997. (See page 96 for full caption information.)

Endpapers: Kelpra Studio, London, with printer Chris Prater (far right). Photo: Courtesy The Tate Gallery Archive, London

Title Page: Based on Andy Warhol. *Cagney* (detail). (1964). Screenprint. Vincent d'Aquila and Harry Soviak Bequest, 1993. (See page 41 for full reproduction and caption information.)

Foreword / Preface and Acknowledgments **6**

8
**Printmaking
in the Pop Era:
The Medium
and the Message**

Wendy Weitman

Proto-Pop 25

Jasper Johns 26
Robert Rauschenberg 28
Daniel Spoerri 30
Christo 32
Enrico Baj 34
Mimmo Rotella 35
Arman 36

Mass Media 37

Joe Tilson 38
Richard Hamilton 40
Andy Warhol 41
Eduardo Paolozzi 42
Richard Hamilton 43
Robert Indiana 44
Roy Lichtenstein 46
Sigmar Polke 47
Dieter Roth 48
Eduardo Paolozzi 50
Öyvind Fahlström 52
Equipo Crónica 53
Bernard Rancillac 54

Consumer Culture 55

Andy Warhol 56
James Rosenquist 58
Andy Warhol 60
Richard Smith 61
Edward Ruscha 62
Allan D'Arcangelo 64
Derek Boshier 65
Colin Self 66
7 Objects in a Box 68
Roy Lichtenstein 70
Roy Lichtenstein 72
Roy Lichtenstein 73
Jim Dine 74
Larry Rivers 75
Patrick Caulfield 76
Marisol 77
Wayne Thiebaud 78

Politics 79

Gerhard Richter 80
Jim Dine 82
Wolf Vostell 84
Eduardo Arroyo 86
Gerhard Richter 87
Richard Hamilton 88
Andy Warhol 90
Joe Tilson 91
Andy Warhol 92
James Rosenquist 94

Erotica 95

Martial Raysse 96
Mel Ramos 98
Peter Blake 99
K.P. Brehmer 100
Peter Phillips 101
Sigmar Polke 102
David Hockney 103
Gerald Laing 104
Alain Jacquet 105
Claes Oldenburg 106
Tom Wesselmann 108
Allen Jones 109

Chronology 110
Judith Hecker and Wendy Weitman

**Notes on the Artists
and Works in the Collection 114**
Notes on the Publishers 128

Selected Bibliography 132
Index 134

Foreword

The Department of Prints and Illustrated Books, one of six curatorial departments at The Museum of Modern Art, is responsible for over 40,000 objects, which it houses, studies, catalogues, and prepares for exhibition. A collection of this size and quality is remarkable for its capacity to document the history of modern art in both breadth and depth, including works from numerous major and minor movements and representations of individual masters throughout their careers. It is the responsibility of the curatorial staff, with expertise in the area of prints and illustrated books, to make this collection accessible to a broad public through publications. With this in mind, we have set out to designate important areas of strength and to issue a series of publications based on this material. *Pop Impressions Europe / USA: Prints and Multiples from The Museum of Modern Art* is the first of these projects.

Associate Curator Wendy Weitman has set a high standard with the present catalogue. Her study focuses on one object at a time, and she has been fortunate to be able to confer with many of the people directly involved in their creation—the artists, publishers, and printers. She has also ignited an enthusiasm for object-based research in the members of the Print Department staff who have been part of her team as she prepared this catalogue. While the exhibition mounted in conjunction with this study is lively and provocative, it is this volume which will make a lasting contribution to art-historical scholarship. All who read it will realize not only how rich and varied the Museum's collection is, but also how pivotal a role printmaking played in the Pop art movement.

Deborah Wye

Chief Curator, Department of Prints and Illustrated Books

Preface and Acknowledgments

Pop art pervaded the culture of the 1960s and became intertwined with the lifestyle of its time more profoundly than any aesthetic movement of the twentieth century. Its accessible imagery and vivid, bright designs permanently expanded the audience for art. Concurrent with Pop's early development in the United States and Europe was a resurgence of interest in printed art that set the stage for the perfect pairing of the movement's conceptual underpinnings with printmaking's technical means. The media-based and populist ideas that fostered Pop art coincided with the multiple nature, lower cost, and commercial processes associated with printmaking, screenprint in particular, yielding an especially rich moment in the history of twentieth-century printed art.

Pop's impact was felt most decisively in the world's industrialized economies that had experienced an explosion of new media and new commercial products during the boom years of the 1950s. This exhibition focuses on the European and American developments particularly because of the exciting arrival of print workshops and publishers on both continents during this period and the strength of the printed art that emerged. In addition, a dynamic communication between European and American artists led to stimulating cross-continental dialogues.

By grouping the works in this exhibition into major thematic issues, this catalogue hopes to reassess this vibrant art within the context that spawned it. The categories here are but one of several possible interpretative frameworks that might shed light on the inspirations and motivations behind the startling imagery of Pop prints. Many of the prints in this catalogue could fit easily into several of the themes discussed, and nearly all illustrate the penetrating influence of the printed and electronic media that catapulted onto the visual arena of European and American society during the 1960s. And it is the reflection of the media that best defines Pop and, more than any formal device, unites the prints in this catalogue.

Documenting the Museum's outstanding and synoptic collection of prints and illustrated books was the motivating force behind this project. A collection exhibition, by definition, limits a curator's selection and restricts the tools with which she can illustrate an artist's work, movement, or theme. For *Pop Impressions Europe / USA*, however, there were very few occasions where I felt constrained by the collection. More frequently, I was impressed at the foresight of the preceding generation of curators and patrons, who acquired the majority of works in this exhibition as contemporary art, shortly after their publication. It has been a privilege to learn from and work with such a rich and distinguished archive of the printed art of this defining decade.

The staff of the Department of Prints and Illustrated Books provided the talented team essential to complete this project. Chief Curator Deborah Wye championed and supported this endeavor from its inception. Judith Hecker, Curatorial Assistant, devoted herself to every aspect of this project. Her "Notes on the Publishers" demanded tenacious research, and her plate commentaries required detailed yet synthetic thinking about these prints, all of which she executed with intelligence and alacrity. Her overall coordination of this volume and the accompanying exhibition was impeccable, tireless, and enthusiastic.

Elaine Mehalakes, Cataloguer, researched the artists' files and meticulously compiled and corrected the Museum collection lists. Jennifer Roberts, Study Center Supervisor, painstakingly catalogued many of the works in this volume, and Charles Carrico, Preparator, willingly pulled and refiled the works in this catalogue on numerous occasions. Sarah Suzuki, Cataloguer, also contributed to the cataloguing efforts. An ongoing group of interns over the past two years provided valuable research support in the Museum's library and elsewhere, including Amanda Zehnder, Maria de Madariaga, Jennifer Raab, Elke Ahrens, Aranzazu Moll, Rainer Klett, Emi Eu, Mette Mortensen, and Nicole Matthiss.

The Department of Publications worked together to produce this catalogue. This volume would not have been possible without the calm good-spiritedness and unflagging determination of its editor Jasmine Moorhead. Her enthusiasm for and perceptive understanding of these prints made her an engaging collaborator and frequently forced me to refine and clarify my remarks. Managing Editor Harriet Bee offered her generous guidance on numerous details from the exhibition title to the footnotes. The visual excitement of this volume is due to the formidable talents, sensitivity, and problem-solving skills of its designer, Santiago Piedrafita, who was presented with a set of constraining, distinct parts from which he created a beautifully integrated whole. The production of this catalogue was ably begun by Senior Production Assistant Heather deRonck and taken over by the experienced, skillful eye of Production Manager Marc Sapir. A thank you is due Michael Maegraith, Publisher, for his encouragement. I also thank Susan Richmond and Dale Tucker for their meticulous proofreading. The catalogue's photography was coordinated by Chief Fine Art Photographer Kate Keller and sensitively executed by John Wronn and Thomas Griesel, Fine Art Photographers. Freelance photographer David Allison helped get the project started under less than optimal conditions. Many thanks need to be extended to The Tate Gallery Archive, London; Robert Miller Gallery, New York; the Institute of Contemporary Art, Philadelphia; Nolan/Eckman Gallery, New York; The Arts Council of Wales, Cardiff; and The Architectural Archives of the University of Pennsylvania, Philadelphia, for supplying photographs for the catalogue's essay.

The paper conservation team at the Museum, most notably Karl Buchberg, Senior Conservator, and Erika Mosier, Associate Conservator, deserves special appreciation for its efforts on numerous works in the exhibition, many with often unknown and untraditional materials—from plastic to glitter. The exhibition that accompanies this volume benefited from the able production assistance of Andrew Davies, Production Manager in the Department of Exhibition Production and Design. For the exhibition graphics thanks go to Kathryn Marsan, Designer; Claire Corey, Production Manager; and John Calvelli, Director; Department of Graphic Design.

Object-based art history is not possible without the cooperation of those involved in the creation of the objects. My greatest debt of gratitude, therefore, must be extended to the artists and their assistants who patiently responded to my lengthy letters of detailed questions about individual works and printmaking in general. Similarly, the publishers and printers, whose foresight and craftsmanship play a fundamental role in the creation of printed art, provided crucial documentation about the works in the exhibition as well as important specifics about the printmaking of the period. My genuine appreciation to all. Special thanks go to printers Steve Poleskie, Michel Caza, Maurice Payne, and George Townsend for sharing with me their experiences with several of the artists. Dealers Alan Cristea of Alan Cristea Gallery in London and Alain Matarasso of Galerie du Centre in Paris deserve individual mention.

My research is founded on the important scholarship in the field of contemporary prints, most specifically represented by the impressive 1994 exhibition and catalogue *The Pop Image: Prints and Multiples* by Judith Goldman at Marlborough Graphics in New York, and the groundbreaking 1997 catalogue *The Great American Pop Art Store: Multiples of the Sixties* by Constance W. Glenn. Several scholars generously offered their assistance in our research. Marie-Cecile Miessner, Bibliothècaire in the Department of Prints and Photographs at the Bibliothèque nationale de France, knowledgeably directed us to further study of French printmaking of the Pop era, and Margit Rowell, Chief Curator in the Department of Drawings at The Museum of Modern Art, kindly lent her expertise on Sigmar Polke. Giovanna Bonasegale, Director of the Galleria Comunale d'Arte Moderna e Contemporanea in Rome; Dr. Dieter Schwarz, Director of the Kunstmuseum Winterthur; and Ann Prentice Wagner, Curatorial Assistant and Collections Manager at the National Portrait Gallery in Washington, D.C., also shared important information with us. Claudia Defendi, Chief Curator at The Andy Warhol Foundation, and Mark Francis, former Chief Curator at The Andy Warhol Museum, tirelessly responded to our numerous exacting inquiries. Sincerest thanks must also go to Pat Marie Caporaso; Jacqueline Chambord; Emma Dexter of the Institute of Contemporary Arts, London; Sharon Avery Fahlström; Samuel Adams Green; Vivian Horan; Myron Kandel; Andrea Miller Keller formerly of The Wadsworth Atheneum; Skip Martin at United Press International; Barbara Martinsons; Tara Reddi and Nicola Togneri at Marlborough Graphics; Andrew Richards at Marian Goodman Gallery; Betty Stocker at the Archiv Spoerri Schweizerische Landesbibliothek, Bern; Judith Tannenbaum at the Institute of Contemporary Art, Philadelphia; and Lance Thompson at Richard L. Feigen & Co.

Producing a catalogue requires substantial financial support and for that I owe my sincerest gratitude to the Contemporary Exhibition Fund of The Museum of Modern Art which embraced this project from the outset. Support for the exhibition's brochure is made possible by The Contemporary Arts Council and The Junior Associates of The Museum of Modern Art.

This catalogue is dedicated to Jed W. Brickner, tireless and loyal friend, editor, and husband, whose astute comments on every word of this volume made it an immeasurably better work and without whose steadfast encouragement this project's completion was unimaginable.

Wendy Weitman
Associate Curator, Department of Prints and Illustrated Books

Printmaking in the Pop Era: The Medium and the Message

Wendy Weitman

Pop Art is:

Popular (designed for a mass audience)
Transient (short-term solution)
Expendable (easily forgotten)
Low cost
Mass produced
Young (aimed at youth)
Witty
Sexy
Gimmicky
Glamorous
Big business[1]

Richard Hamilton's prophetic list written in 1957 encapsulated with uncanny accuracy the defining characteristics of a movement that would sweep across the industrialized world from the late 1950s through the early 1970s. Pop art was iconoclastic, rebellious, and unlike any other movement of the twentieth century in its almost immediate popular acceptance and all-encompassing cultural impact. It flourished out of an era of unprecedented economic prosperity, the multifaceted manifestations of which became the fodder for Pop's artistic upheaval. The expanding economy produced a plethora of competing products vying for the attention of the postwar consumer society. This surge in consumer choice compelled vast expenditures in the burgeoning advertising industry, which in turn contributed to the rapid growth of the blossoming media sector. And it is the media, both printed and electronic, more than any other single aspect that informs the everyday imagery, conceptual underpinnings, and even aesthetic formats of Pop.

The economic strength of the period had a vital ripple effect on the art community as a whole, as scores of art enthusiasts became collectors, and new galleries sprang up in major cities in Europe and the United States. Likewise the audience for art expanded noticeably.[2] In Germany, for example, there were less than a thousand art galleries in the early 1960s. That number had more than doubled by 1970.[3] Scores of galleries opened in London as well during this period. The booming economy and flourishing art market contributed to Pop's proliferation—its increased exposure, publicity, and financial success—as collectors flocked to this bright, new, accessible imagery. The artists of this avant-garde became popular celebrities. The openness and glamour of Pop permanently widened the art-going public from a largely elitist coterie of the privileged to a broader-based and younger general audience.

Pop was expansive, inclusive, and outward-looking in marked contrast to the introspective, abstract modes that dominated the art of the 1950s. The sudden reappearance of representational art came about in Europe and the U.S. after a decade of *art informel*, *tachisme*, and Abstract Expressionism, and reflected artists' desire to engage with their surroundings in reaction against the isolated, escapist aesthetic of their immediate predecessors. This ten-

dency was perhaps best exemplified by the emergence on both continents of Happenings—public art events that combined theater, art, and, often, audience participation. The Pop artists' embrace of contemporary forces from advertising, Hollywood, and popular culture further compounded their rejection of traditional artistic codes.

During the late 1950s and early 1960s, the objects and images of everyday life played center stage in the work of former Independent Group members in London, Nouveaux Réalistes in France and Italy, and so-called neo-Dadaists such as Jasper Johns and Robert Rauschenberg in the U.S. As Pop evolved, American and European artists began employing commonplace mediated imagery.[4] The mature work of Hamilton and Eduardo Paolozzi, and the younger generation emerging from the Royal College of Art in London paralleled that of the seminal American Pop artists such as Roy Lichtenstein, Claes Oldenburg, and Andy Warhol in their mass-media inspirations. The Capitalist Realism group in Düsseldorf appropriated the media's unpretentious techniques as well as its images. In the early 1960s, the members of Nouvelle Figuration, a group of international artists working in France championed by critic Gérald Gassiot-Talabot, rejected the Nouveaux Réalistes' approach as romantic. These artists, painters primarily, including Valerio Adami, Hervé Télémaque, Peter Klasen, Bernard Rancillac, Erró, and Peter Stämpfli, accentuated the narrative aspect of their media-derived forms.

There was no one Pop art. Pop developed differently in Europe, the U.K., and the U.S., with varying aspects taking root depending on cultural circumstances. The weight of the European painting tradition, for example, can be seen in the more artful, painterly strategies of Pop artists from Hamilton to Öyvind Fahlström. (Alain Jacquet, Equipo Crónica, and other European artists even transformed icons of art history into Pop statements.) Subject matter further reflected certain national distinctions. The economic boom and burgeoning consumer culture was experienced first in the U.S. and therefore elicited a more ardent response from American Pop artists, while the turbulent politics of the period were more often mirrored in European work.

More interestingly, however, was the intense interchange of ideas across national and continental boundaries that characterized the Pop period. A strong European presence permeated the New York art scene in the early 1960s. Nouveau Réaliste Jean Tinguely's momentous kinetic, self-destructing environment *Hommage à New York* came to rest in The Museum of Modern Art's Sculpture Garden in 1960, and the Museum's landmark 1961 exhibition *The Art of Assemblage* featured numerous contemporary European artists.[5] Sidney Janis's now-historic exhibition *The New Realists*, which brought together European and American avant-garde artists from Martial Raysse to James Rosenquist, attracted critical attention in 1962.[6]

Conversely, Johns and Rauschenberg both had solo exhibitions in Paris in 1961.[7] Ileana Sonnabend's Paris gallery, which featured the work of the American Pop artists, opened in 1962 and became an important and, often, the initial opportunity for European artists to see the new work from America.[8] 1963 witnessed two adventurous museum exhibitions that traveled throughout Europe and featured American artists of the new figurative styles.[9] The international survey exhibition known as Documenta, held in Kassel, Germany, began in 1955, and its third and fourth manifestations, in 1964 and 1968, showcased the American Pop phenomenon.

In the late 1950s and early 1960s a striking number of young artists from Great Britain and the Continent came to New York for extended visits. Öyvind

Fahlström was an early arrival, coming in 1961. The Chelsea Hotel, a bohemian haunt frequented by musicians, writers, and artists, became an outpost for Nouveaux Réalistes Arman, Raysse, Niki de Saint Phalle, Tinguely, and later Jacquet, whose watershed painting *Le Déjeuner sur l'Herbe* still hangs in the hotel's lobby.[10] Hamilton's first visit to the U.S. was to see the 1963 Marcel Duchamp retrospective at the Pasadena Art Museum in California. Christo emigrated in 1964, and Britons Allen Jones, Gerald Laing, Peter Phillips, Richard Smith, and Joe Tilson all lived in New York at various periods in the sixties.[11] The extent of this cross-fertilization represented a new level of international artistic communication and exchange and contributed to the rapid ricochet of Pop imagery and ideology back and forth across the Atlantic.[12]

The themes that preoccupied artists of the Pop era mirrored the societal and cultural issues defining the period and the bombardment of the public via mass-circulation media. The increasing emphasis on consumer goods, the abundance of sexual imagery, and the ever-growing media itself became the predominant focus of artists working within the Pop orbit. The political turmoil of the sixties, from the American civil rights movement and student unrest to German rearmament, French civil strife, and Spanish Fascist rule, proved to be another potent source for artists' investigations of their contemporary environment. The export of American culture that coincided with the international success of classic Hollywood cinema and with the proliferation of American magazines fostered a keen awareness of American economic prosperity and popular culture in Europe—an awareness repeatedly reflected in the European Pop artists' imagery.

Pop's iconography was borrowed, appropriated, and recycled. Pop artists found their sources not in everyday objects themselves, but in advertisements, billboards, or photographic reproductions of those objects. Nearly every facet of Pop art—from its source material to its dissemination to its philosophy—is tempered by printed matter. Printed images permeate the Pop vision, and fundamental principles of printmaking, including concepts of transference and assimilation, underlie the artistic thinking of the movement. Several artists, most notably Hamilton, Warhol, and Jacquet, incorporated printmaking directly into their painting. But more significantly, the strategies of repetition and reproduction inherent in much of Pop art suggest a deeper resonance with the essence of printmaking as a transfer process able to generate multiple "identical" examples. The manipulation of media images through printmaking raised issues of authenticity, originality, and authorship that overturned existing notions of art and refocused aesthetic concerns, directly contributing to the conceptual framework that dominated art of the 1970s and continues to the present day.

The Outburst of Publishing and Screenprints[13]

Richard Hamilton began incorporating photographic imagery into his paintings as early as 1957. Andy Warhol and Robert Rauschenberg both introduced photoscreenprinting to accommodate photography into their unique work in 1962. Martial Raysse began using fashion photography in his assemblages and installations that year, and by 1963 Sigmar Polke had started making his paintings of simulated reproductive dots. Issues surrounding reproduction and printmaking were in the air as Pop artists explored the contemporary realm of the commercial media. Editioned prints on paper were a natural evolution of these investigations.

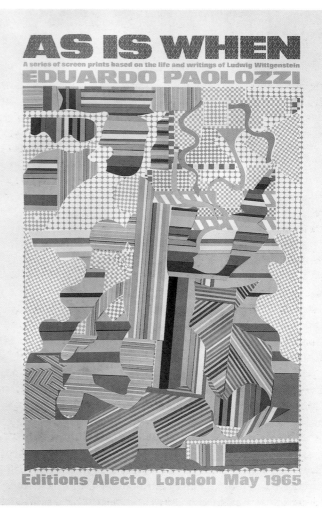

Eduardo Paolozzi. Title page from the illustrated book *As Is When* by Eduardo Paolozzi. 1965. One of thirteen screenprints, printed in color. Composition: (irreg.) 32 ⁷/₈ x 20" (83.5 x 50.8 cm). Page: 37 ¹⁵/₁₆ x 25 ⁷/₈" (96.4 x 65.7 cm). Publisher: Editions Alecto, London. Printer: Kelpra Studio, London. Edition: 65. The Museum of Modern Art, New York. Joseph G. Mayer Foundation Fund, 1967

Enterprising print publishers in Europe and the United States saw the opportunity, given the robust economic climate and thriving art market, to undertake ambitious print projects. It was up to them to persuade the artists to try out these multiple mediums and to find the technicians to execute them. The result was the greatest outpouring of printed art since the German Expressionists took up the woodcut in the first two decades of the century. In the 1960s the screenprint prevailed. Its capacity for vivid, saturated colors, relatively modest production costs, and unmodulated, anonymous surfaces, as well as its facility with photography were not only compatible with but served to enhance Pop's bold visions of the contemporary environment.[14]

England

Prints in England had very little exposure in the immediate postwar years. An expansive 1948 exhibition at The Victoria & Albert Museum, London, celebrating the 150th anniversary of lithography was an important catalyst in the reawakening of interest in printmaking in general. In 1954 Robert Erskine opened St. George's Gallery, a pioneering effort which also played a pivotal role in printmaking's resurgence.[15] Erskine, inspired by the French tradition, commissioned prints by leading British artists and instituted the annual exhibition *The Graven Image* to showcase contemporary printmaking. Despite these

developments, however, screenprinting remained a commercial medium, and trained fine art printers were in short supply.[16]

Things began to change when artist Christopher Prater, after studying in a government-sponsored program and apprenticing with several London commercial screenprinters, set up his own shop, Kelpra Studio (see fig., pp. 14–15), in 1957, primarily producing posters for the British Arts Council.[17] Hamilton, who had worked extensively in etching by this time, made his first screenprint with Prater in 1963[18] and quickly recognized screenprint's adaptability to photographic images and the printed media sources inspiring the work of many artists of the burgeoning Pop generation. Hamilton approached London's Institute of Contemporary Arts (ICA), an organization he had been closely involved with for over a decade as a founding member of the Independent Group, with the idea of doing a portfolio of screenprints as a fundraiser. This historic portfolio, with work by twenty-four artists chosen by Hamilton, was published in 1964 and launched the revival of the screenprint in England.[19] *The Institute of Contemporary Arts Portfolio* project allowed Prater to abandon commercial work and concentrate solely on fine art printing. It also introduced many of England's vanguard artists to the medium for the first time.

Prater proved to be the most inventive and experimental technician in the screenprint's short history and transformed the nature of the medium into a collaborative vehicle and important artistic tool.[20] Nowhere is the brilliance of Prater's working process better illustrated than in Eduardo Paolozzi's portfolios after collages of printed ephemera. Paolozzi clearly understood Prater's incomparable skills as a stencil-cutter[21] when he said, "reinterpreting a series of collages into a sound homogenous graphic is a printer's nightmare. The interpretations by Prater were highly innovative and became, in most artists' views, highly inventive or, in some cases, another art form."[22]

The vitality of the work emerging from Prater's shop encouraged adventurous art enthusiasts to turn to print publishing. Editions Alecto was founded in 1960 by enterprising graduates of Cambridge University. Initially planning to distribute local topographical pictures to alumni, Alecto's founders changed course after moving to London in 1962 and began publishing prints by their contemporaries. Among their earliest projects was David Hockney's narrative masterpiece (after William Hogarth) *A Rake's Progress*, published in 1963. That year Alecto acquired the print inventory of Erskine's St. George's Gallery and quickly established themselves as the major Pop publisher and distributor in London. Projects with Paolozzi, Hamilton, Colin Self, and the younger generation of British Pop artists, including Allen Jones, soon followed. To encourage the print market, Alecto embarked on a public-relations program about printed art, promoting articles on printmaking in art periodicals as well as in mass circulation newspapers and magazines.

The activity generated by Kelpra Studio and Editions Alecto spurred others to begin publishing. Most notably, one of London's premier galleries, Marlborough Fine Art, opened a publishing division (Marlborough Graphics) in 1964 and quickly entered the buoyant fray with important projects by Joe Tilson and R. B. Kitaj, both of whom would make printmaking a major expressive outlet for their media-based Pop imagery. Petersburg Press was founded in 1967 by Paul Cornwall-Jones, one of the initial partners in Alecto, and published some of the most inventive and ambitious projects of the period, including Dieter Roth's boxed portfolio *6 Piccadillies* (plate entry, p. 48) and Patrick Caulfield's illustrated book *Some Poems of Jules Laforgue* (plate entry, p. 76), as well as important prints by Jim Dine, James Rosenquist, Jones, and Hockney.

France

The print boom in London was also experienced on the Continent, but was diffused among a variety of smaller printers and publishers rather than concentrated in a few workshops. France had a long printmaking tradition, and, in particular, the screenprint had a distinct, if modest, history of its own.[23] Its precursor, the pochoir, had enjoyed considerable popularity in the 1930s with numerous artist-designed posters. In 1947 the resounding success of *Jazz*, Henri Matisse's renowned book of twenty dazzling pochoirs, was an unexpected and unparalleled public relations coup for the medium, encouraging other printers and publishers who began collaborating with younger artists. Gallerist Denise René published the first screenprint with Victor Vasarely in 1949, and in 1954 held the first major exhibition in France of the screenprint medium as a contemporary art form.

The response to these events was the start-up of several screenprint workshops, which, in turn, contributed to the flourishing of Pop.[24] Jean-Jacques de Broutelles founded Paris Arts in 1955 and during the Pop era worked with Bernard Rancillac, Hervé Télémaque, and Peter Klasen. In 1963 Michel Caza, who had collaborated with Raysse, Rancillac, and Niki de Saint Phalle, among numerous others, opened his atelier, which was initially devoted to commercial projects but later focused on fine art. These two workshops joined Cuban-born printer Wilfredo Arcay, who concentrated on hard-edged abstraction, and Jacques Marquet as the leading screenprinters in Paris.

The recognition of screenprinting's aesthetic possibilities achieved a new level in 1964 when Alain Jacquet made what would become his signature work, *Le Déjeuner sur l'Herbe*. A photoscreenprint on canvas, created as

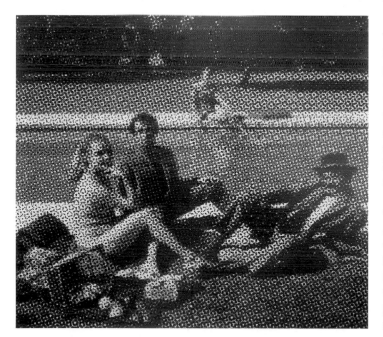

Alain Jacquet. *Le Déjeuner sur l'Herbe*. 1964. Screenprint, printed in color, on canvas. 68 7/8 x 77 1/2" (175 x 197 cm). Edition: 97. Courtesy Robert Miller Gallery, New York

ninety-seven unique variants, this work has become the ubiquitous symbol of French Pop art. The screenprint reached its widest audience in France, however, with the massive poster brigade known as L'Atelier Populaire, which accompanied the student uprisings of May 1968. Operating primarily out of the École des Beaux Arts, students and artists created scores of unsigned, unlimited edition screenprint posters that were surreptitiously plastered on the streets of Paris. Several of the screenprinters, including Caza, assisted the students in their clandestine efforts, as did many of the young Pop artists.[25]

Publishers, print galleries, and print clubs flourished in the 1960s in Paris and "the screenprint was in vogue."[26] Small publishers such as Éditions V, Éditions C.Q.F.D., and the Centre national d'art contemporain sold prints in the department stores Galeries Lafayette and Printemps as well as through subscriptions.[27] Even the low-end retail chain Prisunic was publishing prints.[28] Editions K.A.K., with branches in Berlin, Munich, and Paris, created a lively exchange between French and German artists' prints, selling those of one country in the other, often through mail order.[29] The *Biennale Internationale de l'Estampe*, a large international print fair, began in 1968, and several periodicals that incorporated original prints were launched, including *KWY* founded in 1959 and *Chorus* in 1968.[30] The energy ebbed, however, by the mid-1970s as the French economy, and subsequently the art market, faltered, primarily as a result of the Middle East oil crisis. Many of the small galleries and publishers that had sprung up in the sixties were forced to close, "signaling the twilight of the fine art editions in Europe."[31]

Germany

Germany witnessed a similar outburst of activity from printers, galleries, and publishers. The first workshop to make important strides in screenprint was Edition Domberger. Luitpold Domberger, a young graphic designer, was inspired by a 1948 exhibition of American screenprints at the Amerika Haus in Stuttgart.[32] From the information in the exhibition literature he began experimenting and eventually set up his own screenprint workshop in 1950. Working both as a contract printer and publisher, and producing commercial posters and reproductions as well as original prints, Domberger elevated screenprint to an important medium for artistic expression in postwar Germany. Although he concentrated on hard-edged abstraction more than on Pop, among Domberger's most influential productions are landmarks in Pop printmaking such as Robert Indiana's *Numbers* (1968) and *Decade* (1971) portfolios[33] and several works by Allan D'Arcangelo, Christo, Öyvind Fahlström, Hamilton, and Gerald Laing. Two of Domberger's apprentices, Hans Peter Haas and Frank Kicherer, also became leading screenprinters in Stuttgart. Haas, known for his precision-oriented work, collaborated with Christo, Hamilton, Roth, John Wesley, and Tom Wesselmann, as well as numerous German artists. Kicherer, who opened a workshop a few years later, worked repeatedly with Caulfield, as well as Hamilton and German artists Max Ackermann, Imi Knoebel, and Dane K. H. Sonderborg.[34]

Other workshops, such as Hans Möller's HofhausPresse outside of Düsseldorf, sprang up around Germany in the 1960s.[35] Founded in 1961, Möller opened a modest screenprinting shop in his house and began producing inventive editioned projects that combined printmaking and multiples by young artists, including many of the Nouveaux Réalistes, such as Christo and Raysse, as well as the Zero Group abstract artists prominent in Düsseldorf. In addition, galleries, such as Galerie Rottloff in Karlsruhe, occasionally opened printshops

to publish work by their artists.

The most prominent publisher of the German Pop period was René Block whose progressive Berlin gallery was instrumental in launching the Capitalist Realism group's more political, and often conceptual, strain of Pop.[36] In 1967 Block published the group's most significant portfolio, *Grafik des Kapitalistischen Realismus*, a boxed set of six screenprints.[37] (See plate entries, pp. 47, 84, and 100.) He chose to print at Birkle & Thomer & Co., the firm of a colleague who had just opened a screenprint workshop.[38] Christian Dujardin, the firm's director, in particular recalled Wolf Vostell's close involvement in all phases of the printing of *Starfighter*, his contribution to the portfolio.[39] (After this project, Birkle & Thomer & Co. went on to work with a broad range of German artists of the 1970s including Otmar Alt, Fritz Köthe, and Richard Paul Lohse.)

But Vostell's fascination with the medium of screenprint, was anomalous. Other artists in the group, including Polke, Gerhard Richter, and K.P. Brehmer, generally favored photomechanical processes, whose coarser, less polished effects more closely simulated the media sources they appropriated. Herbert A. Haseke of galerie and edition h, Hannover, released large-edition printed works in collotype and photolithography with Polke and Richter in the mid-1960s. Dorothea Leonhart, in Munich, issued a series of mass-edition prints with Hamilton, Paolozzi, and others. With editions of 5,000–10,000, quantities normally reserved for posters, these prints were truly democratic in their broad dissemination, bringing original art into the homes of thousands.

United States

The blossoming of print workshops in America began in 1957 with Tatyana Grosman's establishment of Universal Limited Art Editions, where so many of the proto-Pop artists such as Johns, Rauschenberg, and Larry Rivers got their start as printmakers. Also of early importance was Tamarind Lithography Workshop, set up by June Wayne in Los Angeles in 1960, which helped train desperately needed teams of talented print technicians. In fact, several of the younger generation of British Pop artists, including Hockney, Jones, Laing, and Peter Phillips, honed their lithography skills there during visits to Los Angeles, as did Californian Ed Ruscha.[40] Both of these shops believed in the primacy of lithography.[41]

But the American Pop artists, like their counterparts in Europe, favored screenprint for their editions. However, unlike in London, where Kelpra Studio dominated the field, in and around New York several smaller printers, both commercial and fine art specialists, emerged during this period to cater to the artists' demands. Among them was screenprint and book-design firm Ives-Sillman, opened in 1955 in New Haven. Ives-Sillman focused primarily on Josef Albers and other abstractionists, but they were creatively responsible for The Wadsworth Atheneum's portfolio *X + X (Ten Works by Ten Painters)*, which included pivotal early prints by Indiana, Roy Lichtenstein, and Warhol. (See plate entries, pp. 70 and 90.) Sirocco Screenprinters, who editioned this portfolio, and would edition most of Ives-Sillman's projects after 1965, was a commercial shop that worked increasingly with artists during this period.[42] In 1967, they produced the quintessential 1960s Pop image, Robert Indiana's *Love* (plate entry, p. 44.), published by Multiples, Inc.

Steve Poleskie opened Chiron Press in New York in 1963, filling the void of available fine art workshops in the city. He quickly became known as an experimental and adventurous technician.[43] Also doing both commercial

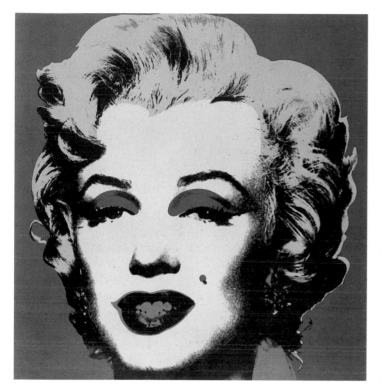

Andy Warhol. *Marilyn Monroe (Marilyn)*. 1967. One from the portfolio of ten screenprints, printed in color. Composition and sheet: 36 x 36" (91.5 x 91.5 cm). Publisher: Factory Additions, New York. Printer: Aetna Silkscreen Products, New York. Edition: 250. The Museum of Modern Art, New York. Gift of Mr. David Whitney, 1968

posters and fine art printing, Poleskie worked with an exciting range of unusual printing surfaces and inks that came to characterize many of the most innovative prints of the American Pop generation. His frequent collaborations with Lichtenstein in the mid-1960s evidence this spectacular creativity with plastics and other commercial materials. Other projects included collaborations with Pop figures Arman, D'Arcangelo, Jones, and Phillips. A 1967 comment by Poleskie on contemporary printmaking aptly assesses the status of the medium at the time.

Now the new artists attracted to this field, naïve about what can or cannot be done, about what is or is not a print, have completely revolutionized the graphic arts. We now not only have prints on plastic, Lucite, Plexiglas, cloth, sandpaper, and a whole range of materials, but a completely new aesthetic regarding the nature of multiple editions. Prints are no longer made to be put in boxes, but rather printed on the boxes, in the boxes, or to be cut up, folded, and made into boxes.[44]

Rosa Esman's Tanglewood Press dominated the outpouring of Pop print publishing in New York in the mid-1960s. *New York 10* of 1965, her first publication, included Oldenburg's *Flying Pizza*, his first collaboration with a professional printer, and sold out within a year. She followed that success with the portfolio *New York International* the following year.[45] When, in the spring of 1965, Nina Kaiden from the public relations firm Ruder Finn contacted Leo Castelli with an exciting Pop print project, Castelli suggested Esman to coordinate it. The proposal was to commission "ten artists to do three prints each in different sizes. . . for them to mount in European museums, supported by Philip Morris as a publicity blitz."[46] Kaiden contacted dealers and museum directors around the country[47] and selected ten of the most engaging Pop artists working in the United States and Britain. Esman added Jim Dine to the list and supervised the production of all thirty-three prints under the stamp of Original Editions. The resulting portfolios, titled *11 Pop Artists*, volumes I, II, and III, include some of the classics of Pop printmaking.[48] (See plate entries, pp. 101, 108, and 109.) The American Federation of the Arts sponsored a national tour in 1965–67, which promoted, along with the cigarette company, the tremendous vitality and artistic potential of the screenprint medium.[49]

But it was Andy Warhol who truly revolutionized the screenprint in America. His iconoclastic approach encompassed unique screenprints on canvas, variant "editions" on paper, and unlimited examples on wallpaper.[50] He fully engaged the screenprint's facility with photography, its capacity for saturated, vibrant hues, and its potential for repetition. Screenprinting allowed Warhol to distance his hand from the artmaking and simulate mechanical processes, inventing radical printing methods that, ironically, became his personal signature.

In 1962 Warhol began "printing" his paintings, and in 1963 his principal studio assistant Gerard Malanga became an active partner in their production. Warhol printed the small variant editions on paper, including *Cagney* and *Suicide*, himself. Early editioned prints went off to professional printers chosen by the publishers, usually Sirocco Screenprinters or Knickerbocker Machine and Foundry. But in 1967, after announcing his retirement from painting, Warhol joined the adventurous league of creative entrepreneurs who had invigorated the field of American prints and decided to become a print publisher. He founded Factory Additions for the express purpose of releasing large editions of screenprints based on his best-known paintings.

Pop art was big business by 1967, and the print boom that Warhol's early work helped to engender was now thriving. Warhol's fame was universal and publishing his own work was a sound economic decision.[51] Through 1970 Factory Additions released several portfolios of ten images each in editions of 250 and printed them with commercial screenprinters to make truly identical editions for a mass audience. The cold, perfect look of these portfolios, *Campbell's Soup I* and *II*, in particular, contrasts with the emotive and more painterly tension of his earlier work, and comes closest to the advertising sources from which Warhol derived so much of his imagery. There is no stronger or more enduring example of the potent aesthetic performance of screenprinting than the ten acid-hued faces of Marilyn Monroe in Factory Additions's first portfolio. This and subsequent sets made Warhol one of the most successful American print publishers of the late 1960s.[52]

Overleaf: Kelpra Studio, London, with printer Chris Prater (far right). Photo: Courtesy The Tate Gallery Archive, London

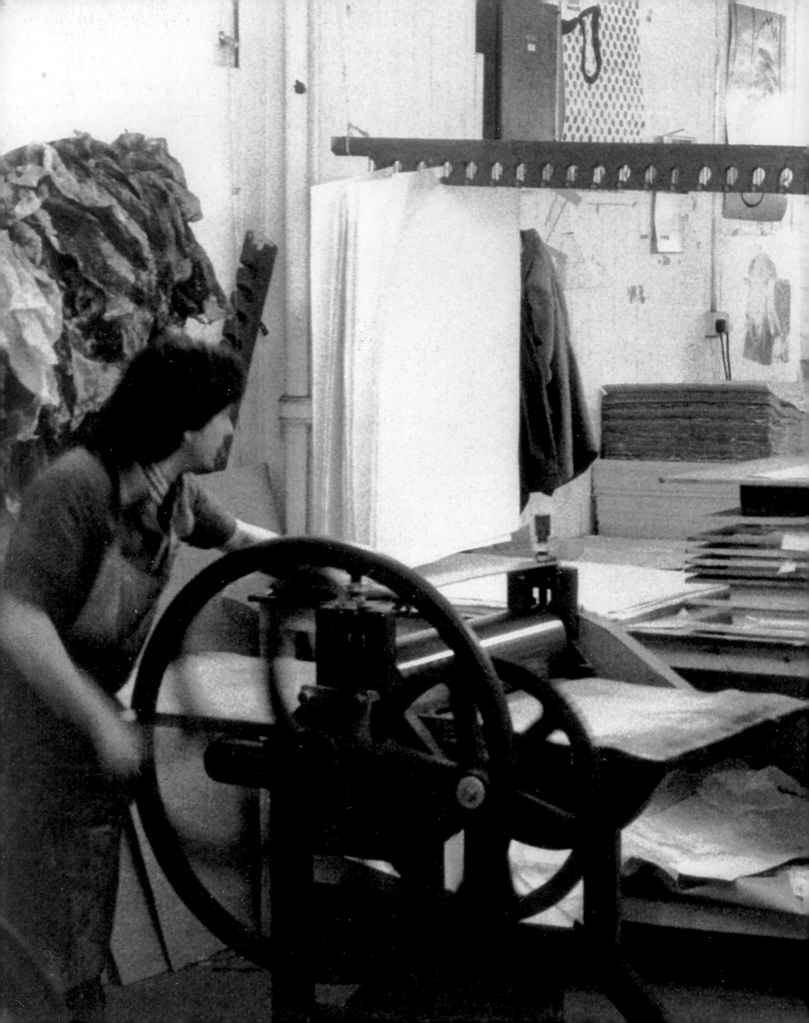

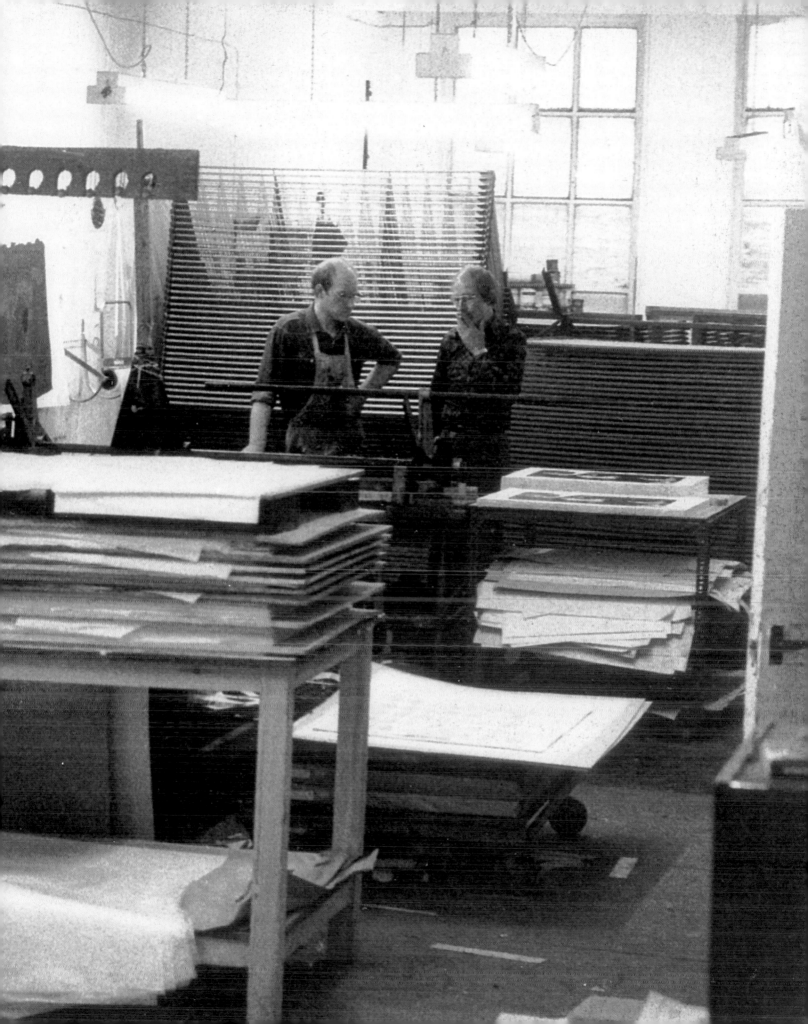

16

Multiples

Concurrent with the expanding print market was the growing awareness and popularity of a relatively new form of editioned art—the multiple. Conceived, though not termed as such, by Marcel Duchamp, with objects such as the *Rotoreliefs* of 1935 and *Boîte-en-valise* of 1941, the multiple flourished in Pop's democratic milieu, offering editioned, modestly priced art for wide dissemination to an ever increasing art public. In 1959 the Swiss artist Daniel Spoerri became one of the earliest publishers of multiples, founding Édition MAT (Multiplication d'Art Transformable), with the intention of producing handmade "originals in series," preferably with a movable or kinetic feature. Spoerri completed three series, each with more than ten artists, in 1959, 1964, and 1965—the first series included Duchamp—and each in an edition of one-hundred; individual works sold for under £100. He never restricted himself to a single movement or style but rather tried to present a cross-section of contemporary art. The second series, in 1964, included several works by members of the Nouveaux Réalistes, a group Spoerri had helped to establish in 1960.

Milan dealer, publisher, and Duchamp scholar Arturo Schwarz played a seminal role in the development of multiples in Europe as well. He released important multiples editions by Man Ray and several by the Nouveaux Réalistes. René Block was also a major catalyst of the movement. In addition to publishing multiples by Hamilton and Joseph Beuys, he gained renown for his innovative multi-artist projects such as the cabinet *En Bloc* of 1969–70, and the suitcase *Weekend* of 1972. These inventively housed compendiums included a creative range of prints and multiples by former Capitalist Realist artists then making Fluxus-inspired, anti-art objects.[53] Block also organized an encyclopedic exhibition on the history of multiples in 1974 at the Neuer Berliner Kunstverein.[54] Edition Staeck in Heidelberg and Edition der Galerie Heiner Friedrich in Munich were two other active German publishers of this vital new art form.

Multiples flourished in France through the activities of Galerie Denise René and the illustrated book and object publisher Claude Givaudin's left bank gallery cum boutique. Jacquet made screenprints on plastic pillows, and Rancillac made several multiple screenprinted portraits on canvas, plexiglass, and wood. The British response to multiples was more limited. Although prints were successfully marketed there through national advertising and mail order, the three-dimensional multiples often required a sizable investment and were more difficult to distribute, thereby discouraging publishers from undertaking these projects.[55]

Multiples found a receptive and enthusiastic audience in New York in the mid-1960s. A 1963 New York newspaper strike forced art dealer Robert Graham to make hand-painted banners to publicize the exhibitions at his Madison Avenue gallery. The banners proved so popular that Graham joined forces with framer Barbara Kulicke and her partner Sonny Sloan to establish the Betsy Ross Flag and Banner Company, commissioning artists—from Indiana and Lichtenstein to Warhol and Wesselmann—to create felt banners in editions of twenty.[56] In 1964, for an exhibition at New York's Stable Gallery, Warhol made a series of screenprinted wood boxes modeled after supermarket cartons, including Campbell's tomato juice, Heinz tomato ketchup, Del Monte peaches, Mott's apple juice, and Brillo soap pads, making dozens of each "brand."[57] Warhol's boxes, unlike Duchamp's readymades, were fabricated objects meant to simulate the found object. They were replicated over and over to approximate the unlimited quantity and lowly value of their ephemeral

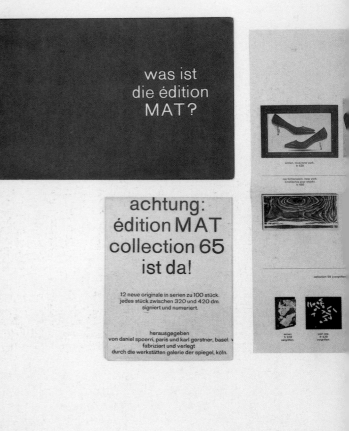

source.[58] Although not recognized as such at the time, these two seminal projects launched the multiple as an art form in the U.S. An exhibition that same year, titled *American Supermarket* at the Bianchini Gallery (see plate entries, pp. 56, 72), ingeniously illustrated the increasingly blurred boundaries between art and commodity, reproduction and original. The exhibition included food-based art and products ranging from real Ballantine ale cans to Johns's famed sculpture of them, *Painted Bronze*, as well as several of Warhol's Campbell's soup-can renderings, from paint on canvas to screenprint on shopping bag to a signed aluminum can. It brilliantly highlighted the ambiguities between art and commerce that Pop art and multiples, in particular, had engendered.

Multiples Inc., founded in 1965 by Marian Goodman, was among the most active in the medium. It produced many of the early multiple projects, from Rivers's *Cigar Box* (plate entry, p. 75) to Oldenburg's *Tea Bag*,[59] and its gallery / store, then at 929 Madison Avenue, became the backbone of the multiples scene in New York.[60] But one of the highpoints of the Pop multiples explo-

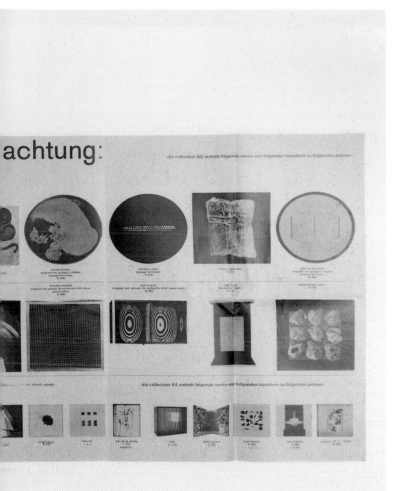

Folded mailers and posters from Edition MAT, Paris / Cologne

sion in the U.S. came in 1966 with the release of Tanglewood Press's ground-breaking production *7 Objects in a Box* (plate entry, p. 68). Esman followed European multiples at the bookstore / publisher Wittenborn and Company[61] which distributed vanguard books and objects from the leading contemporary European publishers. This exposure, along with her knowledge of Tatyana Grosman's productions at ULAE, induced her to devote herself to the endeavor of publishing.

To accomplish the ambitious *7 Objects in a Box* project Esman hired Dawa Basanow, who had designed plexiglass boxes for Kulicke Frames Inc. Robert Kulicke helped Basanow set up Knickerbocker Machine and Foundry at 114 Spring Street to fabricate the seven objects.[62] Basanow's brilliant facility with commercial materials and his problem-solving nature made him an important creative force behind the project, ingeniously producing Wesselmann's

vacuum-formed *Nude* and Warhol's screenprint on plexiglass. Esman, like Goodman, promoted the social ambitions of Pop—the concept that art should be available to people other than the privileged—and resolutely worked to bring about important art in inexpensive editions.

It was Oldenburg who most fulfilled the potential of the multiples medium by using it as a logical extension of his sculpture. Oldenburg's unique work maximized the ambiguity between object and artwork. When he turned to editions, with the help of publishers like Esman and Goodman, he worked in a wide variety of materials and formats, from the simplicity and clarity of *Baked Potato* to the elaborate complexity and humor of *London Knees 1966* (plate entry, p. 106) to the clever screenprint on silk *Nose Handkerchief*. Oldenburg poetically summarized his ideas about the art form: "Anyone who owns a multiple is aware of there being others. It's a shared thing. . . . I think of them as going out into the world and having different experiences all over the world. Some are lying in drawers and some are being carried in planes, and so on. They're always changing hands. They have adventures."[63]

Themes

Proto-Pop

The accessible, mundane, and occasionally vulgar imagery that exploded onto the world with Pop art was unlike anything seen before in its banality, confrontational presentation, and commercial derivation. The art that immediately preceded it set the stage for these breakthroughs. In the mid-1950s, Jasper Johns's edge-to-edge Flag, Target, and Numbers paintings overturned traditional notions about perception and illusion while introducing into art a startling new vocabulary of commonplace subject matter. In his combine paintings, Robert Rauschenberg literally brought the everyday reality into art by affixing objects to the canvas. In Paris, the Nouveaux Réalistes, a group established in 1960 with critic Pierre Restany as its imaginative spokesperson, stated its goal as "new perceptive approaches to the real."[64] In the years 1960 to 1963, these artists made constructions from mass produced products, often discarded goods, that marked the excesses they witnessed in their everyday environment of conspicuous consumption.[65] Many of that group, such as Arman and Christo, came out of the Surrealist assemblage tradition, while Daniel Spoerri was a descendant of Duchamp. Martial Raysse stood out with his assemblages of new, store-bought consumer items, prefiguring the pure Pop art approach that would begin a few years later. Nouveau Réalisme also had a strong performance aspect, as seen in Arman's *Colères*, aggressive actions in which he destroyed musical instruments in front of an audience, and Niki de Saint Phalle's *Tirs*, in which she shot guns at assemblages hanging with paint-filled bags that exploded on contact. These and numerous other theatrical events paralleled the development of Happenings by Allan Kaprow, Jim Dine, and Claes Oldenburg in New York. Oldenburg's 1961 environment *The Store*, during which he sold objects from food to clothing in a lower East Side storefront, can be read as an extended performance. In this store, however, the items were plaster and conceived as art. This blurring of art and commerce anticipated the phenomenon of multiples he would champion several years later.[66]

These proto-Pop figures fell into two groups as printmakers: the draftsmen and the object makers, and the chronology of their editioned work fre-

Claes Oldenburg. *Store Poster*. 1961. Lithograph with watercolor additions. Composition: (irreg.) 19 1/8 x 24 3/8" (48.6 x 62.0 cm). Sheet: 20 x 25 15/16" (50.7 x 66.0 cm). Edition: 6; some with watercolor additions. Printer: Pratt Graphics Center, New York. Publisher: the artist. The Museum of Modern Art, New York. The Associates Fund, 1990

The surprising thing is that it took until the mid-fifties for artists to realize that the visual world had been altered by the mass media and changed dramatically enough to make it worth looking at again in terms of painting. Magazines, movies, TV, newspapers, and comics for that matter, assume great importance when we consider the percentage of positively directed visual time they occupy in our urban society.[69]

The economic prosperity of the 1950s brought about a boom in media development. The flood of new consumer products required advertising to publicize them, the revenues of which, in turn, contributed to an expanding media industry.[70] The increased readership was a result of newfound leisure time in this period of economic vitality as well as the higher level of average education. The number of magazines swelled as well, and their visual look improved considerably after World War II, with more creative and appealing design.[71] A marked increase in color reproductions corresponded with rapidly growing circulation. (Newspapers increased color in the 1950s and early 1960s, too.) And, between 1947 and 1957 the number of televisions in American households went from 10,000 to 10,000,000![72]

The earliest manifestations of the new media's influence on art appeared in London in the early 1950s. The discussion and exhibition circle known as the Independent Group, with members including Alloway, Hamilton, Eduardo Paolozzi, design theorist Reyner Banham, and artist John McHale, began at the Institute of Contemporary Arts in 1952 and focused its intellectual exploration on contemporary popular culture, art, and technology. American pulp magazines, brought back to London by McHale and others in the early 1950s, served as source material for this study of mass culture. Their series of exhibitions reached a climax with *This is Tomorrow* held at the Whitechapel Gallery in 1956. A media event itself, this exhibition received tremendous press coverage, and the opening was attended by Robbie the Robot, the leading character in the MGM sci-fi film *Forbidden Planet*. Collagelike prints, including Hamilton's *Interior* and Paolozzi's *Moonstrips Empire News,* would appear by the mid-1960s reflecting these artists' thorough immersion in the American media. Paolozzi compiled voluminous scrapbooks from magazines and other printed ephemera sources which provided seemingly endless inspiration and raw material for his prints. In the incisive and critical work *Swingeing London 67—poster* of 1968, Hamilton satirized the media coverage of the arrest for drug possession of his art dealer Robert Fraser and Rolling Stone Mick Jagger. By reproducing a collage of press clippings Hamilton highlighted the offensive, contradictory, and sensationalist nature of the media, while reproaching the authorities for their actions.

Warhol's *Cagney* and Hamilton's *My Marilyn* testify to film's influence on the visual arts and the growing celebrity fascination promoted in the expanding popular press. Movie studios made film stills readily available, and these photos were easy to find at New York flea markets and numerous film boutiques in the 1960s. Classic Hollywood films were enjoying a heyday in Europe

quently lagged considerably behind their breakthroughs in painting and sculpture. Johns, Oldenburg, and other Americans including Larry Rivers, made beautifully executed lithographs that evidence their drawing talents and their links to the expressionist tendencies of the previous generation. The brash color and slick surface of the screenprint were not appropriate for their painterly approaches. But it was this generation in America that revitalized printmaking as a valid and integral vehicle for vanguard artists and had a resounding impact on their Pop followers.

Of the Nouveaux Réalistes, Arman and Christo became prolific printmakers but also made multiple objects. Christo's *Wrapped Look Magazine* was part of Spoerri's Édition MAT. Spoerri, himself, found his niche in multiples, claiming prints were "too flat." In 1973 he ingeniously made a lithograph on paper into a three-dimensional pop-up object.[67] Mimmo Rotella turned to prints later in his career, but his 1962 multiple *Little Monument to Rotella* resonates as a Duchampian readymade from a commodity culture. Italian Enrico Baj believed strongly in multiple art and worked extensively in prints, books, and multiple objects beginning in the 1950s. Favoring etching over other mediums, he frequently incorporated commercial logos and other found printed ephemera into his figurative images during the early 1960s. His inventive multiples of plastics and other manufactured found objects were a meaningful part of the object-based European developments.

Mass Media

"The communication system of the twentieth century is, in a special sense, Pop Art's subject," wrote British art historian and early Pop champion Lawrence Alloway in 1969.[68] For the first time in the history of art, items such as advertisements, comic strips, movie stills, postcards, magazine and newspaper photographs, and television played a dominant role in artists' creative thinking. Richard Hamilton wrote about media's influence on the return of representation into art after decades of modernist abstraction:

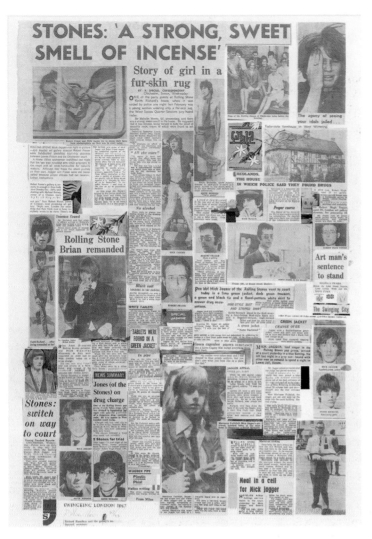

Richard Hamilton. *Swingeing London 67—poster.* (1968.) Photolithograph, printed in color. Composition: (irreg.) 27 3/16 x 18 3/4" (69.0 x 47.6 cm). Sheet: 27 11/16 x 19 3/4" (70.4 x 50.1 cm). Publisher: ED 912, Milan. Printer: Grafica Uno, Milan. Edition: 50 signed plus 1,950 unsigned. The Museum of Modern Art, New York. John B. Jakobson Foundation Fund, 1969

as well. But the radically different compositional structures of these two screenprints illustrate one of the consistent contrasts between European and American Pop. Although Hamilton avoided any personal hand markings in this collagelike image, as did Warhol in his photoscreenprinting technique, the British artist's manipulation of found photographs printed in attractive pinks, blues, and lavenders yields elaborate painterly results. Warhol's bold, confrontational single image by contrast, only barely alludes to such conventions with the stray faulty printing marks that scrape across the surface. A stylistic simplicity and visual potency define the Warhol in opposition to an overall complexity and layered impact in the Hamilton. Many of the American Pop artists had evolved their styles after extended periods as commercial artists, which contributed to their brasher, iconoclastic approach. Despite the conceptual break, the European artists' styles show a greater affinity with the long tradition of European painting.

A parallel dichotomy becomes apparent when comparing Roy Lichtenstein's and Öyvind Fahlström's respective appropriations of the comic strip. Numerous European artists, including Picasso, have been enthusiasts of American comics and have incorporated stylistic aspects into their work. It was not until the late 1950s and early 1960s, however, that American artists turned to this popular art form for inspiration. Lichtenstein used scale as a crucial element in *Foot and Hand,* as the menacing boot nearly fills the entire image. Fahlström, on the other hand, plays off the comic strip's multi-part format in the amalgam of small characters and moveable elements of *Eddie (Sylvie's brother) in the Desert.*

Consumer Culture

Intimately intertwined with the postwar media expansion were the dramatic changes and staggering increase in advertising. In 1962 *Time* reported that the average American was exposed to approximately 1,600 advertisements per day.[73] The industrialized economies of the world had been transformed into avid consumer cultures with the United States in the lead. In England the long postwar austerity had ended by the late 1950s, giving way to the intense development of an internal consumer market by the conservative Macmillan government, in power from 1957–63. A historic surge in research and development by American industry, government, and universities led to countless new products, which in turn met with and appeased a pent-up consumer demand.[74]

The nature of the advertisements themselves was also radically redesigned. Within the print media, the technological changes in photography and printing permitted vivid color images. The advertised products were now isolated in large color photographic depictions with less and less text. Many more ads occupied full pages, and even double-page spreads had become commonplace.[75] The abundance of new products led to a new focus on packaging as well. The development of the supermarket or help-yourself shopping heightened the need for manufacturers to distinguish their products with creative symbols. Advertisers increasingly used repetition and uniformity as stylistic devices to visually imprint these new logos on the consuming public.[76]

The artists who grew up in this milieu responded to this overwhelming visual bombardment through their work. Commodity as art appeared more in the work of the American Pop artists than that of their European counterparts. Warhol's Campbell Soup images are his most well-known representations of this phenomenon, but even more pointed is *S&H Green Stamps,* in which he depicts an actual currency of the commodity culture. The ephemeral format of his printed version of this image, as exhibition mailer and wallpaper, makes ironic comment on the commercial nature of the source. James Rosenquist repeatedly incorporated logos of various everyday household items into his work, from GE to Kleenex to Tide. But unlike Warhol, Rosenquist often used advertisements from the 1950s, just out-of-date but not yet nostalgic, to distance his work from contemporary mass culture. Some artists added a critical tone to their corporate logo borrowings. In Briton Richard Smith's *PM Zoom,* the thrusting and irradiated blue cigarettes appear ominous and contaminated, ridiculing both the manufacturer and the advertising strategy that promotes it. In *Cigar Box,* Rivers's trademark appropriation lampoons the transformation of an American statesman into a symbol of commerce as well as the absurdity of the company's unfounded claim of "superiority."

The burgeoning of the vast urban megalopolis in the 1950s led to the construction of nationwide highway networks, and the increasing numbers of Americans living in suburbs fostered a new attention on the automobile. In 1958 the U.S. government authorized an ad campaign "You auto buy" to promote car consumption.[77] Aggressive advertising by the automobile industry followed suit, reaching new highs in the late 1950s.[78] This ongoing publicity offensive was reflected by several artists, most notably Ed Ruscha and Allan

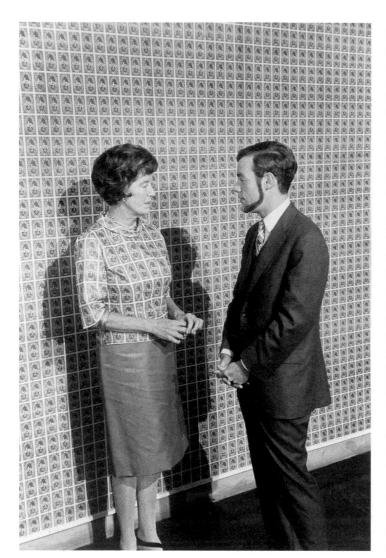

Opening of *Andy Warhol* at the Institute of Contemporary Art, Philadelphia, October 1965, with Eleanor Biddle Lloyd and Samuel Adams Green. © The Architectural Archives of the University of Pennsylvania, Philadelphia

D'Arcangelo, in their imagery of corporate gasoline logos and the endless American highway. The multitude of highway signage that accompanied this construction and its standardized graphic formats undoubtedly inspired Robert Indiana's overall compositional structure of repeated geometric shapes. His clipped, simple word images also spoofed the verbal assault of these signs. Images of cars themselves also proliferated during the Pop period. British artist Colin Self was fascinated with American auto magazines, where he found the model for the car in his Power and Beauty series—a truly monumental vision of potency. Other British artists, including Gerald Laing and Peter Phillips, repeatedly featured glowing silver automobiles in their depictions of the imagined glamour of American culture.

Food became a defining aspect of the American image in this period, which witnessed the development of fast-food chains, brand-name labels, and giant supermarkets.[79] The subject was ubiquitous in American Pop art. Oldenburg and Lichtenstein focused on modest, ordinary food, the kind found

in inexpensive automats and coffee shops. Pizza, sandwiches, baked potatoes, and ice cream sodas were examples of democratic, everyman comfort food. Lichtenstein's *Sandwich and Soda* and *Turkey Shopping Bag* images were ultimately derived from generic newspaper or Yellow Pages advertisements that targeted a broad cross-section of the American public. Warhol, who concentrated on food packaging rather than food itself, also adhered to the most common, universal varieties, illustrating his belief that popular food had become the common denominator between the classes. Although food imagery has historically belonged to the classic still-life genre, these Pop renderings broke new ground in their scale, confrontational pose, and anti-art sources, engendering as much virulent criticism as popular appeal.

Politics

The sixties was a period of political turmoil around the world, from the assassinations of John F. Kennedy, Martin Luther King, Jr., and Robert Kennedy to the Vietnam War, Chinese Cultural Revolution, and 1968 civil unrest in France and Germany. Many Pop artists reflected this upheaval in their work, and printmaking offered the ideal vehicle to focus on the mediated interpretations of these crises. The use of printed art as a tool for social and political expression has a venerable history dating back to Hogarth, Goya, Daumier, and the Mexican muralists.[80] Contrary to the conventional view of Pop artists as ideologically distanced from their subject matter, many, in fact, scrutinized the printed and electronic media for appropriate images to transform into subtle political protest.

By the 1960s the vast media industry in the United States had been consolidated into a few communications giants, which contributed to a uniformity of news reporting across the country. Often the same photograph or video clip was shown again and again in periodicals and television networks, inuring the public to certain images no matter how potent the content. This phenomenon underlies much of Warhol's political imagery such as that in his painfully evocative illustrated book *Flash—November 22, 1963* by Phillip Greer. This quintessential media-based project incorporates instantly recognizable massmedia images of the unforgettable events surrounding the Kennedy assassination with a text simulating a press news wire to accompany them.

Kennedy's role as a television president further encouraged expanded media coverage of political events. The civil rights unrest in the American South was plainly visible in living rooms around the country. Warhol reacted to these events, and to the deadening impact of the media's saturating coverage of them, in *Birmingham Race Riot.*[81] He intended this work to strike a powerful, political chord, repeating to his printer George Townsend that this episode was a "blot on the American conscience" as he requested a muddier printing. Townsend recalled that Warhol "wanted it to be dark and foreboding."[82]

European Pop artists responded to the social and political events of the period to a much greater extent than their American counterparts. Political events occupied their artistic thinking more than relics of consumer culture. Treating powerful political images, however, with the same confrontational stylistic codes used for depicting commercial objects intensified the disturbing impact of these images. In *Kent State*, Hamilton distilled a bold political image to comment on the tragic outcome of a student protest in the United States. Gerhard Richter and Wolf Vostell creatively co-opted media images of military aircraft. Their cool and still depictions comment on the rearmament of the German military and these threatening planes as symbols of sanctioned

Gerhard Richter. *Elisabeth II*. 1966. Photolithograph, printed in color. Composition and sheet: 27 9/16 x 23 7/16" (70.0 x 59.5 cm). Edition: 50. Publisher: edition h, Hannover. Printer: unknown. The Museum of Modern Art, New York. Gift of the Cosmopolitan Arts Foundation, 1978. Photo: Courtesy Nolan / Eckman Gallery, New York

violence. In contrast with these monotone, photo-based images, Spaniard Eduardo Arroyo made his political critique using a vibrant hand-drawn Pop composition of Nazi war planes. Several Pop artists also used their printed art to express their advocacy for revolutionary figures or opposition against reactionary ones. Joe Tilson did a series of prints and unique works of Che Guevara and Lenin. Fahlström lambasted Henry Kissinger in a series of printed works, Richter made images of England's Queen Elizabeth, and Bernard Rancillac did monumental screenprints of Malcolm X. The explosive events of this tumultuous decade engendered an effusion of aesthetic responses, and printmaking offered the most conceptually appropriate, financially viable, and far-reaching form of expression.

Erotica

One of the defining social changes of the turbulent sixties was the drastic liberalization of sexual mores. A broad spectrum of events precipitated more open attitudes toward sexuality allowing greater tolerance for aesthetic displays of erotic imagery. The Kinsey Report, "Sexual Behavior in the Human Female," was published in 1953 inciting a storm of publicity. In a landmark Supreme Court decision of 1957, Justice William Brennan wrote the majority opinion that decisively narrowed the definition of obscenity and opened the floodgates to a wave of previously banned material.[83] Vladimir Nabokov's *Lolita* was published in the U.S. in 1958, although still illegal in France, and the following year D. H. Lawrence's *Lady Chatterley's Lover* was available on American bookshelves as well. *Playboy* magazine was launched in 1953, both responding and contributing to the relaxation of attitudes towards sexuality in

the media. It became an immediate success, selling over 50,000 copies of its first issue and expanding its monthly run to 900,000 by 1957. *Playboy* also signaled a new acceptance of public nudity. It quickly appeared on mainstream newsstands, distinct from the underground pornographic magazines. By 1960 nude photographs had been published in *Harper's* and the European bikini was beginning to pop up on American beaches. Also that year, the U.S. Food and Drug Administration approved a contraceptive pill, which would be marketed in Britain two years later.

A similar phenomenon was occurring in Europe. In England, Reyner Banham gave a lecture in the mid-1950s at the Institute of Contemporary Arts on car styling, Detroit, and sex symbolism. In the sixties, homosexuality was officially decriminalized, and *Lady Chatterley's Lover* was finally published in its native country. Mary Quant's miniskirts and the exaggerated cosmetic styles of "Swinging London" sent an overall erotic chord across Europe and the U.S. In France, the erotic image of woman warrior Barbarella first appeared in 1962 in pornographic magazines, then on an album in 1964, and in a mainstream movie in 1968. By the late 1960s eroticism was a dominant motif in design material from posters to album covers to furniture.[84]

Along with this outburst of sexual imagery arose the issue of sexual stereotyping. The *Playboy* centerfold was presented as a consumer object, following in the tradition of the 1940s pin-up in its subtle debasement of women, but here legitimated by its substantive editorial context.[85] Advertisers quickly caught on to the new permissiveness, and suggestive ads of women in languorous poses further pigeon-holed the "ideal" woman. Pop art's media-based imagery clearly mirrors these stereotypes. A work such as K. P. Brehmer's *Pin-Up 25. The feeling between the fingertips…* exaggerates the erotic intent of an advertisement by attaching seed packets picturing phallic-shaped vegetables. The work's format as a freestanding object mimics store come-on signage and further satirizes the reading of woman as commercial product. European Pop artists more generally appropriated highly suggestive photographic images, as in Sigmar Polke's *Girlfriends*. England's Phillips presented some of the harshest depictions, using provocatively posed photographic renderings of women against metallic cars and brash abstract backgrounds. Raysse used photography to graphically critique society's standards of beauty, appropriating images of fashion models and cosmetic props to spoof the glamorous and superficial.

American artists Tom Wesselmann and Mel Ramos are known for their erotic images, but their hand-drawn figures evoke a less lascivious effect than their European counterparts' photographic renderings. Wesselmann's cropped details appear more abstract than attractive in their limited palette and streamlined contours. Ramos's suggestively dressed comic heroines seem almost nostalgic in tone, reminiscent of 1940s pin-ups. In *Señorita Rio* he even empowers his female model by arming her with the customarily phallic pistol.

But the Pop artist most identified with erotica is Briton Allen Jones. Although not photo-based in format, Jones's prints are closest to the original provocative nature of the classic pin-up, and some of his later work can be quite disturbing. Although a self-proclaimed formalist, Jones made the stiletto heel his trademark, often depicting long-legged, naked women in suggestive poses as sexual objects. And, yet, erotic imagery had become so acceptable by the mid-1960s that the Welsh Arts Council commissioned Jones to make a billboard (see fig., p. 22). In an early use of public art in printed form, these signature, vibrantly colored legs appeared above Welsh streets in 1967.

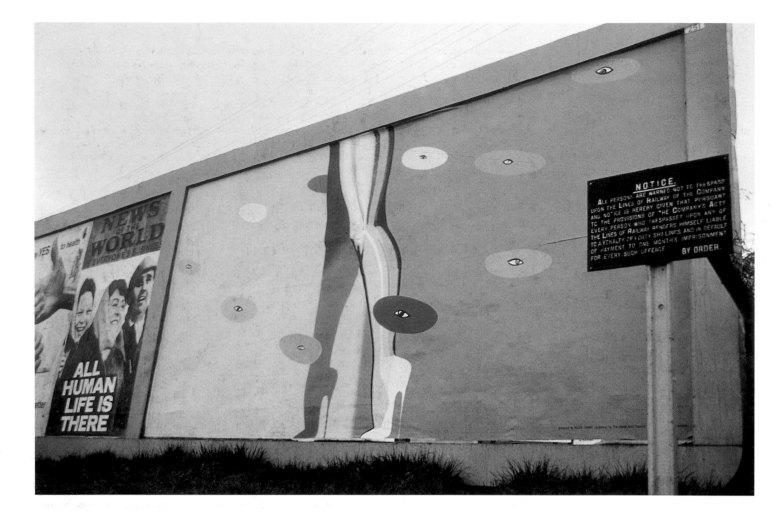

Allen Jones. *Legs.* 1967. Screenprinted billboard, printed in color. Overall: 10 x 20' (304.8 x 609.6 cm). Publisher: The Welsh Arts Council, Cardiff. Photo: Courtesy The Arts Council of Wales, Cardiff

Pop Art was the first art movement for goodness knows how long to accept and reflect the world in which it lives…. In other words, there is a conspicuous absence of 20th century iconography in 20th century art — until Pop Art. Before POP all ART hid behind being "ARTY." Art had reached such a state of insincerity and pretentiousness, POP was a real revelation.[86]

It was startling to see a work of art that depicted a box of Kleenex tissues or an image taken from the newly ubiquitous television set. But it was even more startling to receive art folded up in the mail, printed on a shopping bag, or run off in an edition of several thousand. Printmaking, and screenprinting in particular, philosophically and formally enhanced the fundamental principles of the Pop aesthetic. The conceptual leaps that are embodied in Pop prints and multiples question issues of uniqueness and multiplicity, and originality and reproduction that are at the core of traditional notions about art. These editioned works manifest ideas similar to those in Duchamp's readymades and Sol LeWitt's wall drawings executed by assistants. Artists of the 1980s completely usurped Pop's commercial sources by creating multiple art within the realm of the media itself, as illustrated in Barbara Kruger's billboards and Jenny Holzer's LED signs. Sherrie Levine's photographs of photographic reproductions of another artist's photographs, as audacious as they may be, are unthinkable without Richter's appropriation and transformation of a newspaper photograph of Mao into a collotype edition of 500 or Warhol's reproduced sheet of S&H Green Stamps. Félix González-Torres's 1990 unlimited giveaway stacks of printed images are direct descendants as well. The outburst of printed art that accompanied the "revelation" of Pop iconography has had a lasting impact on the medium and become completely integrated into many of the most compelling arguments in contemporary artistic thinking.

Notes

1 Hamilton used the term "Pop Art" here to refer to art for mass culture. Pop as a fine art movement had not yet surfaced. Hamilton, letter to Peter and Alison Smithson, January 16, 1957. Published in *Richard Hamilton Collected Words 1953–1982* (London: Thames and Hudson, 1982), p. 28.

2 According to The Museum of Modern Art Annual Reports, the Museum's annual attendance was "over 500,000" in 1960–61 and jumped to 1,033,254 for the 1968–69 season. For more on the expanding cultural audience, see Alvin Toffler, *Culture Consumers: Art and Affluence in America* (New York: St. Martin's Press, 1964).

3 Andreas Huyssen, *After the Great Divide: Modernism, Mass Culture, Postmodernism* (Bloomington and Indianapolis: Indiana University Press, 1986), p. 231, n. 2.

4 There were interesting Pop developments in industrial economies worldwide which deserve further study. In Japan, in particular, there were several artists working within a strong Pop aesthetic, including Tadanori Yokoo, Ushio Shinohara, E'wao Kagoshima, and Hideo Yoshihara, as well as Masuo Ikeda in his early work.

5 The exhibition, organized by William C. Seitz, included proto-Pop figures such as Arman, Enrico Baj, Paolozzi, Martial Raysse, Mimmo Rotella, Niki de Saint Phalle, Daniel Spoerri, and Tinguely, as well as Americans Robert Indiana, Johns, Marisol, and Rauschenberg. The exhibition later traveled to Dallas and San Francisco.

6 This exhibition was modeled after an exhibition organized by Pierre Restany at Galerie Rive Droite, Paris, titled *Nouveau Réalisme à Paris et à New York*. See Stephen Henry Madoff, ed., *Pop Art: A Critical History* (Berkeley: University of California Press, 1997) for contemporary reviews, including Brian O'Doherty, "Art: Avant-Garde Revolt," reprinted from *The New York Times*, October 31, 1962, p. 41.

7 Johns's exhibition was held at Galerie Rive Droite in June 1961, and Rauschenberg's was held at Galerie Daniel Cordier in May 1961.

8 Gerhard Richter, for example, has cited the Sonnabend exhibitions as extremely important for him. See "An Interview with Gerhard Richter by Benjamin H. D. Buchloh," in Roald Nasgaard, *Gerhard Richter Paintings* (London: Thames and Hudson, 1988), p. 17.

9 The *Popular Image Exhibition* was originally held at the Washington Gallery of Modern Art, Washington, D.C., and then traveled to London. *Schrift en beeld* was held at the Stedelijk Museum in Amsterdam and traveled in West Germany. In 1964 there were other important European museum exhibitions that featured the American Pop artists including *Amerikansk pop-kunst* at the Moderna Museet in Stockholm, which also traveled extensively, *New Realists and Pop Art* at the Berlin Academy of Art, and the XXXII Venice Biennale, which featured the work of Johns, Rauschenberg, Oldenburg, and Jim Dine in the American Pavilion.

10 See Alfred Pacquement, "Les Européens à New York, l'hôtel Chelsea, Happening et Fluxus," in Pontus Hulten, ed., *Paris–New York* (Paris: Musée national d'art moderne, Centre Georges Pompidou, 1977), p. 608.

11 Laing had worked for Robert Indiana during the summer of 1963, before moving to New York.

12 For more on this period of fertile exchange between Paris and New York artists, see Pacquement, "Nouveau Réalisme et pop art: Le début des années 60," in Hulten, ed., *Paris–New York*, pp. 730–53.

13 For specific information about publishers represented in this volume, see the "Notes on the Publishers" beginning on p. 128.

14 It is not known exactly when the screenprint medium was invented. It was patented in the U.S. for use with photography in 1906 and was used commercially by signwriters beginning in the mid-1910s. Because of the simplicity of the tools required, screenprinting could be used by artists without the assistance of a major workshop, and up through the 1950s American artists primarily printed screenprints themselves. Richard S. Field's essay in *Silkscreen: History of a Medium* (Philadelphia: Philadelphia Museum of Art, 1971) provides the most cogent and insightful description of the artistic potential of the medium.

15 British art schools after World War II had active printmaking programs, and graduates were usually experienced in the medium, creating an eager and knowledgeable audience.

16 In the mid-1950s because of the lack of workshops open to artists, British artist John Coplans set up a screenprint shop in his studio and offered his friends the use of its facilities. At this point, there was more artistic activity in the medium in England than in the U.S. See Reba and Dave Williams, "The Later History of the Screenprint," *Print Quarterly* IV, no. 4 (1987): 393. This article and "The Earlier History of the Screenprint," *Print Quarterly* III, no. 3 (1986): 287–96, present important original research on the artistic developments of the medium.

17 For the history and development of Prater's historic workshop, see Pat Gilmour, *Kelpra Studio* (London: The Tate Gallery, 1980).

18 Hamilton was introduced to Prater by artist Gordon House. House had collaborated with Prater in 1961 on a suite of five screenprints, the printer's first project with an artist.

19 For a list of the artists in this portfolio see the Derek Boshier plate entry, p. 65, n. 1.

20 Indicative of the conservative views of printmaking at the time, a controversy ensued in 1965 at the 4th Paris Biennial, Salon de la Jeune Peinture, over Patrick Caulfield's print *Ruins*, from *The ICA Portfolio*. The show's organizers segregated it from the "original prints" section because they felt that Prater's stencil cutting after a gouache by the artist represented too much involvement by the printer / craftsman. In spite of this, Caulfield won the Prix des Jeunes Artistes.

21 Prater initially worked with hand-cut stencils only and contracted out the photographic work. In 1967 he hired cameraman Dennis Francis, enabling Kelpra to complete the photoscreenprint projects in-house as well.

22 Paolozzi, letter to the author, June 1998.

23 For an excellent history of screenprinting in France, see Sylvie Bacot, "La sérigraphie d'art en France," *Nouvelles de l'Estampe* (Paris) 72 (1983): 9–13.

24 Though they continued to work in lithography and etching, respectively, even France's established workshops Maeght Éditeur and Éditions Georges Visat, known for their collaborations with modern masters such as Matisse and Max Ernst, published the young French Pop artists in the late 1960s and early 1970s. Klasen and Télémaque collaborated with both of these workshops.

25 According to Caza, the French police, unaware of the simple tools needed for screenprinting, raided the school in search of printing presses in order to stop the poster making. Caza, letter to the author, January 1998. For more information on this fascinating moment in printmaking's history, see *Posters from the Revolution, Paris, May, 1968: Texts and Posters by Atelier Populaire* (London: Dobson Books, 1969).

26 Bacot, "La sérigraphie d'art en France," p. 13.

27 Carol Cutler, "Multiples in Paris," *Art in America* 56, no. 6 (November 1968): 92–94.

28 Prisunic published prints by several of the Nouveaux Réalistes, including Arman, Christo, and Saint Phalle.

29 The full name was Editions Kerlikowsky, Audouard + Kneiding and they published works by Erró, Klasen, Raysse, Télémaque, and Wolf Vostell, among others.

30 KWY was founded by Portuguese artists René Bertholo and Lourdes Castro. A different artist was asked to guest edit each issue. Several of the Nouveaux Réalistes, including Christo and Raysse, were asked to contribute original prints.

31 Caza, letter to the author, January 1998.

32 After World War II, the United States Information Agency embarked on a series of international traveling exhibitions of American screenprints.

33 Domberger met Indiana on his first trip to New York in 1968 and published *Numbers* later that year.

34 Haas founded his workshop in 1960. Hamilton went to Stuttgart expressly to work with Haas for his print *I'm Dreaming of a Black Christmas*. He knew of his work through Roth, whose *6 Piccadillies* was printed with Haas. For more on Haas, see Roth plate entry, p. 48, n. 3. Kicherer studied art and began at Domberger's in 1957 on a student internship. For more on these printers, see Michael Domberger, *30 Jahre Domberger, 20 Jahre Haas, 15 Jahre Kicherer* (Tübingen, Germany: Kunsthalle Tübingen, 1979). Text by Manfred de la Motte.

35 Möller was trained in commercial printing and then worked as a graphic designer developing trademarks for a large marketing firm. The name HofhausPresse was derived from the location of the original house / workshop, which was located in a small courtyard or "Hof" in Düsseldorf.

36 Galerie René Block opened in 1964 with the exhibition *Neodada, Pop, Décollage, Kapitalistischen Realismus*. Block became a leading force in the Berlin art world and used his gallery to stage Happenings and events, as well as art exhibitions. He was also active in social and political activities in Berlin and became a prominent supporter of Fluxus.

37 The artists in the portfolio are K. P. Brehmer, K. H. Hödicke, Konrad Lueg, Polke, Richter, and Vostell.

38 Block, conversation with the author, June 1998.

39 Dujardin, conversation with the author, August 1998.

40 Ruscha credits Tamarind Lithography Workshop as the most instrumental in his development as a printmaker. Ruscha, letter to the author, May 1998.

41 It was, however, two European publishers, Arturo Schwarz in Milan, and E. W. Kornfeld in Bern, who offered many of the American Pop artists their introduction to printmaking with their respective ambitious projects *International Anthology of Contemporary Engraving: The International Avant-Garde; America Discovered* and *1¢ Life*.

42 Sirocco was founded in 1950 in New Haven by tycoon inventor and photographer Paul Sperry. (The firm was named after his yacht.) It was managed by George Townsend who later became a partner and then owner. They continued to work with artists through the 1980s, while also sustaining their commercial business. The firm still exists as a commercial screenprinter and is run by Townsend's son, James.

43 As a young artist, Poleskie moved to New York from Pennsylvania. He made several woodcuts as a student and taught himself screenprinting from a Sherwin-Williams Company manual. Chiron Press, named after the mythological Greek centaur and craftsman, made their first prints with Alfred Jensen, but also did commercial work — posters, cards, announcements — for a variety of institutions, including The Museum of Modern Art. It was originally located at 614 East 11 Street, moving to 76 Jefferson Street in lower Manhattan in 1965. In 1968 Poleskie began teaching art and printmaking at Cornell University, in Ithaca, N. Y., where he still lives. He sold the press to Andrew Vlady, who relocated it to Mexico City. It is now called Kyron Ediciónes Gráficas Limitadas and focuses on lithography. Poleskie, conversation with the author, August 1998.

44 Poleskie, quoted in "On Silkscreen Printing," Artist's Proof: The Journal of Contemporary Prints VII (New York: The Pratt Center for Contemporary Printmaking in cooperation with Barre Publishers, 1967): 78.

45 New York 10 included prints by Richard Anuszkiewicz, Dine, Helen Frankenthaler, Nicholas Krushenick, Robert Kulicke, Mon Levinson, Lichtenstein, Oldenburg, George Segal, and Wesselmann. See Arman plate entry, p. 36, for more on New York International.

46 Esman, letter to the author, May 1998.

47 Kaiden spoke with museum directors including Jack Bauer of the Whitney Museum of American Art, Thomas H. Messer of the Solomon R. Guggenheim Museum, as well as others in Houston, Dallas, San Francisco, and Washington, D.C. Nina Kaiden Wright, conversation with the author, August 1998.

48 Printer and fabricator Dawa Basanow of Knickerbocker Machine and Foundry printed nearly all of the thirty-three editions in the three portfolios. The three prints by Phillips were printed by Chiron Press and the three by Jones by J. & P. Atchinson, London.

49 The AFA exhibition was titled Pop and Op. A separate international tour of the three portfolios was organized titled 11 Pop Artists: The New Image.

50 Warhol's casual approach to concerns of authorship is exemplified by the broad range of his signed and unsigned printed ephemera from shopping bags to exhibition mailers to wallpaper. These pieces strongly influenced the development and popularity of this facet of printed art during the Pop period.

51 Warhol's decision to take over the means of production of his prints is similar to the Beatles's takeover of their own music production with the 1968 founding of their personal record label, Apple Records. Warhol's move was inspired in part by his increasing desire to work in film, which required considerable financial investment.

52 The four portfolios published by Factory Additions between 1967 and 1970 are Marilyn Monroe (Marilyn) (1967), Campbell's Soup I (1968), Campbell's Soup II (1969), and Flowers (1970).

53 Fluxus was a loosely knit, nonconformist, international group noted for their Happenings, mixed-media events, publications, concerts, and mail art.

54 Multiples: Ein Versuch die Entwicklung des Auflagenobjektes darzustellen / Multiples: An Attempt to Present the Development of the Object Edition, May 8 – June 15, 1974.

55 Charles Spencer, "The life and death of the multiple," Studio International 186, no. 958 (September 1973): 93.

56 The Betsy Ross Flag and Banner Company was later bought out by Marian Goodman's Multiples, Inc. For an excellent, in-depth study of the development of Pop multiples in the U.S., see Constance W. Glenn, The Great American Pop Art Store: Multiples of the Sixties (Long Beach: University Art Museum, California State University; Santa Monica: Smart Art Press, 1997).

57 Over 400 boxes were made by a team of carpenters for the 1964 Stable Gallery exhibition. See Eric Shanes, Warhol (London: Studio Editions, 1991), p. 96.

58 Warhol had purchased a copy of Duchamp's Boîte-en-valise around 1962 and saw the Duchamp retrospective at the Pasadena Art Museum in 1963.

59 Tea Bag from Four on Plexiglas was fabricated by Basanow.

60 In Europe, stores like Seriaal, which opened in Amsterdam in 1968, were based on similar ideals.

61 Wittenborn and Company, initially Wittenborn & Schultz, became a gathering place for European and American artists and intellectuals from the 1940s on. Originally located on 57 Street, Wittenborn relocated to 1018 Madison Avenue in 1956.

62 Esman, conversation with the author, August 1998.

63 Oldenburg, quoted in John Loring, "Multiple Art in Three Dimensions," Architectural Digest 22, no. 2 (September–October 1976): 138.

64 Bernadette Contensou, 1960: Les Nouveaux Réalistes (Paris: Musée d'Art Moderne de la Ville de Paris, 1986), p. 75.

65 The initial eight members of Nouveau Réalisme were Arman, François Dufrêne, Raymond Hains, Yves Klein, Raysse, Spoerri, Tinguely, and Jacques de la Villeglé. César, Christo, Rotella, and Saint Phalle joined later.

66 Warhol is known to have been very influenced by his visit to The Store. See Shanes, Warhol, p. 96.

67 Spoerri also made two screenprints on cloth, one in 1964 and another in 1970.

68 Alloway, "Popular Culture and Pop Art," Studio International 178, no. 913 (July–August 1969): 17.

69 Hamilton, "Roy Lichtenstein," Studio International 175, no. 896 (January 1968): 24.

70 American magazine readership rose from 32.3 million households in 1947 to 41.5 million in 1959. Life's circulation to American households increased from twenty to twenty-five percent from 1950 to 1962. See Theodore Peterson, Magazines in the Twentieth Century (Urbana: University of Illinois Press, 1964), pp. 45, 57.

71 Peterson, Magazines in the Twentieth Century, p. 36.

72 William L. O'Neill, Coming Apart: An Informal History of America in the 1960s (Chicago: Quadrangle Books, 1977). Reprinted in Jonathan Fineberg, Art Since 1940: Strategies of Being (New York: Harry N. Abrams, 1995), p. 244.

73 See Sidra Stich, Made in U.S.A.: An Americanization in Modern Art; The '50s & '60s (Berkeley and London: University of California Press, 1987), p. 89.

74 Edwin Emery, Phillip H. Ault, and Warren K. Agee, Introduction to Mass Communications (New York: Dodd, Mead & Company, 1970), p. 325.

75 Richard W. Pollay, "The Subsidizing Sizzle: A Descriptive History of Print Advertising 1960–1980," The Journal of Marketing 49, no. 3 (summer 1985): 24.

76 The Hidden Persuaders, Vance Packard's influential book on the subject of advertising's subliminal tactics, was published in 1957.

77 Stich, Made in U.S.A., p. 99.

78 For more on the impact of advertising on modern art, see Kirk Varnedoe and Adam Gopnik, High and Low: Modern Art and Popular Culture (New York: The Museum of Modern Art, 1991), p. 324.

79 For more on this issue, see Stich, "American Food and American Marketing," in Made in U.S.A..

80 For this trend in contemporary American printmaking, see Deborah Wye, Committed to Print: Social and Political Themes in Recent American Printed Art (New York: The Museum of Modern Art, 1988).

81 Indiana, in his Decade portfolio, among other works, also reflected his strong concerns about the American civil rights movement.

82 Townsend, conversation with the author, August 1998.

83 In Samuel Roth v. United States, Brennan wrote that for a work to be deemed pornographic "an average person, applying contemporary standards, [would find that] the dominant theme of the material taken as a whole appeals to prurient interest."

84 For more on eroticism in late 1960s France, see David Mellor and Laurent Gervereau, eds., The Sixties: Britain and France, 1960–1973; The Utopian Years (London: Philip Wilson Publishers Limited, 1997), pp. 65–66.

85 For a history of the pin-up in modern art, see Thomas B. Hess, "Pinup and Icon," in Woman as Sex Object: Studies in Erotic Art, 1730–1970 (New York: Newsweek, 1972), pp. 223–37.

86 Colin Self, quoted in unpublished letter to Marco Livingstone, December 1987, published in Livingstone, ed. Pop Art (London: Royal Academy of Arts and Weidenfeld & Nicolson, 1991), p. 160.

Proto-Pop

Jasper Johns 26

Robert Rauschenberg 28

Daniel Spoerri 30

Christo 32

Enrico Baj 34

Mimmo Rotella 35

Arman 36

Works in the plate section are divided according to the five themes described within the essay. Titles not in English are given in their original language followed by English translations. Dates within parentheses do not appear on the works. Dimensions are given in inches and centimeters, height preceding width for prints and books, and height preceding width preceding depth for three-dimensional objects.

The commentaries on the works of art followed by the initials J. H. were written by Judith Hecker. All others were written by the author.

Jasper Johns

Flag I. 1960

Lithograph
Composition: 17 $^1/_2$ x 26 $^3/_4$" (44.5 x 67.9 cm)
Sheet: 22 $^1/_4$ x 30" (56.5 x 76.2 cm)
Publisher and printer: Universal Limited Art Editions, West Islip, New York
Edition: 23
Gift of Mr. and Mrs. Armand P. Bartos, 1962

Jasper Johns is arguably the most influential artist to emerge in the late 1950s, and his work is of singular importance in the development of Pop. Johns irrevocably altered the way art was perceived through his sensual, painterly attention to commonplace flat objects such as flags, targets, numbers, and maps. He transformed his painted images into objects themselves, creating a perceptual conundrum between illusion and reality that would characterize his entire career. His depiction of single, everyday objects on a field heralded Pop's enlarged, isolated borrowings from the mass media, and his conceptual framework contributed to the European object-based work of Nouveaux Réalistes artists such as Arman and Christo.

Johns made his first *Flag*, a red, white, and blue encaustic and collage on canvas, in 1954–55.[1] In what would become his typical working method, he reiterated the image in various colors, formats, mediums, and contexts, completing forty Flag images by the time he began the lithograph *Flag I* in 1960.[2] Tatyana Grosman, founder of the Long Island print workshop Universal Limited Art Editions (ULAE), had seen Johns's work at Leo Castelli Gallery in 1958 and again in The Museum of Modern Art exhibition *16 Americans* in 1959. She wrote to him in South Carolina in the summer of 1960, inviting him to make prints at her workshop. "I have been following your work for some time. I would like very much to stimulate your interest in working lithography on stone. Your work would lend itself beautifully to this medium."[3] She had met Johns the year before through Larry Rivers, who had previously made prints with ULAE, and it was Rivers who encouraged him to work with Grosman. In September 1960, Johns ventured out to ULAE and, by the end of the month, had completed five lithographs, *Target, Coat Hanger I, 0 through 9, Flag I,* and *Flag II.*[4]

Johns was precocious as a printmaker from the very start and quickly realized that, as Grosman had predicted, printmaking was well suited to his artistic concerns of repetition and change. Working with printer Robert Blackburn, who was with ULAE from 1957 to 1962, Johns initiated a sophisticated approach of reworking and reusing stones to make progressive series of images that allowed him to explore further the motifs that preoccupied him in painting.[5]

Johns made three monochrome prints from the stone used for *Flag I*, changing the ink and the paper, as well as adding marks to the stone with each successive state.[6] For *Flag I* he worked exclusively in black tusche, a liquid medium, covering the stone with broad marks and fluid, scribbled gestures that barely allow the stripes to come into view. The field of stars is so dense that the discernment of a few must serve to satisfy the viewer that they are indeed all there. This blurred, gestural treatment is most reminiscent of a graphite-wash-on-paper drawing that Johns completed in 1959.[7]

Although prints traditionally appear in black and white, a certain morbidity or funereal quality pervades *Flag I* as it slowly emerges from the washy black medium. Perhaps this occurs because the viewer is aware of the vibrant red, white, and blue of its model, notwithstanding Johns's own prior painted versions. Floating on the white paper with full margins, this flag, like the many drawings on paper that preceded it, does not carry an object-like quality typical of the paintings. Rather, it conveys a sign of an object, by now referring back to its progenitors in Johns's own work as much as the original patriotic banner.

1 *Flag.* 1954–55. Encaustic, oil, and collage on fabric mounted on plywood. The Museum of Modern Art, New York.
2 See *Jasper Johns, Flags 1955–1994* (London: Anthony d'Offay Gallery, 1996), with an essay by David Sylvester titled "Saluting the Flags," for a complete listing of Johns's Flag images in all mediums.
3 Tatyana Grosman, draft of letter to Johns, ULAE Archives. August 7, 1960. Published in Kirk Varnedoe, *Jasper Johns: A Retrospective* (New York: The Museum of Modern Art, 1996), p. 168.
4 See the Chronology compiled by Lilian Tone in Varnedoe, *Jasper Johns.* The *0–9* portfolios were begun by this time as well but were not completed until 1963.
5 Johns has typically introduced new motifs in his painting and used printmaking to explore further possibilities of earlier images.
6 For *Flag II* Johns printed the image in white on brown Kraft paper, making the flag almost disappear amidst the expressionistic tusche and added crayon markings. For *Flag III* he used a scraper to animate the surface with energetic lines, printing the image in gray ink on white paper.
7 *Flag.* 1959. Graphite wash on paper. Private collection.

Robert Rauschenberg

License. 1962

Lithograph
Composition: (irreg.) 39 $^3/_8$ x 28 $^1/_2$" (100.0 x 72.4 cm)
Sheet: 41 $^3/_8$ x 29 $^7/_{16}$" (105.1 x 74.8 cm)
Publisher and printer: Universal Limited Art Editions, West Islip, New York
Edition: 16
Gift of the Celeste and Armand Bartos Foundation, 1962

Anything that creates an image on a stone is potential material…a printer's mat, a metal plate, a wet glass or a leaf…. They are an artistic recording of an action as realistic and poetic as a brush stroke.[1]

Robert Rauschenberg was a pioneering figure at mid-century who, along with Jasper Johns, Jim Dine, and Larry Rivers, introduced into American art an iconography based on the real world and literal scale. His strategies also paralleled those of the Paris-based Nouveaux Réalistes Arman, Mimmo Rotella, and Daniel Spoerri, whose techniques and materials incorporated evidence of everyday life. Rauschenberg brought this new level of realism to art with his unusual "combines" of the mid- and late 1950s, which coupled painterly gestures and splashes with jarring three-dimensional objects and collaged photographic images.[2] His experimental approach to artmaking was an important catalyst in the development of a new type of art—one more consciously based on everyday objects and popular culture—that became known as Pop.

Rauschenberg's artistic innovation evidenced itself in his early printmaking experiments. In 1949 he created a work by taking imprints of the flow of feet walking. He made life-size photograms in 1950 with his wife, Susan Weil, by posing their bodies and other objects on architectural blueprint paper that was then exposed to light. With John Cage he created a monumental monoprint, *Automobile Tire Print* (1953), by driving the tire of a Model A Ford through paint and over a twenty-foot scroll of paper. In 1958 he began transferring solvent-saturated newspaper and magazine illustrations onto paper and, four years later, started screenprinting photographic imagery onto canvas. Also in 1962, after a year of urging him, Tatyana Grosman of Universal Limited Art Editions convinced Rauschenberg to try his hand at lithography.

From its inception Rauschenberg's lithography, like his other work, questioned accepted notions of subject, style, and medium. He challenged both the dominance of Abstract Expressionism, which prioritized the spontaneous assertion of the artist's hand over content, and the conventions of lithography, which was valued as a painterly printmaking technique. *License,* Rauschenberg's fifth lithograph, typifies the artist's bridging of gestural abstraction with photo- and object-based imagery. Its strong splashed-out

compositional mass, which expands almost to the edge of the paper, incorporates images from newspapers,[3] including ones of horseracing, car racing, baseball, rafting, industrial construction, and the New York Stock Exchange, as well as reproductions of an Old Master painting and a photograph of a prowling cat. Rubbings of actual objects also appear, as seen in the partial license plate, in the bottom center, from which the work takes its title (perhaps as a pun on Rauschenberg's "artistic" license) and the round object with a pentagonal middle, in the top center.

Though most of the imagery in *License* is photomechanical, it is not sharply defined or easily discerned. Pictures are overlapping, multi-directional, and sometimes reversed and duplicated within the composition, intensifying the feel of media saturation. Rauschenberg also reused photographic elements from *License* in other prints, furthering the interrelationships of his imagery and continually giving life to the material traces of daily existence.[4] As well, heavy markings overlay the images in *License,* blurring the distinction between what is borrowed and what is a product of the artist's hand. The print's monotone palette of brown, gray, and black, together with its photographic graininess and whirling handwork amplify the abstract and suggestive nature of this work, leaving the act of interpretation to the spectator.[5]

But while precise meaning is obscured and Rauschenberg's working method improvisatory, the viewer is still able to recognize the print's common images and their mass media and environmental sources. More broadly, *License* exemplifies how inventively Rauschenberg translated his early insertion of actual objects, his imprinting of bodies and objects, and his transfer of photographs onto canvas and paper into the practice of lithography. This innovative approach to image-making not only marked a critical turning point in printed art but also laid the groundwork for Pop's more explicit immersion in the commonplace object and the mediated image. — J. H.

1 *Robert Rauschenberg in Black and White: Paintings 1962–1963, Lithographs 1962–1967* (Newport Beach, Calif.: Newport Harbor Art Museum, 1969), n. p.
2 The most notable combines are *Bed* (1955), in which Rauschenberg painted and drew on a framed pillow and quilt, and *Monogram* (1959), in which he placed a taxidermied goat through an automobile tire and on top of a mixed-media canvas on the floor.
3 From 1962 to 1964, Rauschenberg used images from discarded printers' mats (photoengraved halftone plates), which he salvaged from *The New York Times* and *The Herald Tribune,* brought to ULAE, and transferred to lithographic stone.
4 Compare, for instance, the images in *License* to images in *Urban* (1962), *Suburban* (1962), *Stunt Man I, II,* and *III* (all 1962), *Accident* (1963), and *Shades* (1964). See Esther Sparks, *Universal Limited Art Editions: A History and Catalogue, The First Twenty-Five Years* (Chicago: The Art Institute of Chicago; New York: Harry N. Abrams, 1989), pp. 430–32. Because four stones were used to print *License* (Rauschenberg's stones frequently broke due to uneven pressure in the press), the individual components appear in other prints. Rauschenberg also reused individual images by retransferring his photoscreens to other stones.
5 In 1969 Rauschenberg began photosensitizing stones in a way that could produce an exact transfer of an original image. With this technique, and his introduction of photoetching in 1979 and photogravure in 1986, his content became more literal.

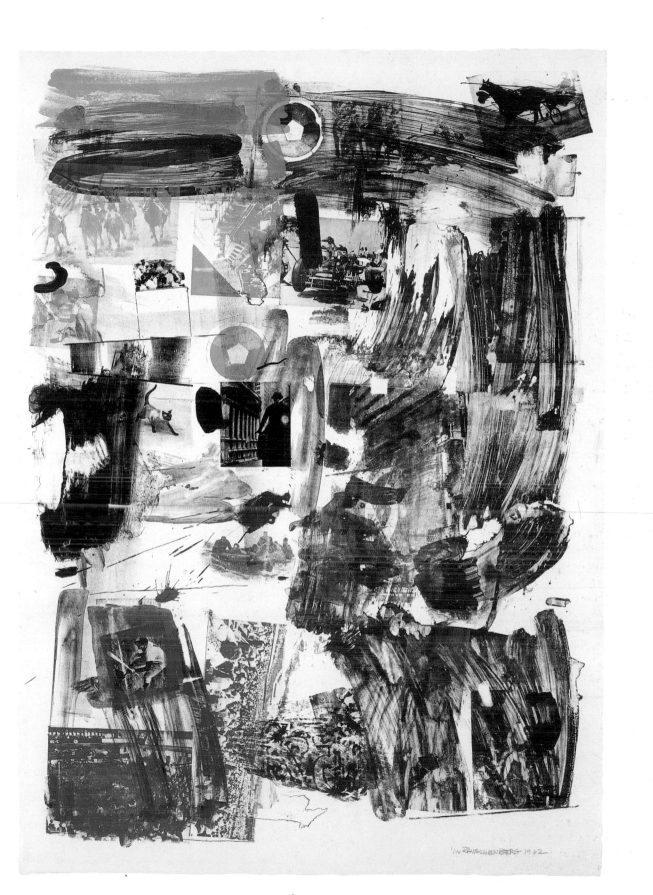

Daniel Spoerri
(Daniel Isaac Feinstein)

Untitled from the portfolio *Les Nouveaux Réalistes*
(The New Realists). (1973)

Pop-up photolithograph and matchstick collage mounted on board
Composition: (open) 26 $^{13}/_{16}$ x 26 $^{13}/_{16}$ x 5 $^{5}/_{8}$" (68.1 x 68.1 x 14.2 cm);
(closed) 19 $^{1}/_{8}$ x 19 $^{1}/_{8}$" (48.5 x 48.5 cm)
Publisher: Attilio Codognato, Venice, for Ars Viva, Zurich
Printer: Studio L'Ariete, Milan
Edition: 600
Walter Thayer Bequest, 1989

Daniel Spoerri was a founding member, along with Arman, Yves Klein, and Martial Raysse, of the Paris-based movement known as Nouveau Réalisme, whose concerns paralleled those of Americans such as Jasper Johns and Robert Rauschenberg in their search for a means to incorporate the everyday world into their art. Prior to becoming a visual artist, Spoerri was a professional dancer, travelling throughout Europe and meeting many of the vanguard artists of the period. He finally settled in Paris in 1958 and began making art two years later. His found-object assemblages, coming out of a Surrealist / Dadaist aesthetic, focused on food and the ritual of eating. He is best known for his *tableaux-pièges*, or "snare pictures," made by gluing down the objects left on a table after a meal—used plates, empty wine bottles, dirty ashtrays—and hanging the resulting construction on the wall. Many of these "snare pictures" were exhibited in the Restaurant Spoerri and its upstairs Eat-Art Gallery, which he opened in Düsseldorf in 1968 and 1970, respectively.

In the early 1970s, publisher and dealer Attilio Codognato, owner of Galleria del Leone in Venice, collaborated with printer Giorgio Barutti of Studio L'Ariete in Milan on an elaborate project to document the artists associated with Nouveau Réalisme. Boxed in a large leather suitcase inspired by Marcel Duchamp's *Boîte-en-valise*, *Les Nouveaux Réalistes* appeared nearly a decade after the group had disbanded. It is the only printed compendium of the artists in this vanguard movement and comprises eleven prints and one multiple in an edition of 600. Spoerri's contribution is this photolithographed pop-up construction based on a photograph of a meal at the Restaurant Spoerri. He made a mass edition of paper tablecloths of this image in 1971, printing 16,500[1]; one of these ephemeral tablecloths served as the foundation for this pop-up, completed two years later. A commercial printer made the 600 photolithographs, and the pop-up assembly was carried out at Studio L'Ariete in Milan.

This unusual three-dimensional format was Spoerri's inventive solution to creating a multiple printed object. As he admitted:

I never dealt with prints. It was too flat....I cannot draw...and I love objects.[2]

He had previously completed multiples in 1964 and 1965 for his own Edition MAT (Multiplication d'Art Transformable) publications, one made of bread, the other a collection of household objects on two angled mirrors. With this lithograph he created a quintessential *tableau-piège* in multiple form, complete with cigarette butts, empty coffee cups, and used cutlery. In its tablecloth format, this work also exemplifies Spoerri's ironic humor by transforming the detritus of one meal into the setting for another. The extraordinary tactility and photographic nature of the printed paper distinguish this piece among Spoerri's multiple projects and illustrate his creative fusion of form and materials.

1 Printed and published by Vontobel-Druck AG in Feldmeilen. The tablecloths were sold in sets of fifty, with one signed example in each set. Many of the tablecloths were actually used in the Restaurant Spoerri.
2 Spoerri, letter to the author, March 1998.

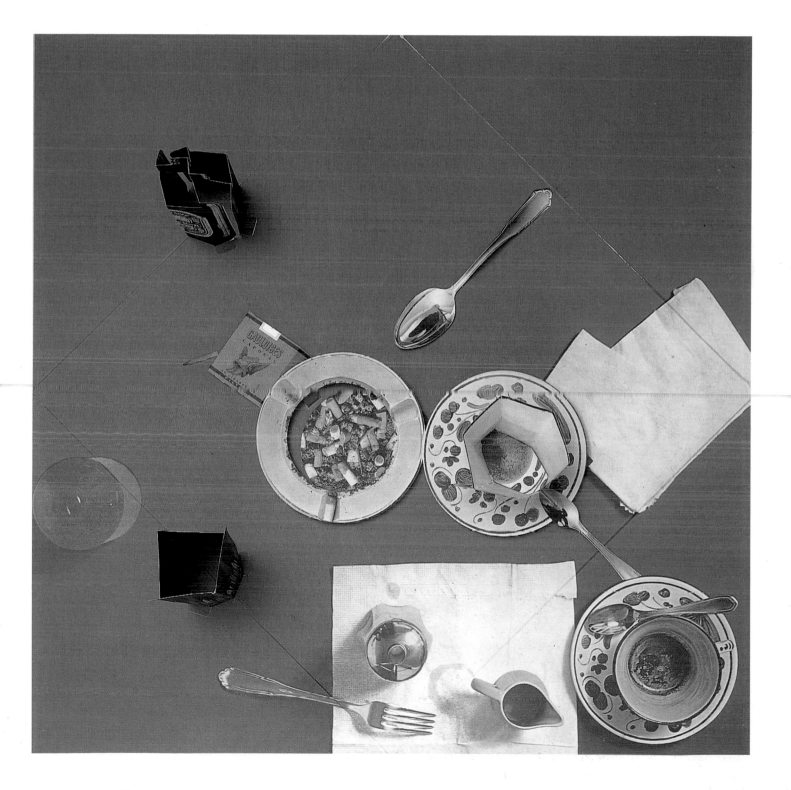

Christo
(Christo Javacheff)

Look Magazine Empaqueté
(Wrapped Look Magazine). 1965

Multiple of *Look* magazine over foam, wrapped in polyethylene and cord,
on wood support
Composition (with wood support): 22 1/8 x 18 x 3 1/4" (56.0 x 45.6 x 8.2 cm)
Publisher: Édition MAT/Galerie Der Spiegel, Cologne
Fabricator: the artist
Edition: 100
Lee and Ann Fensterstock Fund, 1997

Christo left his native Bulgaria in 1956 after years of exposure to Communist ideology and an art based on social realism. After settling in Paris, he became closely associated with the Nouveaux Réalistes group, which included Arman, Martial Raysse, and Daniel Spoerri, among others. In response to the urban and highly materialistic world around them, several of the group, like their American and British counterparts, created assemblages including found objects. In a similar fashion, Christo eschewed the artistic touch and used his work to raise questions about the nature of art and artistic authorship, presaging some of the crucial issues that would emerge in Pop.

Christo began wrapping objects in 1958, the year he arrived in Paris, and wrapping has remained his signature conceptual style. His packaging materials have ranged from polyethylene plastic to burlap, and his objects have ranged from a female figure to a Renault automobile to Florida's outer islands. The theme of commodity packaging and its power to manipulate the consumer was a central issue in the Pop movement. Andy Warhol's numerous depictions of Campbell's soup cans and Brillo boxes are but two examples of Pop's focus on surface appearances. By contrast, while the underlying premise of Christo's wrapping process emphasizes the commodification of our culture, his packaging often draws attention to the contents within, particularly when he wraps in transparent plastic.

His first wrapped magazines appeared in 1961, and Christo completed a large wrapped work, titled *Look*, containing several different popular magazines, in 1963. In the wrapped magazine pieces, Christo mummified the ephemera of the mass media, embalming the record and residue of our culture. An irony resonates within these works, in particular because of their resemblance to actual bundles of tied newspapers and magazines. In 1963 Christo wrapped other commercial objects such as a printing machine, a supermarket cart, and a postcard stand. He also completed his first multiple, a wrapped magazine piece titled *Wrapped Der Spiegel*.

Wrapped Look Magazine, Christo's second multiple, was created for his friend Daniel Spoerri, who had initiated a publishing venture known as Édition MAT, or Multiplication d'Art Transformable. Spoerri was interested in creating multiple objects in order to make three-dimensional art inexpensive and avail-

able to a wide audience. Each object was produced in an edition of 100 and initially sold for under £100. He thought of these multiples as original works in series since, unlike most editioned works, each example in a MAT edition is slightly different. Three series of objects were completed. Ironically, many of these pieces have become rare and expensive collector's items today.

Wrapped Look Magazine was part of the 1965 Édition MAT series. Christo and his wife, Jeanne-Claude, had moved to New York in 1964, and at this time *Look* represented the essence of American consumer culture. The cover story of this particular example, dated January 11, 1966,[1] boldly reads "The American woman" above the alluring face of a well-made-up model, an example of the typical depiction of the American woman as seductress in the popular press of the period.

Christo made each package himself.[2] During its production, an Édition MAT exhibition was planned which led him to design a black wood frame so the piece could be installed on a wall.[3] This essential component lends the work its pictorial quality in contrast to the object quality of the earlier *Wrapped Der Spiegel*, which is meant to be displayed on a flat surface.[4]

By creating a multiple out of an already existing mass-editioned item, Christo further confused the issues of artistic authorship already suggested by his wrappings. Christo's handmade multiples anticipate the explosion of the industrially produced multiple format, seen in such examples as Claes Oldenburg's *Baked Potato* and *London Knees 1966*, and Larry Rivers's *Cigar Box*, which coincided with the Pop movement.

1 The production of this edition began in 1965 but apparently carried into 1966.
2 Christo wrapped a copy of *Look* magazine over several sheets of foam for each. Foam, rather than additional magazines, was used to avoid undue weight. Only fifty-six of the intended edition of one hundred were produced.
3 Christo, conversation with the author, April 1998.
4 In 1964 Christo made a unique piece, *Wrapped Magazines*, a stack of magazines displayed in a white wood frame, that is also meant to hang on the wall.

Enrico Baj

Baj at Marconi's. 1969

Multiple of screenprinted plastic shopping bag with handles, containing two
screenprinted plastic ties, four postcards, three exhibition brochures,
a mannequin arm, and a publicity button
Bag: 17 3/4 x 15 3/4" (45.2 x 40.1 cm)
Publisher: Studio Marconi, Milan
Printer and fabricator: unknown
Edition: 30
Jacqueline Brody Fund, 1997

Enrico Baj's artistic roots are in Surrealism, a movement he came to know
firsthand after meeting Marcel Duchamp, Max Ernst, and André Breton in
Paris. By the late 1950s he was working primarily in collage and assemblage,
placing found objects he had carefully collected—from signs and game
boards to medals and clock faces—against patterned-fabric backgrounds. His
inventiveness with and penchant for readymade materials and his occasional
use of advertising in his collages link him to Pop art sensibilities. With an irrev-
erent humor he attacked humanity's foibles in an eclectic and varied art com-
prised of the stuff of everyday life.

Baj is perhaps best known for his baffoonish images of generals lavishly
decorated with medals which, for him, represent empty symbols of honor and
status. From the medals he developed the motif of the necktie in a series of

works in the late 1960s, and in a 1970 artist's book titled *La Cravate ne Vaut
pas une Médaille,*[1] he explained the tie's iconography as a common man's
medal—the everyday badge of honor. During this period Baj also began
exploring the aesthetic possibilities of plastic and began working in multiples,
which seemed the perfect format for this synthetic material.

In 1968 Baj made a large plastic work titled *The Big Tie* and followed it
with several screenprinted plastic multiples. The centerpiece of his 1969
Studio Marconi exhibition was the *Jackson Pollock Tie,* a monumental plastic
work. The exhibition included several other tie images, all made of plastic. To
accompany the exhibition he made the multiple *Baj at Marconi's*—a plastic
shopping bag replete with souvenirs of his various activities, including post-
cards he had collected in Paris flea markets, catalogues from recent exhibi-
tions of his work, a mannequin arm, and two polka-dot plastic ties.[2] This
light-hearted multiple, which was sold at the exhibition's opening, typifies the
inventive approach to new mediums and man-made materials that character-
izes much of Baj's work and brought him into the orbit of Pop art. In addition,
his strong belief in the social ambitions of art—the desire for a broad dissem-
ination of original work—was in sync with Pop's democratic ideology and nur-
tured his commitment to multiples and printed art.

1 *La Cravate ne Vaut pas une Médaille* by Enrico Baj (Geneva: Rousseau Editeur, 1970). Illustrated
 book containing one lithograph and three multiples.
2 Baj, conversation with the author, June 1998.

Mimmo Rotella

Petit Monument à Rotella
(Little Monument to Rotella). (1962)

Multiple of found Shell oil can on painted wood pedestal with engraved
and painted brass plate
Composition (with wood pedestal): (irreg.) 11 $^3/_{16}$ x 4 $^5/_{16}$ x 4 $^5/_{16}$"
(28.3 x 10.9 x 10.9 cm)
Publisher: Galleria Schwarz, Milan
Fabricator of pedestal and plate: unknown
Edition: 100
Purchase, 1997

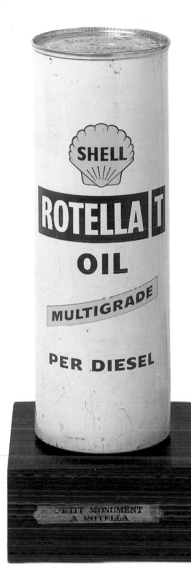

The use of advertising as raw material for art is seen most explicitly in the
work of the *affichistes*, artists, primarily of the Paris-based Nouveaux
Réalistes group, whose work comprised layers of torn-down street posters.
Mimmo Rotella began ripping posters off the walls of Rome streets in 1953,
unaware of French artists Raymond Hains and Jacques de la Villeglé, who had
been working in a similar fashion since 1949.[1] Known as *décollages*, these
readymade objects also paralleled the investigations being made by Robert
Rauschenberg and Jim Dine in the United States in their assemblages with
found objects. The *affichistes* fostered an awareness of the common object as
a tool for artistic expression, both in their use of posters and the posters'
commercial signage, anticipating critical issues of the Pop movement.[2]

Concurrently with the torn-poster works, in the early 1960s Rotella also
made several three-dimensional pieces from found objects, some multiple and
some unique, and, as with the *décollages*, he intervened in their composition
only minimally.[3] In 1962, in an exhibition titled *Cinécittà Ville Ouverte* in Paris,[4]
Rotella brought together a thematic series of *décollage* works centered on
film.[5] (Among the *affichiste* artists, he most clearly presages the Pop fascina-
tion with celebrity, especially in his series of Elvis, Marilyn Monroe, and John F.
Kennedy *décollages*.) In conjunction with the exhibition, Rotella completed his
most well-known multiple, *Little Monument to Rotella*, consisting of a found
Shell oil can on a black wood base. The oil company is named after a seashell,
the *rotella gigantea*. The obvious pun on his name and the derivation of the
word appealed to Rotella's poetic instincts.

Publisher Arturo Schwarz purchased the cans directly from Shell Oil
Company in Milan.[6] Rotella placed them on a wood base with a traditional title
plaque elevating the can to art object status and distinguishing it from a pure
readymade. He used the Shell logo again in a 1968 photographic work. In 1971
he made a polished brass multiple in the form of a shell titled *Rotella Gigantea*,[7]
and in 1972 a series of lithographs with the corporate logo juxtaposed against
a racing-car flag. *Little Monument to Rotella* foreshadows the outburst of mul-
tiples that accompanied Pop and illustrates an early example of the commodity
emphasis that is one of Pop art's most distinctive characteristics.

1 Rotella's torn-poster works, more content-driven than those of his French counterparts, are
carefully "ripped" to create a focus on consumer items or media personalities.

2 The *décollages* also embodied a spirit of protest and defiance, a quality reflected in the radical
content and confrontational compositional effects that would later define Pop.

3 See René Block and Ursula Block, *Multiples: Ein Versuch die Entwicklung des Auflagenobjektes
darzustellen / Multiples: An Attempt to Present the Development of the Object Edition* (Berlin:
Neuer Berliner Kunstverein, 1974). Europe has a longer tradition of multiples than the United
States. Italian artist Bruno Munari was an important force in the popularization of the multiple in
Europe, as was Daniel Spoerri and his Édition MAT.

4 The exhibition was held at Galerie J, run by Jeanine Restany, the wife of critic and co-founder of
Nouveau Réalisme, Pierre Restany.

5 Rotella was an avid film enthusiast, and Cinécittà was the name of a movie studio located near
his home in Rome.

6 Rotella, letter to the author, April 1998.

7 The multiple was produced in an edition of 300, published by Studio Bellini in Milan.

202/225

Arman
(Armand P. Arman)

Boom-Boom
from the portfolio *New York International*. 1966

Screenprint with pencil additions
Composition: (irreg.) 16 ⁵/₈ x 21 ⁵/₈" (42.2 x 54.9 cm)
Sheet: 16 ¹⁵/₁₆ x 21 ¹⁵/₁₆" (43.1 x 55.8 cm)
Publisher: Tanglewood Press, New York
Printer: Chiron Press, New York
Edition: 225
Gift of Tanglewood Press, 1966

Accumulation and repetition are the hallmarks of the work of Nouveau Réaliste artist Arman. In common with the art of other members of this loosely defined Paris-based group, Arman's work signaled the return of interest in the industrialized urban environment after the predominance of abstract painting. His inventive constructions incorporate numerous manufactured goods, such as shoes, car parts, violins, and paint tubes. Eschewing the personal artistic mark, Arman began making rubber stampings in 1955, which, by the end of the decade, evolved into his tracings—impressions on canvas made by objects dipped in paint.

Revolvers have been a constant motif in Arman's work, beginning with the accumulation *Boom!Boom!* of 1960 and appearing as recently as 1979 in *Tools of Persuasion*. Other objects of violence, including sabers and gas masks, also appeared in the early 1960s work. During this period, Arman began his aggressive actions titled *Colères* or *Tantrums*, which included dynamiting a car and smashing a cello on stage. This period of violent motifs, reflects in part, Arman's wartime experiences and coincides with the increased tension in Paris over the Algerian war (1956–62).

Arman was inspired by the prints of Jasper Johns that he saw on his first trip to New York in 1961. Among Arman's earliest prints are several lithographs and monotypes composed of repeated renderings or imprints of an object. In 1966 Rosa Esman of Tanglewood Press invited him to participate in her portfolio *New York International*.[1] After the success of her first publishing venture, *New York 10*, Esman chose to work with an international roster of artists, many of whom had had successful exhibitions in New York that season. More established artists, such as Robert Motherwell and Ad Reinhardt, were also included.

Arman's approach to printmaking paralleled that of his sculptural accumulations: for this print he made a template of a revolver and drew repeatedly with it on the screen, sometimes outlining and at other times filling in the entire stencil using opaque and metallic inks.[2] To individualize the prints in the edition, Arman layered additional revolvers by hand, and in this example he drew one revolver at the left in pencil after printing. Like Johns's art, Arman's compositions combine expressive draftsmanship with repeated images of commercially produced, highly charged, everyday objects.

1 The other artists in the portfolio are Mary Baumeister, Öyvind Fahlström, John Goodyear, Charles Hinman, Allen Jones, Robert Motherwell, Ad Reinhardt, James Rosenquist, and Saul Steinberg.
2 Esman, letter to the author, April 1998.

Mass Media

Joe Tilson 38

Richard Hamilton 40

Andy Warhol 41

Eduardo Paolozzi 42

Richard Hamilton 43

Robert Indiana 44

Roy Lichtenstein 46

Sigmar Polke 47

Dieter Roth 48

Eduardo Paolozzi 50

Öyvind Fahlström 52

Equipo Crónica 53

Bernard Rancillac 54

Joe Tilson

P. C. from N. Y. C. 1965

Screenprint
Composition: 6' 5 ⁵/₈" x 26 ¹/₂" (197.2 x 66.3 cm)
Sheet: 6' 6 ³/₄ x 26 ¹/₈" (200.0 x 66.3 cm)
Publisher: Marlborough Graphics, London
Printer: Kelpra Studio, London
Edition: 70
Joseph G. Mayer Foundation Fund, 1966

I was trying to make very strong unforgettable images using the latest technology and printing and vacuum forming methods — consciously avoiding "Fine Art" etching and lithography — making work that strongly represents the time and culture — avoiding nostalgia....Richard Smith, Peter Blake, Derek Boshier, and myself were all engaged in making paintings using ideas taken from paper ephemera — enlarged Japanese paper toys, post cards, tickets, air mail letters, newspapers, sweet wrappers, packaging, match boxes, etc., etc.[1]

Joe Tilson was part of the first generation of Pop artists to graduate from London's Royal College of Art, along with Peter Blake and Richard Smith. By the early 1960s he had become an object-maker more than a painter, attracted to industrial surfaces and the popular imagery found in his collection of printed ephemera. His early work consisted of brightly painted wood reliefs that combined text and symbols in bold grids or ziggurats and conveyed a Pop sense of contemporary life.[2] Tilson delighted in the novel materials that then-new technology had made available and which facilitated his three-dimensional constructions. By the mid-1960s his printed work also reflected this interest, typically combining plastics and other man-made products with photographic images taken from the media.

Tilson's first screenprinting effort was in 1961 for a unique work on wood. But *P. C. from N. Y. C.* was his first experience working with Chris Prater at Kelpra Studio and marked the beginning of a long and intense collaboration between artist and craftsman. Since the mid-1960s screenprinting has played an integral role in Tilson's career often inspiring his unique work and setting up a fruitful cross-fertilization between mediums. Tilson took an iconoclast's approach to printmaking. He brought back to London a plethora of printed materials from his 1965 trip to New York and set out to make permanent objects out of the ephemeral.

P. C. from N. Y. C. was derived from a foldout postcard package of New York City landmarks titled "New York — Magic City of Lights," images in sync with Tilson's general interest in urban life during this period. Enlarging it photographically to over six feet in height, Tilson emblazoned famous American symbols in brash colors against dramatic night skies. He created the illusion of a three-dimensional, unfolding accordion with the zigzag format composed of three sheets of irregular-shaped paper, and cleverly simulated details like the wrapper flap and publicity text out of stiffer board in his complex paper assemblage.[3] Tilson, like so many of the Pop artists, was attracted to screenprint for its photographic capabilities, and this print is a tour de force for the artist as well as for Prater, who specialized in elaborate photographic transfers for screenprinting. There was little response to this print at the time of its publication but it has become one of the quintessential examples of the inventiveness with materials, the creative recycling of popular imagery, and the British fascination with American culture that characterized printmaking of the Pop era.

1 Tilson, letter to the author, February 1998.
2 The importance of wood in his art may stem from his work as a carpenter in the mid-1940s.
3 A diagram accompanies the print.

Richard Hamilton

My Marilyn. 1966

Screenprint
Composition: 20 ¹/₄ x 25" (51.5 x 63.3 cm)
Sheet: 27 ¹/₁₆ x 33 ³/₁₆" (68.7 x 84.3 cm)
Publisher: Editions Alecto, London
Printer: Kelpra Studio, London
Edition: 75
Joseph G. Mayer Foundation Fund, 1966

Richard Hamilton's fascination with popular culture, its dissemination, and the myriad of perceptual issues that ensues is clearly embodied in his 1965 screenprint *My Marilyn*. In his typical working process, Hamilton reiterated, reexamined, and re-created this image in a series of works in different mediums. They are all based on George Barris's photographs of Marilyn Monroe published in the British magazine *Town* shortly after her 1962 suicide. Hamilton featured Hollywood film stars in other works but usually by incorporating a film still showing the star in his or her acting persona.[1] In *My Marilyn*, however, his decision to use rejected publicity stills as the image's framework magnifies the poignant sense of vulnerability and exposure that defined Monroe's life.

Hamilton first made negatives of the *Town* photographs and from these printed a series of black-and-white enlargements in three different sizes.[2] In 1964, he made a collage from this series which incorporated twelve images of Monroe. For a 1965 painting he photographed the collage, printed it on canvas, and heavily overpainted it in a range of styles.[3] For the print he used the same collage as a starting point, photographing and transferring it to screens which he then manipulated to achieve a simultaneously mechanical and handcrafted effect .

Since the basis of the print was a group of photographs with markings made by Marilyn Monroe's hand, it became an objective of the prints to produce a painterly result without actually making marks with mine.[4]

Hamilton's elaborate processes included enlarging, masking, negative reversals, and numerous color overprintings to achieve this ghostly, bleached-out memorial to the media icon. Monroe's Xs and other markings stand out more violently against the pastel, even tonalities of the printed version than they do in the painting, highlighting the contrast between the drawn and the printed areas while confusing the issues of authorship. The resulting amalgam of reproductive manipulations by Hamilton and handmade vetting marks by Monroe—crosses that now resonate as symbols of her suicide—reinforces the conceptual underpinnings of Hamilton's image-making.

My Marilyn was Hamilton's sixth screenprint. It was the first, however, for which he prepared the screens himself, at the University of Newcastle-upon-Tyne where he was then teaching. Trying out the school's new screenprinting facilities Hamilton crudely printed several variations. He selected one of the proofs and brought it to Kelpra Studio from which the edition of seventy-five was made.

1 See *Patricia Knight* of 1964 and *I'm Dreaming of a White Christmas* of 1967 and its complement *I'm Dreaming of a Black Christmas* of 1971, featuring Bing Crosby.
2 Hamilton remembers four small strips of 35mm contact photographs. Hamilton, conversation with the author, April 1998.
3 *My Marilyn*. 1965. Oil and collage on photograph. Ludwig Forum für Internationale Kunst, Stadt Aachen.
4 Hamilton, quoted in Richard S. Field, *The Prints of Richard Hamilton* (Middletown, Conn.: Davison Art Center, Wesleyan University, 1973), p. 31. Monroe insisted that the results of all photograph sessions be submitted to her for selection before publication. She indicated her approval or rejection with black Xs on the photographers' contact sheets, proofs, or transparencies.

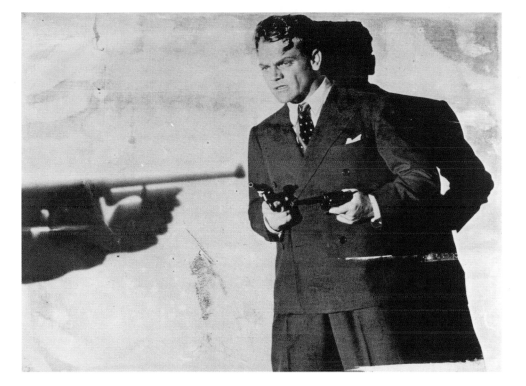

Andy Warhol

Cagney. (1964)

Screenprint
Composition and sheet: 29 ⁷/₈ x 39 ¹³/₁₆" (75.9 x 101.2 cm)
Publisher: unpublished
Printer: the artist
Edition: approximately five
Vincent d'Aquila and Harry Soviak Bequest, 1993

Andy Warhol's personal interest in film led to an important career as an underground filmmaker. His fascination with glamour and celebrity was a defining feature of all his work, culminating in *Interview* magazine, his major publishing venture founded in 1969 to showcase famous figures from Hollywood and the arts. In his own numerous artworks of female film stars, such as Marilyn Monroe and Elizabeth Taylor, Warhol usually worked from publicity stills, many of which came from the picture collection he had been amassing since his youth.[1] His depictions of male film stars, however, usually presented the actors in their film roles, and often in violent action poses, seen most clearly in his images of Marlon Brando, Elvis Presley, and James Cagney.[2]

When, in 1962, Warhol began screenprinting photographs onto canvas, Hollywood movie stars were among the first to appear. In 1962 and 1963 he made several unique screenprints on paper, including *Cagney* and *The Kiss (Bela Lugosi)*. These are among Warhol's earliest printed efforts, printed by the artist himself in the black-and-white monotone of their film sources. They reveal his initial painterly approach to the medium, evidenced by the white streaks that run through the images. The frozen, cinematic effect of these works is enhanced by these dynamic marks which, although made by the

action of the printing squeegee, suggest the scratchiness of rough-cut film.

Cagney's source was a film still from *Angels with Dirty Faces*, a 1938 gangster movie centered on young juvenile delinquents.[3] In 1962 Warhol used the screen made from this photograph to produce two works, a work on paper with a single image and a work on canvas with five vertically stacked renderings.[4] One important distinction, however, is the fact that the screen in the work on canvas includes the full shadow of Cagney's adversary, as seen in the studio-issued film still, whereas Warhol dramatically cropped the still for this work on paper, creating a tighter close-up around Cagney and highlighting his disturbing, angry expression.[5] This smaller image is far more mysterious and menacing, as the threatening, floating rifle juts in from the left edge. This aesthetic intervention further reveals Warhol's hands-on involvement with his printmaking of the early 1960s, distinguishing it from much of his later printmaking efforts. In 1964 he made five additional versions of *Cagney* on paper, each with unique printed qualities. This impression is notable for its mottled, painterly background and clarity of image.

1 Film stills and publicity photographs were easily attainable at memorabilia stores and through the individual movie studios.

2 See the paintings *Silver Marlon* of 1963, *Double Marlon* of 1966, *Triple Elvis* of 1962, and *Single Elvis* of 1963.

3 This image has been misidentified in the Warhol literature as taken from the film *The Public Enemy* of 1931. As seen in an original Warner Brothers film still, however, the image comes from *Angels with Dirty Faces*, directed by Michael Curtiz in 1938. See The Museum of Modern Art Film Stills Archive.

4 See *Cagney*. 1962. Silkscreen ink on canvas. Hamburger Bahnhof, Berlin. Thanks to Deborah Wye, Chief Curator in the Department of Prints and Illustrated Books, The Museum of Modern Art, for bringing this work to my attention.

5 Similarly, in 1962 Warhol printed the *Suicide* image as a screenprint on paper as well as a screenprint on canvas. Like *Cagney*, the canvas version of *Suicide* incorporates five vertical printings of the screen.

Eduardo Paolozzi

Tortured Life from the illustrated book
As Is When by Eduardo Paolozzi. 1965

One of thirteen screenprints
Composition: (irreg.) 30 $^{11}/_{16}$ x 22 $^{1}/_{2}$" (78.0 x 57.1 cm)
Page: 37 $^{15}/_{16}$ x 25 $^{15}/_{16}$" (96.5 x 66.0 cm)
Publisher: Editions Alecto, London
Printer: Kelpra Studio, London
Edition: 65
Joseph G. Mayer Foundation Fund, 1967

Similarly my approach to screenprinting — a theme — Wittgenstein — utmost exploitation of the technical method — elegance — precision joins hands with myth.[1]

As Is When is Eduardo Paolozzi's homage to the twentieth-century Viennese philosopher Ludwig Wittgenstein, whose texts are judiciously excerpted on each of the book's thirteen screenprints. Paolozzi was attracted to this theme after reading *The Life of Ludwig Wittgenstein* by George Vaughan Wright, one of the philosopher's publishers.[2] Wittgenstein's study of linguistic systems coincided with Paolozzi's love of toys and games and influenced his approach to the "syntax" and "vocabulary" of picture-making. The series also relates to Paolozzi's three-dimensional work of the period, and in some cases, as with *Parrot*, the prints are direct translations of his glossy aluminum and steel sculptures of curving tubular and mechanical-looking forms.

This screenprint project began as a series of collages whose components were drawn from Paolozzi's vast collection of found printed ephemera, which included such diverse materials as Woolworth wrapping paper and clippings from engineering manuals.[3] As he described, "The actual collages were made on my kitchen table in a small house in the country, usually after the children had gone to bed. This house was only a few miles away from several popular coastal resorts for people from the East End, which meant cheap stores full of toys and cut-out books—a rich source of material which occurs in each print."[4]

Tortured Life comprises solid blocks, concentric circles and squares, checkerboards, and curved parallel lines. Despite its abstract qualities, however, the imagery clearly suggests the cinema as spools of trailing film cascade from box-like cameras. Paolozzi, himself, had made two films in the early 1960s,[5] and, for him, the medium represented the ideal melding of visual stimuli and perpetual motion that characterized his obsessive investigations into art and technology. Paolozzi composed the meandering, stream-of-consciousness text accompanying the suite from found text fragments including long passages describing film production.[6] Wittgenstein was also a known film enthusiast, of American popular films in particular, which may have been Paolozzi's most direct inspiration for the imagery in this print.

The screenprint process for this book was perfected by master printer Chris Prater of Kelpra Studio. Paolozzi credits Prater with "reinterpreting a series of collages into a sound homogenous graphic [that was] ...highly innovative, highly inventive, or, in some cases, another art form."[7] In this image in particular, a comparison between the collage and the final print reveals the artist's manipulations of color and space as he transformed the collaged papers into a shimmering composition of silver and copper metallic inks, which yields an overall industrial, high-tech impact. The thirteen dazzling images in *As Is When* are considered by many to be the first Pop masterworks of screenprint in England. In the U. S., Warhol had only released isolated editions by this point, and important portfolios such as *11 Pop Artists* and *Grafik des Kapitalistischen Realismus* were yet to happen.

1 Paolozzi, quoted in unpublished notes by Peter Selz, curator at The Museum of Modern Art, New York, August 1964, written in preparation for the exhibition *Eduardo Paolozzi: Sculpture* held at the Museum from September 21—November 10, 1964.

2 The artist also identified personally with the Austrian, who spent much of his life in Cambridge, England, but never assimilated, remaining an eternal outsider in his adopted homeland. Paolozzi is of Italian descent and grew up in Scotland.

3 The collages are in the collection of The Museum of Modern Art, New York.

4 Paolozzi, letter to the author, June 1998.

5 The films are *The History of Nothing* (1960—62) and *Kakafon Kakkoon* (1965). In 1971 he also made *Mr. Machine.*

6 The text, *Wild Track for Ludwig: The Kakafon Kakkoon Iakaoon Elektrik Lafs*, interweaves fragments on the *Laocoön*, film production, and Bedouin nomads with a story of airplane warfare.

7 Paolozzi, letter to the author, June 1998.

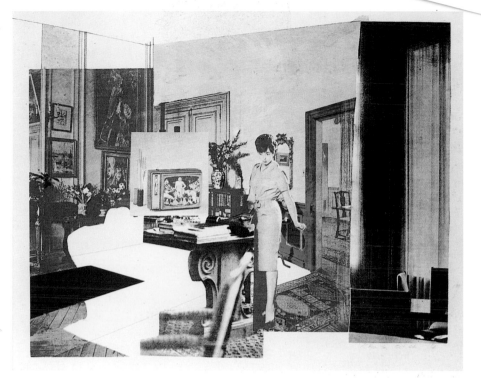

Richard Hamilton

Interior (initial state). 1964

Screenprint
Composition: 19 5/16 x 25 1/8" (49.1 x 63.8 cm)
Sheet: 22 1/4 x 27 7/16" (56.5 x 69.7 cm)
Publisher: Editions Alecto, London
Printer: Kelpra Studio, London
Edition: 4 (final state, edition: 50)
Gift of Mrs. Joseph M. Edinburg, 1965

There is no better example of mass media's defining role in the art of the 1960s than Richard Hamilton's screenprint *Interior* of 1964. Like his compatriot Eduardo Paolozzi, Hamilton often worked in collage, creating lively juxtapositions of found printed material from magazine advertisements and newspapers. Hamilton's involvement with the interior theme began in the early 1950s with his renowned collage *Just what is it that makes today's homes so different, so appealing?*, designed as the poster and catalogue illustration for the Independent Group exhibition *This is Tomorrow,* held in London in 1956. This historic image introduced commodity culture of the postwar period, from television sets and vacuum cleaners to movie marquees and comic books, as valid and expressive subject matter for art.

Interior is based on one of three collages Hamilton made on this theme in 1964. Spatial distortions define all of these images in the various furniture styles and reproductive modes juxtaposed in this media-saturated space. The range he drew from was remarkable: the central figure is taken from a washing machine magazine advertisement and the overall interior from a photographic reproduction of the drawing room of Claude Monet's daughter.[1] A film still from a 1940s movie[2] was the initial inspiration behind this image, and a television set showing a popular sports event is prominently positioned.

In addition to the three collages, this image evolved through two paintings and three states of the screenprint. Hamilton's fascination with photography, reproduction, and varying degrees of perception is manifested in the process of this print's creation. He took a black-and-white photograph of the collage and manipulated the color with additional screens. In a complex and ironic series of steps, Hamilton layered screens of benday dots under the photographic screens to simulate "a pseudo-photographic effect of half-tone reproduction,"[3] mechanically imitating the effects of photographic reproductions onto the already photographic imagery.

In the states of the print, Hamilton experimented with the disjointed spatial configurations of the edges of the room and some of the decorative elements in the background. In the final image, he eliminated the Old Master paintings and floral arrangements seen in the left background of this state and removed certain overall background colors, resulting in a starker and slightly less cacophonous composite of borrowed, processed media images.

1 Richard Morphet, *Richard Hamilton* (London: The Tate Gallery, 1970), p. 50.
2 The film was *Shockproof*, directed by Douglas Sirk in 1949.
3 Hamilton, quoted in Richard S. Field, *The Prints of Richard Hamilton* (Middletown, Conn.: Davison Art Center, Wesleyan University, 1973), p. 30.

Robert Indiana

Love. 1967

Screenprint
Composition and sheet: 33 $^{15}/_{16}$ x 33 $^{15}/_{16}$" (86.3 x 86.3 cm)
Publisher: Multiples, Inc., New York
Printer: Sirocco Screenprinters, North Haven, Connecticut
Edition: 250
Riva Castleman Fund, 1990

Robert Indiana's heraldic images of words and numbers were one of the cornerstones of New York Pop in the early 1960s. His early totemlike sculptures were assemblages of found objects—a contemporary urban archaeology which often included scraps of discarded stencils spelling the names of manufacturers that had once thrived in the vicinity of his studio. These stencils are often cited as the germ for his taut, textual two-dimensional compositions. The work of his neighbor Ellsworth Kelly also played a defining role in Indiana's development of a style of increasingly austere, flat forms and solid, vibrant colors.

Few icons of American Pop art are more widely recognized than Indiana's *Love.* Appearing in paintings, sculptures, prints, tapestries, and rings, it is one of the most ubiquitous art images of the twentieth century. Indiana cites personal sources for the derivation of the image:

Know that the reason that I became so involved with LOVE is that it is so much a part of the peculiar American environment, particularly in my own background, which was Christian Scientist. "God is Love" is spelled out in every church.[1]

Indiana tried to get at the essence of his chosen subjects, and for him, the *Love* images were a distillation of the complex erotic, religious, and familial meanings of the word. His reductive composition of boldface, stenciled letters furthers that goal. His design has the visual power of an advertisement, corporate logo, or promotional poster, reflecting the symbiotic feedback between the artistic and commercial milieus during the 1960s.

Although the first exhibited *Love* was a 1966 painting, its initial conception was as a Christmas card design for The Museum of Modern Art, published in 1965.[2] Indiana submitted three twelve-by-twelve-inch *Love* paintings in different colors, and the Museum chose the red, green, and blue version for the card.[3] Numerous paintings, sculptures, drawings, and prints followed. In 1966 Indiana had an exhibition devoted to his Love images,[4] and the same year he executed two editioned interpretations, a five-foot-square *Love* banner for the Betsy Ross Flag and Banner Company and an aluminum multiple for publisher Multiples, Inc.[5]

Indiana quickly realized that screenprint was the ideal medium for the translation of his paintings into printed art, and it remained the predominant choice in his printmaking until the mid-1980s. Typically, his printed work has followed the compositions of earlier paintings. Aside from the Christmas card, the first printed *Love* appeared in 1967, also published by Multiples, Inc., in an edition of 250. Indiana also wanted to release an unlimited edition of the image, making it affordable to the widest public. To accomplish this, Multiples joined forces with collector Eugene Schwartz's mass-marketing company, Mass Originals. With a more economical printer, Maurel Studios, the artist produced two additional *Love* screenprints that year, creating nearly 2,500 additional examples of the popular image.[6]

Indiana has completed over twenty printed variations of the original *Love.* The most renowned and certainly most widely seen interpretation was a 1973 eight-cent U.S. postage stamp, with a total edition, including an unprecedented two reprints, of approximately 330,000,000.

1 Vivien Raynor, "The Man Who Invented LOVE," *Art News* 72, no. 2 (February 1973): 60.
2 According to Inge Heckel, former executive secretary of The Junior Council of The Museum of Modern Art, Indiana brought three paintings elaborately inset into beautifully crafted wood boxes to the Museum from which the Christmas card committee selected. The other two color variants included one in red, yellow, and black, and one in more muted earth tones. Lily Auchincloss, co-chairman of The Junior Council at the time, had initially contacted Indiana to make the card. The final decision appears to have been unanimous for the red, green, and blue version, since it was the most evocative of Christmas.
3 See interview with Indiana by Poppy Gandler Orchier in Susan Sheehan, Orchier, and Catherine Mennenga, *Robert Indiana Prints: A Catalogue Raisonné 1951–1991* (New York: Susan Sheehan Gallery, 1991), p. 13.
4 *The LOVE Show* was Indiana's third solo exhibition at the Stable Gallery in New York.
5 The Betsy Ross Flag and Banner Company was subsumed by the newly founded Multiples, Inc., in 1965, although it still used its own name for some time. For more information, see Constance W. Glenn, *The Great American Pop Art Store: Multiples of the Sixties* (Long Beach: University Art Museum, California State University; Santa Monica: Smart Art Press, 1997).
6 Marian Goodman, founder of Multiples, Inc., conversation with the author, April 1998.

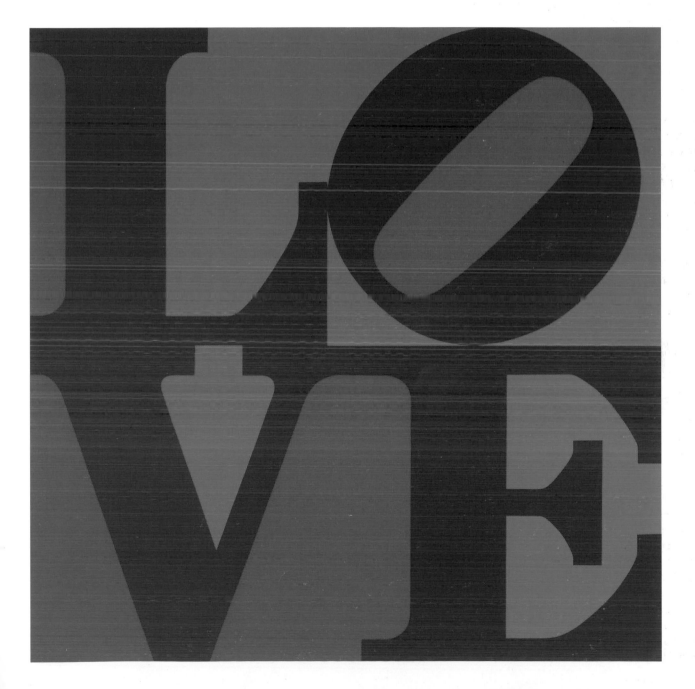

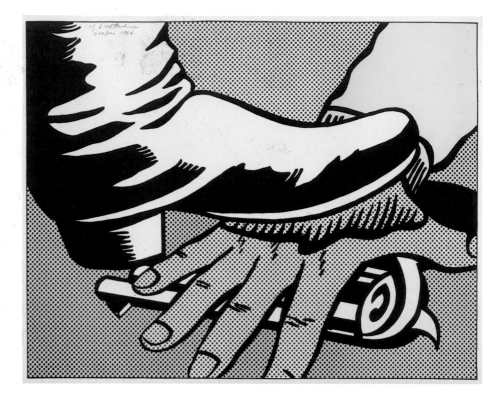

Roy Lichtenstein

Foot and Hand. 1964

Photolithograph
Composition: 16 ⅝ x 20 ¹⁵/₁₆" (42.2 x 53.3 cm)
Sheet: 17 ¼ x 21 ½" (43.8 x 54.7 cm)
Publisher: Leo Castelli Gallery, New York
Printer: unknown
Edition: 300; plus unknown quantity of unnumbered proofs
Gift of Leo and Jean-Christophe Castelli in memory of Toiny Castelli, 1988

The emergence of a wide range of printed ephemera during the Pop period is consistent with an ideology that embraced a broader dissemination of art, a lessening of art's precious status, and the eager reception of commercial technologies. Printed matter from shopping bags to wallpaper to exhibition mailers proliferated in the 1960s. From his first solo exhibition at Leo Castelli Gallery in 1962 and continuing through 1967, Roy Lichtenstein created original mailers, making drawings to be reproduced as photolithographs and to serve as exhibition announcements. Overruns were often kept unfolded at the gallery and given away during the course of the exhibition; Lichtenstein frequently issued a specified number of these as a signed and numbered edition.[1]

Lichtenstein's art investigated modes of representation—the visual properties of style and reproduction. The industrial look of commercially reproduced images, with the ubiquitous benday dots, simplified lines, and pure flat colors, became the subject of much of his work. Many of the Castelli exhibition mailers depict Lichtenstein's familiar comic-strip images, and as such they conceptually blurred the distinctions between the image's role in its original context and its current function. Drawing a frame of a commercial comic strip makes a unique statement out of mass-produced work of printed ephemera; having that image re-offset for distribution through the mail returns the image to its original audience, only now stripped of its original context.

Foot and Hand employs all of Lichtenstein's signature compositional tools. The regularized dots separate the background from the yellow sweater arm, black boot, and gun, while simultaneously flattening the space. A typical heavy black outline marks off the streamlined forms. "I use color in the same way as line, I want it oversimplified—anything that could be vaguely red becomes red. It is mock insensitivity," the artist explained.[2] The solid red gun handle and yellow sweater echo the color of the dot patterns and unify this tightly designed composition. The abruptly cropped arm, boot, and fingertips also impart a monumental quality to what was most likely a mere detail of a frame. "The subject—the cartoon—is supposed to be right here so you know that it has no existence other than on the printed page or canvas; it isn't a painting of a comic book lying on a table. It should have much more immediacy."[3]

1 See Mary Lee Corlett, *The Prints of Roy Lichtenstein: A Catalogue Raisonné 1948–1993* (New York and Washington, D.C.: Hudson Hills Press in association with the National Gallery of Art, 1994), p. 253.

2 Lichtenstein, quoted in "Roy Lichtenstein: An Interview," in John Coplans, *Roy Lichtenstein* (Pasadena, Calif.: Pasadena Art Museum, 1967); reprinted in Richard Morphet, *Roy Lichtenstein* (London: The Tate Gallery, 1968), p. 12.

3 Lichtenstein, quoted in "An Interview with Roy Lichtenstein," *Roy Lichtenstein Graphic Work 1970–1980*, exh. bro. (New York: Whitney Museum of American Art, 1981), n. p.

Sigmar Polke

Wochenendhaus (Weekend House)
from the portfolio *Grafik des Kapitalistischen Realismus*
(Graphics of Capitalist Realism). 1967

Screenprint
Composition: 20 1/2 x 32 15/16" (52.0 x 83.9 cm)
Sheet: 23 5/16 x 32 15/16" (59.5 x 83.9 cm)
Publisher: René Block for Stolpe Verlag, Berlin
Printer: Birkle & Thomer & Co., Berlin
Edition: 80[1]
Linda Barth Goldstein Fund, 1995

In his intentional defiance of stylistic consistency and legibility of meaning, Sigmar Polke remains one of the most enigmatic artists of the postwar period. He came to recognition in the early 1960s when he co-founded, with Gerhard Richter and Konrad Lueg, the German group known as Capitalist Realism. These artists, like their American counterparts, were responding to the media saturation and new-found affluence in postwar society. Polke was a student at the Düsseldorf Kunstakademie in the early 1960s and was influenced by the iconoclastic and anti-style ideas of its resident guru, Joseph Beuys. Like Richter, he was also impressed by the anti-painterly bent of some of the American Pop artists, especially the inartistic simplification of Lichtenstein's work and the rejection of artistic authorship inherent in Warhol's. His work remains at an ironic, often cynical, distance from his subject matter, as he makes pictorial reality one of his overriding themes. And although Polke was not initially drawn to printmaking, in his unique work he embraced several techniques and issues inherent to printmaking from stencils and color separation to photography and reproduction.

Berlin gallerist and publisher René Block was one of Polke's earliest supporters.[2] When colleagues of Block's opened a screenprinting establishment, he convinced them to inaugurate the new facility with a portfolio of the Capitalist Realist artists.[3] All of the artists were eager to participate; several, including Polke, were new to the medium.[4] For his contribution, Polke chose a diagrammatic depiction of a country leisure home, emblematic of his emphasis on Germany's new leisure class and objects from its rapidly growing consumer culture. As was his typical working method, he made a drawing after a newspaper photograph and simulated the photograph's dot screen by hand. The image was black-and-white until Block asked Polke to add color to the foreground flower.[5] The drawing (now lost) was then photographically transferred to the screen for printing. This unique way of creating an image, screenprinting a drawing made from a photograph, indicates Polke's fascination with issues of reproduction and authenticity. Polke's overall dot pattern is a constant reminder of the print's reproductive source. The contrasting hand-drawn additions of bright pink and green add an unreal, even eerie, irradiated look to the otherwise generic, black-and-white image and create a tension between the autographic and the photographic that characterizes his work of this period.

1 An unknown number was also printed on thinner paper as a poster.
2 Polke had solo exhibitions at Galerie René Block in 1966, 1968, and 1969.
3 Block, letter to the author, June 1998.
4 The other artists in the portfolio are K. P. Brehmer, K. H. Hödicke, Konrad Lueg, Gerhard Richter, and Wolf Vostell.
5 Block, letter to the author, June 1998.

Dieter Roth

6 Piccadillies. 1970

Four from the portfolio of six double-sided screenprints over photolithographs, one with iron filings, mounted on board. Housed in paper-covered cardboard box with photolithograph on front, handle, and paper tag
Composition: (each) 19 $^1/_8$ x 27 $^3/_{16}$" (48.6 x 69.0 cm)
Board: (each) 19 $^5/_8$ x 27 $^9/_{16}$" (49.9 x 70.0 cm)
Publisher: Petersburg Press, London
Printer: H. P. Haas, Korntal, and Staib & Mayer, Stuttgart
Edition: 150
Purchase, 1990

Dieter Roth was one of the most original and enigmatic figures in postwar European art, creating an exceedingly inventive body of work in a wide range of mediums. His work traversed the movements of Op, Pop, Fluxus, and Conceptual art and was characterized by experimentation, elusive materials, and, often, oblique meaning. He worked as a painter, sculptor, printmaker, poet, and book artist, possibly making his most important contribution in artist's books, a medium with which he was preoccupied from the mid-1950s on. Through Daniel Spoerri, Roth became acquainted with several of the Paris-based Nouveaux Réalistes. Sharing their desire to remove the barriers between art and life, he chose to focus on the process of change and decay through his use of organic materials such as food and earth. Spoerri also introduced him to Richard Hamilton in 1961, a friendship that blossomed into numerous collaborative printed works.

At an early age, Roth became involved in nearly all the mediums of print-making and quickly learned to manipulate them in unconventional ways. The mass-produced postcard became an important element in his work of the 1960s, appearing in his prints by 1965.[1] In 1957, recently married to an Icelander, Roth moved to Reykjavik and began sending handpainted postcards to his friends in Europe.[2] In the early 1960s Roth discovered that Hamilton's wife had a vast collection of Piccadilly Circus postcards.[3] Piccadilly Circus, with its central London location and its plethora of commercial billboards and streaming humanity, became an important motif for Roth in the late 1960s, culminating in an artist's book 96 Piccadillies, comprising ninety-six reproductions of his Piccadilly imagery, many of which originated as handpainted postcards.

The screenprint portfolio 6 Piccadillies, begun in 1969, initiated a long relationship between Roth and the London publisher Petersburg Press and marked the onset of concentrated efforts in screenprint. The portfolio is a brilliant and inventive exploration of the medium and this quintessential depiction of commercial urban life. The works in the portfolio are printed on paper laminated to board and double-sided, paralleling the mirror imagery found in many of Roth's books and two-handed drawings. The image of Piccadilly Circus was first offset-printed on both sides of the board.[4] Roth then screenprinted over one side with a variety of hand-drawn screens creating a mesmerizing range of effects, from obscured London fog to frightening, Day-Glo psychedelia, sometimes highlighting, sometimes nearly obliterating the bustling urban scene below the ink. To achieve the deep build-ups of ink in the thickly layered surfaces, screenprinter Hans Peter Haas in Stuttgart developed a new technique specifically for this portfolio.[5] The underlying theme of the tourist is enhanced by the portfolio's cardboard suitcase housing, complete with a luggage tag that lists artist, title, and publisher. Roth's itinerant life inspired numerous suitcase images.

In a poetic stream-of-consciousness introduction to 96 Piccadillies, Roth obliquely described the evolution of the screenprint portfolio and the importance of the Piccadilly image in his work. He wrote:

As Piccadilly, stations of fear, to be stationed too far from stations of comfort and other goals at the other end of life, where tourists are waiting.[6]

1 See Hat. 1965. Screenprint over photolithograph with handworked addtions.
2 Dr. Dieter Schwarz, Director, Kunstmuseum Winterthur, letter to the author, February 1998.
3 Hamilton, conversation with the author, April 1998.
4 The offset printer Staib & Mayer, Stuttgart, was a commercial printer; one of the partners was the father of Roth's primary publisher Hansjörg Mayer.
5 Hamilton, conversation with the author, April 1998. Haas, with whom Hamilton had worked, kept the screens a certain distance from the paper to allow for thick accumulations of ink.
6 Roth, quoted in 96 Piccadillies: Postcards of Works 1968–1977 (Stuttgart and London: Edition Hansjörg Mayer, 1977), n. p. (opposite plates M–N).

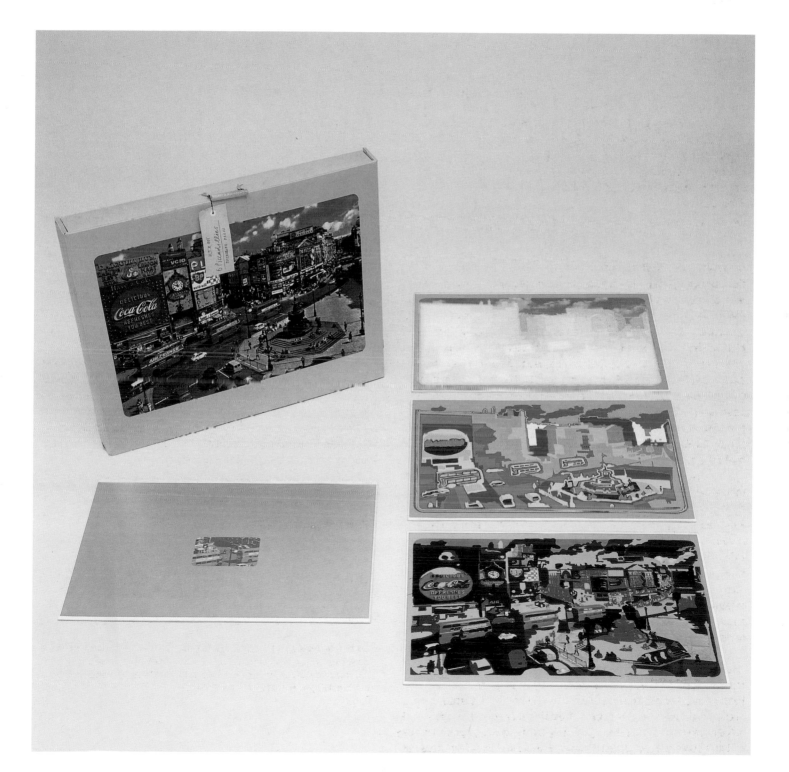

Eduardo Paolozzi

Moonstrips Empire News by Eduardo Paolozzi. 1967

Illustrated book with 101 screenprints housed in a plastic box
Page: 14 $^{15}/_{16}$ x 9 $^{15}/_{16}$" (38.0 x 25.2 cm)
Publisher: Editions Alecto, London
Printer: Kelpra Studio, London
Edition: 500
Gift of the artist, 1967

California scientists have proposed image-banks orbiting the Earth. *Moonstrips* is a terrestrial prototype.[1]

Eduardo Paolozzi's collages, the medium for which he is arguably best known, express the constantly shifting and random quality of everyday life. Emerging on the British art scene in the early 1950s as a sculptor and founding member of London's forward-looking Independent Group (an intellectual discussion and exhibition group that focused on issues of popular culture and modernism) he was an obsessive collector of printed material, from pulp books and magazines to engineering diagrams and weaving patterns.[2] He amassed numerous scrapbooks that served as a rich source for his aesthetic adventures and reflected the bombardment of visual stimuli present in postwar consumer culture. The influence of Surrealist collage strategies on his work is undeniable,[3] but Paolozzi was careful to emphasize the richness of contemporary imagery and champion the ever-growing influence of technology in modern society. Through his involvement in lectures and exhibitions with the Independent Group, he spearheaded radical thinking about art and the mass media that would foster the development of a Pop aesthetic on both sides of the Atlantic. In printmaking he played a seminal role in overturning the long-held idea that originality resided only in the artist's hand and that works without hand markings were by nature reproductive.

Free association is the leitmotif of the psychedelic compendium of text and images in *Moonstrips Empire News*. Marcel Duchamp's *Green Box*, a facsimile of Duchamp's collection of randomly ordered notes on *The Bride Stripped Bare by her Bachelors, Even* (*Large Glass*), was an important inspiration for Paolozzi's format.[4] The 101 sheets, housed in a high-tech-looking magenta plastic box—so fitting for this study of technology and art—have no predetermined order, a fact that sanctions the viewer to arrange and rearrange them at will and become an active editor of the suite.

The sources for the text range from classical literature to advertising slogans and are presented in a dazzling array of typefaces and colors on a variety of papers. Paolozzi's extensive reading of James Joyce, William S. Burroughs, and the Surrealist writer Raymond Roussel also influenced his arrangement of the text as a schizophrenic assemblage of fragments. But textual meaning is subordinate to visual design. Juxtaposed in multiple layers, the provocative images are designed in busy allover patterns, combining geometric abstraction, iconic Disney characters, film sequences, advertisements, newspaper reproductions, and computerized diagrammatic designs. The images were culled from popular magazines and focus on American popular culture, science fiction, and technology—some of Paolozzi's favorite themes.

Paolozzi was only the second artist to make fine-art prints at Kelpra Studio with master screenprinter Chris Prater.[5] In an experimental and open-ended approach, Paolozzi allowed tremendous input from his printers and incorporated accidents that occurred during the printing process into the work. The images always began with a collage from which photographic films were made for each color and then transferred to screens; additional patterns were often printed in the last stages. In an exceptional display of printmaking's versatility, Paolozzi printed each screenprint in this set in varying color combinations, creating numerous, often dramatically different permutations within an edition.[6]

It was through Prater's meticulous stencil cutting that Paolozzi was able to unify and eternalize his collages of disparate found material. Through elaborate manipulation and reproduction, Paolozzi was also able to achieve an evenness of tone and surface in these prints. In their processed and often machine-oriented imagery, the photomechanical screenprints in *Moonstrips Empire News* embody the technology that Paolozzi championed. His work represents Pop printmaking's complete integration with the contemporary mass media and is surely one of the clearest examples of the symbiosis of the medium and the message.

1 Christopher Finch, describing Paolozzi's work, untitled spiral-bound gallery catalogue of Paolozzi's sculpture and prints from 1963–67. Abby Aldrich Rockefeller Print Room, The Museum of Modern Art, New York.

2 For more on the Independent Group, see David Robbins, ed., *The Independent Group: Postwar Britain and the Aesthetics of Plenty* (Cambridge, Mass., and London: The MIT Press, 1990).

3 Paolozzi lived in Paris from 1947–49 and there garnered first-hand experience with the Surrealist aesthetic.

4 See Rosemary Miles, *The Complete Prints of Eduardo Paolozzi: Prints, drawings, collages 1944–77* (London: The Victoria & Albert Museum, 1977), p. 26.

5 Gordon House was the first.

6 The combinations were determined by a system established by the artist.

Öyvind Fahlström

Eddie (Sylvie's brother) in the Desert[1]
from the portfolio *New York International*. 1966

Screenprint
Composition and sheet: 17 1/16 x 21 13/16" (43.4 x 55.4 cm)
Publisher: Tanglewood Press, New York
Printer: M. H. Lavore Co., New York
Edition: 225
Gift of Tanglewood Press, 1966

Öyvind Fahlström was a playwright, filmmaker, concrete poet, painter, print-maker, and politically engaged intellectual who became best known for his "variable" art, in which detachable elements could be rearranged at will by the viewer. A descendant of Surrealism, he actively incorporated chance into art, a theme that also preoccupied many of the Paris-based Nouveaux Réalistes. For his format and imagery, often political in nature, Fahlström borrowed heavily from popular culture sources, continuously drawing on his vast files of magazine photographs and comic books.[2]

Fahlström often worked in series in several mediums. His prints usually followed his efforts in painting; he considered them a fundamental part of his overall art. "It is time to incorporate advances in technology and to create mass-produced works of art, obtainable by rich or not rich," he once proclaimed.[3] When publisher Rosa Esman of Tanglewood Press invited Fahlström

to participate in her portfolio *New York International*, he had just completed the variable painting *Eddie (Sylvie's brother) in the Desert*.[4] To make the print, he had the painting photographically reproduced, adding a strip of small elements along the left edge with the words "CUT OUT AND ARRANGE" at the lower right. He had developed a cutout paper-doll format, hoping the collectors would do just that and create their own variable print. In an unusual twist, he cut up the rejected proofs for the print and made at least three variable collages, thereby, ironically, creating unique works out of this multiple project.[5]

Fahlström was fascinated by larger-than-life figures that captured the public's imagination, titling this work, for instance, after the beloved European pop singer Sylvie Vartan and her brother Eddie, the band leader. Many of the individual elements are derived from dreamlike imagery, often based on Fahlström's native Brazil, including the mountains at lower left and the column of people marching through the desert in the center.[6] Fahlström's playful format, fragmented compositions, and small, simply outlined elements resonate with the sensibility of comic books and anticipate the work of European artists of the Nouvelle Figuration group. The pale, muted tones also suggest the weak color typical of comics' cheap printing and commercial paper.

1 Sharon Avery Fahlström, the artist's widow, notes in her forthcoming catalogue raisonné of Fahlström's prints that the artist partially applied Swedish capitalization rules to this title.
2 Avery Fahlström, conversation with the author, May 1998.
3 Fahlström, quoted in Susan Tallman, "Pop Politics Öyvind Fahlström's Variables," *Arts* 65, no. 4 (December 1990): 15.
4 *Eddie (Sylvie's brother) in the Desert*. 1966. Tempera on vinyl. Private collection, Germany.
5 The Museum of Modern Art, New York, has one of these collages in its collection.
6 Avery Fahlström, conversation with the author, May 1998.

Equipo Crónica
(Rafael Solbes and Manolo Valdés)

Alpino. (1974)

Screenprint
Composition and sheet: 27 x 18 ⁵/₁₆" (68.7 x 49.0 cm)
Publisher: Equipo Crónica, Valencia, Spain
Printer: Ibero-Suiza, Valencia, Spain
Edition: 75
Frances Keech Fund, 1997

Equipo Crónica was a collective team of artists Rafael Solbes, Manolo Valdés, and, briefly, Juan Antonio Toledo.[1] Formed in 1964 in Valencia, Spain, this group was strongly influenced by American Pop in its crisp, bold figurative style and vibrant palette, and they repeatedly borrowed from the mass media as well as modern and Old Master paintings for their juxtapositions of popular culture and fine art. But underlying these motifs were more serious, political themes and the potential conflict between their social responsibilities and their role as artists. In an effort to confront these issues, their work focused on the state of art in the realm of a totalitarian regime and, in common with much of Pop, raised questions about issues of originality and artistic authorship through their appropriation of found images.

 Equipo Crónica became involved with printmaking as founding members of the Valencia branch of Estampa Popular.[2] This Spanish underground movement addressed issues of poverty and injustice through printmaking, continuing the long tradition of using prints as a vehicle for communicating social and political ideals to a wide audience. Like the work produced by other branches of Estampa Popular, Equipo Crónica's earliest prints were linoleum cuts, the least complicated and least expensive printmaking method. But the team quickly turned to screenprint, a format more easily adapted to the transformation of sources from popular culture and which offered greater compositional versatility. Of this switch, Valdés wrote:

Screenprinting was a modern procedure that let us introduce as many colors as we wanted....In Europe, artistic screenprinting was not being used and we got the impression that we were incorporating new approaches to the world of art. It was indeed very gratifying. I remember visiting an industrial screenprinting atelier and being taken aback by the technique. From then on we began to use it.[3]

Themes of violence are repeatedly presented in Equipo Crónica's appropriated media images. In 1972 they completed a series of paintings titled *Serie Negra*, or Black Series, based on gangster images from Hollywood film noir of the 1940s. *Alpino* is one of the first prints based on this theme and depicts the criminal doctor in John Huston's jewel-heist thriller *The Asphalt Jungle*.[4] The doctor is holding an index card that bears a fingerprint, the essen-

tial evidence placing a suspect at the scene of a crime. But here, it is the artist himself who is implicated since the fingerprint is printed on an index card tabbed with the letter "E" for Equipo Crónica, and the doctor's face is obscured by artists' tools—a box of the popular Spanish brand of colored pencils, Alpino.[5] Equipo Crónica uses the film noir narrative to conflate the "Who done it?" story line with issues of artistic authorship, simultaneously confirming the identity of both artist and villain.

1 Toledo left the group in 1965.
2 For more on Estampa Popular, see *Estampa Popular* (Valencia: IVAM Centre Julio González, 1996).
3 Valdés, letter to the author, June 1998.
4 Lola Garcia Giménez, publisher and gallery owner, letter to the author, November 1997. The film was a classic film noir starring Sam Jaffe as Dr. Erwin Riedenschneider. It also featured Marilyn Monroe in a supporting role, one of her first film appearances.
5 Giménez, letter to the author, November 1997.

Bernard Rancillac

Dr. Barnard. 1969

Screenprint
Composition: 31 ¼ x 23 ⁷/₁₆" (79.4 x 59.5 cm)
Sheet: 31 ½ x 23 ½" (79.9 x 59.8 cm)
Publisher: the artist
Printer: Jean-Jacques de Broutelles, Paris
Edition: 100
Frances Keech Fund, 1998

Bernard Rancillac was among the most original voices in the group of artists who founded the Paris-based Nouvelle Figuration, a movement formed in reaction to American and British Pop art and which rejected the more romantic found assemblages of Nouveau Réalisme. Beginning in 1964, Rancillac depicted Disney comic-book characters dramatically posed with other imaginary figures in a brash, expressionist style, often presenting these Surrealist-inspired menageries in narrative, multi-frame formats.[1] With critic Gérald Gassiot-Talabot and artists Hervé Télémaque and Peter Foldes, he co-organized the landmark 1964 exhibition *Mythologies Quotidiennes* which heralded the renewal in France of a narrative and graphic figurative art based on an everyday reality.[2]

Starting in 1966 Rancillac abandoned the comic-strip figures and format for a more streamlined approach using photographic imagery from the popular media. Images of jazz musicians, avant-garde writers, and politicians alternate with scenes from the major political trouble spots of the period, including Vietnam, Albania, and Mao Tse-Tung's China. Rancillac's new working method entailed projecting a photographic image onto the canvas and painting in broad areas of vivid, synthetic hues and exaggerated tonal contrasts which resembled the stark silhouettes of commercial printing.

Screenprinting began to play a major role in Rancillac's art in 1968 when he started experimenting with small editions on plexiglass and other plastic surfaces, primarily printing portraits of contemporary figures, such as Malcolm X and Beat-generation writers Jack Kerouac, Allen Ginsberg, and William S. Burroughs.[3] That same year, Paris exploded in the May uprisings. Striking students occupied the École des Beaux Arts and established a screenprinting shop known as L'Atelier Populaire.[4] Several artists participated as well, and dozens of anonymous protest posters were plastered throughout the streets of Paris. Interested in breaking out of the small circle of the art world and disseminating his work to a larger, less elite audience, Rancillac made several posters for the student printing shop. Printmaking offered him the perfect vehicle and L'Atelier Populaire the ideal venue.[5]

Inspired by the activities of L'Atelier Populaire, the following year Rancillac and a group of five other artists glued 600 prints, including *Dr. Barnard*, to walls and publicity panels on the streets of Paris, thereby circumventing typical commercial art viewing and distribution channels.[6] This screenprint depicts the renowned South African heart surgeon Dr. Christiaan Barnard, who received tremendous press coverage when he performed the first heart transplant in December 1967. Derived from a photograph taken from a popular magazine, and in keeping with the Pop tradition of celebrity portraiture, Rancillac graphically streamlined and exaggerated the doctor's features. Zooming in on the heroic surgeon's life-giving hands, he also conveyed an ominous sense of power, positioning Dr. Barnard looming above the viewer and bursting off the sheet with larger-than-life impact.[7]

1 The vibrant and iconoclastic comic-book style of American expatriate Peter Saul, who had been living in Paris for several years, was an important influence.
2 The exhibition opened at the Musée d'Art Moderne de la Ville de Paris in July 1964 and included, among others, Eduardo Arroyo, Öyvind Fahlström, Leon Golub, Peter Klasen, Jacques Monory, Martial Raysse, Niki de Saint Phalle, Peter Saul, and Jan Voss.
3 These works were all exhibited in *Les Américains* at the Galerie Mommaton, Paris, October 1968.
4 For more on the artistic production of L'Atelier Populaire, see *Text and Posters by Atelier Populaire: Posters From The Revolution, Paris, May 1968* (London: Dobson, 1969).
5 Rancillac was familiar with all the traditional printmaking techniques, having studied at Stanley William Hayter's Atelier 17 workshop. He found these mediums too constraining, however, and inappropriate for depicting everyday reality.
6 The other artists were Michel Dronda, Alain Dufo, Bernard Frangin, Alexandre Goetz, and Claude Vimard.
7 The artist cannot recall where he found this photograph but thought the magazine *Paris-Match* the most likely source.

Consumer Culture

Andy Warhol 56

James Rosenquist 58

Andy Warhol 60

Richard Smith 61

Edward Ruscha 62

Allan D'Arcangelo 64

Derek Boshier 65

Colin Self 66

7 Objects in a Box 68

Roy Lichtenstein 70

Roy Lichtenstein 72

Roy Lichtenstein 73

Jim Dine 74

Larry Rivers 75

Patrick Caulfield 76

Marisol 77

Wayne Thiebaud 78

Andy Warhol

Campbell's Soup Can on Shopping Bag. 1964

Screenprint on shopping bag with handles
Composition: 6 x 3 $^1/_2$" (15.2 x 8.8 cm)
Bag: (irreg.) 18 $^{13}/_{16}$ x 17 $^1/_{16}$" (47.9 x 43.4 cm)
Publisher: Bianchini Gallery, New York
Printer: Ben Birillo, New York
Edition: approximately 200
Gift of Jo Carole and Ronald S. Lauder, 1997

I used to drink it (Campbell's soup), I used to have the same lunch every day, for twenty years, I guess, the same thing over and over again. Someone said my life has dominated me; I liked that idea.[1]

Andy Warhol has come to define the Pop art movement in America. The first images to establish that reputation were his repeated renderings of a Campbell's soup can, first seen in his solo exhibition at the Ferus Gallery in Los Angeles in 1962. Warhol depicted several commercial products during this period, and, with the exception of the Brillo box, all were mass-produced, machine-made food items—symbols of the common denominators or equalizers of American society. Warhol's images of Campbell's soup cans epitomize the aggressive formal traits of isolation, enlargement, and bright color that have become the hallmarks of Pop. They not only represented the commodities themselves, and the consumer culture of the 1960s by extension, but the power of the printed advertisements and the media that published them to transform these products into ubiquitous household staples.

Issues of quantity, repetition, and mechanical production are at the core of Warhol's art. In 1962 Warhol began his signature process of screenprinting on canvas, matching his mass-produced images with a commercial and infinitely-repeatable medium in which he could work directly from the photographs that inspired him.[2] The mechanical ease of the medium revolutionized his work and encouraged him to repeat his images in multiple rows on one canvas or individually on several.

He did not turn to editioned printmaking in earnest until 1967 when he began his series of large thematic portfolios comprising ten prints each. Before then, however, in several large-edition printed ephemera works, he created some of his most incisive printed statements about reproduction and originality. 1964 was a particularly prolific year for Warhol in this medium: he contributed to two large-edition group projects and completed his first two mass-produced offset prints designed as exhibition give-aways.[3] *Campbell's Soup Can on Shopping Bag* was Warhol's first editioned version of the soup

can image and accompanied the historic *American Supermarket* exhibition at Bianchini Gallery, New York. It was printed in an edition of approximately 125–200[4] which sold for twelve dollars each (as was Roy Lichtenstein's *Turkey Shopping Bag*, see p. 72). The shopping bags were meant to be used to carry out the visitors' purchases, making examples in good condition quite rare.

The exhibition displayed a pyramid of actual Campbell soup cans adjacent to a painted version by Warhol and a stack of his multiple wood supermarket cartons screenprinted with the Campbell's Soup logo, also made in 1964. Interestingly, the shopping bag is the only version that shows the can to scale, giving it an intimacy and starkness as it floats on the large white ground not seen in other renderings. The off-register printing, which was typical of the autographic quality of Warhol's printmaking in these early years, adds further poignancy to this mass-produced image and creates a conflict between the viewer's awareness of the machine-made product and the expressive hand-made interpretation.[5]

In 1965 Warhol made neon-colored paintings of the soup cans and, in 1966, for his exhibition at the Institute of Contemporary Art in Boston, produced another shopping bag, this time in neon colors with the image of the can enlarged nearly to the edges.[6] These compositional changes drastically alter the perception of the cans, transforming them into tools for artful interpretation rather than images for blatant, straightforward portrayal. As Roberta Bernstein has pointed out, the portfolios *Campbell's Soup I* and *II* of 1968 and 1969 offer a mechanical perfection not seen in the earlier printed versions and suffer from a loss of impact and immediacy.[7]

With the Campbell's soup can image, perhaps more than any other in his career, Warhol hit upon the symbol of the contemporary American consumer society of the 1960s. With the shopping bag he found its surrogate.

1 Warhol, quoted in G. R. Swenson, "What is Pop Art? Answers from Eight Painters, Part I," *Art News* 62 (November 1963), p. 26.
2 The early Campbell's soup can paintings, however, of 1962–63, were made mostly by hand and with the aid of stencils, not with photoscreenprinting.
3 The group projects were the illustrated book *1¢ Life* and the portfolio *X + X (Ten Works by Ten Painters)*; the offset prints were *Flowers* and *Liz.*
4 Although the catalogue raisonné lists an edition of 300, recent research indicates that many fewer were actually printed. See Constance W. Glenn, *The Great American Pop Art Store: Multiples of the Sixties* (Long Beach: University Art Museum, California State University; Santa Monica: Smart Art Press, 1997), p. 40.
5 It has been often suggested that Jasper Johns's 1960 ale-can sculpture, *Painted Bronze*, served as an inspiration for Warhol's soup can images. Johns's work is characterized by the tension between the handmade cast sculpture and mass-produced consumer item.
6 He also produced a Campbell's soup can banner with the Betsy Ross Flag and Banner Company in 1966 in these variant colors.
7 Roberta Bernstein, "Warhol as Printmaker," in Frayda Feldman and Jörg Schellmann, eds., *Andy Warhol Prints: A Catalogue Raisonné 1962–1987* (New York: Ronald Feldman Fine Arts, Edition Schellmann, and Abbeville Press, 1985), p. 16.

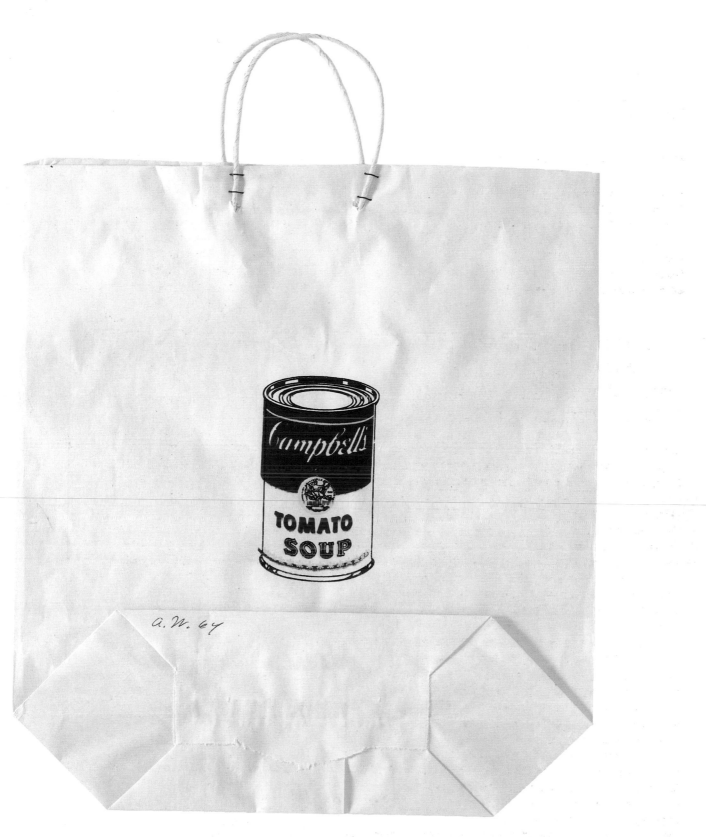

James Rosenquist

Campaign. 1965

Lithograph
Composition and sheet: 29 ³/₈ x 22 ³/₈" (74.6 x 56.9 cm)
Publisher and printer: Universal Limited Art Editions, West Islip, New York
Edition: 26
Gift of the Celeste and Armand Bartos Foundation, 1965

I'm amazed and excited and fascinated about the way things are thrust at us, the way this invisible screen that's a couple of feet in front of our mind and our senses is attacked by radio and television and visual communications, through things larger than life....[1]

These words crystallize the underlying motivation behind James Rosenquist's dazzling approach to artmaking and present one of the critical themes of the Pop movement. Trained as a billboard painter, Rosenquist felt that commercial advertising had an impact and excitement that he wanted to infuse into his own art. In 1961 he began to incorporate the disjunctive scale and clashing saccharine colors of advertising into large works distinguished by emotionally neutral, anonymous images, flat, uniform surfaces, and a fragmented vision in order to simulate the bombardment of visual stimuli in contemporary life.

Tatyana Grosman had invited Rosenquist to make prints at Universal Limited Art Editions (ULAE) in 1962 after seeing his first solo exhibition, but he showed little interest in printmaking at the time. Some years later, Jasper Johns convinced him to try. After an initial unsuccessful attempt, Rosenquist tried working with an airbrush, a common tool in commercial art but strictly unorthodox at ULAE, signaling the experimental tack he would maintain in his approach to printmaking. With the airbrush and an eraser Rosenquist proceeded to develop his style of even tonality and an overall sense of remove.

Rosenquist consistently mined magazines of the 1940s and 50s for source material, seeking out images that were generic and unstylish and would not arouse feelings of nostalgia. *Campaign*, one of his first prints at ULAE, illustrates Rosenquist's typical method of overlapping unrelated forms, using color to unify compositionally as it confuses contextually. He directs our

vision, bringing some images into focus sooner than others; in this work zeroing in on the hand, the salt shaker, and the Kleenex boxes, while allowing the soldier's uniform to emerge more slowly.

The title refers both to a twenty-day printmaking "campaign" at the workshop and a military campaign.[2] Rosenquist was very involved in political issues, and although he maintains that his work is not overtly political, subtle references surface frequently. The imagery in *Campaign* appeared again in a twenty-four-foot painting on a float for the 1967 Spring Mobilization Against the Vietnam War, which showed a hand pouring salt on war medals. The painting created tremendous controversy and was destroyed by hecklers in Central Park.[3]

In addition, the flowers, made with a wallpaper roller, seem almost alive and irradiated and represent the artist's fears about environmental pollution.[4] Rosenquist used the same wallpaper rollers for *Campaign* that he had used in his monumental and most audaciously political work, *F-111*, which also dates from 1965.[5] Of the *F-111* flowers he said, "I saw the pattern in an elevator lobby and thought of a solid atmosphere...all of a sudden [you] feel that it has become solid with radioactivity and other undesirable elements. So I used a wallpaper roller with hard artificial flowers to hang in the atmosphere like a veil."[6]

1 Rosenquist, quoted in G. R. Swenson, "What is Pop Art? Interviews with Eight Painters, Part II," *Art News* 62, no. 10 (February 1964): 63.

2 Esther Sparks, *Universal Limited Art Editions: A History and Catalogue: The First Twenty-Five Years* (Chicago: The Art Institute of Chicago; New York: Harry N. Abrams, 1989), p. 256.

3 Rosenquist, letter to the author, June 1998.

4 Sparks, *Universal Limited Art Editions*, p. 256.

5 Rosenquist, letter to the author, June 1998.

6 Rosenquist, quoted in "What is the *F-111*?(Interview with G. R. Swenson)," *Partisan Review*, (Autumn 1965); reprinted in John Russell and Suzi Gablik, eds., *Pop Art Redefined* (New York and Washington, D. C.: Frederick A. Praeger, 1969), p. 106.

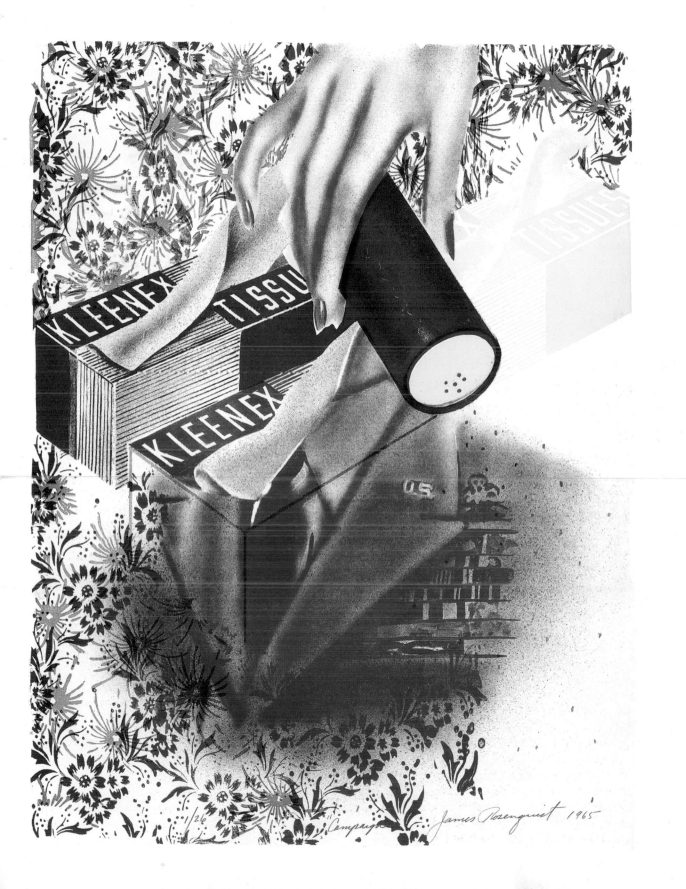

Andy Warhol

S&H Green Stamps. (1965)

Photolithograph
Composition: 22 ¹/₂ x 22 ¹/₄" (57.0 x 56.5 cm)
Sheet: 23 ¹/₈ x 22 ³/₄" (58.8 x 57.9 cm)
Publisher: Institute of Contemporary Art, Philadelphia
Printer: Eugene Feldman, Philadelphia
Edition: approximately 300; plus 6,000 folded exhibition mailers
Gift of The Junior Associates of The Museum of Modern Art, 1997

Andy Warhol's depictions of S&H Green Stamps, like his early images of dollar bills, illustrate his quintessential vision of art as commodity. Warhol's mother avidly collected the popular trading stamps and frequently enlisted the help of her son and his friends. The image, which is simultaneously numerous and solitary, is typical of the artist's fascination with both serial formats and the singular image. But unlike the majority of Warhol's work in which the repetition is of his own design, in *S&H Green Stamps* this quality was readymade.

The print is predated by Warhol's 1962 paintings *S&H Green Stamps* and *Seventy S&H Green Stamps*, which were made with rubber stamps carved from artgum or soft erasers.[1] This photolithograph version of 1965 is based on a photograph of an original sheet of the stamps[2] and creates a more mechanical and precisely gridded image than in the paintings. This process and format both eradicate the evidence of the "artist's hand" and make the image available for broad dissemination, mimicking the original source.

S&H Green Stamps was published to coincide with the opening of the artist's first retrospective, held at the Institute of Contemporary Art (ICA), Philadelphia, in the fall of 1965. Approximately 300 were printed as exhibition posters and sold for fifteen dollars each. (The proceeds subsidized the exhibition catalogue.) Some impressions were signed and dated, not by Warhol but by Samuel Adams Green, ICA director and exhibition organizer, further complicating the questions of originality, reproduction, and authorship that were central to Warhol's ideology.[3] One hundred of the 300 prints were also installed as wallpaper within the gallery space. On one wall hung forty-nine prints, seven high by seven wide, and two adjacent swinging doors were also plastered, obliterating the notion of the individual work and suggesting a seamless, infinitely repeatable sequence of images.

In addition to these formats, *S&H Green Stamps* was produced in an edition of 6,000 as a folded exhibition announcement mailer. Like the wallpaper, it underscored Warhol's interest in using this image as printed ephemera, a subtle comment on the "value" of its original source. Extending the playful nature of the project, Samuel Green and Mrs. H. Gates Lloyd, ICA director of the board, arranged for the production of a unique *S&H Green Stamps* tie and blouse, which they wore at the opening (see p. 20, fig. 8). With its wry subject and multiple formats and functions, *S&H Green Stamps* stands as one of Warhol's most ironic statements on the relationship between the different and often contradictory levels of consumer culture and art production. —J. H.

1 Warhol and his studio assistant Nathan Gluck hand-carved the erasers and stamped the canvases by hand. *Airmail Stamps* of the same year was made in a similar manner. Ultimately, Warhol abandoned this technique entirely, for the mechanical ease of screenprinting.
2 Mrs. Rosina Feldman, the printer's widow, conversation with the author, August 1998.
3 Warhol's "signature" had been frequently added by others to his works beginning in 1953, when the artist's mother signed his drawings. He began employing a rubber-stamp signature in 1966.

Richard Smith

PM Zoom from *The Institute of Contemporary Arts Portfolio.* 1963 (Published 1964)

Screenprint
Composition: 19 x 30" (48.3 x 76.2 cm)
Sheet: 23 1/16 x 35" (58.6 x 88.8 cm)
Publisher: Institute of Contemporary Arts, London
Printer: Kelpra Studio, London
Edition: 40
Abby Aldrich Rockefeller Fund, 1965

We are all archaeologists, though for the most part we are digging up things we ourselves buried....[1]

Richard Smith's excavations included commercial packaging and corporate logos from contemporary culture. During a two-year Harkness Fellowship, which brought him from London to New York between 1959 and 1961, Smith's work took on the monumentality of billboards and the slick, vibrant color of American glossy magazines. An admirer of Richard Hamilton and fellow student of Peter Blake's at London's Royal College of Art in the late 1950s, Smith became interested in consumer packaging design, advertising, and the mass media, encouraged by the writings of Marshall McLuhan. By the mid-1960s his work had evolved from images derived from mass culture to abstract canvases and three-dimensional constructions whose forms obtusely suggested the commodities themselves (often only revealed by titles such as *Clairol Wall*).

PM Zoom is Smith's first published print and was part of the seminal print portfolio sponsored by the Institute of Contemporary Arts in 1964. Closely related to such paintings as *Tip Top* and *Staggerly*, both of 1963, the print depicts four packs of Philip Morris cigarettes aggressively shooting into the foreground in progressive close-up, with one cigarette popped up for easy grabbing. Smith's interest in advertising strategies is clearly illustrated in the bright color and central isolated pose of the cigarette packs. But presented in this way, the cigarettes take on a menacing posture. Enhanced by the irradiated blue ink, the image seems to critique, not applaud, the advertiser's tactics and suggests the seductive danger of the product itself.

Although Smith rarely abandoned the painterly brushstroke in his other work, the richness and opacity of flat color attainable with screenprint matched his goals for this initial print. He assimilated both the imagery and the medium from consumer packaging. With the sophisticated help of printer Chris Prater of Kelpra Studio, Smith used photographic means to repeat the image in successive magnifications.[2] Its title alludes to this process.

1 Smith, quoted in John Russell and Suzi Gablik, eds. *Pop Art Redefined* (New York and Washington, D.C.: Frederick A. Praeger, 1969), p. 114.
2 Smith recalls making a maquette for Prater with the four enlargements of the cigarette pack which was printed photographically. He made the background screens by hand. Smith, conversation with the author, April 1998.

Edward Ruscha

Standard Station. 1966

Screenprint
Composition: 19 1/2 x 36 15/16" (49.5 x 93.8 cm)
Sheet: 25 9/16 x 39 15/16" (65.0 x 101.5 cm)
Publisher: Audrey Sabol, Villanova, Pennsylvania
Printer: Art Krebs Screen Studio, Los Angeles
Edition: 50
John B. Turner Fund, 1968

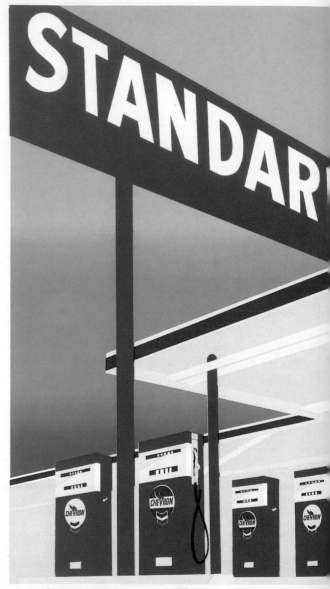

Ed Ruscha was the leading proponent of the Pop aesthetic on the West Coast. Like many of the Pop artists, he worked in various aspects of graphic design before turning to fine art as a career. Ruscha's varied and experimental print-making career has encompassed lithography, screenprint, and artist's books, often using unusual and inventive materials. Not particularly interested in the multiple aspect of the medium, he chose printmaking for the aesthetic quali-ties it offered. "It is the love of the appearance and peculiarities of these tech-niques like litho, etching, silkscreen, photography that gets my full attention. They perform for me rather than the other way around," he has remarked.[1]

In 1962, Ruscha began making artist's books, which recorded his photographic essays on unpeopled vernacular architecture. The service station image depicted in *Standard Station* first appeared as one of a series of photographs he took on a trip along Route 66 from Oklahoma to Los Angeles.[2] These deadpan, documentary photographs were reproduced as unpretentious photolithographs for his first artist's book, *Twentysix Gasoline Stations*.[3] The following year, Ruscha transformed the photograph into a monumental paint-ing in which he dramatically foreshortened the station to diagonally bisect the picture plane in a looming cinematic composition. His love of movies undoubt-edly inspired its theatrical, horizontal format, typical of his work of this period.[4]

When Audrey Sabol offered to underwrite the production of a print based on the 1963 painting, Ruscha chose to do a screenprint. The purity of solid, flat color available with screenprint made it a natural choice for the translation of this slick, stylized depiction. *Standard Station*, Ruscha's first published screen-print, was produced at the commercial workshop Art Krebs Screen Studio. This ambitious, multi-colored print is one of the signature images of the Pop period. Although closely following the painting's composition, the print's blue daylight sky contrasts with that version's theatrical night sky. He adds a note of irony by accentuating the smog-filled Los Angeles atmosphere as the backdrop for its progenitor, the gasoline station. In 1969 Ruscha printed three other versions of this image, *Mocha Standard*, *Cheese Mold Standard with Olive*, and *Double Standard,* using the same screens.

1 Ruscha, letter to the author, May 1998.
2 For a discussion of Ruscha's early printmaking see Elizabeth Armstrong, *First Impressions: Early Prints by Forty-six Contemporary Artists* (New York and Minneapolis: Hudson Hills Press in association with Walker Art Center, 1989), pp. 45–46.
3 This book marked the beginning of this innovative and inexpensive form of printed art.
4 Ruscha also made two films in the mid-1970s. Ruscha, letter to the author, May 1998.

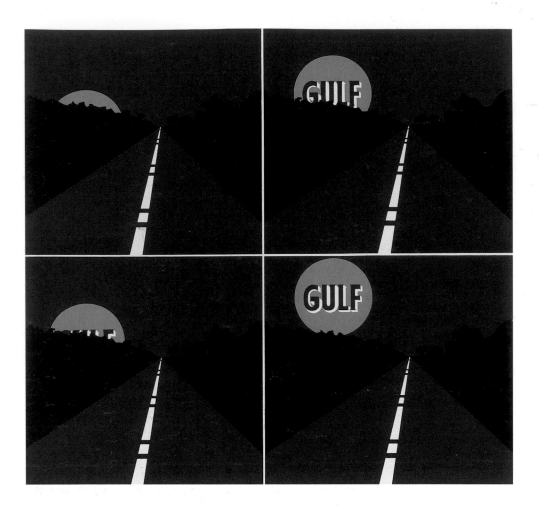

Allan D'Arcangelo

June Moon from the portfolio *69*. 1969

One of seven screenprints
Composition and sheet: 23 1/2 x 25 9/16" (59.7 x 64.9 cm)
Publisher and printer: Edition Domberger, Stuttgart/Bonladen
Edition: 120
Gift of the artist, 1969

The allure of the endless American vista has appealed to numerous artists including several of the Pop period, in particular Robert Indiana, Ed Ruscha, and Allan D'Arcangelo. By 1962 the mystique of the highway had become the principal motif in D'Arcangelo's work. Depicting barren stretches of road in steep perspective and devoid of humanity, his paintings are populated only by gasoline logos or road signs and are often imbued with a caustic, satirical edge. He places the viewer in the unseen car speeding along into the infinite horizon. These streamlined images combine the classic Pop themes of commodity signage and the cult of the automobile with the flat, unmodulated color and distinctly outlined forms that define Pop's formal clarity.

D'Arcangelo made his first print, an etching, in 1962 but quickly turned to the screenprint because of its capacity for broad areas of bright, uniform color. In 1969 a leading German screenprinter, Luitpold Domberger, approached him about making a portfolio. D'Arcangelo suggested a retrospective suite that would comprise his images from the last seven years. He sent slides of seven paintings to Germany with exact color samples of the paint. The images were photographed and translated into austere, almost minimal fields of stark, flat color. Given the distance and the impersonal translation that D'Arcangelo was after, and Domberger's expertise at rich precision printing, the artist never needed to visit the shop; instead, proofs were mailed back and forth until both artist and printer were pleased with the results.[1]

In *June Moon*, D'Arcangelo incorporated four vistas within one work, each with a slightly altered viewpoint, and introduced a temporal element to his highway images. His sarcastic tone is evident as the orange Gulf sign, receding over the horizon, has replaced the waxing moon as a prominent feature in the American landscape—a symbol of the triumph of the man-made and commercial over the natural.

1 D'Arcangelo, conversation with the author, May 1998.

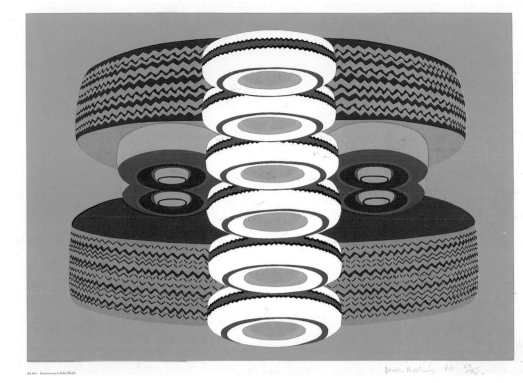

Derek Boshier

Untitled from *The Institute of Contemporary Arts Portfolio*. 1964

Screenprint
Composition: 21 x 29 3/8" (53.4 x 74.6 cm)
Sheet: 23 1/16 x 31 7/8" (58.6 x 81.0 cm)
Publisher: Institute of Contemporary Arts, London
Printer: Kelpra Studio, London
Edition: 40
Purchase, 1965

Derek Boshier was part of a second generation of Pop artists, along with David Hockney, Allen Jones, and Peter Blake, to emerge from London's Royal College of Art. In the heady "Swinging London" of the 1960s, the Royal College of Art was the hub of youthful, rebellious activity in the arts. The British artists often responded to American pulp media before American artists, and Boshier completed his first Pop paintings while still in school in 1962. His work frequently made reference to the manipulative power of advertising and included a variety of images popularized in the press. Like the work of several others of this group, Boshier's paintings focused on the Americanization of British culture, but they possessed a critical edge and pointed political stance that distinguished his work from that of his fellow students.

This untitled screenprint was Boshier's first published print and part of a now-historic portfolio initiated by Richard Hamilton and sponsored by London's Institute of Contemporary Arts (ICA). Hamilton invited numerous young artists to participate. For many, Boshier included, this was their first experience with the printmaking medium.[1] The project was a decisive factor in its printer Chris Prater's decision to abandon commercial work and commit his workshop, Kelpra Studio, to full-time fine-art printing. Prater and Kelpra went on to revolutionize the medium of screenprint and worked extensively with several of the leading Pop artists in London in the 1960s.

The automobile tire remains a symbol of the American fascination with cars, a phenomenon that was abundantly reflected in 1950s American advertising and in the ubiquitous Michelin tire ads in European media. Boshier borrowed the image of this tire from a framed newspaper advertisement that had been lying about his house for several years (he had originally planned to use it in a 1962 painting).[2] The Day-Glo colors, looming forms, and decorative repetition of the tires glamorize this otherwise plebeian product in a style akin to advertising and are typical of Pop art's formal strategies. Boshier recently moved to Los Angeles[3] and returned to this image in a 1997 drawing titled *Los Angeles Interstate 5*, part of a series of drawings devoted to that city, which reveals a renewed interest by this artist in the lure of the American highway.

1 There are twenty-four artists included in *The ICA Portfolio*: Gillian Ayres, Peter Blake, Derek Boshier, Patrick Caulfield, Bernard Cohen, Harold Cohen, Robyn Denny, Richard Hamilton, Adrian Heath, David Hockney, Howard Hodgkin, Gordon House, Patrick Hughes, Gwyther Irwin, Allen Jones, R. B. Kitaj, Henry Moore, Eduardo Paolozzi, Victor Pasmore, Peter Phillips, Bridget Riley, Richard Smith, Joe Tilson, and William Turnbull. Boshier, in a letter to the author, March 17, 1998, recalled several of the artists' eager responses to the invitation to make a print.

2 In the late 1960s, while teaching at a London art school, Boshier used the image for a student project. Boshier, letter to the author, March 1998.

3 Boshier moved from Texas, where he had lived for most of the 1980s, teaching at the University of Houston.

Colin Self

Untitled (variant of *Power and Beauty No. 3*) from the series Power and Beauty. (1968)

Screenprint
Composition and sheet: 26 13/16 x 41 5/8" (68.1 x 105.8 cm)
Publisher: unpublished
Printer: Editions Alecto, London
Edition: unique variant (final edition: 75)
Celeste and Armand Bartos Foundation Fund, 1969

Colin Self's experience growing up near an American Air Force base in East Anglia, England, proved to be a defining influence on his art. "I'm a war baby and it's gone very deep."[1] Two extended visits to the United States in 1962 and 1965 cemented his impressions of American culture as well as his fears of Cold War politics. While at the Royal College of Art in the early 1960s, he met David Hockney, Peter Phillips, and other young nonconformist artists. His realist imagery of cinema interiors and hot dogs was pervaded by a darker, more haunting mood, however, and kept his work on the edges of the Pop sensibility.

Self's earliest prints were meticulous, diagrammatic etchings. He enjoyed the intense physicality of the press, the somber effects of black ink, and the tactility of the etched line as opposed to what he considered the other, more "reproductive" printmaking mediums. By the late 1960s he began using photography to accurately reproduce his subjects and eliminate all personal gesture, which led him to produce the monumental 1968 series of prints titled Power and Beauty, which used photographs from a variety of commercial sources. "The images are collected. I was cutting [out] so many photographs and eventually it appeared they were all on a definite theme."[2]

Comprising five screenprints and one etching, the series includes images of a cat, a whale, a car, a cockerel, an elephant, and a peacock. The grossly exaggerated close-ups of the animal images make them nearly unrecognizable and decidedly ominous. The shimmering, iridescent inks lend an eerie, unearthly effect. The only manufactured object in the series is the car. This image, taken from a 1964 American auto magazine, shows a customized car by the California designer Joe Baillon. Self described the car as "elephantine, sinister, and oppressive—he [Baillon] made it feel like a nuclear threat."[3]

For the edition, Self made a photoscreen from the magazine reproduction and transferred the image onto an etching plate before printing it in black ink. The enlarged halftone dots actually became embossed when printed and add a sculptural feel to the surface. Self, however, never believed in identical editions; proofs in varying colors and mediums are not unusual.[4] This screenprint version of *Power and Beauty No. 3* is printed from the photoscreen. (The editioned etching appears in the reverse.) Its vivid coloration enhances its Pop sensibility and softens what Self intended as a foreboding, omnipotent machine.

1 Self, conversation with the author, November 1997.
2 Self, quoted in "Colin Self and David Hockney Discuss Their Recent Work," in *Studio International* 176, no. 96, p. 277.
3 Self, conversation with the author, November 1997.
4 Many of his images exist in editions of fewer than ten.

7 Objects in a Box

(1965–66, published 1966)
Wood box, with stenciled paint additions, containing seven multiples
Publisher: Tanglewood Press, New York
Fabricator (except Lichtenstein): Knickerbocker Machine and Foundry, New York
Edition: 75
Gift of Mr. and Mrs. Lester Francis Avnet, 1967

Allan D'Arcangelo. *Side-View Mirror.* (1965)
Screenprint on plexiglass set into chrome side-view mirror mounted on acrylic base
Composition: 6 $7/8$ x 5 $1/2$ x 6 $1/8$" (17.5 x 14.0 x 15.5 cm)

Jim Dine. *Rainbow Faucet.* 1965
Sand-cast aluminum dipped in acrylic paint
Composition: (irreg.) 2 $5/8$ x 4 $3/4$ x 5 $1/2$" (6.6 x 12.0 x 13.7 cm)

Roy Lichtenstein. *Sunrise.* (1965)
Enamel on steel
Composition: 8 $9/16$ x 11 x 1" (21.7 x 27.9 x 2.5 cm)
Fabricator: unknown

Claes Oldenburg. *Baked Potato.* (1966)
Cast resin with acrylic paint and porcelain plate
Potato: (irreg.) 4 $1/8$ x 4 $7/8$ x 8 $1/4$" (10.0 x 21.0 x 12.5 cm)
Plate: (irreg.) 1 $3/16$ x 10 $1/2$ x 7 $1/8$" (3.0 x 26.6 x 18.1 cm)

George Segal. *Chicken.* (1966)
Cast acrylic and fiberglass
Composition (upright): (irreg.) 18 $1/2$ x 13 x 4 $3/4$" (47.1 x 33.3 x 12.0 cm)

Andy Warhol. *Kiss.* (1966)
Screenprint on plexiglass frame
Composition: 12 x 8 x 5 $5/16$" (30.4 x 20.3 x 13.5 cm)

Tom Wesselmann. *Little Nude.* 1966
Spray-painted vacuum-formed plexiglass with foam backing
Composition (upright): (irreg.) 7 $3/4$ x 7 $1/2$ x 1" (19.7 x 19.1 x 2.5 cm)

7 Objects in a Box is a groundbreaking project that reflects the influences of its enlightened publisher, Rosa Esman, as well as an outburst of new technologies on the multiple art of the 1960s. Esman began her involvement in the art world as a young collector who studiously attended New York's galleries and developed a passion for Pop art. Encouraged by European friends' accounts of the lively activity in multiple art abroad and aware of Universal Limited Art Editions's (ULAE) printmaking efforts in Long Island, Esman began Tanglewood Press to offer inexpensive art to young collectors.[1] With her first publication, *New York 10* of 1965, she showed her sensitivity to the art of her time by recognizing printmaking's potential as an important expressive vehicle for the vibrant graphic style of Pop. The suite of ten prints sold out in less than a year.

New technologies, such as vacuum-form molding and other modes of plastic reproduction, had only become readily available after World War II, and consumer goods from Teflon to Tupperware had begun to utilize them in ever-increasing abundance.[2] The dissemination of art to a wider public was a central tenet of Pop ideology and it only took the inventiveness of a few publishers to realize the possibilities these new processes could offer.

For *7 Objects in a Box* Esman initially approached Claes Oldenburg, whose Pop sculptures of food and clothing seemed ideal for the multiple format of small-scale, mass-produced editioned sculptures. Oldenburg completed his first published multiple, *Baked Potato*, for this project. Fabricator Dawa Basanow, who solved many of the technical problems presented by the artists, cast *Baked Potato*.[3] To have the multiple handpainted and, yet, remain philosophically in tune with the multiples' mass-production concept Oldenburg devised a painting scheme for someone else to execute. Artist John Wesley individually painted each potato, spraying green paint from a toothbrush for the chives. Oldenburg once described the project as "a balance of individuality, objectivity, and chance, such as that developed in the Happenings earlier in the 1960s. The multiple object was for me the sculptor's solution to making a print."[4]

Esman ordered the mirrors for Allan D'Arcangelo's *Side-View Mirror* from an auto supply store.[5] Basanow removed the mirror and replaced it with plexiglass screenprinted with the artist's signature highway image. Roy Lichtenstein had already shown his penchant for unusual materials in multiple projects with his screenprinted shopping bag in 1964 and ceramic dishes in 1966. The hard, glossy surface of an enamel metal plaque produced a radiant yet industrial backdrop for his hard-edged, stylized *Sunrise*. Tom Wesselmann had experimented with a large vacuum-form mold in 1964, but with *Little Nude* he captured all the titillating qualities of his more ambitious attempts in this small format. Warhol had been making screenprints from Hollywood movies since *The Kiss (Bela Lugosi)* of 1963, and in 1965 he made two screenprints on plexiglass from his own films, *The Kiss* and *Sleep*. The transparency of this material evokes the translucent nature of film, and the repeated image suggests the serial nature of filmmaking. To house the works Esman designed a simple art-packing crate, as straightforward as the objects inside. It holds seven inventive multiple works but captures a movement, medium, and philosophy of art.

1 Esman ran Tanglewood Gallery (named after the Tanglewood Music Festival near her country home in Stockbridge, Mass.) with partner Suzanne Lubell from 1957 to 1962. It focused on small works of American modernism. For more on the development of Esman's career, see Constance W. Glenn, *The Great American Pop Art Store: Multiples of the Sixties* (Long Beach: University Art Museum, California State University; Santa Monica: Smart Art Press, 1997), p. 40.
2 Teflon was first produced commercially in 1950, and Tupperware, although available since 1946, did not develop a major market until the 1950s.
3 Basanow was an innovative technician and had worked at Kulicke Framers before opening Knickerbocker Machine and Foundry, located on Spring Street in lower Manhattan.
4 Oldenburg, quoted in *Claes Oldenburg Multiples in Retrospect 1964–1990* (New York: Rizzoli International Publications, 1991), p. 34.
5 Esman bought the plates for *Baked Potato* at a restaurant supply store on Manhattan's Bowery.

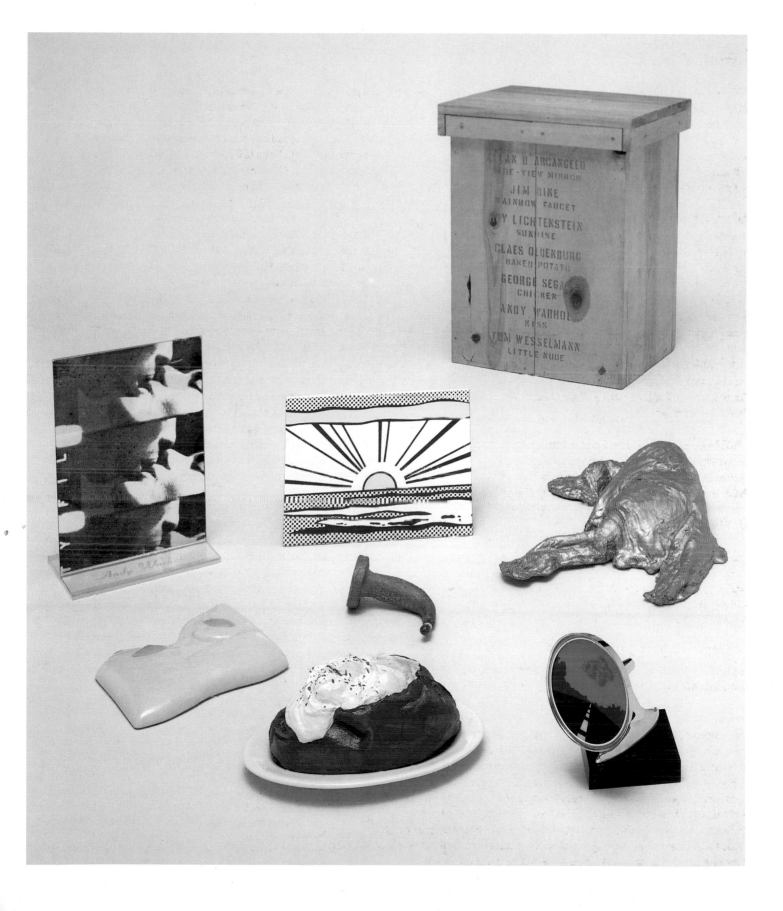

Roy Lichtenstein

Sandwich and Soda from the portfolio
X + X (Ten Works by Ten Painters). (1964)

Screenprint on clear plastic
Composition: 19 x 22 $^{15}/_{16}$" (48.3 x 58.4 cm)
Sheet: 19 $^{15}/_{16}$ x 23 $^{15}/_{16}$" (50.7 x 60.8 cm)
Publisher: The Wadsworth Atheneum, Hartford, Connecticut
Printer: Sirocco Screenprinters, North Haven, Connecticut,
supervised by Ives-Sillman, New Haven, Connecticut
Edition: 500
Gift of Harry C. Oppenheimer (by exchange), 1965

In the 1960s, printed imagery, from comic books to advertisements, was at the essence of Roy Lichtenstein's art. His deadpan depictions of solitary objects in aggressive frontal stance were appropriated primarily from newspaper and Yellow Pages advertisements and came to define Pop as an intertwining of banal subject matter and the mass media. Lichtenstein revolutionized the art of his time by aggrandizing these unsophisticated forms of advertising and photographic processes. His streamlined, primary-hued enlargements of popular culture images deny the artist's handmade mark by emulating the look of commercial reproduction. His graphic sensibility was also reflected in his heavy outlines and unmodulated color, qualities that would characterize his seminal Pop work.

Lichtenstein's career as a printmaker was varied, prolific, and groundbreaking. He was open and experimental in his approach to the medium, using photographic and hand-drawn techniques interchangeably. In the late 1940s and 1950s, he made over thirty-five woodcuts, lithographs, and etchings before completing his first published print in 1962 for *The International Avant-Garde: America Discovered.* But in 1964 Lichtenstein began to experiment with the possibilities of screenprint and helped to establish its newfound prominence in the printmaking renaissance of the 1960s.

Also instrumental to that end was the 1964 portfolio of screenprints *X + X (Ten Works by Ten Painters)* published by The Wadsworth Atheneum in Hartford, Connecticut. Printed in an edition of 500, this varied set introduced the prints of several Pop artists to a wide audience of collectors and contributed to a reevaluation of screenprint as a fine-art medium. The portfolio was coordinated by Samuel J. Wagstaff, Jr., then curator of paintings at the museum.[1] The prints were made after works in other mediums and were created specifically for this project. In Wagstaff's introduction he wrote that screenprint "seemed to be most apt to translate the effect of [these artists'] painting, both the flatness which is the unifying bond between the ten, and the insistence of paint on the surface of canvas so like the visible heft of ink on paper here."[2]

For his contribution, Lichtenstein made an ink drawing of a generic meal on a counter. He depicted the lowest common denominator of a meal, the Horn and Hardart's cafeteria brand, and lifted it, as he typically did, from cheap advertisements rather than the award-winning Madison Avenue variety.

Lichtenstein's transformations from advertisement to drawing exemplify his exaggerated graphic approach.[3] He tilted the image up at a distorted angle so the entire meal can be seen as if the viewer is looking down at the counter. He removed a straw from inside the glass that detracted from the tight compositional structure and eliminated the manufacturer's distracting lettering from the horizontal straw's wrapper. But most characteristically he streamlined the shading marks into generalized claw-like shapes on the plate and clear, simple reflections on the glass, simplifying the forms into abstracted black-and-white patterns. The final graphic depiction suggests advertising's representation of a meal but bears little resemblance to any real or edible commodity.

Sandwich and Soda evolved further in its translation from drawing to screenprint. The drawing was black and white like most of Lichtenstein's early work in the medium. For the screenprint, however, he changed the ink to blue reflecting his background in graphic design.[4] "I like the idea of blue and white very much because a lot of commercial artists use it to get a free color. Blue does for black as well; it is an economic thing."[5] He further transforms the drawing by adding a vivid red background, dramatically confusing the space as the blue counter metamorphoses into an abstract striped backdrop.

In addition to the compositional alterations from the drawing, *Sandwich and Soda* is the first of Lichtenstein's frequent examples of printing on unorthodox surfaces, in this case a clear plastic sheet, a choice most likely inspired by his work as a commercial draftsman. This precocious early print fostered the kind of experimentation by artists and printers alike that shattered the accepted conventions of printmaking, making Pop one of the most inventive periods in the medium's history.

1 The other artists in the portfolio are Stuart Davis, Robert Indiana, Ellsworth Kelly, Robert Motherwell, George Ortman, Larry Poons, Ad Reinhardt, Frank Stella, and Andy Warhol.
2 Samuel J. Wagstaff, Jr., quoted in the introduction to the portfolio *X + X (Ten Works by Ten Painters).*
3 For a reproduction of what appears to be the corresponding advertisement, see John Rublowsky, *Pop Art* (New York: Basic Books,1965), pp. 52–53.
4 For another early work in blue and white, see *Ice Cream Soda.* 1962. Oil on canvas.
5 Lichtenstein, quoted in an interview with John Coplans. Reprinted in Richard Morphet, *Roy Lichtenstein* (London: The Tate Gallery, 1968), p. 12.

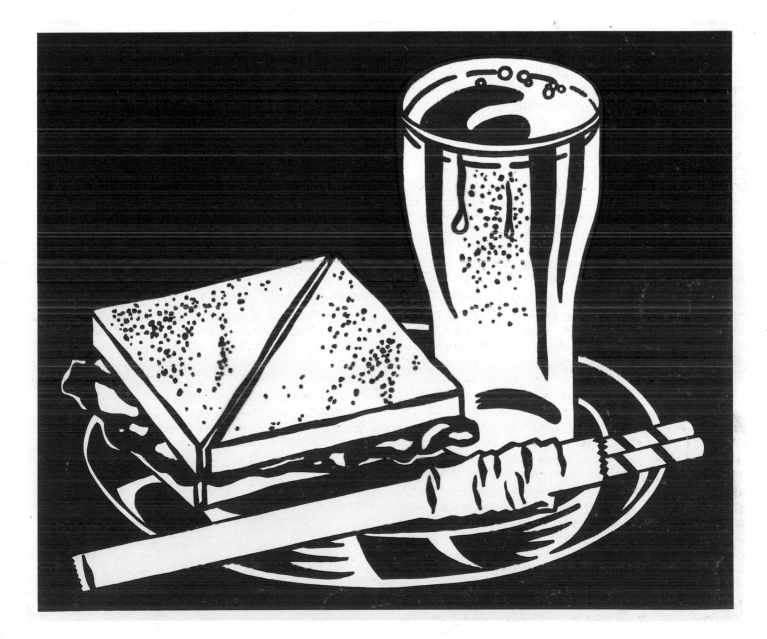

Roy Lichtenstein

Turkey Shopping Bag. (1964)

Screenprint on shopping bag with handles
Composition: 7 $^{1}/_{2}$ x 8 $^{9}/_{16}$" (19.1 x 22.8 cm)
Bag: (irreg.) 19 $^{5}/_{8}$ x 16 $^{7}/_{8}$" (49.9 x 43.0 cm)
Publisher: Bianchini Gallery, New York
Printer: Ben Birillo, New York
Edition: approximately 200
Fractional gift of Jo Carole and Ronald S. Lauder, New York, 1998

Pop art reflected not only an interest in popular culture but also an attempt to reach a wider, more popular audience. The flourishing of multiples — inexpensive, small-format sculptural objects in large editions — was inextricably tied to this goal and exemplified the blurring of boundaries between art and commodity that characterizes the Pop art movement. Department stores sold art, and art galleries emulated retail shops.[1] Printed ephemera of all types, from wrapping paper to wallpaper, blossomed in this atmosphere.[2] Two of the period's most playful examples — paper shopping bags by Roy Lichtenstein and Andy Warhol (see p. 56) — were issued in connection with an exceptional exhibition, *American Supermarket*, held at the Bianchini Gallery in 1964, that highlighted these ambiguities.

The brainchild of artist Ben Birillo, the exciting installation was designed to resemble a supermarket, complete with aisles, shelves, and a checkout counter. The goods on display included a range of food-related art intermingled with actual and plastic food items. Jasper Johns's *Painted Bronze* dominated the beverage section; Warhol's Soup Can paintings hung next to a pyramid of stacked Campbell's soup cans; and several plastic food items made specially for the exhibition sat next to Robert Watts's chrome-plated varieties.[3]

The shopping bags, intended as posters for the exhibition, sold for twelve dollars each and were among the show's most popular items.[4] Birillo screenprinted one of Lichtenstein's trademark food images, the turkey, taken from a

1961 painting (included in the exhibition) and most likely inspired by a newspaper advertisement.[5] Many visitors used the shopping bags to carry out purchases from the exhibition, enhancing the concept of art as commerce and underscoring the philosophy behind the groundbreaking show. "When I returned to graphics, I guess it was the idea of Pop. Pop looked like printed images and putting the printed images back into print was intriguing."[6] *Turkey Shopping Bag* returned the image to its original role as signifier of a commodity. Only now the commodity was art not food.

1 Bonwit-Teller housed an art gallery beginning in 1969. Claes Oldenburg's *The Store* in 1961 was one of the first manifestations of the intentional art gallery / retail establishment ambiguity.

2 Lichtenstein made printed wallpaper in 1968 and paper plates in 1969 for Bert Stern's multiples store, On 1st.

3 For a detailed description of the *American Supermarket* exhibition, see Constance W. Glenn, *The Great American Pop Art Store: Multiples of the Sixties* (Long Beach: University Art Museum, California State University; Santa Monica: Smart Art Press, 1997).

4 Ibid., p. 40.

5 Birillo, conversation with the author, July 1998.

6 Lichtenstein, quoted in "An Interview with Roy Lichtenstein," in *Roy Lichtenstein Graphic Work 1970–1980*, exh. bro. (New York: Whitney Museum of American Art, 1981), n. p.

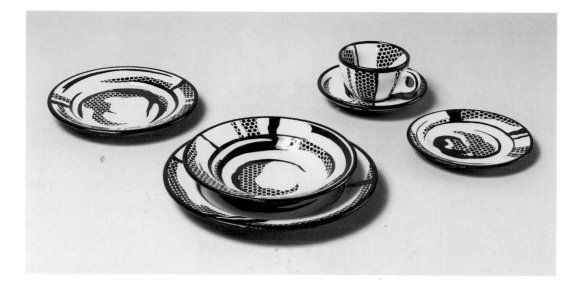

Roy Lichtenstein

Dishes. (1966)

Six-piece place setting of glazed ceramics
Composition (height x diameter): salad plate, 1 1/16 x 8" (2.7 x 20.3 cm); soup bowl, 1 9/16 x 8 1/4" (4.0 x 21.0 cm); dinner plate, 1 3/16 x 10 1/4" (3.0 x 26.0 cm); cup, 2 7/16 x 4 3/4" (6.2 x 12.2 cm); saucer, 1 x 6" (2.7 x 15.4 cm); bread and butter plate, 11/16 x 6 7/16" (1.8 x 16.4 cm)
Publisher: Durable Dish Co., Villanova, Pennsylvania
Fabricator: Jackson China Co., Syracuse, New York
Edition: 800
Gift of David Whitney, 1966

In the early 1960s, Roy Lichtenstein began creating pictures of food products, consumer goods, and objects taken from daily life in the cool, inexpensive style of his appropriated comic-strip images. By representing form with flat shapes and exaggerated black outlines, and light and shadow with areas of even color and patterned benday dots, he reduced objects to their prosaic information and conflated the production of high and commercial art forms. Even Lichtenstein's sculptural work, begun in 1964 with an enameled steel sculpture based on his *Varoom!* painting of a cartoon explosion, continued to prioritize the look of flatness despite the work's three-dimensionality. A year later he applied these conventions to ceramic molds of everyday dishes, further complicating the categories of two and three dimensions, reality and illusion, high and low.[1] Working with ceramicist Ka Kwong Hui,[2] Lichtenstein stacked cups and dishes on top of one another and applied surface adornment to represent, in his stylized way, "volume."

After seeing Lichtenstein's 1965 ceramics exhibition at Leo Castelli Gallery, Audrey Sabol and her partner Joan Kron of the Beautiful Bag Co., a business that specialized in artist-designed multiples, approached the artist to create functional dishes for mass-production. For the project Lichtenstein selected diner-quality, durable dishes (from which the publishers took their name) that paralleled, in three-dimensions, the banality of his flat, everyday imagery. He created a maquette which was then reproduced by Jackson China Co., a restaurant custom-design china manufacturer, in an edition of 800.[3]

While the streamlined ceramic forms and Lichtenstein's applied surface design maintain a level of reductiveness typical of Lichtenstein's other work, the tension between the dishes' actual volume and the artist's rendering of volume results in a more playful and complex visual effect. Instead of applying simple areas of flat color and dots, Lichtenstein creates arabesque designs to suggest the reflection of light on contours and glossy surfaces as well as the casting of shadows, as seen from the handle of the cup onto its saucer. (A thick black rim was added to each piece during production, giving the set a look of commercial uniformity.)

The functional nature of the dishes also crystallized the sense of irony in Lichtenstein's work. They were durable enough to eat on and run through the dishwasher, and collectors purchased anywhere from one to twelve place settings for fifty dollars each through Leo Castelli Gallery, Multiples, Inc., or the Durable Dish Co. mail-order brochure.[4] Three years later, perhaps as a logical evolution of art based on and produced for mass culture, Lichtenstein created his *Paper Plate*, which was produced in an unlimited edition.[5] — J. H.

1 See Constance W. Glenn, *Roy Lichtenstein: Ceramic Sculpture* (Long Beach: California State University, 1977), and Diane Waldman, *Roy Lichtenstein* (New York: Solomon R. Guggenheim Museum, 1993), especially chapter 14, for a discussion of Lichtenstein's technique.

2 In 1965 Lichtenstein collaborated for one year with Hui, his former colleague at Douglass College, Rutgers University, where Lichtenstein taught from 1960–63.

3 Lichtenstein created the prototype most likely by applying decals of benday dots, masking tape stencil, and/or handpainted additions to a white set of dishes (the same technique he used to create his unique ceramic sculpture).

4 Pre-publication price, before October 1, 1966, was $40. The dishes were available again May 10–28, 1967, at *The Museum of Merchandise* exhibition at the YM/YWHA, Philadelphia, organized by Sabol and Kron for its arts council.

5 Produced by Bert Stern for his New York multiples store, On 1st, which featured everyday goods designed by artists.

Jim Dine

A Tool Box.[1] 1966

Plastic box, title page, and three from the portfolio
of ten screenprints with collaged elements: nine
on various papers (one mounted on board) and
one on plastic sheet
Sheet: each approximately 23 3/4 x 18 7/8" (60.3 x 47.9 cm)
Publisher: Editions Alecto, London
Printer: Kelpra Studio, London
Edition: 150
Gift of the artist, 1966

Jim Dine's early work often featured common household objects, such as tools, plumbing fixtures, and clothing, attached to the surface of a painting, continuing the trend dramatically begun by Robert Rauschenberg's "combine" paintings of the mid-1950s. Dine grew up in Cincinnati and acquired his passion for tools while working in his father's and grandfather's hardware stores. Tools began appearing in his paintings as early as 1961 and in his prints by 1962.[2] Although Dine's expressionistic brushstrokes and luxuriant draftsmanship contrasted with the slick, cool style of colleagues such as Roy Lichtenstein, James Rosenquist, and Tom Wesselmann, his sensual paintings of isolated everyday objects on a flat background allied him with some of the basic tenets of Pop.

Dine excelled as a printmaker, making his first published prints in 1960, working predominantly with Universal Limited Art Editions in lithography. In 1965 he made his first screenprints for the three 11 Pop Artists portfolios, and in 1966, he went to London to collaborate with master printer Chris Prater, of Kelpra Studio, who specialized in manipulating photographic imagery for screenprints. Dine often developed his ideas in series, and his work at Kelpra resulted in A Tool Box, one of his most exciting and anomalous printed series. In London, Dine met British artist Eduardo Paolozzi, whose collage-style screenprints, also printed by Prater, undoubtedly influenced his approach to this Dada-like amalgam of images. The mid-1960s was a particularly fertile period for Dine and was characterized by several major collaborative projects, including books, costume designs, and even a series of joint assemblages with Paolozzi. His work with Prater on A Tool Box occurred during this vital time and represents one of the high points of Dine's collaborative and experimental spirit.

Cutting images out of industrial design magazines and engineering textbooks, Dine cleverly integrated the photographic depictions of tools and apparatus with hand-drawn markings. The immediate precedent for this approach can be seen in his designs for the sets and costumes for a production of A Midsummer Night's Dream, executed in February 1966, for which the drawn figures are often "dressed" in collaged magazine cutouts.[3] A sense of humor pervades the prints in the contrasts between hard and soft, mechanical and natural, photographic and autographic. Hammers pound on a pair of red lips, a power drill penetrates a polka-dot cloth, a vice clamps down on a trail of smoke, and a metal hook attempts to hoist an amorphous black mountain of hair.

Dine and Prater chose ten different and unusual papers for these prints, ranging from clear acetate to silver mylar to blue graph paper, and collaged several metal and plastic pieces. The inventiveness is unlike anything he had attempted in his previous work but is typical of the creativity that flourished with Pop's fresh outlook on the role of printmaking in art. Dine, however, has never again experimented with screenprinting and photography in as elaborate a manner as he did in A Tool Box, preferring the more direct mediums of lithography and etching.

1 The catalogue raisonné titles this portfolio Tool Box.
2 Colorful Hammering. 1961. Oil on canvas with hammer; Four C Clamps. 1962. Lithograph, printed in color.
3 The production first appeared at the San Francisco Actor's Workshop from March 11–April 11, 1966, and later traveled to Pittsburgh and New York.

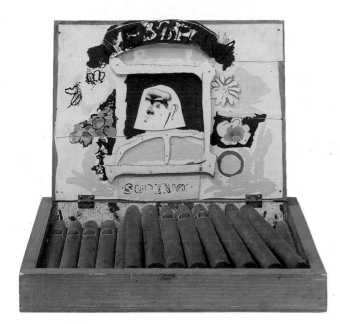

Larry Rivers

Cigar Box. (1967)

Multiple of hinged wood box with painted, screenprinted, photo-lithographed, and collaged wood, board, canvas, paper, and plexiglass
Composition: (open) 13 ³/₈ x 16 x 13 ¹/₄" (33.9 x 40.6 x 33.7 cm);
(closed) 5 x 16 x 13 ¹/₄" (12.6 x 40.6 x 33.7 cm)
Publisher: Multiples, Inc., New York
Printer: Chiron Press, New York
Fabricator: unknown
Edition: 20
Gift of Jeanne C. Thayer, 1989

I'm quite a one-eyed face maker and probably think my drawing is greater than anyone's around. Letters of the alphabet & home-made stencils found there in great abundance, because of their manufactured look, set off the artiness of my rendering.[1]

In the mid-1950s heyday of Abstract Expressionism, Larry Rivers first garnered acclaim for his painterly interpretations of art-historical masterpieces and narrative themes in addition to his superb draftsmanship. In the late 1950s, however, he began looking at everyday objects for his sources, and by 1961 commercial images and trademark packaging from playing cards to money had become central themes in his art.[2] Rivers exhibited almost annually in New York from 1950 up to his retrospective at The Jewish Museum in 1965, giving his work great visibility and making him a catalyst for the reevaluation of consumer culture as viable subject matter for art.

Rivers began depicting cigarette packages in 1960. The Tareyton label was the first to attract his attention, primarily for its formal design of text and shape. Images based on Lucky Strike, Camel, and Dutch Masters cigars soon followed.[3] In 1961 he began his series of Webster Cigar Box images after seeing the popular brand's box top at a local restaurant, attracted by the figure's stern, badly distorted, and "totally absurd looking" face.[4] Starting with *Webster Flowers*, a loose, painterly transcription of the label, Rivers made numerous paintings, drawings, and collages in the early 1960s of the stoic-faced American statesman Daniel Webster, for whom the brand was named.

By the mid-1960s Rivers had shown increasing interest in working in relief, making large constructions out of wood, metal, electric lights, and other found objects.[5] He also designed stage sets for several theatrical productions between 1964 and 1966. This engagement with objects encouraged his work in multiples, an art form that had gained notoriety in the early 1960s and reached its peak between 1964 and 1967.[6] The New York-based publishing firm Multiples, Inc., pioneered this mini-explosion of the medium and published two of Rivers's three multiple projects of the period, including *Cigar Box*.

This seemingly whimsical multiple unites the design of the Webster box lids with the actual cigar box seen in the Dutch Masters series.[7] Most closely related to the relief *Electric Webster* of 1964, *Cigar Box* combines screenprinted areas with wood relief for the lettering and right-hand flowers, and features a wood window frame to highlight the oddly shaped and partly photographic depiction of the face.[8] Rivers makes ironic comment on the word "superior" at the label's lower edge, rendering it as a badly worn, crudely drawn, and barely legible description of these twenty-five-cent cigars.

The multiple phenomenon flourished in the Pop period, and although *Cigar Box* displays Rivers's sustained attachment to painterly gesture and historical motifs, it remains an icon of Pop's preoccupation with consumer goods, product packaging, and multiplicity.

1 Rivers, quoted in a statement read to the International Association of Plastic Arts at The Museum of Modern Art symposium "Mass Culture and the Artist," October 8, 1963. Reprinted in John Russell and Suzi Gablik, eds. *Pop Art Redefined* (New York and Washington, D. C.: Frederick A. Praeger, 1969), p. 104.
2 This trend is clearly seen in the *Cedar Bar Menu I* and the *Last Civil War Veteran* paintings of 1959, the former taken from a restaurant menu and the latter from a photograph in *Life* magazine.
3 Rivers moved to Paris for a year in 1961, where the café lifestyle inspired further interest in cigarette motifs, including images of Gauloises and Gitanes. The French Money series also dates from this stay.
4 A small black lithograph of the box top also dates from 1961. The artist estimates that he has made over fifty Webster images in his career. In the late 1970s he saw a photograph of Webster in *The New York Times* which inspired another series of images based on his cigar box portrait.
5 For example, see his 1965 mixed media construction *The History of the Russian Revolution: From Marx to Mayakovsky*.
6 See Constance W. Glenn, *The Great American Pop Art Store: Multiples of the Sixties* (Long Beach: University Art Museum, California State University; Santa Monica: Smart Art Press, 1997), p. 51.
7 Rivers's multiple *Dutch Masters Cigar Box* of 1970 was published by Edition Schellmann in Munich.
8 In Glenn's *The Great American Pop Store*, p. 51, Multiples Inc. owner Marian Goodman describes how she searched the Yellow Pages for the variety of vendors and fabricators, including screenprinters and model-makers, which was necessary to produce this complex construction. She later recalled that most of the production of this edition occurred in the artist's studio. Andrew Richards, associate director of Marian Goodman Gallery, conversation with the author August 1998.

Patrick Caulfield

Some Poems of Jules Laforgue. 1973

Illustrated book with twenty-two screenprints and an additional suite of six screenprints
Page: 16 ¹/₂ x 14 ¹/₄" (42.0 x 36.3 cm)
Publisher: Petersburg Press in association with Waddington Galleries, London
Printer: (plates and text) Frank Kicherer, Stuttgart
Edition: 200 (English edition); 200 (French edition); 100 (unbound edition)
Mary Ellen Meehan Fund, 1997

Patrick Caulfield was a student at the Royal College of Art in London, along with David Hockney and Allen Jones. Unlike them, he remained uninspired by London's increasingly commercial environment and preferred to focus his attention on masters of modern art such as Henri Matisse and Georges Braque. His streamlined and emblematic still lifes and interiors, however, are visually similar to the graphic nature of commercial art and resonate with a Pop sensibility.

Caulfield discovered the screenprint when Richard Hamilton invited him to participate in *The Institute of Contemporary Arts Portfolio*, published in 1964. For this project, twenty-four artists made prints at Chris Prater's Kelpra Studio, many for the first time. Caulfield's unmodulated expanses of color and clean lines made a perfect match for the aesthetic capabilities of screenprinting. He has restricted his printmaking to screenprint ever since, and in 1973 he completed his most ambitious work in the medium to date, the illustrated book *Some Poems of Jules Laforgue*.

Caulfield was introduced to the work of this French Symbolist poet (1860–87) by a friend at the Royal College and it impressed him enormously.[1] Considered a precursor to modern poetry, Laforgue's text alternates between free association and humorous commentary on daily life. The book includes twenty-two screenprints, each based on a line from one of the poems. It is printed on an unusual, vinyl-like paper that enhances the synthetic quality of Caulfield's distilled images. He chose the paper because "it had the impersonal feel of marble and seemed to relate to the nature of the poetry."[2] Caulfield worked on these images for three years, and his taut, understated depictions of everyday objects exemplify the anonymous, impersonal look and saturated color that characterize some of Pop's strongest work. The book was released in three editions, one in English, one in French, and one as an unbound portfolio.

1 Caulfield, letter to the author, January 1998.
2 Ibid.

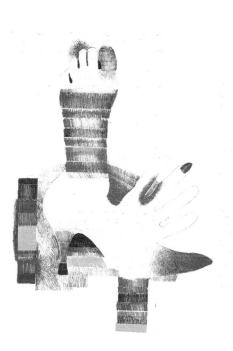

Marisol
(Marisol Escobar)

Pappagallo. 1965

Lithograph
Composition: (irreg.) 16 $^{13}/_{16}$ x 11 $^{5}/_{8}$" (42.7 x 29.5 cm)
Sheet: 25 $^{5}/_{16}$ x 20 $^{3}/_{16}$" (64.3 x 51.3 cm)
Publisher and printer: Universal Limited Art Editions, West Islip, New York
Edition: 20
Gift of the Celeste and Armand Bartos Foundation, 1965

Marisol's art does not fit neatly into the Pop aesthetic but several of the distinguishing characteristics of her figurative wooden sculptures reflect strong affinities with the underlying themes of Pop, including an emphasis on celebrity and popular culture, glamour, and the everyday object. In her portrait sculptures, she frequently depicted popular subjects ranging from Hollywood stars to political leaders such as Mao Tse-Tung, Charles de Gaulle, and Lyndon B. Johnson. In addition, like other artists of the period, Marisol incorporated found objects and random pieces of wood from around her lower-Manhattan neighborhood into her work, in part to counter the prevailing dominance of the spontaneous artistic gesture typical of much of the Abstract Expressionists' work of the 1950s.

Marisol's prints, executed in the delicate style of her refined drawings of the early 1960s, focus on notable details from her sculpture, usually body parts or clothing accessories. Fingers, hands, and feet shown in strange juxtapositions with shoes and handbags are the dominant motifs in her first prints. She alludes to the sensations of touching and caressing through her emphasis on fingers, contributing an erotic quality to the images. She made her first five lithographs at Universal Limited Art Editions (ULAE) on Long Island in 1964—65 and has often cited Jasper Johns and Robert Rauschenberg, who both made prints at ULAE, as important influences. In an approach similar to Johns's,[1]

Marisol chose to trace or imprint her body parts and accessories onto the lithographic stones, culminating in a monumental 1971 self-portrait titled *Diptych.*

Pappagallo is her only color lithograph of the period. The shoe takes center stage in negative space, surrounded by the oddly posed, wrapped foot and manicured hand, each balanced by a carefully-drawn column of colored lines. Tatyana Grosman, founder of ULAE, sent the stones to Marisol's studio where she traced her hand and foot.[2] As seen in the passages of the parallel lines, she experimented with the layering of color to avoid using a different stone for each. The space is compressed, making foreground and background merge into one plane. In the milieu of Pop art, an elegantly drawn shoe is immediately reminiscent of Andy Warhol's renowned I. Miller shoe designs. In keeping with a Pop trend, Marisol chose to title the print with the brand name of the consumer product, in this case, a high-fashion shoe manufacturer.

1 Johns made numerous lithographs at ULAE that incorporate imprints of his body parts, including *Hand* (1963), *Hatteras* (1963), and *Pinion* (1963—66).
2 The artist also recalls enjoying her visits to the workshop where she would often spend the night. The atmosphere at ULAE encouraged her to continue working in the medium. Marisol, conversation with the author, June 1998.

Wayne Thiebaud

Plate 17 from the illustrated book *International Anthology of Contemporary Engraving: The International Avant-Garde. America Discovered*, Volume 5 by Billy Klüver. (1963, published 1964)

Etching
Composition: 4 ³/₈ x 5 ³/₄" (11.1 x 14.7 cm)
Page: 11 ¹³/₁₆ x 9 ⁷/₁₆" (30.0 x 24.0 cm)
Publisher: Galleria Schwarz, Milan
Printer: (plate) Georges Leblanc, Paris; (text) Grafiche Gaiani, Milan
Edition: 60
Gift of Peter Deitsch Gallery, 1967

Wayne Thiebaud was already an experienced printmaker when asked to contribute a print to Italian art dealer and publisher Arturo Schwarz's book *International Anthology of Contemporary Engraving*. The project was an ambitious one, encompassing seven volumes and incorporating over one hundred etchings by as many artists.[1] Bound in small black books, these intimate prints represent the range of artists, established as well as emerging, working in avant-garde circles at mid-century. Schwarz had focused predominantly on European artists until this last volume, subtitled *America Discovered*. Schwarz enlisted the help of Bell Labs engineer and artist collaborator Billy Klüver in the selection of the twenty American artists and the overall coordination of the project.[2] Klüver and Schwarz brought together the printed work of the American Pop artists for the first time, many of whom were making their first attempt at the medium.[3] Klüver's letter to the artists reveals their status as novice printmakers: "If you initial the plate or use words remember to write backwards if you want the words to read forwards."[4]

Although based on the West Coast, Thiebaud gained critical attention with his first sell-out exhibition at Allan Stone Gallery in New York in 1962. He made realist, lusciously painted depictions of mass-produced food and toys in serial line-ups as if on display in a shop window. These confectionary delights appeared at the same time Claes Oldenburg was doing pastry cases and Roy Lichtenstein was painting ice cream sodas, placing Thiebaud squarely in the discourse about Pop and the return of representational art. By the late 1960s, however, he had expanded his vocabulary of expressionistic still lifes to include figurative and landscape imagery which emphasized his aesthetic roots in a vernacular realism that harkened back to Edward Hopper.

Thiebaud had been making prints for many years by this point and had even done a stint teaching printmaking.[5] By the early 1960s, however, he typically tried his images in a variety of mediums and formats to test out different effects. "It has a lot to do with the concept of transposition, of being able to transpose say a thick, rich colorful painting into black and white in a spare or less sensual medium and see what sorts of things occur."[6] In 1963 Thiebaud made a painting titled *Yo-Yos* which served as the inspiration for the etching in Schwarz's book. Thiebaud's experience as an illustrator and commercial designer contributed to his graphic style of streamlined and isolated forms in empty surroundings. When he transposed a small painting into this even smaller etching he simplified the palette and narrowed the composition, heightening the tension between abstract and illusionistic effects. Thiebaud particularly enjoyed the "fidelity of the etched line,"[7] the delicacy of which revealed his talents as a draftsman. The composition reflects the elevated vantage point and stark lighting that would characterize his outpouring of printed work that began in 1964 with his portfolio *Delights* and his collaboration with Crown Point Press. That year he also tried this playful image in woodcut[8] creating a bolder, more graphic rendering comprising high constrast, black-and-white stars and circles.

1 The first two volumes are subtitled *The Forerunners of the Avant-Garde* and the following five volumes are called *The International Avant-Garde*. Each volume contains twenty prints except for the second volume of *The Forerunners*, which has only ten.
2 Schwarz contacted Klüver through Öyvind Fahlström, a participant in an earlier volume of the project and who knew them both. Klüver also wrote the introduction to *America Discovered*.
3 The other artists included in *America Discovered* are George Brecht, Allan D'Arcangelo, Jim Dine, Stephen Durkee, Letty Eisenhauer, Stanley Fisher, Sam Goodman, Red Grooms, Robert Indiana, Allan Kaprow, Roy Lichtenstein, Boris Lurie, Claes Oldenburg, James Rosenquist, George Segal, Richard Stankiewicz, Andy Warhol, Robert Watts, and Robert Whitman. Jasper Johns and Robert Rauschenberg were among the artists who declined to participate.
4 Klüver's letter also specified the dimensions, the due date, and where to mail the finished copper plates. Undated handwritten letter from Klüver to artists, in Klüver archive, Berkeley Heights, New Jersey.
5 He guest taught printmaking in 1958 at the California School of Fine Arts (now San Francisco Art Institute).
6 Thiebaud, quoted in Constance Lewellen, "Interview with Wayne Thiebaud, August, 1989," *View* (San Francisco) VI, no. 6, (Winter 1990): 8.
7 Ibid.
8 It was part of a series of five woodcuts published by the artist and distributed by Allan Stone Gallery.

Politics

Gerhard Richter 80
Jim Dine 82
Wolf Vostell 84
Eduardo Arroyo 86
Gerhard Richter 87
Richard Hamilton 88
Andy Warhol 90
Joe Tilson 91
Andy Warhol 92
James Rosenquist 94

Gerhard Richter

Mao. 1968

Collotype
Composition and sheet: 33 x 23 ³/₈" (83.9 x 59.4 cm)
Publisher: edition h, Hannover
Printer: unknown
Edition: 500[1]
Jeanne C. Thayer Fund, 1993

The work of Gerhard Richter is among the most intriguing and influential art to emerge from this period. It has been labeled as Pop, postmodern, political, and conceptual, and indeed, it encompasses all of these characteristics. Emigrating from Dresden to Düsseldorf in 1961, Richter came to artistic maturity under the influence of his charismatic teacher, Joseph Beuys, who was eleven years his senior. In 1962 or 1963, he saw his first works by Roy Lichtenstein, which he credits, along with those of Andy Warhol and Claes Oldenburg, as singularly significant for him in their anti-artistic stance and astonishing simplicity. Partly in response to this work, in 1963 Richter cofounded, with Sigmar Polke and Konrad Lueg, the group known as the Capitalist Realists, which was dedicated to the objective depiction of consumerism in an increasingly commodity-oriented Germany.

Photography was central to Richter's pictorial documentation of his environment and his rejection of the expressionist painting popular at the time.[2] He began collecting photographs in the early 1960s. In 1962 Richter began making paintings after photographs, either amateur family snapshots, advertisements, or magazine illustrations, citing that he "painted photos, just so I would have nothing to do with *peinture*: it stands in the way of all expression that is appropriate to our times."[3] In 1965 he made his first print, a screenprint with the workshop HofhausPresse in Düsseldorf.[4] Richter explored a variety of photographic printmaking processes—screenprint, photolithography, and collotype—in search of the medium that would best emulate his blurred, gray paintings. He was interested in the dissemination of images to a wider public that printmaking offered but he eschewed the traditional techniques of etching and woodcut because of their collaborative prerequisites.[5]

Initially Richter denied the significance of any particular subject matter in his work other than the issues of perception and illusion. In later interviews, however, referring to his images of military fighter planes and crime victims in particular, he admitted that his selection of photographs was "very definitely concerned with content."[6] In the mid-1960s he began assembling his photography collection onto panels for his opus work *Atlas*, an ever-growing encyclopedia of images taken from newspapers, magazines, books, and photographs of friends and family. *Atlas* includes portraits of numerous political, cultural, and historical leaders intermingled with household items, landscapes, and every possible animal, vegetable, and mineral. A blurred photograph of Mao Tse-Tung taken from a newspaper, is part of this vast archive.[7]

At the time that Richter clipped this photograph of the Chinese leader, the horrors of Mao's Cultural Revolution, begun in 1966, were attracting extensive international press. Likewise, when asked about his interest in portraiture as a genre, Richter responded that "it was a serious intention to produce portraits in keeping with the times."[8] The resulting work is, as the artist had hoped, a provocative statement against extreme political establishments, whether left- or right-wing.

Richter did not make a painting of Mao. Instead, he used the collotype medium to transform the newspaper photograph into an edition.

Sometimes, I tried to refrain from painting the photos. I tried to use a photo directly, but most of these attempts failed. However, with Mao as collotype it worked…. I chose the collotype because I wanted to try something new, and in this case, I didn't want to get the somewhat disturbing screen on the sheet you can see by a magnifying glass.[9]

He printed *Mao* in a very large edition, which satisfied his primary reason for turning to printmaking—the dissemination of images in vast number for little cost. In addition, the collotype medium closely resembled the cheaply printed newsprint of the original photograph. The blurry, almost veiled image of Mao, bleeding off the edge of the sheet, simultaneously lends an aura of power and inaccessibility with a posterlike immediacy and recognition unique to printed art. The medium further alludes to the countless images of Mao ubiquitously plastered on the streets of China. With this print, Richter found the perfect match between medium and message.

1 Of the edition of 500, twenty-two were signed, dated, and numbered.
2 Richter had once held a job as a darkroom assistant which may have contributed to his initial interest in the medium.
3 Richter, quoted in "Interview with Gerhard Richter by Benjamin H. D. Buchloh," in Roald Nasgaard, *Gerhard Richter Paintings* (London: Thames and Hudson, 1988), p. 18.
4 HofhausPresse owner Hans Möller worked with several avant-garde artists at the time including Martial Raysse and Christo. See "Notes on the Publishers" section in the back of this volume.
5 Richter, letter to the author, March 1998.
6 Richter, quoted in "Interview with Gerhard Richter by Benjamin H. D. Buchloh," p. 20.
7 See Richter, *Atlas* (New York: D.A.P./ Distributed Art Publishers, in association with Anthony d'Offay London, and Marian Goodman, New York, 1997), p. 28.
8 Richter, letter to the author, March 1998.
9 Richter did manipulate the photograph further, making an enlargement nearly twice the size of this collotype. Richter, letter to the author, March 1998.

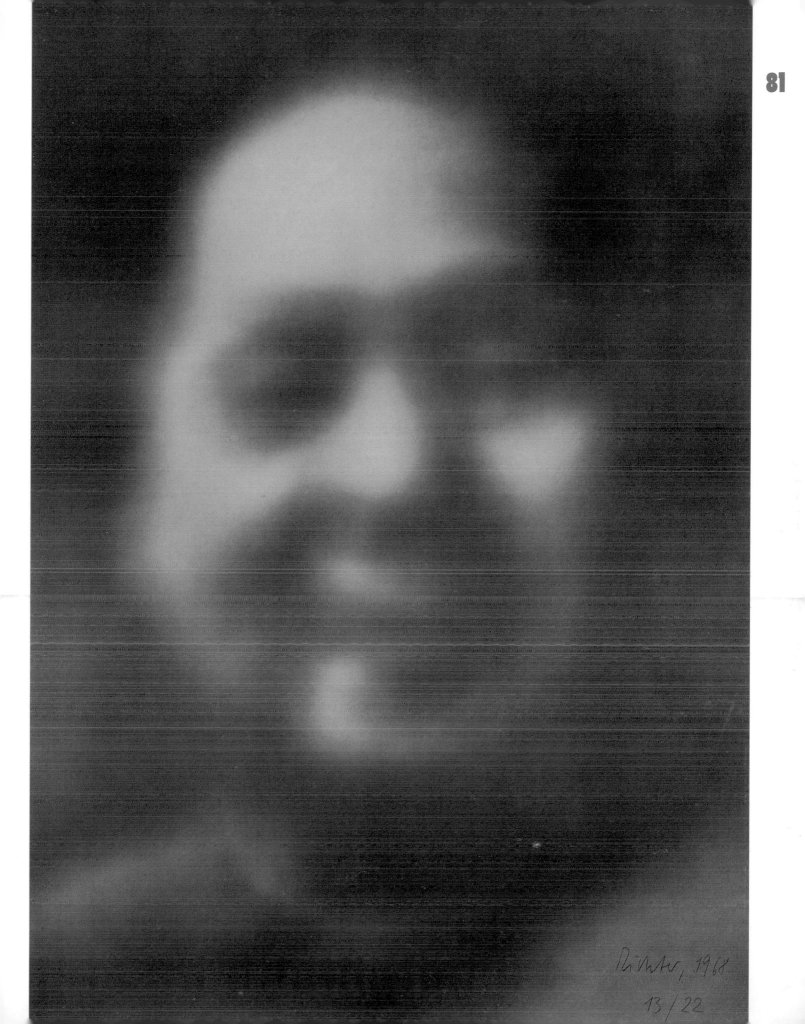

Richter, 1968

13/22

Jim Dine

Drag — Johnson and Mao. 1967

Etching and aquatint
Composition: (irreg.) 31 1/4 x 47" (79.4 x 119.3 cm)
Sheet: 34 1/4 x 47" (87.0 x 121.9 cm)
Publisher and printer: Editions Alecto, London
Edition: 53
Gift of Barbara Jakobson and John R. Jakobson, 1967

Jim Dine moved to London in 1967 and while there created work that comes closest in formal terms to a Pop sensibility than at any other period in his career. It was also at this time that he stopped painting to focus his attention on printmaking and writing. He began exploring photo-based printmaking mediums which led to the incorporation of found printed materials, reflecting the media-infused style of Pop.

Dine first used photographic imagery in his printmaking in 1965—66 for his screenprints in the *11 Pop Artists* and *A Tool Box* portfolios. Dine followed *A Tool Box* with another photographically derived image, this time a monumental etching titled *Drag—Johnson and Mao*.[1] He began with two photographs taken from magazines or newspapers of then President Lyndon B. Johnson and Chairman Mao Tse-Tung and wanted to magnify them as large as possible without losing the resolution of the images.[2] The heads were blown-up to enormous scale, which accounts for the large dot patterns, and then transferred to zinc plates. The dot patterns on the two heads differ from one another which offers a clue to Dine's sources: the regular circular dots on Johnson's face indicate a black-and-white original source and the honeycomb pattern on Mao's head is typical of color processing. Two plates were made for each head, one for the face itself and another for the colored makeup. Printer Maurice Payne used an electric saw to cut out the metal plates and create the silhouette effect of heads floating on the page. The image went through extensive proofs as Dine experimented with the color and placement of the makeup.

Drag—Johnson and Mao was by far Dine's largest printed work to date and the least autographic, evidencing virtually none of his extraordinary skills as a draftsman that had characterized most of his prints to this point.[3] The sense of slapstick humor seen in this print belies a more serious anxiety: China's Cultural Revolution had begun in 1966 and put a renewed spotlight on Mao and his policies. Johnson was embroiled in the increasing U. S. involvement in Vietnam, which would ultimately lead to his March 1968 announcement that he would not seek reelection. According to Editions Alecto publisher Joe Studholme, Dine was intrigued by the distinctly different circumstances of the two leaders, Mao's strong political control and Johnson's weakening influence, and reflected that in their respective makeup.[4]

1 In a conversation with the author, June 1998, publisher Paul Cornwall-Jones suggested that the choice of etching was predicated in part by the dearth of lithographers available in London during this period who would have been able to work on such a large scale.
2 Printer Maurice Payne, conversation with the author, June 1998.
3 Even his other photographic project, *A Tool Box*, incorporated hand-drawn passages.
4 Frances Carey and Antony Griffiths, *American Prints 1879–1979* (London: British Museum, 1980), p. 46.

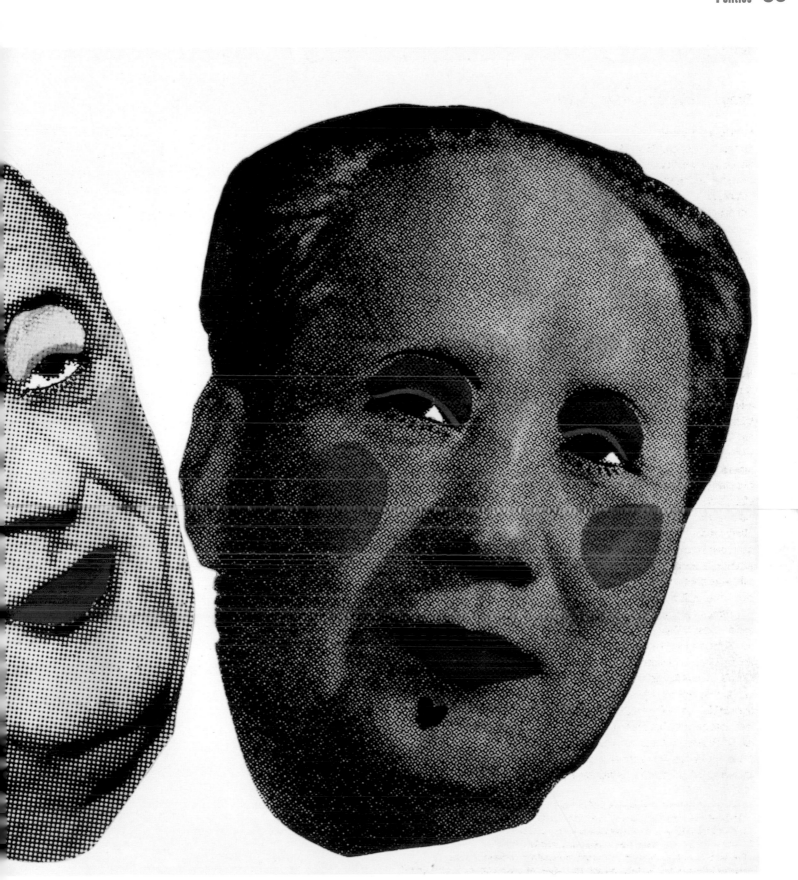

Wolf Vostell

Starfighter from the portfolio
Grafik des Kapitalistischen Realismus
(Graphics of Capitalist Realism). (1967)

Screenprint and glitter collage
Composition and sheet: 20 ⁷⁄₈ x 32" (53.0 x 81.3 cm)
Publisher: René Block for Stolpe Verlag, Berlin
Printer: Birkle & Thomer & Co., Berlin
Edition: 80[1]
Linda Barth Goldstein Fund, 1995

One of the most politically engaged artists to emerge from postwar Germany, Wolf Vostell addressed relevant issues of violence, destruction, and consumer excess in his complex body of work which traversed a panoply of artistic mediums. His early *décollage* (torn-poster) style was influenced by the work of the *affichistes* artists he saw in Paris in the early 1960s, including Nouveaux Réalistes Raymond Hains and Jacques de la Villeglé. In his Happenings and Actions of the late 1950s and early 1960s he employed electronic and mechanical props—from televisions to automobiles—and his reliefs were based on photographic images taken from magazines and newspapers. Vostell became a founding member of Germany's Fluxus movement, which experimented with a wide range of unconventional formats, and continued to express his own vision of the integration of art and life. Only tangentially related to Pop art, Vostell, nevertheless, represents an important facet of the European approach to assimilating the popular media into art.

In a style most reminiscent of Robert Rauschenberg, Vostell combined technology and his autographic touch to create a prolific body of work encompassing painting, performance, installation, photography, film, video, printmaking, artist's books, and multiples. Many of his works, unique as well as multiple, incorporated printmaking techniques, usually screenprint because of its success reproducing photographic imagery. Vostell had previously studied lithography in school. He had also worked as a graphic designer doing layouts for a Cologne magazine in the early 1960s and acquired a sophisticated knowledge of printmaking's versatility.

Beginning in the early 1960s, images of fighter planes first appeared in Vostell's work, although other subtle references to destruction had appeared even earlier.[2] By the late 1960s, the image of the Starfighter aircraft became a prominent motif. Using a newspaper photograph as his starting point, Vostell made a painting in 1966 that juxtaposes the violent war machine with images of toddlers in a barren landscape. The following year, the same photograph appeared in several works: a monumental piece titled *Goethe Today*, a seven-minute film titled *Starfighter*, and this screenprint of the same title from publisher René Block's innovative portfolio *Grafik des Kapitalistischen Realismus*.

Vostell was undoubtedly inspired by the flood of news stories about the Starfighter aircraft circulating at the time. In a dramatic scandal in Germany that plagued the Defense Ministry and brought down three high-ranking generals, the plane's manufacturer, the American company Lockheed, was suspected of bribing German government officials to ensure the purchase of the aircraft. The Starfighter also came to represent the hotly debated issue of German rearmament in the 1960s. In addition, these planes, nicknamed "widowmakers," had a disastrous crash record—in 1965 and 1966, forty-seven of the planes crashed.[3]

In the screenprint, Vostell zooms in for a close-up of these fighter planes, heightening the ominous nature of their formation. Vostell adds silver glitter to the print, making a crown and stripe down each plane's back. This decorative touch transforms these potent destroyers into a chorus line of foolish pranksters and exemplifies Vostell's biting critique of the military establishment in Germany and abroad. The glitter also accentuates the graininess of the black-and-white photoscreenprint medium itself.

The print reflects Vostell's often expressed sentiments about the role of art in society:

The artistic treatment of destruction is an answer! Documentation as permanent artistic protest and rebellion of the conscious and subconscious mind against the contradictions and inexplicabilities of life.[4]

1 An unknown number was also printed on thinner paper as a poster.
2 In 1963 Vostell made a TV-film titled *Sun in Your Head*, which incorporated numerous views of an ominous-looking airplane.
3 See *The Independent* (London), May 23, 1991, p. 14. Sixty-one German pilots crashed, and thirty-six died in Starfighter planes between their initial purchase in 1962 by the Luftwaffe and 1966. Also see *The New York Times*, August 31, 1966, p. 7.
4 Vostell, quoted in *Von der collage zur assemblage* (Nuremberg: Institut für Moderne Kunst, 1968); reprinted in *Art Since Mid-Century: The New Internationalism; Volume 2: Figurative Art* (Greenwich, Conn.: New York Graphic Society, 1977), p. 323.

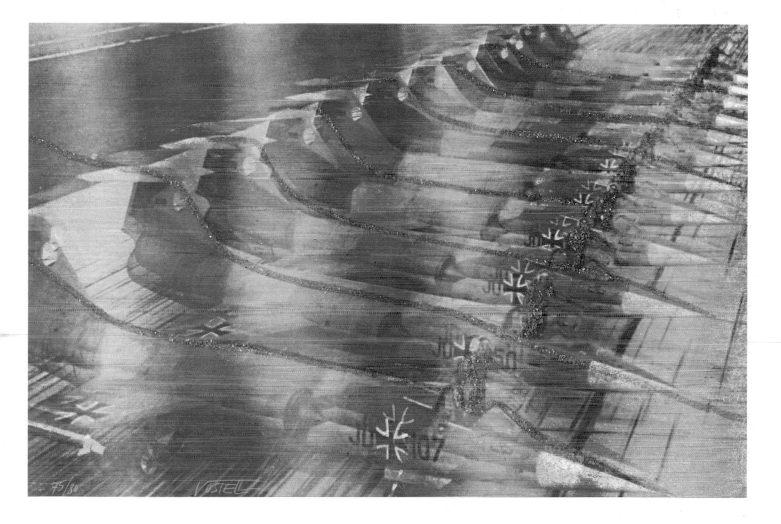

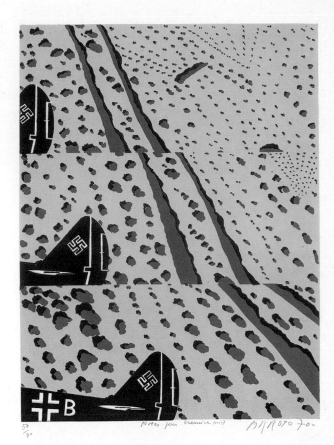

Eduardo Arroyo

Notas para Guernica (Notes from Guernica). 1970

Lithograph
Composition: 21 ⁷/₈ x 16 ¹/₂" (55.5 x 41.7 cm)
Sheet: 27 ¹/₂ x 19 ⁵/₈" (69.8 x 50.1 cm)
Publisher and printer: Edizione dell'Aldina, Rome
Edition: 70
The Ralph E. Shikes Fund, 1997

Among the European proponents of a genuine Pop style, Eduardo Arroyo stands out for his sustained engagement with political issues. His training as a journalist is reflected in the strong narrative content of his work and is typical of the Nouvelle Figuration group in Paris, with which he was frequently associated. Often autobiographical in nature, much of Arroyo's work is closely based on Spanish history and passionately criticizes Fascism and political injustices. Exiled from his native Spain in 1958, he used his art to protest Francisco Franco's dictatorship until the latter's death in 1974. He employed vibrant colors and sharply delineated forms to translate his political ideology into Pop aesthetics.

In 1964, to celebrate the twenty-fifth anniversary of Franco's reign, the Spanish government organized official festivals including the exhibition *Twenty-Five Years of Peace*. These events inspired some of the exiled artist's most ardently anti-Franco works, and that year he completed a somber painting titled *Notes from Guernica*. In a cinematic layout of progressive images, Arroyo depicted three planes of the German Condor Legion, rumored to have collaborated with Franco on the bombing of the Basque city of Guernica on April 26, 1937.[1]

In 1967, Arroyo began splitting his time between France and Italy. Although he made his first prints in France, the majority of his printmaking of this period was executed in Italian workshops, primarily Edizione dell'Aldina in Rome and Edizioni Il Bisonte in Florence. His printed images often followed the paintings, and in 1970 he made a large group of lithographs in Rome, including a work based on *Notes from Guernica*. To reinforce his Fascist rebuke, Arroyo added the swastika to the planes. The printed version also exaggerates the graphic quality of the image by heightening the color contrast and repeating only the black tail of the Nazi planes. These qualities, along with Arroyo's tripartite division, reflect the increasingly streamlined nature and formal Pop characteristics that typified his work at this point.

1 The destruction of Guernica was history's first air bombardment of an undefended town, aimed solely at terrorizing civilians. See "Who Ordered Town's Bombing? Survivors Seek Answers from Madrid; Guernica Accepts German Apology but Awaits Another," *International Herald Tribune* (Paris), May 13, 1998, p. 2.

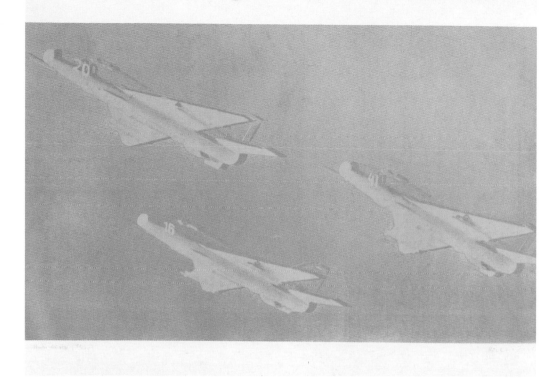

Gerhard Richter

Flugzeug I (Airplane I). 1966

Screenprint
Composition: 19 ¹/₁₆ x 31 ¹/₂" (48.3 x 80.0 cm)
Sheet: 23 ⁵/₈ x 31 ¹/₂" (60.0 x 80.0 cm)
Publisher: Edition Rottloff/Edition Kaufhof, Karlsruhe, Germany[1]
Printer: Löw Siebdrück, Stuttgart
Edition: 50
Miles O. Epstein and Richard A. Epstein Funds, 1993

Perhaps it's just a little exaggerated to speak of a death thematic there. But I do think that the pictures have something to do with death and with pain.[2]

In these words Gerhard Richter is referring to his iconography of the 1960s, the airplane images in particular. Depictions of fighter planes began to appear in Richter's work in 1963 and 1964.[3] It has been suggested that the warplane images relate to his childhood in Dresden and his memories of the catastrophic bombing of that city by the Allies during World War II.[4] Discussing one of the airplane pictures he said that the "airplane flying swiftly past was an image I found very interesting and something not to be found in art history, with the exception, perhaps, of Lichtenstein."[5] Roy Lichtenstein was an early influence on Richter, who saw the Pop master's work in 1963 at Ileana Sonnabend's Paris gallery. But in contrast to Lichtenstein's brightly colored interpretations,

Richter sought out black-and-white images that were inartistic, banal, and somehow mirrored his own contemporary surroundings. The isolated images of war machines also reflect the hotly debated political issue of German military rearmament, which was raging in the press during this period.[6]

Like so many of Richter's prints, this screenprint is based on a newspaper photograph. In an unusual twist he made two versions, one in the grays typical of his paintings after photographs and reflective of its newsprint source, and another in startling Pop hues of vivid pink and green.[7] By printing the two screens slightly off-register, he simulates the blurred effects of his paintings and enhances the sense of the planes' sonic speed, barely allowing them to penetrate our vision.[8] The slightly skewed appearance also reinforces the look of newspaper photographs in which mass-production printing methods often yield a hazy afterimage. Richter printed *Airplane I* with margins only at the top and bottom, creating a cinematic feel and further extending a sense of movement to this powerful vision of contemporary vehicles of destruction.

1 Edition Kaufhof, named for the German department store which distributed the print, was a division of Edition Rottloff, Karlsruhe.

2 Richter, quoted in "Interview with Gerhard Richter by Benjamin H. D. Buchloh," in Roald Nasgaard, *Gerhard Richter Paintings* (London: Thames and Hudson, 1988), p. 20.

3 The painting *Bombers* dates from 1963 but several other fighter plane images were made in 1964, including *XL 513*, *Stukas*, *Mustang Squadron*, and *Phantom Interceptors*.

4 See John T. Paoletti, "Gerhard Richter: Ambiguity as an Agent of Awareness," *The Print Collector's Newsletter* XIX, no. 1 (March–April 1988): 4.

5 Richter, quoted in *Gerhard Richter* (London: The Tate Gallery, 1991), p. 125.

6 There was also a scandal over the Defense Ministry's purchase of Lockheed Starfighter aircraft. See the Wolf Vostell entry on p. 84 of this volume.

7 See Hubertus Butin, *Gerhard Richter Editionen 1965–1993* (Munich: Verlag Fred Jahn, 1993), n. p., plate 4b.

8 Although Andy Warhol's off-register printed works, such as the *Marilyn Monroe (Marilyn)* screenprints, are later than this work, Richter may have been aware of Andy Warhol's paintings in which he had begun using off-register printing by 1964.

Richard Hamilton

Kent State. (1970)

Screenprint
Composition: 26 $^7/_{16}$ x 34 $^3/_8$" (67.2 x 87.3 cm)
Sheet: 28 $^{11}/_{16}$ x 40 $^1/_4$" (72.9 x 102.2 cm)
Publisher: Dorothea Leonhart (Edition München International), Munich
Printer: Dietz Offizin, Lengmoos, Germany
Edition: 5,000
John R. Jakobson Foundation Fund, 1970

The mechanical reproduction of images and the transmission of visual information have been the underlying themes in Richard Hamilton's work since he emerged as a leading member of London's Independent Group in the 1950s. Fascinated with the visual content of popular media and its possibility for integration into contemporary art, Hamilton was a leading intellectual figure in the development of the Pop idiom. His unique work has often combined painting and printmaking techniques reflecting his preoccupation with the ways images are perceived and translated through different commercial and artistic mediums.

Hamilton had been making prints since his student years in the late 1930s. His first professionally printed edition, a screenprint made at Kelpra Studio, appeared in 1963. Although Hamilton was an eager experimenter with all mediums, throughout the 1960s screenprints dominated his printmaking. He was intrigued when, in 1970, Munich publisher Dorothea Leonhart proposed to publish prints in large editions of several thousand.[1] The challenge for Hamilton was to produce a print in a mass edition that reflected as intense a participation by artist and printer as did his smaller editions. His solution, the screenprint *Kent State*, was ironically his most difficult print to produce, and involved a complex transmission of images from amateur film to television screen to photograph to a final screenprint edition of 5,000.

The print depicts one of the fallen Kent State University students wounded during the tragic National Guard shootings at an anti-Vietnam demonstration in May 1970. Hamilton photographed the BBC television broadcast footage taken by an amateur filmmaker of the Kent State massacre.[2] That photograph then began an odyssey that involved dozens of failed attempts and reprintings and resulted in an image printed from thirteen screens, including several transparent layers of overall color. Throughout this process, however, Hamilton added no handmade marks to the screens, preferring to effect change and transformation mechanically. Ironically, through these manipulations "the image became more diffuse, more painterly, more interesting coloristically, but never lost its identity as a transmitted picture."[3] The mechanical distortion of the event is the essence of Hamilton's statement.

Kent State is Hamilton's most pointed political image—he has said that he was strongly against the American involvement in Vietnam—and he felt printmaking offered the most appropriate vehicle for that statement.

I set up a camera in front of the TV for a week. Every night I sat watching with a shutter release in my hand....I didn't really choose the subject, it offered itself. It seemed right, too, that art could help to keep the shame in our minds; the wide distribution of a large edition print might be the strongest indictment that I could make.[4]

Hamilton placed *Kent State* within printmaking's long tradition as a tool for social and political protest. He never made a painting of this image, and only one preparatory pastel drawing exists. There is little working material because the composition was predetermined by the television screen. The extensive proofing of *Kent State* reveals, instead, how Hamilton poignantly and lucidly explored the processing of imagery by the mass media, a fundamental issue in the Pop aesthetic, to create one of his most potent and hypnotic works.

1 According to Leonhart, Hamilton's first proposal for this project was a self-portrait after Francis Bacon. She did not feel this image was appropriate for a very large edition and asked him to reconsider. *Kent State* was his second proposal. Leonhart, conversation with the author, June 1998.
2 The off-center placement of the image on the sheet suggests a television set.
3 Richard S. Field, *The Prints of Richard Hamilton* (Middletown, Conn.: Davison Art Center, Wesleyan University, 1973), p. 14.
4 Hamilton, quoted in *Richard Hamilton Collected Words 1953–1982* (London: Thames and Hudson, 1983), p. 94.

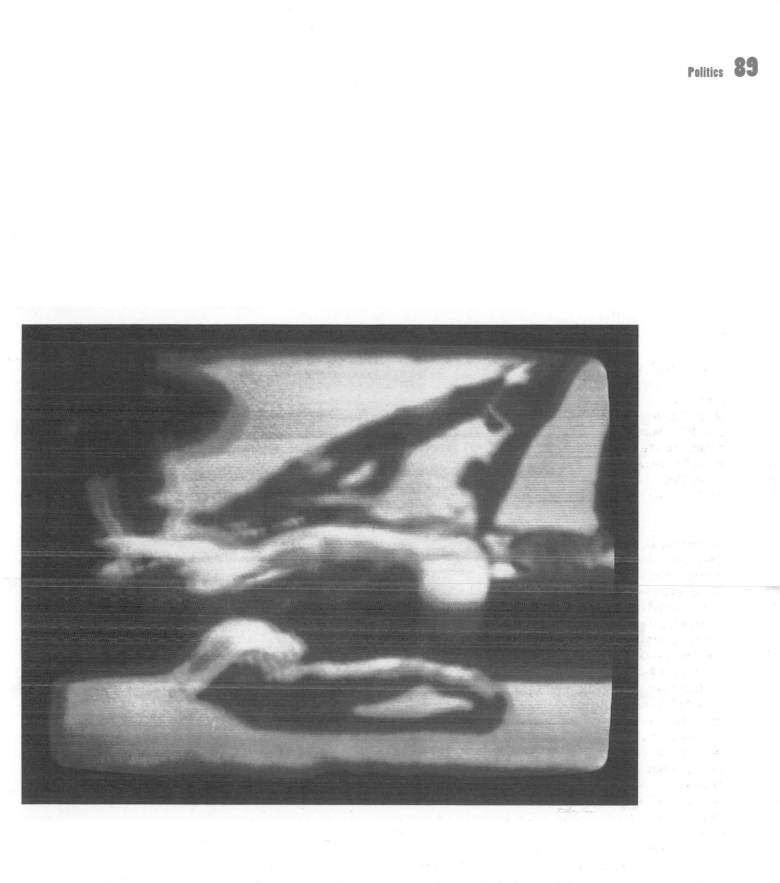

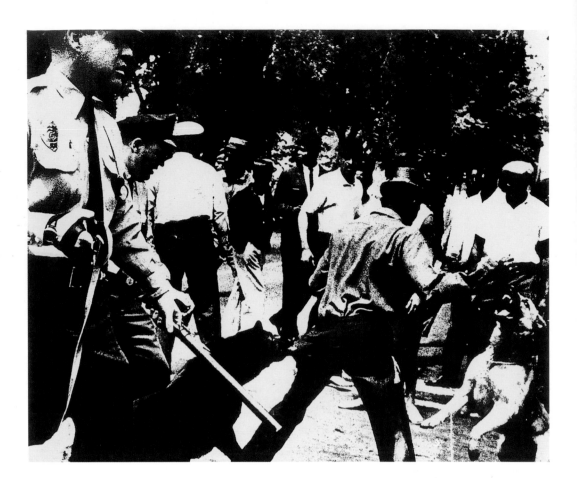

Andy Warhol

Birmingham Race Riot from the portfolio X + X (Ten Works by Ten Painters). (1964)

Screenprint
Composition and sheet: 19 15/16 x 23 15/16" (50.7 x 60.9 cm)
Publisher: The Wadsworth Atheneum, Hartford, Connecticut
Printer: Sirocco Screenprinters, North Haven, Connecticut,
supervised by Ives-Sillman, New Haven, Connecticut
Edition: 500
Gift of Harry C. Oppenheimer (by exchange), 1965

In the early 1960s Andy Warhol turned to themes of grisly catastrophe culled from newspapers and magazines, beginning with the painting *129 Die in Jet (Plane Crash)* taken from the cover of the June 4, 1962 *New York Mirror*. In 1963 he began in earnest to focus on images of conflict and death in works that have collectively come to be known as his Disaster Series. Although Warhol never avowed any political connections, several works in this body of images evidence a strong reaction to social and political issues of the time from civil rights to the death penalty.

In contrast to his works on canvas, which often incorporated repeated images, Warhol typically depicted only a single photographic image in his early works on paper, isolating and compounding the tension between the artwork and its media source. The single image is starker and more confrontational than the decorative, often numbing effects created by repetition. Also, as in most of his early prints, Warhol used black ink against white paper, again recalling its photographic source, whereas color plays a critical role in the expressive qualities of painted versions.

For the *Race Riot* images, Warhol made screens from three photographs he found in a 1963 *Life* magazine series by Charles Moore showing the brutal police confrontation with protesters during the Birmingham, Alabama, civil rights riots.[1] In 1963 and 1964, Warhol based several paintings and a series of unique images on paper on these photographs, as he had done with *Cagney* and *Suicide* in 1962.[2] For the editioned print in 1964, titled *Birmingham Race Riot*, he reversed and cropped one of the photographs, focusing on a central detail. This close-up ironically makes the crowded scene more difficult to decipher as figures are abruptly cut off. The truncated image engenders a narrative, cinematic impulse as the viewer expects the image to be completed in the next frame.[3] The high-contrast black-and-white contributes an optically dizzying effect, and the off-register printing exaggerates the illegibility, adding an urgent, frantic dynamic.

Warhol's artful manipulation of this photojournalistic image heightens its disturbing, frenzied qualities and offers evidence of Warhol's reaction to an issue of civil strife that came to define the 1960s in America. The work's printer, George Townsend of Sirocco Screenprinters, clearly remembers Warhol's intent with this image. Warhol called this episode a "blot on the American conscience" and asked Townsend for a muddier printing.[4]

1 The photographs appeared in the May 17, 1963 issue. The segregationist police commissioner Bull Conner unleashed attack dogs and fire hoses on a nonviolent demonstration by school-children and freedom fighters led by Martin Luther King, Jr. The Birmingham police clubbed the crowd in front of television and newspaper cameras.
2 For works on canvas, see *Red Race Riot* and *Mustard Race Riot*, 1963, and *Little Race Riot*, 1964.
3 Warhol's cropping in *Cagney* achieves very different effects. See p. 41 of this volume.
4 Townsend, conversation with the author, August 1998.

Joe Tilson

Is This Che Guevara? 1969

Screenprint, paper and grommet collage, and paper-clipped photograph
Composition: 39 $^{7}/_{8}$ x 23 $^{11}/_{16}$" (101.3 x 60.2 cm)
Sheet: 40 x 26 $^{15}/_{16}$" (101.6 x 68.4 cm)
Publisher: Marlborough Graphics, New York
Printer: Kelpra Studio, London
Edition: 70
Donald Karshan Fund, 1969

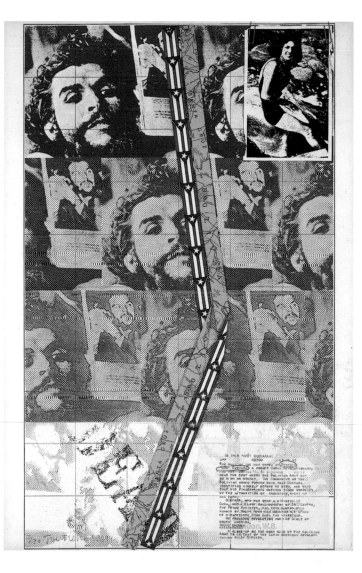

In the late 1960s, British artist Joe Tilson became involved in antiauthoritarian politics, and this interest is reflected in a series of works based on cult heroes such as Ho Chi Minh, Che Guevara, and Malcolm X. In 1969–70 he executed Pages, a series of complex images which incorporated screenprint on canvas and wood relief in collagelike formats suggestive of newspaper pages. By enlarging the photograph's halftone dots, Tilson enhanced the reproduced look of these twenty works, an effect that he had been exploiting in his printmaking since the early 1960s with Chris Prater of Kelpra Studio.

In 1969 Tilson made a series of unique and multiple images focused on the Cuban revolutionary Che Guevara, including several from the Pages series as well as the screenprints *Letter from Che* and *Is This Che Guevara?* In the latter, in a format reminiscent of a bulletin board, six photographic depictions of Che's face zigzag down the sheet, each row's images becoming paler and more ghostlike with varying exposures and additional manipulations of the dot screens.[1] The heads are juxtaposed against a clipping of Che in a triumphant pose. Atop these printed reproductions Tilson collaged several printed items: a wrinkled snapshot of Che's girlfriend is paperclipped in the upper right,[2] and two paper strips cascade down the center. One side of each strip is printed with a repeating image of the Cuban flag, the other with a detail of a map of Bolivia, the country where Che was murdered in 1967. The title of the print is derived from the typed document printed at the lower right, a news wire questioning the identity of the dead body found in Bolivia, headed "IS THIS CHE GUEVARA?"[3]

This print exemplifies Tilson's technically masterful application of the halftone dot screen to aesthetically simulate the printed page. He emphasized the layers of reproduced and processed images and exploited the screenprint's inherent adaptability to photographic imagery. The gray-and-black tonality further enhances the printerly effect of this passionate elegy to a fallen hero.

1 Tilson had friends who obtained photographs from press archives for him, some of which he used for the images in this print. Tilson, letter to the author, February 1998.
2 Tilson recalls the snapshot as a photograph of Che's girlfriend Tania. Tilson, letter to the author, February 1998.
3 In July 1997 Che Guevara's body was exhumed in Bolivia and definitively identified. His remains now rest in Cuba, his adopted homeland.

Andy Warhol

Flash—November 22, 1963 by Phillip Greer. (1968)

Screenprinted cover and three from the illustrated book of eleven screenprints
Composition and sheet: 20 $^7/_8$ x 20 $^7/_8$" (53.1 x 53.1 cm)
Text page: 21 $^1/_2$ x 21 $^1/_4$" (54.6 x 54.0 cm)
Publisher: Racolin Press, Briarcliff Manor, New York
Printer: Aetna Silkscreen Products, New York
Edition: 200
Gift of Philip Johnson, 1973

In the early 1960s Andy Warhol created his seminal celebrity portraits and scenes of death and disaster, appropriating images from newspapers, magazines, and television to reveal the mass media's impact on our collective consciousness. He screenprinted pictures of Marilyn Monroe, Elvis Presley, and Elizabeth Taylor, as well as anonymous victims of car crashes and suicides, in repetitive sequences that forced a new way of looking at and evaluating images.

Warhol began making print portfolios from these and other subjects in the late 1960s, altering colors from print to print to illustrate both the playful and profound effects of image variation and repetition.[1] In 1968 Warhol was approached by book publisher Alexander Racolin of Racolin Press[2] to create a project. The result was *Flash—November 22, 1963*, an unbound illustrated book. Although Warhol had been making offset-printed artist's books in limited editions since 1953, this work was his only commissioned project of its kind.

Flash—November 22, 1963 is thematically related to Warhol's 1963–64 screenprints on canvas of Jackie Kennedy, created in the aftermath of President John F. Kennedy's assassination, as well as to his 1966 prints of Jackie.[3] In these works Warhol extracted Jackie's image as a symbol for the tragedy as a whole, distilling this painful episode of American history to one essential face.[4] In contrast to these works and his other print portfolios of the time, *Flash—November 22, 1963* is a fragmented narrative comprised of disjointed snapshots spanning events from the Kennedy campaign to Lee Harvey Oswald's capture. The images range from a campaign poster and the President framed by a television monitor to an advertisement for the assassin's alleged gun and the President's face obscured by a filmmaker's clapboard. Also included are images of the presidential seal and a photograph of the Texas Schoolbook Depository from which the shots were fired. These motifs mimic the media frenzy surrounding the events and the Kennedy presidency in general, and also allude to Warhol's own role as director or manipulator of images.[5]

The images in *Flash—November 22, 1963* are formally altered in ways that both distort and exaggerate the look of television and journalistic photography, thereby underscoring the media's role in shaping what we see and how we see it. Colors are either discordant or faded; scale varies; images are blurred and graininess enhanced; pictures are superimposed, reversed, enlarged, and cropped. Although elements of these manipulations appear elsewhere in Warhol's work, *Flash—November 22, 1963* is his first project to employ so many distortions simultaneously.

Furthering this momentum, the prints in *Flash* are accompanied by text written and printed to simulate a Teletype wire service report of news bulletins and "flashes" on the day of the assassination and the two days following. The typewritten face of the text and its staccato rhythm on the page parallel the frozen, excerpted nature of the images. And although the text is chronological, the prints are not, adding to the project's montage quality. The book cover design comprises a pattern of flowers, taken from a commercial sheet of graphic design samples,[6] superimposed over the front page of the *New York World Telegram* on November 22, 1963, the date of the assassination. This playful decoration and its reflective silver ink provide a disturbing contrast to the underlying headline, "PRESIDENT SHOT DEAD."

The interaction between historical documentation and artistic distance gives *Flash—November 22, 1963* its riveting tension and exemplifies Warhol's biting commentary on the effects of media saturation. His complex use of formal devices, rarely seen in his other prints of this period, coupled with the emotional power of the images, make this book one of his most creative forays into printmaking and one of the most resonant printed statements of 1960s America. — J. H.

1 See *Marilyn Monroe (Marilyn)* of 1967, *Flowers* of 1970, *Electric Chair* of 1971, and *Mao* of 1972.
2 Fritzie Miller, of Fritzie Miller Associates, was a friend of Racolin and introduced him to Warhol, whom she had represented as a commercial illustrator in the advertising industry.
3 Similarly, Warhol's prints and paintings of Marilyn Monroe were produced after her death, underscoring the way celebrity is often heightened as a consequence of tragedy.
4 The image of Jackie used in *Flash* appears in Warhol's paintings, *Jackie (The Week That Was)* of 1963, *Sixteen Jackies* and *Round Jackie*, both of 1964, and in his print series *Jacqueline Kennedy (Jackie) I, II* and *III* of 1966. This and other images of Jackie are based on photographs from both before and after the assassination. For a fuller discussion and interpretation of the Jackie Kennedy works and their sources see "Warhol, the Public Star and the Private Self," chapter 16 in Cécile Whiting, *A Taste for Pop: Pop Art, Gender, and Consumer Culture* (Cambridge, Eng.: Cambridge University Press, 1997). For original source material for *Flash—November 22, 1963*, see *Life* magazine, November 29 and December 6, 1963, and *The New York Times*, November 24 and 25, 1963.
5 Warhol began making underground films in 1963.
6 For similar uses of graphic floral designs see *Lincoln Center Ticket* of 1967, *SAS Passenger Ticket* of 1968, and *Daily News* of 1967.

James Rosenquist

See-Saw, Class Systems. 1968

Lithograph
Composition and sheet: 24 ⅛ x 34 ⁷/₁₆" (61.3 x 87.5 cm)
Publisher: Richard Feigen Graphics, New York
Printer: Mourlot Graphics, New York
Edition: 100
The Ralph E. Shikes Fund and John B. Turner Fund, 1995

In his personal life, James Rosenquist was the most politically active of the American Pop artists who gained notoriety in the early 1960s. He ardently protested against the Vietnam War and supported various other causes and regularly contributed art to political candidates.[1] As an artist, however, he tried to keep politics at a distance for the most part, although he is arguably best known for the room-sized painting environment *F-111* of 1965, his threatening critique of the American military complex.[2]

Rosenquist has made other pointed political artworks as well. In 1968 when police mobs assaulted protesters at the Democratic National Convention in Chicago and horrified the nation, several artists, including Rosenquist, responded by supporting a two-year boycott of Chicago, timed to coincide with the end of Mayor Richard Daley's term in office. Instead, gallery owner Richard Feigen convinced over fifty artists to participate in a protest exhibition titled *Richard J. Daley*, which took place in Feigen's Chicago gallery in October 1968.

Rosenquist's piece for the exhibition, *Facade*, featured a pink and white mylar portrait of Mayor Daley's face slashed into strips.[3] It was from this same image of Daley, based on a newspaper photograph, that Rosenquist designed the poster for the exhibition, titled *See-Saw, Class Systems*, which Feigen then published as a lithograph.

Rosenquist printed the lithograph at master printer Fernand Mourlot's Bank Street workshop, where he had just completed other collaborations with Feigen.[4] The shop had an offset press, which does not require an artist to work on an image in the reverse and thereby facilitated the textual component of the print.[5] Rosenquist adapted his usual disjointed collagelike style for the poster design, depicting Daley front and center, and printing the work in patriotic red, white, and blue. He drew the image by hand on a lithographic stone, grinding down the stone to achieve the highlights in the Mayor's scowling face.[6] An unsigned poster version of this image, with smaller margins and on different paper, was also printed.

1 Judith Goldman, *James Rosenquist* (New York: Penguin Books, 1985), p. 40.
2 Rosenquist's political interests are reflected even earlier in *President Elect*, 1960–61, and *Painting for the American Negro*, 1962–63.
3 To paint Daley's face onto the mylar, Rosenquist employed a stipple technique used to paint illuminated marquees. Rosenquist, letter to the author, June 1998.
4 *Forehead I* and *Forehead II*, both Feigen publications, were also printed there.
5 Rosenquist felt that the printers at Mourlot's shop were more commercial and mechanical than those at Universal Limited Art Editions, the other workshop he printed with in the mid-1960s.
6 Rosenquist, letter to the author, June 1998.

Erotica

Martial Raysse 96

Mel Ramos 98

Peter Blake 99

K. P. Brehmer 100

Peter Phillips 101

Sigmar Polke 102

David Hockney 103

Gerald Laing 104

Alain Jacquet 105

Claes Oldenburg 106

Tom Wesselmann 108

Allen Jones 109

Martial Raysse

Untitled from the illustrated book *Das Grosze Buch*
by various authors. (1963, published 1964)

Screenprint and feather powder puff collage, mounted on board
Composition: 11 $^7/_8$ x 6 $^3/_4$" (30.1 x 17.1 cm)
Board: 16 $^1/_8$ x 14 $^3/_8$" (41.1 x 36.5 cm)
Publisher and printer: HofhausPresse, Düsseldorf
Edition: 100
Linda Barth Goldstein Fund, 1997

I wanted my works to possess the serene self-evidence of mass-produced refrigerators to have the look of new sterile inalterable visual hygiene.[1]

A founding member of the Paris-based Nouveaux Réalistes, Martial Raysse became the leading exponent of Pop art in France with his garish colors, mechanical techniques, and emphasis on consumer culture. Like many of the group, he made assemblages of found objects, often using plastic supermarket items to integrate the everyday environment into his art and to emphasize the consumer excess that he felt characterized the period. In the early 1960s he concentrated on depictions of feminine stereotypes in popular magazine advertisements, overpainting photographic enlargements in vibrant color. Represented in banal poses, looking in the mirror, or sitting for a photographer, the anonymous women symbolized for Raysse the artificiality of ideal beauty promoted through the media in contemporary society.

Raysse's penchant for fluorescent colors and glossy surfaces made screenprinting an appropriate choice for his printed work. For this untitled work, his first print, he depicted the face of a woman in bold, synthetic hues of pink and green with royal blue hair against an acid orange-and-pink background. In 1962 Raysse had begun adding three-dimensional objects to his fashion-model images, often in ironic or humorous positions. In this work, the artist collaged a white powder puff onto her forehead. The seductive gaze, enhanced by the veil of color, suggests that the model is unaware of the oddly placed cosmetic device, thereby creating the inherent tension and critique. Raysse used these makeup props to underscore bourgeois society's superficial concerns with appearance and disguise.

The print was commissioned by the German publisher and printer Hans Möller of HofhausPresse whom Raysse had met at Yves Klein's house in Paris.[2] In this case, instead of a found photograph, Raysse took a photograph of a friend. He sent it to Möller with precise color indications and an example of the powder puff and its exact position. (Möller found the powder puffs, which vary in color throughout the edition from pink to blue to violet, in local beauty shops in Germany.) The print was a part of HofhausPresse's ambitious first project, *Edition Original 1, Das Grosze Buch*, a large boxed book which contains a range of prints and multiple works by fifteen artists including Dieter Roth

and Nouveaux Réalistes Arman, Christo, and Jean Tinguely.[3] The project also contains a bound book with texts by each of the artists. Raysse appropriately used a found text ripped from a newspaper and Möller printed it exactly as submitted.[4] A fitting parallel to the languorous image, the short text fragment describes a woman on a hammock, studying the face of her companion through her eyelashes.

Raysse made another screenprint of a woman's head in 1963, this time reusing a photograph from one of his first powder puff paintings.[5] It appeared in the avant-garde periodical *KWY*, published in Paris in the late 1950s and early 1960s.[6] Raysse's interest in printmaking, however, did not result from any particular interest in the dissemination of his images but rather from the aesthetic effects attainable with specific mediums.[7] The Day-Glo colors, photographic head shot, and collage of familiar household items in this print embody many of the characteristics of Raysse's classic Pop period and explain screenprinting's appeal as a natural extension of his unique work. Even in this small format, the print contains the quintessential ingredients of the Pop formula and exemplifies Raysse's defining role in the Pop movement in Europe.

1 Raysse, quoted in *Martial Raysse* (Los Angeles: Dwan Gallery, 1967), p. 17.
2 Raysse, letter to the author, May 1998.
3 This innovative project, housed in a white plastic box, was issued in 1964 and contains works from 1962−63. The other artists included are Lucio Fontana, Oskar Holweck, Yves Klein, Heinz Mack, Almir Mavignier, Otto Piene, Jesús Rafael Soto, Günther Uecker, Per Olof Ultvedt, and Jef Verheyen. Klein died while this book was in production and his widow approved posthumous works in his characteristic blue pigments to be included.
4 Möller recalls that Raysse ripped this text fragment from an issue of the French newspaper *Le Monde*.
5 *Jolie comme tout* (Pretty as everyone). 1962. Mixed media on panel with powder puff. In this work, however, the powder puff is only a printed illusion.
6 *KWY* was published in Paris three times a year by Portuguese artists Lourdes Castro and René Bertholo in an edition of 300. It began in 1959 and continued to 1963 and included texts and printed images by several European artists. An artist was selected as guest designer for each issue. *KWY 7*, which included the Raysse screenprint, was designed by Christo.
7 Raysse, letter to the author, March 1998.

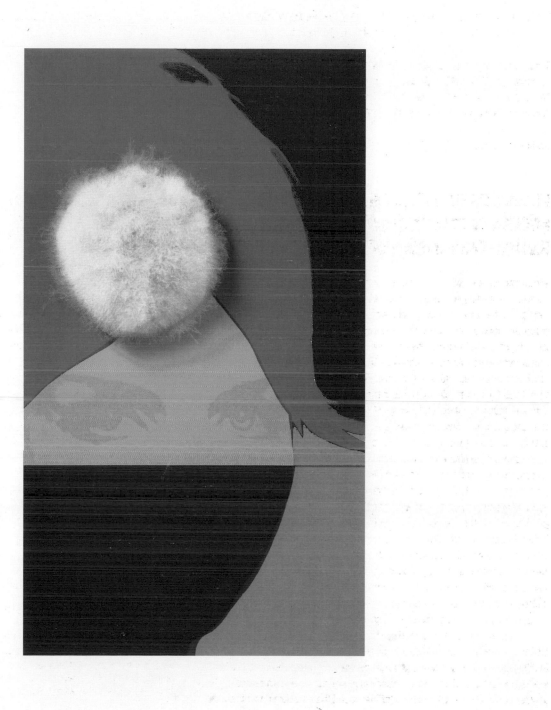

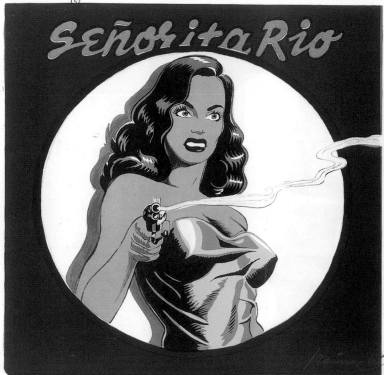

Mel Ramos

Señorita Rio from the illustrated book
1¢ Life by Walasse Ting. 1964

Double-page plate, pages 152 and 153
Lithograph
Composition: 15 $^{11}/_{16}$ x 21 $^{1}/_{16}$" (38.9 x 53.5 cm)
Page: 16 $^{1}/_{16}$ x 11 $^{7}/_{16}$" (40.8 x 29.1 cm)
Publisher: E. W. Kornfeld, Bern
Printer: (plate) Maurice Beaudet, Paris; (text) Georges Girard, Paris
Edition: 2,100
Gift of the author, Walasse Ting, the editor, Sam Francis, and the publisher,
E. W. Kornfeld, 1964

Mel Ramos's painterly depictions of comic book heroes and heroines made him one of the principal figures of West Coast Pop art in the early 1960s, working in Northern California with other artists including his teacher Wayne Thiebaud. He integrated images from newspapers and magazines into the pin-up nudes which, by 1964, had become his trademark. Ramos's early use of graphic devices such as block lettering and bold enclosures reinforced the tension between his expressive brushstrokes and the commercial source material that characterizes his strongest art.

In 1964 Walasse Ting sent a special-delivery package to Ramos, enclosing several sheets of transfer paper and Charbonnel tusche lithography ink and inviting Ramos to participate in his creative book project titled *1¢ Life*.[1] For this ambitious and elaborate project, Ting and editor Sam Francis brought together twenty-eight artists, an unusual amalgam of Europeans and Americans spanning COBRA, Abstract Expressionism, and Pop, to make lithographs illustrating Ting's poems.[2] In an inventive layout of brightly colored images and wildly varying typefaces, the unbound book, a landmark in contemporary printmaking, also intermingled numerous reproductions of advertisements and other commercial art items in a brash, Pop-infused document.

Ting specifically requested that Ramos compose a lithograph based on the Señorita Rio image. A voluptuous comic book figure, Señorita Rio first appeared in a 1963 painting from a series known as The Heroines and marked Ramos's transition from comic book stars to real-life models. In the book Ting positioned this Puerto Rican heroine adjacent to his poem "America," an abstract exegesis of corporate domination and rampant racism in the United States.[3]

Unlike many of the Pop artists included in *1¢ Life*, Ramos was an experienced printmaker, although this was his first professionally published print.[4] But the liveliness embodied in *1¢ Life* inspired several of the Pop artists included in it to turn seriously to printmaking, lithography in particular, as an important means of expression, and the project exemplifies the vitality of Pop's connection with printed art.[5]

1 Ramos, conversation with the author, May 1998.
2 The other artists included in the book are Pierre Alechinsky, Karel Appel, Enrico Baj, Alan Davie, Jim Dine, Öyvind Fahlström, Sam Francis, Robert Indiana, Alfred Jensen, Asger Jorn, Allan Kaprow, Kiki Kogelnik, Alfred Leslie, Roy Lichtenstein, Joan Mitchell, Claes Oldenburg, Robert Rauschenberg, Reinhoud, Jean-Paul Riopelle, James Rosenquist, Antonio Saura, Kimber Smith, K. H. Sonderborg, Walasse Ting, Bram Van Velde, Andy Warhol, and Tom Wesselmann.
3 It has been suggested that the depiction of this Hispanic seductress holding a gun suggests her need for self-defense in a hostile society. See Manfred Kratz, "*1¢ Life* Ein amerikanisch-europäisches Künstlerbuch der sechziger Jahre," in *Much Pop More Art: Kunst der 60er in Grafiken, Multiples und Publikationen* (Stuttgart: Amerika Haus und Mercedes-Benz AG, 1992), p. 50.
4 Ramos and Thiebaud had editioned several lithographs and screenprints together at California state fairs in Sacramento and at the San Jose State College printshop in the late 1950s and early 1960s.
5 Ramos has said that although he was initially disappointed with this lithograph's off-register printing he has come to seriously appreciate the effort. Ramos, conversation with the author, May 1998.

Peter Blake

Babe Rainbow. 1968

Screenprint on tin
Composition and tin sheet: 26 x 17 ³/₈" (66.0 x 44.0 cm)
Publisher: Dodo Designs, London
Fabricator: Metal Box Co., Nottingham, England
Edition: 10,000
Purchase, 1997

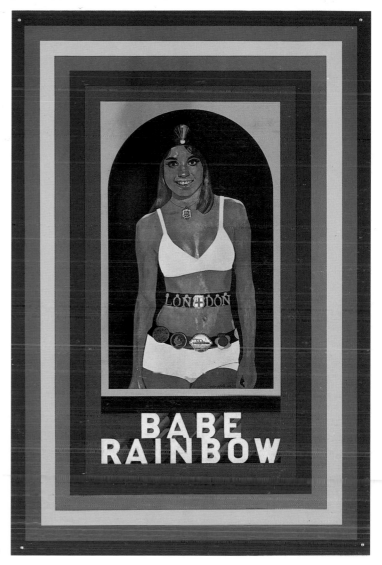

Peter Blake's work reached millions of people with his cover design for the Beatles album *Sgt. Pepper's Lonely Hearts Club Band* released in 1967. Trained as a commercial artist before attending the Royal College of Art in London, Blake was unfazed by the blurry distinction between his art and his commercial work. His art, in fact, often incorporated Pop music figures, including Elvis Presley, the Beatles, and the Beach Boys, and was frequently based on printed images such as publicity stills or music magazines. In stark contrast, English folk art—old wood toys, postcards, traditional decoration of local fairgrounds—was another important influence on Blake. His art of the 1960s evidences a unique fusion of these traditional and avant-garde elements.

Blake's celebration of the popular culture heroes of his era extended to circus performers, film stars, and female wrestlers—some real and others imaginary. He often attended wrestling matches and, in 1965, completed a series of five wrestler paintings. Three years later, recognizing Blake's graphic style and established reputation, a commercial sign-making company named Dodo Designs commissioned Blake to make an enameled sign. The result was a sixth wrestler portrait, *Babe Rainbow*. The enameling process proved unsatisfactory so the image was screenprinted on tin instead. An edition of 10,000 was printed, and each sold for £1 at fashionable boutiques on Carnaby Street and elsewhere around London.

Blake used the cover of a 1967 issue of *Marie Claire,* the French fashion magazine, as a starting point for *Babe Rainbow.*[1] He gave the model a youthful appearance but voluptuous figure, simultaneously suggesting innocence and sexuality. Typical of Blake's work, her outfit includes a variety of patriotic symbols, such as the London souvenir belt and a British flag pendant. The tin edition came with a leaflet giving Blake's account of his heroine's life and details of the artist's career. In it he described her as "twenty-three years old and has broken her nose in the ring."

With holes punched in the four corners, *Babe Rainbow* came ready to hang on the wall and epitomized the exuberance of London's Pop scene in the 1960s. With this mass-edition multiple, Blake may have come closest to satisfying his deeply felt desire to reach an audience beyond the art world with his nostalgic cast of Pop characters.

1 See *Peter Blake* (London: The Tate Gallery, 1983), p. 93.

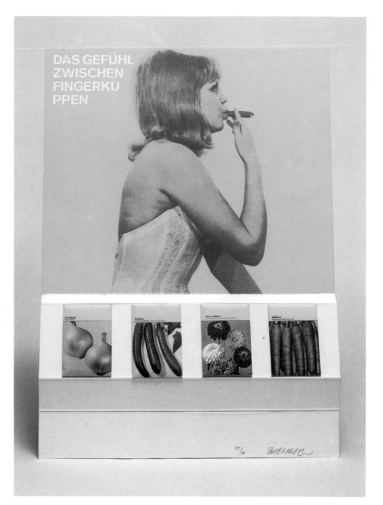

K. P. Brehmer
(Klaus Peter Brehmer)

Aufsteller 25. Das Gefühl zwischen Fingerkuppen…
(Pin-Up 25. The Feeling Between Fingertips…)
from the portfolio *Grafik des Kapitalistischen Realismus*
(Graphics of Capitalist Realism). (1967)

Freestanding screenprint, fabric, and seed-packet collage on folded board
Composition and board: (flat) 27 $^3/_8$ x 19 $^9/_{16}$" (69.6 x 49.7 cm);
(standing) approximately 26 $^3/_{16}$ x 19 $^9/_{16}$ x 8 $^3/_{16}$" (66.5 x 49.7 x 20.8 cm)
Publisher: René Block for Stolpe Verlag, Berlin
Printer: Birkle & Thomer & Co., Berlin
Edition: 80
Linda Barth Goldstein Fund, 1995

Many artists in postwar Germany actively engaged political issues in their artmaking. The short-lived Capitalist Realism group, considered Germany's response to British and American Pop art developments, included two of the most committed political artists of the period, Wolf Vostell and K. P. Brehmer.[1] Printmaking was at the core of Brehmer's work. To disseminate his ideas, he chose to work primarily with photo-based printmaking mediums, many of which he had learned in the late 1950s at a commercial printing establishment.[2] In the 1960s he frequently combined these techniques with imagery borrowed from the printed media and other graphic ephemera, such as postcards and postage stamps.[3] In an inventive, prolific, and often acerbic body of work, he expanded on printmaking's long tradition as a vehicle for social and political statement and transformed his art into a "meaningful instrument of consciousness emancipation."[4]

In the mid-1960s Brehmer focused many of his images on excesses in advertising and its degrading treatment of women. Numerous printed works of photographically rendered, scantily clad women taken from newspapers and magazines critique advertising's use of erotic appeal for profit.[5] Brehmer also co-opted from the commercial sphere the format of his *aufsteller* or "upright object-prints," in which he simulated advertising's use of freestanding printed signage often seen in shop windows or sidewalk displays.

For this *aufsteller*, his first screenprint, Brehmer began with a magazine advertisement, printed it in Pop colors of yellow and pink, and collaged four seed packets below it. The intensity of color paired with the phallic imagery of the vegetables and the added text "the feeling between the fingertips" satirize the eroticism of the cigar-smoking and provocatively dressed woman in a spoof of the media's transparent manipulation tactics.[6] With cardboard flaps on the back, the unusual format comes ready to install as scintillating parody.

1 Brehmer began using his initials, K. P., as a political statement since they also stood for *Kommunistische Partei* (Communist Party).

2 He worked at Verlag Carl Lang in Duisburg. Beginning in 1969 he also worked in film, using it as an artistic outlet for his political viewpoints.

3 In later work, Brehmer regularly borrowed the formats of charts and maps for pointed political invectives.

4 Brehmer, quoted in Hubertus Butin, *Grafik des Kapitalistischen Realismus* (Frankfurt: Galerie Bernd Slutzky, 1992), p. 37.

5 For other images on this theme, see René Block, *Grafik des Kapitalistischen Realismus* (Berlin: Edition René Block, 1971), n.p., plates 22–50.

6 Josephine Meckseper, freelance picture editor at *Stern* magazine, has suggested that the white lettering was added to the composition by the artist and was not preexisting on the advertisement because the words are neither hyphenated nor broken into syllables.

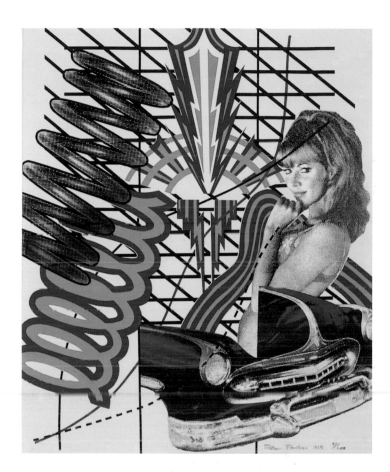

Peter Phillips

Custom Print I from the portfolio
11 Pop Artists, Volume I. 1965 (Published 1966)

Screenprint
Composition and sheet: 24 x 20" (61.0 x 50.8 cm)
Publisher: Original Editions, New York
Printer: Chiron Press, New York
Edition: 200
Gift of Original Editions, 1966

By 1961 the British artist Peter Phillips, one of the youngest on the London Pop scene, had established a style of fragmented montage paintings based on found images from magazines and other printed and photographic sources. Before attending the Royal College of Art, he had studied graphic design and technical draftsmanship, which fostered his receptiveness to such commercial imagery as board games, comics, and glossy periodicals. His meticulous, hard-edged approach and his use of strident color created aggressive, confrontational effects with an intentionally machine-made appearance.

Phillips moved to New York in 1964 for two years. His New York paintings are bigger and brasher, with jarring spatial incongruities and provocative juxtapositions of car parts and pin-up models. With the help of an airbrush, he could achieve slick, mechanical surfaces. Using this technique he began a series titled Custom Paintings, a clear reference to custom autobody shops where polished enamel sheen is applied onto cars. Inspired by these paintings, he made three screenprints titled *Custom Print I*, *II*, and *III*, which appeared in Original Editions's 1966 portfolios *11 Pop Artists*, Volumes I, II, and III, respectively.[1] Introduced to the screenprint medium at London's

Kelpra Studio in 1964, Phillips had found the ideal match for his paintings in the screenprint's saturated colors, photographic capabilities, and sleek surface. All three of the *Custom Print* works were printed at Steve Poleskie's Chiron Press, a screenprint workshop that catered to artists' limited editions but also served as a contract printer for posters, announcements, and greeting cards. Accustomed to ephemeral commercial projects, Chiron was open to untraditional approaches and encouraged Phillips to print on bright silver foil with very glossy inks. The figure, coil, and car images were printed photographically against a background of brazen color and dynamic lines. Combined with the suggestive pose of the bikini-clad woman and the nostalgia-inducing car grill, the metallic paper and technical effects convincingly evoke the darker, more lurid side of 1960s Pop culture.

1 The other artists in the portfolio are Allan D'Arcangelo, Jim Dine, Allen Jones, Gerald Laing, Roy Lichtenstein, Mel Ramos, James Rosenquist, Andy Warhol, John Wesley, and Tom Wesselmann.

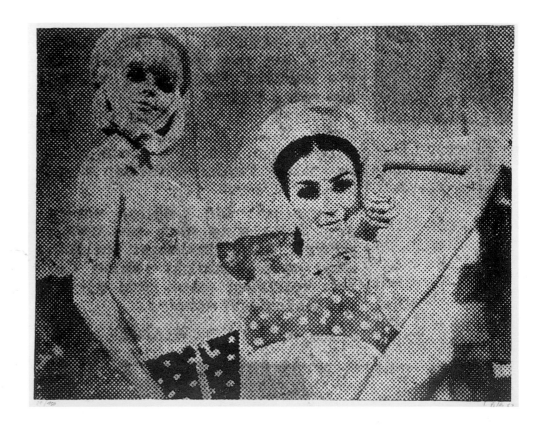

Sigmar Polke

Freundinnen (Girlfriends). 1967

Photolithograph
Composition: 18 5/$_{16}$ x 23 1/$_4$" (46.6 x 59.0 cm)
Sheet: 18 13/$_{16}$ x 23 7/$_8$" (47.8 x 60.7 cm)
Publisher: edition h, Hannover
Printer: Freimann and Fuchs, Hannover
Edition: 150
Richard A. Epstein Fund, 1984

Sigmar Polke's work of the early 1960s represents the strongest Pop statement to emerge from Germany. Along with that of fellow students at the Düsseldorf Kunstakademie Gerhard Richter and Konrad Lueg, Polke's art reflected the growing influence of advertising and the media within an increasingly affluent postwar German society. Deriving his images from newspaper and magazine photographs, he embraced the everyday consumer items and publicity strategies common in the popular press.

During this period Polke's work frequently incorporated images of pin-up girls, holiday resorts, and other items popular for male entertainment. Paintings of Playboy bunnies, Japanese cabaret dancers, and women posing in bathing suits are repeated motifs in his mid-1960s work.[1] In 1965 he completed a painting titled *Girlfriends* based on a newspaper photograph. The composition is typical of the suggestive advertisements of the period for women's clothing, and Polke's pseudo-photographic rendering enhances these effects by seductively veiling the women's entrancing gazes and enticing body language.[2] The painting's layers of different dot screens for each color reveal Polke's understanding of four-color separation[3] and his obsession with issues of perception. He used perforated metal stencils to make his laborious, handmade painting process appear photographic.

By contrast, in his prints Polke's populist thinking led him to use the most economical, prosaic, and photo-based techniques. He preferred the banal, reproductive effects of photolithography, commonly known as offset, to the vibrant screenprint medium favored by American Pop artists.

In 1967 gallerist Herbert August Haseke of galerie h in Hannover invited Polke to make an edition of prints, following an exhibition there in 1965.[4] For this, his first print project, Polke sent a large-format photograph of the *Girlfriends* painting taken before the painting's completion, a version with only one overall dot pattern. Haseke reduced it and printed a one-color photolithographic edition of 150.[5] The print's scale and its status as a multiple also represent a close parallel to the original photographic source in a mass-circulation periodical. And in yet another conceptual toggle from the painted version, in 1968 Polke hand-colored several examples of the photomechanical print.

Polke's technique of simulating and enlarging the reproductive dot patterns of his photographic sources was undoubtedly influenced by Roy Lichtenstein's approach. Also like Lichtenstein, his interest in distancing the artist's hand is ingeniously achieved in his prints through photographic manipulation. But Polke ultimately corrupts the pattern by enlarging the screen to near illegibility creating a friction in these prints between photography and perception, issues central to American and European Pop art.

1 Polke's earliest painting on this theme is *Engel* (Angel) of 1962, one of his earliest known works.
2 See Martin Hentschel, "Solve et Coagula: On Sigmar Polke's Work," in *Sigmar Polke: The Three Lies of Painting* (Ostfildern-Ruit, Germany: Cantz Verlag, 1997), p. 53, for a magazine cover illustration related to this image.
3 In four-color reproduction, a screen with a differently shaped opening is used to print each color.
4 As with many galleries at the time, Haseke made inexpensive offset editions with several of the artists he showed.
5 The painting measures 59 x 74 5/$_8$", the photograph 26 5/$_8$ x 31 7/$_8$", and the print 18 1/$_4$ x 23 1/$_8$".

David Hockney

Cleanliness is Next to Godliness
from *The Institute of Contemporary Arts Portfolio*. 1964[1]

Screenprint
Composition: (irreg.) 32 ³/₁₆ x 19 ¹/₂" (81.7 x 49.5 cm)
Sheet: 35 ¹⁵/₁₆ x 23" (91.2 x 58.5 cm)
Publisher: Institute of Contemporary Arts, London
Printer: Kelpra Studio, London
Edition: 40
Abby Aldrich Rockefeller Fund, 1965

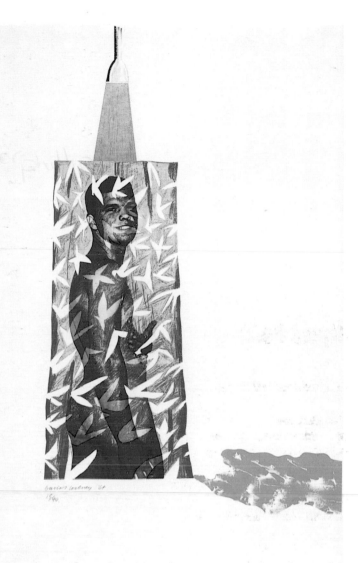

Emerging from London's Royal College of Art in 1962, David Hockney was part of the rebellious group of young artists (including Derek Boshier, Allen Jones, and Peter Phillips) who challenged the status quo of the centuries-old art establishment. His open homosexuality and frank depiction of gay life gained him notoriety among the vanguard art circles. His extraordinary, facile draftsmanship and intelligent wit, combined with his subject matter of opulent Los Angeles lifestyle,[2] made Hockney one of the most popular British artists to come on the scene in the Swinging London of the 1960s.

Hockney found the bathrooms in many Los Angeles homes particularly luxurious as compared with those in London, inspiring his frequent depiction of showers.[3] The American homoerotic magazine *Physique Pictorial*, which he discovered after moving to London from his native Bradford in 1959, was a source of inspiration for the setting and mood of many of his shower paintings of 1963–64.

Precocious as a printmaker, Hockney had begun working with professional printers in 1961 on a series of etchings. Unlike many Pop artists of the time, he favored the autographic mark and had quickly responded to the aesthetic effects available with the various intaglio mediums. In 1964, however, when invited to participate in the Institute of Contemporary Arts's screenprint portfolio, he chose to exploit the medium's facility with photography, incorporating a reproduction of one of the models from *Physique Pictorial* into a shower scene.[4]

The result, *Cleanliness is Next to Godliness*, is an anomaly in Hockney's graphic career. It is his only screenprint of the period and his only attempt at direct borrowing from mass-media sources. The escaping water at lower right is another borrowed printed image—a fragment from one of fellow artist Harold Cohen's screenprints which Hockney had seen at the printer. The collagelike construction of the image further distinguishes this print among Hockney's early work. In addition, as Andrew Brighton has pointed out, the photographic reproduction of the anonymous poser, unlike most of his other naked images which are portraits, makes this one of Hockney's most sexually charged works.[5] The medium, bold color and clearly delineated forms place it squarely within the Pop style of the early 1960s.

Ultimately Hockney did not enjoy the lack of control he felt with the screenprint process. Although this print exemplifies the medium's strong expressive potential, Hockney preferred to focus his creativity on the more draftsmanlike and handmade effects of etching and lithography.[6]

1 This work is dated in pencil 1964, but the catalogue raisonne lists the work as 1965.
2 Hockney made his first trip to Los Angeles in 1963.
3 This theme also combined two of his recurring motifs, water in motion and curtains. Hockney began the swimming pool images after the shower paintings.
4 The image in this screenprint is from the July 1962 issue. The shower curtain is the same as that used in his 1963 painting *Two Men in a Shower*.
5 Andrew Brighton, *David Hockney Prints 1954–77* (London: The Midland Group and the Scottish Arts Council in association with Petersburg Press, 1979), n. p.
6 See Marco Livingstone, *David Hockney* (1981; rev. ed. London: Thames & Hudson, 1996), p. 90.

Gerald Laing

Stacy from the portfolio *Baby Baby Wild Things.* 1968

Screenprint
Composition: 29 ⁵/₈ x 18 ¹¹/₁₆" (75.2 x 47.5 cm)
Sheet: 35 ¹/₁₆ x 23 ¹/₈" (89.1 x 58.7 cm)
Publisher and printer: the artist
Edition: 200
Celeste and Armand Bartos Foundation Fund, 1968

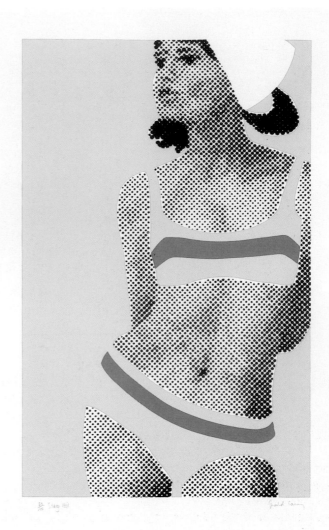

British artist Gerald Laing was so preoccupied with the myth of American culture popularized through pulp magazines that he moved to New York in 1964. While still a student in London in the late 1950s, he began painting enlarged halftone dot patterns to simulate reproductive printing methods such as screenprint. Unaware of Roy Lichtenstein's work, Laing's sources came directly from magazine and news photographs. He became fascinated by the new commercial images.

[They were]...appearing around us...after the peeling stucco of wartime neglect. I was transfixed by the crude but powerful printing process used in the poster advertisements...the dots and lines and cacophony of form and colour visible at short range, and the reassuring integrity of the image at a distance.[1]

During his Pop phase of 1962–65, Laing's two favorite subjects were "dragster" race cars and bikini-clad women, stereotypes that, to him, reflected the optimistic and classless American society where "every American has his hot-rod and his surfboard."[2] He credits Richard Smith and Robert Indiana, for whom he worked in 1963 on his first visit to New York, as influences in his exploration of simplified form and flat color.

Laing's first one-man show in New York was in 1964 at Richard L. Feigen & Co., a gallery which showed a number of British Pop artists in the 1960s. From that time on, he worked with Feigen, and in 1968 completed four portfolios of prints — *Baby Baby Wild Things*, *Dragsters*, *Parachutes*, and *Witness* — which Feigen distributed. They were all printed and published by the artist in his loft above Feigen's gallery in SoHo.[3] Laing wanted *Baby Baby Wild Things* to appear garish and tasteless, evidencing an iconoclastic and anti-art attitude. To ensure this end he designed the portfolio cover

in pink flocking with lace flaps and blue velvet ribbon ties. He even picked women's names that seemed kitsch to him to title the individual prints.[4]

Baby Baby Wild Things contains six screenprints, each derived from paintings made in 1964–65. This print, *Stacy*, is based on a painting titled *No. 71* from March 1965. Laing plays formal games and denies any spatial depth by allowing the blue of her bathing suit to bleed into the background. In addition, *Stacy* is literally bursting off the margins of the image, a tactic that enhances her powerful and erotic impact. The dot areas of the print were made from a photoscreenprint of the painting while the colored areas were handpainted on the screen and do not necessarily correspond to the painted source. Thus, in the creation of these prints, Laing traversed several levels of simulation, making screenprints of photographs of paintings of photographs.

1 Laing, quoted in *Gerald Laing: Starlets, Skydivers & Dragsters*, exh. bro. (London: Whitford Fine Art, September 19–October 18, 1996).
2 Laing, quoted in Michael Compton, *Pop Art* (London and New York: The Hamlyn Publishing Group, 1970), p. 77.
3 Both were located at 141 Greene Street in lower Manhattan.
4 In addition to Stacy, Laing chose Tracy, Starlet, Francine, and Sandra for the other names. An image of Brigitte Bardot completed the set of six. Laing, letter to the author, January 1998.

Alain Jacquet

Portrait de Laure (Portrait of Laure). (1969)

Etching and aquatint with embossing
Composition: 18 ⁷/₈ x 12 ³/₁₆" (47.9 x 30.9 cm)
Sheet: 29 ¹⁵/₁₆ x 22" (76.0 x 56.0 cm)
Publisher and printer: Éditions Georges Visat, Paris
Edition: 85
Frances Keech Fund, 1997

Working in Paris in the 1960s, Alain Jacquet was associated with critic Pierre Restany and the Nouveaux Réalistes and was inspired by the *affichistes'* use of torn posters. But Jacquet represented a younger voice responding to the commercial nature of contemporary popular culture. His work centered on issues of illusion and mechanical reproduction through the manipulation of imagery with dots and lines in order to test the threshold of their legibility. He first explored this theme in a series of camouflage paintings in 1962 and later used screenprint and the halftone dot as a means to distort and disintegrate. Advertising signs began appearing in the early camouflage works and further recommended screenprint to him as a contemporary medium for the dissemination of information through art.

Printmaking was the foundation of nearly all of Jacquet's work from 1964 to 1970. He was attracted to screenprint because of its adaptability with photographs, and he printed numerous images on canvas, many in editions. For his first, *Le Déjeuner sur l'Herbe* of 1964, he worked with a commercial poster company in Paris to print and enlarge his own photograph onto canvas.[1]

Jacquet's prints on paper were always based on photographs. For *Portrait of Laure* Jacquet took a photograph of his friend Laure Gemajner at New York's renowned Chelsea Hotel, where he was living. Three photoscreens were made from the photograph and transferred to copper plates for etching.[2]

The last plate carried the embossing. Here Jacquet used lines instead of dots or camouflage to interrupt our vision. Laure appears naked and blurred, distorted by the concentric circles and embossed surface. The circles immediately suggest a bull's-eye and the flower on her head an apple, forcing the viewer to see her as a target for male possession, an erotic theme seen in many of Jacquet's images, those of his own design as well as those he appropriated from other artists.[3] The blurring also imparts an anxious tone to the woman's face which enhances this reading and exemplifies the creative melding of photographic imagery and innovative printmaking techniques that characterizes Jacquet's work of the Pop period.

1 Jacquet said that his initial reason for making multiple canvases was economical. The expense of printing more than one was only marginally greater than that for a unique work and resulted in more works for sale. He printed ninety-seven on canvas and approximately fifty on paper. He cut up a few of the canvas versions and made several smaller works. Jacquet, conversation with the author, November 1997.

2 In 1965 the artist made a series of small prints with Éditions Georges Visat and returned in 1969 to work on a larger series, which included *Portrait of Laure*.

3 In addition to his work based on Édouard Manet's *Le Déjeuner sur l'Herbe*, erotic themes appear in works based on Manet's *Olympia*, Edgar Degas's *Le Tub*, as well as in Jacquet's own compositions such as *Two Friends* and *The Birthday*.

Claes Oldenburg

London Knees 1966. (Published 1968)

Multiple of polyurethaned latex "knees," acrylic base, and twelve photolitho-graphs in various formats: notebook pages with overleafs, postcards, foldouts, and loose sheet (not all shown). Housed in cloth-covered case
Composition: each "knee" (irreg.), 15 x 5 $^1/_2$ x 6 $^7/_{16}$" (38.1 x 14.0 x 16.4 cm); base, 1 x 16 x 10 $^1/_2$" (2.5 x 41.6 x 26.7 cm); photolithographs, various dimensions; case, 11 $^5/_8$ x 17 x 7 $^1/_2$" (29.5 x 43.2 x 19.1 cm)
Publisher: Editions Alecto, London, in association with Neuendorf Verlag, Hamburg
Printer: Lautrec Litho, Leeds, and Editions Alecto, London
Knees cast: Models, London
Knees coating: Hadfields Radiation Research, Surrey
Acrylic base: J. Watson and Co., London
Case: F. & J. Randall, London
Edition: 120
Gift of Mr. and Mrs. Lester Francis Avnet, 1968

The most influential sculptor of the Pop movement, Claes Oldenburg was also one of the period's most creative minds, writing statements and staging per-formance events that epitomize the American Pop phenomenon. His innovative installations, beginning with his open storefront environments, *The Street* in 1960 and *The Store* in 1961, irrevocably altered the aesthetic landscape and overturned the existing notions of the relationship between art and commerce. His oversize sculptures of food, clothing, and household paraphernalia epito-mize the domestic content, technical inventiveness, and light-hearted humor of so much of American Pop.

Printed imagery has played a central role in Oldenburg's art since his earliest installations for which he made a range of printed programs and announcements. Beginning in 1965, as his three-dimensional work evolved into large-scale sculptural commissions, prints often played an additional documentary role, illustrating his potential, existing, or rejected proposals. Also around this time, Oldenburg embarked on another important facet of his published work, one which explored his interests in industrial production and issues of reproduction—the multiple.

During that technical period, I thought of myself more or less as being a person without any basic skills, only a thinker, so that all of the skills lay outside of me in a factory somewhere.... I had to give them some sort of object that they could identify with and be interested in then all sorts of interesting processes would begin to take place.... The end result would be a work of art....[1]

The collaborative and technological aspects of multiples appealed to Oldenburg and contributed to his engagement with the medium. In 1966 he made his first trip to London and collaborated with Editions Alecto on a work that would capture his British experience. By showing only the midsection of the legs, *London Knees 1966* reflects the British fashion craze of miniskirts and go-go boots. Oldenburg once explained the response to the miniskirt as a "paradoxical combination of masculine voyeurism and feminine liberation."[2] He also described the numerous inspirations around London that suggested the knees' upright format to him, from the columns in the city's architecture to the "ubiquitous posters of a government anti-smoking campaign showing heaps of butts, or 'fagends.'"[3] The twelve printed sheets accompanying the knees illustrate these various sources. They also document several proposals including one to make a colossal knees monument on London's Victoria Embankment. Oldenburg's engagement with printed matter is evident in the variety of lively formats from postcards to foldouts that accompany the knees and provide its inspiring and amusing context.

London Knees 1966 took two years to complete because of Oldenburg's very specific demands and was published in 1968. The multiple itself was pro-duced by a mannequin manufacturer. Made out of slightly malleable latex, it was cast from two right knees of a 1940s mannequin, one the mirror of the other.[4] Oldenburg wanted the knees to be touchable—given a human quality to soften their industrial creation. He also intended them to be repositioned as suggested in the cigarette butt illustrations. "Most people don't realize that the knees are flexible and intended to be squeezed and moved around. They're meant to look hard but be soft...."[5] They are painted a color to resemble the Elgin marbles in the British Museum and are packed in soft felt bags which accentuate a precious and erotic overtone.[6]

The monument was never erected but the multiple lives on in 120 exam-ples. Oldenburg himself succinctly summarized how well matched this medium is to his artistic vision. "The fact that a multiple, like a book, goes out into the world to many persons seems to suit my compulsion to explain my intentions and investigate the motives of the so-called art process."[7]

1 Oldenburg, quoted in John Loring, "Oldenburg on Multiples" *Arts Magazine* 48 (May 1974): 43.
2 Oldenburg, quoted in David Platzker, *Claes Oldenburg Multiples in Retrospect 1964–1990* (New York: Rizzoli International Publications, 1991), p. 58.
3 Ibid.
4 This explains why the legs appear slightly knock-kneed.
5 Oldenburg, quoted in Judith Goldman, "Sort of a Commercial for Objects," *The Print Collector's Newsletter* II, no. 6 (January–February 1972): 119.
6 Platzker, *Claes Oldenburg*, p. 60.
7 Oldenburg, quoted in ibid., p. 60.

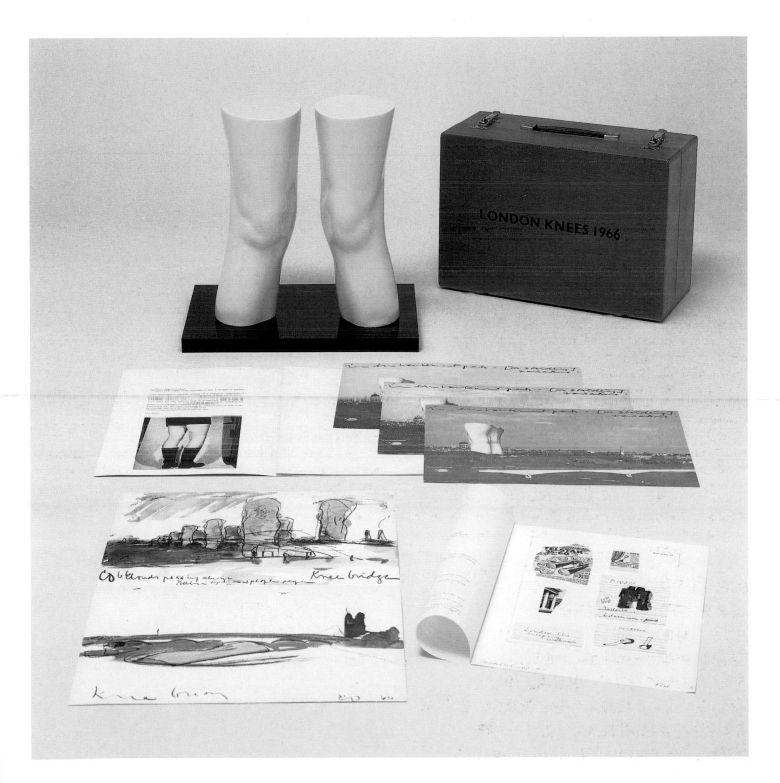

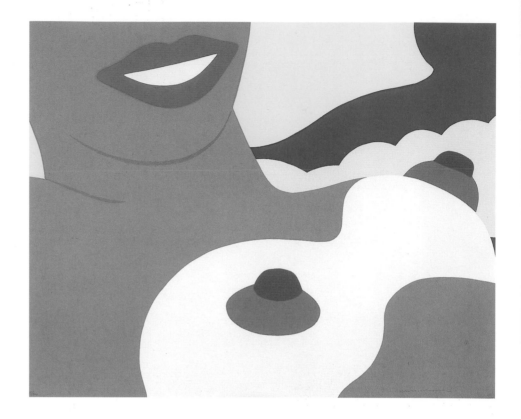

Tom Wesselmann

Nude from the portfolio
11 Pop Artists, Volume II. (1965, published 1966)

Screenprint
Composition and sheet: 23 $^{7}/_{8}$ x 29 $^{5}/_{8}$" (60.7 x 75.3 cm)
Publisher: Original Editions, New York
Printer: Knickerbocker Machine and Foundry, New York
Edition: 200
Gift of Original Editions, 1966

Erotic imagery appeared frequently in Pop art,[1] and in America this theme is perhaps best represented by the work of Tom Wesselmann. By the early 1960s Wesselmann had established the two major motifs that would characterize his mature work: the Still Life and the Great American Nude.[2] The nudes began in 1961 as a creative melding of the European odalisque tradition, Henri Matisse and Amedeo Modigliani in particular, and the influence of the printed visual culture of the everyday environment, such as billboards, magazines, and newspapers.[3] Formally austere and streamlined, Wesselmann's nudes were erotic in pose and subject but decidedly flat, abstracted, and quintessentially Pop in treatment.

Wesselmann's prints closely follow the imagery in his paintings and reliefs. Like many Pop artists, he favored screenprint for its strong saturated colors and clean edges. Although not a prolific printmaker, he explored a range of creative multiple formats, capturing the contagious innovative energy in the medium during this period. For Rosa Esman's 1966 portfolios *11 Pop Artists* he made two screenprints and a plastic multiple. For *Nude* he closely followed the truncated, close-up figure from a painting titled *Great American Nude #84* of 1965. In the print, he eliminated details of the sky and background and further cropped the figure, which accentuates the mouth and breasts and heightens the sexual impact. With vivid, unmodulated color he depicted this blonde-haired female as a faceless commodity for the voyeuristic gaze, perpetuating the sexual stereotyping that was common in the 1950s and 1960s. The tension between the overt sexuality and the abstracted forms exemplified here distinguishes Wesselmann's strongest work but also illustrates its most controversial aspect.

1 This phenomenon was the result of a confluence of events including, among other things, the liberalization of obscenity laws, the use of sex in advertising, and the extraordinary success of *Playboy* and other men's magazines.
2 The Great American Nude series was titled after such generic terms as the Great American Novel.
3 In his unique work, Wesselmann often incorporated the actual printed ephemera.

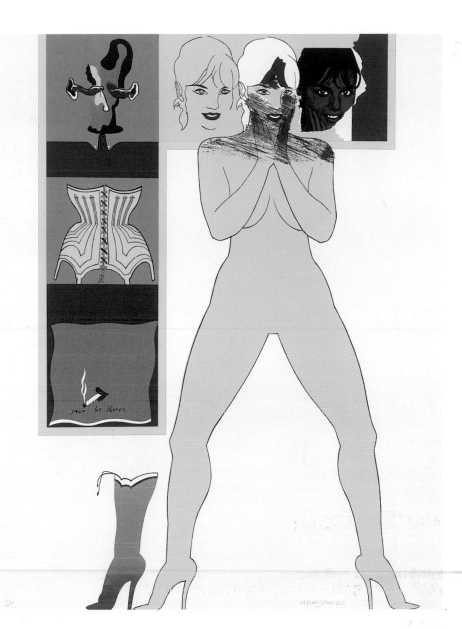

Allen Jones

Pour les Lèvres (For the Lips)
from the portfolio *11 Pop Artists,*
Volume II. 1965 (Published 1966)

Screenprint
Composition: 30 1/8 x 20" (76.5 x 50.8 cm)
Sheet: 30 1/8 x 23 15/16" (76.5 x 60.9 cm)
Publisher: Original Editions, New York
Printer: J. & P. Atchinson, London
Edition: 200
Gift of Original Editions, 1966

Like many other British Pop artists, Allen Jones lived in the United States for a period in the mid-1960s, and the visit had a lasting effect on his work. In New York, where he was living at the Chelsea Hotel, he developed his mature style of richly colored and sensually painted erotic images based on photographs from *Playboy* and other sex glossies.[1] While in New York he also abandoned his expressionistic draftsmanship in favor of more graphic, flat forms for his depictions of long-legged, stilettoed women.

Jones was a prolific printmaker and taught lithography at the Croyden College of Art. "Often ideas worked out in paintings can be seen postulated in the prints of six months before. For me lithography is a substitute for drawing," he once commented.[2] Although lithography was his preferred medium, he decided to make a screenprint when publisher Rosa Esman invited him to participate in the three *11 Pop Artists* portfolios. The screenprint *Pour les Lèvres* was one of his most openly fetishistic images to date and combined many of the erotic motifs he had been exploring up to that point.

In several of his early prints Jones combined photographic and hand-drawn passages to contrast differing modes of representation.[3] In *Pour les Lèvres* Jones juxtaposed a photograph of a model's face against two schematic renderings. He made a second vertical figure stacked along the left edge, depicting a stylized self-portrait head in a button-down collar, above the corset, that recalled the hermaphrodite forms common in his work at this time. Jones's suggestive placement, below the corset, of the red handkerchief (from which the print derives its title) reinforces this sexual allusion. The handkerchief had been given to Jones by Morton G. Neumann, the Chicago art collector and cosmetics tycoon.[4] Jones found it amusing that a cosmetic firm would design a red handkerchief to camouflage the stains from their lipstick.[5] The three faces at the top now seem to allude to before-and-after cosmetic makeovers and exemplify Jones's light-hearted but provocative depictions of stereotyped women of the 1960s.

1 Jones had collected a broad range of fetish magazines, mail-order catalogues, movie posters, and other printed ephemera that served as source material.
2 Jones, quoted in "Lithographs and Original Prints," *Studio International* (June 1968, suppl.): 336.
3 His use of photographic imagery began in 1961 with *Secret Valentines* and culminated in the Life Class series of 1968.
4 Jones visited the Neumanns during a 1965 cross-country trip with Peter Phillips.
5 Jones, letter to the author, May 1998.

Chronology

Compiled by Judith Hecker and Wendy Weitman

Pop Printmaking

1960

Tamarind Lithography Workshop established, Los Angeles

Editions Alecto established, Cambridge, England

Dine begins making lithographs, at Pratt Graphics Center, New York

Johns begins making lithographs, at Universal Limited Art Editions (ULAE), West Islip, New York

Brehmer and Vostell make first prints, Germany; Arman makes first print and multiple, Paris

Collection '59, Édition MAT's first series of multiples, tours Europe

1961

Screenprint workshop HofhausPresse established, Düsseldorf

Oldenburg makes etchings and lithographs at Pratt Graphics Center

Arroyo, Hockney, and Marisol begin printmaking in Paris, London, and New York respectively

1962

Editions Alecto relocates to London

Dine and Rauschenberg begin collaborating with ULAE

Paolozzi begins collaborating with Kelpra Studio

Ruscha begins printmaking and self-publishing artist's books, Los Angeles

Warhol makes first screenprint on paper, New York

Rotella makes multiple *Little Monument to Rotella*, Milan

Pop Art

1963

Betsy Ross Flag and Banner Company established, New York

Screenprint workshop Chiron Press established, New York

Marlborough Fine Art establishes Marlborough Graphics to begin print publishing, London

Michel Caza establishes print workshop, Paris

Hamilton begins collaborating with Kelpra Studio

Christo makes first wrapped multiple, for HofhausPresse

Hockney has first solo print exhibition, Editions Alecto; show travels to MoMA

1964

Tanglewood Press established, New York

Marlborough Graphics opens in New York

Rosenquist and Marisol begin making lithographs at ULAE

Warhol makes *Brillo Box* and other multiple wood cartons, New York

X + X (Ten Works by Ten Painters) published, Hartford, Connecticut

The ICA Portfolio published, London

1¢ Life published, Bern

The International Anthology of Contemporary Engraving: The International Avant-Garde; America Discovered published, Milan

Édition MAT releases second series of multiples, *Collection '64*, Cologne

Brehmer has first solo print exhibition, Berlin

Jones has first solo print exhibition, Editions Alecto

1965

Multiples, Inc. established, New York

Print workshop Gemini Ltd. (later Gemini G.E.L.) established, Los Angeles

Laing begins printmaking, at Tamarind Lithography Workshop

Jacquet collaborates with Georges Visat, Paris

Richter begins printmaking, with HofhausPresse

Baj makes first multiple, Cologne

Tanglewood Press publishes *New York 10* portfolio

Editions Alecto publishes Paolozzi's illustrated book *As Is When*

Édition MAT releases third series of multiples, *Collection '65*

Rauschenberg exhibits prints in solo exhibition at Amerika Haus, Berlin

1966

Dine begins screenprinting at Kelpra Studio

Richter begins publishing with edition h, Hannover

Fahlström makes first variable multiples, New York

Lichtenstein's ceramic dishware published by Durable Dish Co., New York

11 Pop Artists portfolios published by Original Editions, New York, which tour Europe and U.S.

New York International portfolio and *7 Objects in a Box* multiples portfolio published by Tanglewood Press

Andy Warhol: Wallpaper and Clouds exhibition at Leo Castelli Gallery

Smith has first solo print exhibition, Editions Alecto

Paolozzi has solo print and sculpture exhibition, Scottish National Gallery of Modern Art, Edinburgh

1967

Petersburg Press and Waddington Graphics established, London

Warhol establishes Factory Additions, New York

Polke begins printmaking, with edition h

Grafik des Kapitalistischen Realismus portfolio published by René Block for Stolpe Verlag, Berlin

Paolozzi makes illustrated book *Moonstrips Empire News*

Blake designs cover picture for Beatles's *Sgt. Pepper's Lonely Hearts Club Band* album, London

Welsh Arts Council commissions billboard by Jones, Cardiff

The Museum of Merchandise exhibition at Philadelphia Arts Council

1968

On 1st, a Pop multiples store, opens, New York

Seriaal, a multiples store, opens, Amsterdam

Screenprint workshop Advanced Graphics established, London

Student uprisings lead to founding of screenprint workshop L'Atelier Populaire at École des Beaux Arts, Paris

Dorothea Leonhart (Editions München International) begins publishing, Munich

Dine begins collaborating with Petersburg Press

Indiana begins collaborating with Edition Domberger, Stuttgart

Self begins collaborating with Editions Alecto

Warhol's *Flash—November 22, 1963* published by Racolin Press, New York

Oldenburg completes *London Knees 1966* with Editions Alecto

Hockney has solo print exhibition, MoMA

First *Biennale Internationale de l'Estampe*, Paris

Documenta IV features Pop prints and multiples and publishes numerous benefit editions

1969

Castelli Graphics established to expand publishing activities of Leo Castelli Gallery; opens with Warhol print exhibition

Lichtenstein begins collaborating with Gemini G.E.L.

Ruscha begins collaborating with Tamarind Lithography Workshop

Roth begins collaborating with Petersburg Press

Ruscha has first solo print exhibition, Los Angeles

Superlimited: Books, Boxes and Things exhibition at The Jewish Museum

1970

Raysse publishes original insert in New York's weekly *The Village Voice*

Hamilton makes mass-edition print, *Kent State*, with Dorothea Leonhart (Edition München International)

Roth's *6 Piccadillies* published by Petersburg Press

Richter has first solo museum print exhibition, Museum Folkwang, Essen

New Multiple Art exhibition at Whitechapel Gallery

Notes on the Artists and Works in the Collection 114
Notes on the Publishers 128
Selected Bibliography 132
Index 134

Notes on the Artists and Works in the Collection

Compiled by Wendy Weitman

Information on the artists focuses on their printmaking activities during the years 1960 to 1975. Bibliographic references cite a major publication or catalogue raisonné of the artist's editioned work. Bibliographic numbers reference entries in sections II and III of the Selected Bibliography beginning on page 132. The Museum of Modern Art's holdings of each artist's editioned work dating from 1960 to 1975 are listed. Titles not in English are given in their original language followed by English translations. Dates within parentheses do not appear on the works.

Arman (Armand P. Arman)

Born in Nice, France in 1928. Lives in New York. Founding member of Nouveau Réalisme in Paris in 1960. Known for his accumulations of machine-made objects often encased in plastic. Much of his work based on the imprinting of objects. Made first multiple, a sardine can filled with paper, in 1960 as invitation for his historic exhibition *Le Plein*. By 1975 had completed nearly one hundred published prints, working mostly in lithography, but sporadically in screenprint and etching as well. Prints often paralleled his process for unique works: throwing or dropping inked objects onto plates and stones. Worked with a variety of publishers during this period including Galerie Alexandre de la Salle, Vence, France; Prisunic, Paris; Tanglewood Press, New York; as well as occasional museums and galleries. Also produced several illustrated books and contributed to numerous books and portfolios of various artists.

Biblio.: Otmezguine, Jane, and Marc Moreau. *Arman Estampes: Catalogue Raisonné*. Paris: Marval, 1990. See also no. 115.

Boom-Boom from the portfolio *New York International*. 1966. Screenprint, printed in color, with pencil additions. Otmezguine & Moreau 254.

Tortured Color from the periodical *S. M. S.*, no. 4 (August 1968). New York: The Letter Edged in Black Press, 1968. Two sheets of plexiglass, three lithographs, printed in black and in color, one tube of paint, and nuts and bolts, all housed in plastic bag. Not in O & M.

Caméra négative (Negative Camera). (1973). Lithograph, printed in color. O & M 62.

Untitled from the portfolio *Les Nouveaux Réalistes* (The New Realists). 1973. Screenprint, printed in color. O & M 261.

Untitled from the portfolio *Hommage à Picasso*, Volume 5. 1975. Lithograph, printed in color. O & M 265.

Eduardo Arroyo

Born in Madrid in 1937. Lives in Paris. Fled political turmoil in Spain and settled in Paris in 1958. Exile became defining motivation in his art. Developed graphic figurative style of vibrant color and well-defined forms with strong political content. Became associated with Nouvelle Figuration, a Paris-based group interested in narrative figurative style. Began making prints in 1961, working primarily in lithography, with occasional examples in screenprint and etching. In May 1968, at the École des Beaux Arts, helped striking students establish L'Atelier Populaire, a printmaking workshop that made political street posters. Had completed nearly seventy prints by 1975, collaborating most often with publishers Edizione dell'Aldina in Rome, Edizioni Il Bisonte in Florence, and M.A. in Milan. Designed sets for numerous theatrical productions and also worked in ceramics.

Biblio.: di Rocco, Fabienne. *Eduardo Arroyo: Obra Gráfica*. Valencia: Instituto Valenciano de Arte Moderno (IVAM) Centre Julio González, 1989.

Notas para Guernica (Notes from Guernica). 1970. Lithograph, printed in color.

Enrico Baj

Born in Milan in 1924. Lives in Vergiate, Italy. Continuing in the European Surrealist tradition, became known primarily for his assemblages of found objects. Came closest to Pop concerns in work from the late 1950s that combined found objects with printed advertisements from the popular media. Closely associated with Nouveaux Réalistes Arman, Spoerri, and Rotella in late 1950s and early 1960s. Began making etchings as a student and published first prints in 1952. Became prolific and accomplished printmaker, completing over 400 prints including forty illustrated books during this period. Experimented with printing unconventional mediums onto plastics and laminated surfaces, often collaging labels and stickers. Inspired by Surrealist book production, created numerous book-objects. Published first books with Arturo Schwarz in Milan in 1958 but turned more seriously to the medium in the late 1960s. Also made over sixty multiples, beginning in 1965 for Édition MAT, Cologne. Collaborated with a wide range of publishers and printers in France, Switzerland, and Italy, often with Sergio Tosi, Studio Marconi, and Grafica Uno in Milan. Also made numerous posters.

Biblio.: Petit, Jean. *Catalogue de l'oeuvre graphique et des multiples d'Enrico Baj: Volume I, 1952–1970*. Geneva: Rousseau Éditeur, 1970.
———. *Catalogue de l'oeuvre graphique et des multiples d'Enrico Baj: Volume II, 1970–1973*. Geneva: Éditions Rousseau, 1973. See also nos. 67, 96.

Ultracorpo (Ultrabodies) from the illustrated book *International Anthology of Contemporary Engraving: The International Avant-Garde*, Volume 1 by Franco Russoli. Milan: Galleria Schwarz, 1962. (Print executed 1961). Etching. Petit I, 84.

Dames et Généraux by Benjamin Péret. Paris and Milan: Berggruen and Schwarz, 1964. (Prints executed 1963–64). Illustrated book with ten soft ground etchings with aquatint, etching, collage, and/or chine collé: nine printed in color; and lithographed false "title" page, by Marcel Duchamp. Petit I, Book 5 and Petit I, 88–97.

Generale, plate (page 161) from the illustrated book *1¢ Life* by Walasse Ting. Bern: E. W. Kornfeld, 1964. Lithograph, printed in color. Petit I, 102.

The General's Wife, headpiece (page 168) from the illustrated book *1¢ Life* by Walasse Ting. Bern: E. W. Kornfeld, 1964. Lithograph, printed in color. Petit I, 103.

Double-page plate (pages 54, 55) from the illustrated book *L'Albero Poeta*. Milan: Galleria Schwarz, 1966. Collagraph, printed in color. Petit I, 104.

Le Comte de Guebriant (The Count de Guebriant), plate from the illustrated book *Larmes de Généraux* by André Pieyre de Mandiargues. Stockholm: Igell, 1965. Lithograph, printed in color. Petit I, 106.

The Archduke Charles at the Battle of Aspen-Essling. (1965). Etching and aquatint, printed in color. Petit I, 115.

Constant d'Aubigné, Baron de Surineau. (1965). Etching and aquatint, printed in color. Petit I, 118.

L'Homme, la Femme et les Vêtements by Yvon Taillandier. Milan: Sergio Tosi, 1966. Illustrated book with four screenprints with watercolor additions and eight collages. Petit I, Book 7 and Petit I, 126–29.

Meccano, ou l'Analyse Materielle du Langage by Raymond Queneau. Milan: Sergio Tosi, 1966. Illustrated book with seventeen collagraphs, printed in color, and supplementary unbound screenprint, printed in color. Petit Book 10 and Petit I, 146–50.

Glove from the periodical *S. M. S.*, no. 3 (June 1968). New York: The Letter Edged in Black Press, 1968. White plastic glove with pink tissue backing, housed in mylar folder. Not in Petit.

Baj at Marconi's. (1969). Multiple of screenprinted plastic shopping bag with handles, containing two screenprinted plastic ties, four postcards, three exhibition brochures, a mannequin arm, and a publicity button. Petit I, 15.

Femme Assise (Seated Woman) from the portfolio *Hommage à Picasso*. (1972, published 1973). Screenprint, printed in color, with flocking. Petit II, 392.

Peter Blake

Born in Dartford, England in 1932. Lives in London. Member of the Independent Group in the early 1950s and among the first generation of Pop artists to emerge from London's Royal College of Art in the late 1950s. Painting style combined a Pop aesthetic with the influence of English folk art. Best known for his depictions of entertainers from popular culture, which often combined photographic and painted images with areas of hard-edged abstraction. Very interested in wide dissemination of his work, attempting to reach the pop music audience with his images of their idols. Made first print for London's *Institute of Contemporary Arts Portfolio* in 1964. Often worked in series, creating several screenprint portfolios in the early 1970s, including *The Wrestlers*, *Six Victorian Nudes*, and *Alice in Wonderland*. Has also worked in wood engraving. Did numerous poster commissions for rock groups. Designed record cover for the Beatles's album *Sgt. Pepper's Lonely Hearts Club Band*.

Biblio.: *Peter Blake*. London: The Tate Gallery, 1983. Texts by Michael Compton, Robert Melville, and Nicholas Usherwood. See also nos. 67, 92.

The Beach Boys from *The Institute of Contemporary Arts Portfolio*. 1964. Screenprint, printed in color.

Babe Rainbow. 1968. Screenprint, printed in color, on tin.

Alice Through the Looking Glass. (1972). Portfolio of eight screenprints.

Penny Black from the series *The Wrestlers*. (1972). Screenprint, printed in color.

Pretty Boy Michaelangelo from the series *The Wrestlers*. (1972). Screenprint, printed in color.

Derek Boshier

Born in Portsmouth, England in 1937. Lives in Los Angeles. After short Pop phase in the early 1960s, made abstract, Op-related constructions and sculptures. Stopped painting from 1966 to 1979. In the early 1970s made films and photographically based works. Always politically active, in the late 1960s and early 1970s he contributed numerous banners, posters, and flyers to political organizations and trade unions protesting the Vietnam War, the nuclear bomb, and racism. Completed occasional screenprints in

his abstract style, mostly self-published. Made editions sporadically throughout the 1960s and 70s including a multiple and two lithographs with Editions Alecto in London and several photo-based prints while teaching at London's Royal College of Art in the mid-1970s. Interested in making art affordable to those outside the art world, he made several large-edition artist's books.

Biblio.: See no. 92.

Untitled from *The Institute of Contemporary Arts Portfolio*. 1964. Screenprint, printed in color.

K. P. Brehmer (Klaus Peter Brehmer)

Born in Berlin in 1938. Died in Hamburg in 1998. Painter, printmaker, and filmmaker who gained recognition in the mid-1960s as part of Capitalist Realism. Focused primarily on political issues and incorporated printmaking and multiple editions into his work in order to reach a wide audience. Completed over 150 printed works, mostly using photographic processes, many of which were printed in commercial-sized editions of as many as 30,000. Also worked in linoleum cut and etching, and in the 1970s turned primarily to screenprint, which he sometimes used to create proposals for his social and political billboard projects. Pioneered development of three-dimensional prints with the *aufsteller* (pin-up) series of "object prints" modeled after advertisements. Created postage stamp series in 1966, and used printed formats such as postcards and maps as the basis for several other series. Self-published many works in small editions as prototypes for unlimited runs, many of which were never realized. Also completed several multiples. Professional publishers included Edition Griffelkunst in Hamburg and Edition René Block in Berlin. Worked primarily with commercial printers.

Biblio.: Block, René. *Grafik des Kapitalistischen Realismus*. Berlin: Edition René Block, 1971. Text by Carl Vogel.
———. *K.P. Brehmer, K.H. Hödicke, Sigmar Polke, Gerhard Richter, Wolf Vostell: Werkverzeichnisse der Druckgrafik. Band II. September 1971 bis Mai 1976*. Berlin: Edition René Block, 1976. See also no. 67.

Aufsteller 25. Das Gefühl zwischen Fingerkuppen. . . (Pin-Up 25. The Feeling Between Fingertips. . .) from the portfolio *Grafik des Kapitalistischen Realismus* (Graphics of Capitalist Realism). (1967). Free-standing screenprint, printed in color, on folded board and seed-packet collage. Block B108.
Testbild TV (Braun werte 1–5) (TV-Test Pattern [Brown Values 1–5]) from the portfolio *Weekend*. (1970/72). Series of five stereotype-plate (electroprint) and linoleum cuts, printed in color. Block 127.
Selbstbildnis (Self-Portrait), first supplementary plate from the book *Grafik des Kapitalistischen Realismus* (Graphics of Capitalist Realism). Berlin: Edition René Block, 1971. Etching and relief, printed in color. Block B135.

Patrick Caulfield

Born in London in 1936. Lives in London. Studied at London's Royal College of Art, along with Hockney and Jones, in the early 1960s. Developed a consistent style of schematic landscapes, interiors, and still lifes made from opaque, bright colors outlined in broad black contours. Made his first print for *The Institute of Contemporary Arts Portfolio* in 1964 and went on to work exclusively in screenprint, which was well suited to his painting style. Completed nearly seventy screenprints by 1975, including one illustrated book with twenty-two images. Major publishers have

been Waddington Graphics and Editions Alecto in London. Also collaborated with publishers Bernard Jacobson and Petersburg Press in London.

Biblio.: *Patrick Caulfield Prints 1964–1981*. Hasselt: Provinciaal Museum Voor Actuele Kunst, 1981. Introduction by Bryan Robertson. See also nos. 77, 78, 85, 96, 115.

Small Window at Night. (1972). Screenprint. Robertson 25.
Pipe. (1972). Screenprint, printed in color. Robertson 27.
Napkin and Onions. (1972). Screenprint, printed in color. Robertson 28.
Tulips. (1973). Screenprint. Robertson 32.
Pipe and Jug. (1973). Screenprint. Robertson 37.
Some Poems of Jules Laforgue by Jules Laforgue. London: Petersburg Press in association with Waddington Galleries, 1973. Illustrated book with twenty-two screenprints, printed in color, and an additional suite of six screenprints, printed in color. Robertson 38.

Christo (Christo Javacheff)

Born in Gabrovo, Bulgaria in 1933. Lives in New York. Emigrated to Paris in 1958 and became associated with Nouveau Réalisme group. That year began signature style of wrapping found objects. Influential in his focus on packaging, which would become an important motif in Pop art. His first multiple works were wrapped magazine editions and published in 1963 for HofhausPresse, Düsseldorf, and in 1965 for Édition MAT, Cologne. In printmaking worked primarily in lithography and screenprint and completed fifty-three prints, many with collaged elements, and ten multiples during this period. Printed work often incorporates photography and documents large-scale ephemeral projects. Uses proceeds from print sales to underwrite completion of these projects. Has published many of his lithographs with Landfall Press in Chicago. Has also collaborated with a variety of international printers and publishers, including Galerie Der Spiegel in Cologne, Edition Staeck in Heidelberg, as well as numerous museums.

Biblio.: Schellmann, Jörg, and Joséphine Benecke. *Christo Prints and Objects, 1963–1987: A Catalogue Raisonné*. New York and Munich: Edition Schellmann; New York: Abbeville Press, 1988. Introduction by Werner Spies. See also nos. 67, 96, 100, 106, 115.

Look Magazine Empaqueté (Wrapped Look Magazine). 1965. Multiple of *Look* magazine over foam, wrapped in polyethylene and cord, on wood support. Schellmann and Benecke 2.
Store Front from the periodical *S. M. S.*, no. 1 (February 1968). New York: The Letter Edged in Black Press, 1968. Photolithograph, printed in color, and collage. Not in S & B.
Packed Tower—Spoleto (Proposals + Projects) from the portfolio *Artists and Photographs*. (Published 1970). Nine photolithographs. Not in S & B.
(Some) Not Realized Projects. (1971). Portfolio of five lithographs, printed in color, two with collage. S & B 35–39.
Wrapper Sylvette, Project for Washington Square Village, New York from the portfolio *Hommage à Picasso*, Volume 3. (1973). Lithograph and screenprint, printed in color, and collage. S & B 60.
Wrapped Monument to Vittorio Emanuele, Piazza del Duomo, Milan, 1970 from the portfolio *Les Nouveaux Réalistes* (The New Realists). 1970 (Published 1973). Photolithograph, printed in color. S & B 69.
Texas Mastaba, Project for 500,000 Stacked Oil Drums from the

portfolio *America: The Third Century*. 1976. Lithograph and screenprint, printed in color, and collage. S & B 85.

Allan D'Arcangelo

Born in Buffalo, New York in 1930. Died in Kenozo Lake, New York, 1998. Landscape painter of the 1960s who focused on the consumer signage of the American highway, depicting barren vistas devoid of humanity as seen from the driver's seat of a car. Used hard-edge vocabulary of saturated color and often added actual car mirrors to his paintings to emphasize the contrast between illusionary and authentic images. Completed first print in 1962, an etching for Arturo Schwarz's book *International Anthology of Contemporary Engraving: The International Avant-Garde; America Discovered*. Subsequently worked primarily in screenprint, completing forty-five prints, multiples, and original posters by 1975. Executed several multiples based on a rearview mirror in 1965 and 1971, as well as a banner in 1968. Collaborated with a variety of dealers and publishers including Tanglewood Press, New York; Edition Domberger, Stuttgart; Fishbach Gallery, New York; and Marlborough Graphics, New York; as well as numerous cultural organizations. Made prints with several printers including Edition Domberger, Chiron Press, New York; Gemini G.E.L., Los Angeles; and Kelpra Studio, London. Also designed occasional book and magazine covers.

Biblio.: *The American Landscape: Paintings by Allan D'Arcangelo*. Buffalo: Burchfield Center, Western New York Forum for American Art, State University of New York, 1979. Text by Dore Ashton. See also nos. 67, 100, 115.

American Madonna, plate 2 from the illustrated book *International Anthology of Contemporary Engraving: The International Avant-Garde. America Discovered*, Volume 5 by Billy Klüver. Milan: Galleria Schwarz, 1964. (Print executed 1962). Soft ground etching.
Landscape I from the portfolio *11 Pop Artists, Volume I*. 1965 (Published 1966). Screenprint, printed in color.
Landscape II from the portfolio *11 Pop Artists*, Volume II. 1965 (Published 1966). Screenprint, printed in color.
Landscape III from the portfolio *11 Pop Artists*, Volume III. 1965 (Published 1966). Screenprint, printed in color.
Untitled. 1965. Screenprint, printed in color.
Landscape. 1966. Lithograph, printed in color.
Side View Mirror from the multiples portfolio *7 Objects in a Box*. (1965, published 1966). Screenprint, printed in color, on plexiglass set into chrome side-view mirror mounted on black acrylic base.
Dipped, plate 5 from the illustrated book *Artists and Writers Protest Against the War in Vietnam*. New York: Artists & Writers Protest Inc., 1967. Screenprint, printed in color.
Double-page plate (folios 91 verso and 92) from the book *In Memory of My Feelings* by Frank O'Hara. New York: The Museum of Modern Art, 1967. Photolithograph.
Untitled from the portfolio *Graphik USA*. 1968. Screenprint, printed in color.
Untitled from the portfolio *National Collection of Fine Arts*. 1968. Screenprint, printed in color.
69. 1969. Portfolio of seven screenprints, printed in color.
Untitled from the portfolio *America's Hommage à Picasso*, Volume 5. 1973 (Published 1975). Screenprint, printed in color.
Beginning from the portfolio *America: The Third Century*. 1975 (Published 1976). Lithograph and screenprint, printed in color, with embossing.

Trem

30
14

Jim Dine

Born in Cincinnati, Ohio in 1935. Lives in Putney, Vermont. By late 1950s brought street life into his art by incorporating everyday objects, such as tools, clothing, and plumbing fixtures, into his paintings. With Oldenburg and Kaprow, organized the first American Happenings in 1959. Excelled as a draftsman and became prolific printmaker, beginning in 1960 with lithograph series based on one of his Happenings. Completed over 250 prints by 1975, depicting his signature tools, bathrobes, hearts, and portraits. Favored lithography during this period, but turned more consistently to etching in early 1970s. Began working at Universal Limited Art Editions (ULAE), West Islip, N. Y., in 1962, and Petersburg Press, London, in 1968, which remained his most important publisher throughout the 1960s and 1970s. Collaborated with printers Chris Prater of Kelpra Studio in London and Tony Towle of ULAE, and extensively with intaglio printer Maurice Payne during this period. Completed numerous original posters, an album cover, and several multiples.

Biblio.: *Jim Dine Complete Graphics*. Berlin: Galerie Mikro Berlin; Hannover: Kestner-Gesellschaft; London: Petersburg Press, 1970. With texts by John Russell, Wieland Schmied, and Tony Towle.

Krens, Thomas, ed. *Jim Dine Prints: 1970–1977*. New York: Harper & Row, in association with Williams College, 1977. Text and interview with artist by Riva Castleman. See also nos. 65, 67, 70, 80, 85, 86, 95, 106, 115.

Car Crash I–VI and *End of the Crash*. (1960). Series of six lithographs, printed in black and in color. Mikro 1–6.

The Universal Tie. (1961). Drypoint with watercolor additions. Mikro 7.

Little Flesh Tie. 1961. Drypoint with hand additions. Mikro 11.

"These Are Ten Useful Objects Which No One Should Be Without When Traveling." 1961. Portfolio of ten drypoints with gouache additions. Not in Mikro.

Four C Clamps. 1962. Lithograph, printed in color. Mikro 12.

Toothbrushes #1. 1962. Lithograph. Mikro 13.

Toothbrushes #2. 1962. Lithograph. Mikro 14.

Toothbrushes #3. 1962. Lithograph. Mikro 15.

Toothbrushes #4. 1962. Lithograph. Mikro 16.

Corner Brace, plate 3 from the illustrated book *International Anthology of Contemporary Engraving: The International Avant-Garde. America Discovered*, Volume 5 by Billy Klüver. Milan: Galleria Schwarz, 1964. (Print executed 1962). Etching. Mikro 17.

Pliers. 1962. Lithograph. Mikro 18.

Cut & Snip. 1962-63. Lithograph. Mikro 19.

Black Bathroom. 1963. Lithograph, printed in color. Mikro 20.

Pink Bathroom. 1963. Lithograph, printed in color. Mikro 21.

White Teeth. 1963. Lithograph, printed in color. Mikro 22.

Brush after Eating. 1963. Lithograph, printed in color. Mikro 23.

Colored Palette. 1963. Lithograph, printed in color. Mikro 24.

Self-Portrait from the portfolio *New York 10*. 1964 (Published 1965). Etching. Mikro 26.

Eleven Part Self-Portrait (Red Pony). 1965. Lithograph, printed in color. Mikro 27.

Boot Silhouettes. 1965. Lithograph. Mikro 28.

Flesh Palette in a Landscape. 1965. Lithograph, printed in color. Mikro 29.

Night Palette. 1965. Lithograph, printed in color. Mikro 30.

Double Apple Palette with Gingham. 1965. Lithograph, printed in color, and cloth collage. Mikro 31.

Birthday. (1965). Lithograph, printed in color. Mikro 32.

The Creation (Rainbow). 1965. Lithograph on seven sheets and a glass containing five painted wood discs. Mikro 33.

Awl from the portfolio *11 Pop Artists*, Volume I. 1965 (Published 1966). Screenprint, printed in color. Mikro 35.

Throat from the portfolio *11 Pop Artists*, Volume II. 1965 (Published 1966). Screenprint, printed in color. Mikro 36.

Calico from the portfolio *11 Pop Artists*, Volume III. 1965 (Published 1966). Screenprint, printed in color. Mikro 37.

Kenneth Koch Poem Lithograph. 1966. Lithograph, printed in color. Mikro 39.

Untitled. 1966. Lithograph, printed in color. Mikro 40.

Rainbow Faucet from the multiples portfolio *7 Objects in a Box*. 1965 (Published 1966). Sand-cast aluminum dipped in acrylic paint. Not in Mikro.

Midsummer Wall. 1966. Lithograph, printed in color. Mikro 41.

A Tool Box. 1966. Portfolio of eleven screenprints (including title page), printed in color and in black, and collage. Mikro 42.

Drag—Johnson and Mao. 1967. Etching and aquatint, printed in color. Mikro 44.

Wall. 1967. Etching, printed in color. Mikro 45.

The Picture of Dorian Gray by Oscar Wilde. London: Petersburg Press, 1968. Illustrated book with thirteen lithographs (including half title page), printed in color (one with lithographed mylar overlay); photolithographic reproductions after pen and ink drawings annotating text; six unbound duplicate lithographs, printed in color; and four unbound etchings (one with aquatint and three with soft ground etching), three printed in color. Mikro 47.

The Poet Assassinated by Guillaume Apollinaire. New York: Tanglewood Press, 1968. Illustrated book with eight pochoirs, seven printed in color; fifty photolithographic reproductions after photographs or photomontages (including detail of frontispiece repeated sixteen times); and two screenprinted reproductions after photograph detail (wrapper and slipcase). See Mikro, "Texts created or illustrated by Dine."

IV from the series *Four Palettes*. 1969. Lithograph, printed in color. Mikro 59.

Untitled, plate VII from the portfolio *Vegetables*. (1970, published 1971). Lithograph, printed in color, and collage. Mikro 66g.

Art Poster. 1968. Photolithograph, printed in color. Mikro 71.

Double-page headpiece (pages 144, 145) from *1¢ Life* by Walasse Ting. Bern: E. W. Kornfeld, 1964. Lithograph, printed in color. Mikro 78.

The Poets' Twelve Hearts. 1969. Etching with watercolor additions. Not in Mikro or Krens.

Pliers 2. 1969 (Published 1970). Lithograph. Not in Mikro or Krens.

2 Hearts (The Donut). (1970, dated and published 1972). Lithograph, printed in color. Krens 1.

The World (For Anne Waldman). 1972. Lithograph, screenprint, and woodcut, printed in color, with pencil additions and collage. Krens 38.

Self-Portraits (1971). 1971. Series of nine drypoints. Krens 47–55.

Silhouette Black Boots on Brown Paper. 1972. Lithograph. Krens 93.

Flaubert Favorites (Edition A). 1972. Series of four lithographs. Krens 95–98.

Flaubert Favorites (Edition B). 1972. Series of four lithographs. Krens 99–102.

Five Paintbrushes (Third State). 1973. Etching. Krens 137.

Big Red Wrench in a Landscape from the portfolio *Hommage à Picasso*, Volume 4. 1973. Lithograph, printed in color. Krens 146.

Braid (Second State). 1973. Etching, printed in color. Krens 149.

Untitled from the portfolio *The New York Collection for Stockholm*. (Published 1973). Screenprint, printed in color. Not in Krens.

Rimbaud, Alchemy on Japanese Paper. 1973. Etching. Krens 154.

Wall Chart I. 1973. Lithograph, printed in color. Krens 166.

Plant Becomes a Fan #1–#5. 1975. Series of five lithographs and screenprints. Krens 171–75.

Self-Portraits— Second Published State (The Dartmouth Portraits). 1975. Series of nine etchings with aquatint. Krens 184–92.

A Hand Painted Self-Portrait. 1975. Etching, drypoint, and monotype, printed in color, with paint and pastel additions. Krens 194.

Positive Self-Portrait, State 2. 1975. Etching, drypoint, and power tool. Krens 195.

Self-Portrait as a Negative. 1975. Etching, drypoint, and power tool, printed in white. Krens 196.

Black and White Bathrobe. 1975. Lithograph, printed in color. Krens 197.

The Woodcut Bathrobe. 1975. Woodcut and lithograph, printed in color. Krens 198.

Equipo Crónica

Rafael Solbes (1940–1981), Manolo Valdés (born 1942) and Juan Antonio Toledo (born 1940; left the group in 1965) in Valencia, Spain. Collective team formed in 1964 in Valencia, Spain that became known for biting, visual commentary on art and politics. Critiqued Franco regime in graphic style imbued with satire and irony, often creating Pop interpretations of art historical master-pieces. Participated in Estampa Popular, a movement that exploited printmaking's traditional role as a vehicle for social and political art. Earliest prints were linoleum cuts in small editions, often in grid format. By 1966 turned to screenprint, often working in series, completing over fifty prints by 1975. Also worked in multiples, beginning in 1970, making nearly twenty screenprints on stone inspired by their interest in Valencian folk art tradition of fallas, ornate wood and wax statues of politicians or celebrities. Also made several screenprints on cloth. Self-published their prints until 1971 after which dealer Galerie Val i 30 in Valencia became major publisher. Printed mostly at the commercial screenprint workshop Ibero-Suiza in Valencia during this period. After 1978 many prints and multiples published by Galeria Maeght in Barcelona. Also made numerous unsigned posters in large editions.

Biblio.: *Equipo Crónica: Catalogación Obra Gráfica y Múltiples (1965–1982)*. Bilbao: Museo de Bellas Artes de Bilbao, 1988. Text by Michèle Dalmace-Rognon. See also nos. 74, 82, 115.

Alpino. (1974). Screenprint, printed in color. Dalmace-Rognon 45.

Öyvind Fahlström

Born in São Paolo, Brazil of Swedish and Norwegian parents, in 1928. Died 1976. Multi-faceted and politically committed artist. Broke down barriers between art forms and incorporated influence of mass-produced popular culture artifacts such as comic books and board games into Surrealist inspired collagelike formats. Most well-known for variable paintings begun in 1962 in which detachable elements could be arranged by the viewer. Organized Happenings in the early 1960s. Wrote plays and concrete poetry. Published word game in early 1960s. After two experimental prints for Surrealist periodicals in the 1950s, made first etching for Arturo Schwarz's book *International Anthology of*

Contemporary Engraving: The International Avant-Garde, in 1962. In 1966 completed first variable prints, and a banner and multiple for Multiples, Inc. Made prints sporadically in early 1970s, completing twenty-seven, mostly screenprints. Also produced three mass editions, including a highly political image in edition of 7,000 as centerfold for liberal newspaper in 1972. Made several variable multiples that incorporated magnets, vinyl, and plexiglass.

Biblio.: Tallman, Susan. "Pop Politics: Öyvind Fahlström's Variables." *Arts Magazine*, 65, no. 4 (December 1990). See also nos. 67, 96, 100.

Plate 7 from the illustrated book *International Anthology of Contemporary Engraving: The International Avant-Garde*, Volume 3 by Franco Russoli. Milan: Galleria Schwarz, 1962. Soft ground etching.
Double-page headpiece (pages 120, 121) from the illustrated book *1¢ Life* by Walasse Ting. Bern: E. W. Kornfeld, 1964. Lithograph, printed in color.
Eddie (Sylvie's brother) in the Desert from the portfolio *New York International*. 1966. Screenprint, printed in color.
Opera. (1968). Screenprint on ten sheets.
$108 Bill. (1972). Lithograph, printed in color.
Sketch for "World Map" Part I (Americas, Pacific). (1972). Photolithograph.
Column No. 2 (Picasso 90) from the portfolio *Hommage à Picasso*, Volume 5. 1973 (Published 1975). Screenprint, printed in color.
$108 Bill from the portfolio *The New York Collection for Stockholm*. (1973). Screenprint.
Column No. 4 (ID Affair). 1974. Screenprint, printed in color.
Simplicity. 1974. Screenprint.
Sketch for Kidnapping Kissinger. (1974). Screenprint, printed in color.

Richard Hamilton

Born in London in 1922. Lives in Oxfordshire, England. Seminal figure in the foundation of Pop ideology and imagery in London. Active member of London's Independent Group (IG) of the 1950s, whose ideas centered on the interaction between art and popular culture. Organized numerous discussions, lectures, and innovative interdisciplinary exhibitions for the IG at the Institute of Contemporary Arts. Through complex layering of painting and photographic techniques, his art explored the means through which the still and electronic media influence our perception of reality. Has written extensively on his major works. Taught etching at the University of Newcastle in 1950s and 1960s. Experimental printmaker working in all mediums, with the exception of relief, producing nearly fifty prints during this period, as well as occasional multiples. Has collaborated with printers all over Europe, seeking out those who are most expert in their medium. Major publishers are Petersburg Press and Waddington Graphics, London.

Biblio.: *Richard Hamilton Prints 1939–83*. Stuttgart: Edition Hansjörg Mayer; Stuttgart: Waddington Graphics, 1984. Introduction by the artist. See also 64, 67, 68, 71, 73, 77–80, 85, 96, 115.

5 Tyres Abandoned from *The Institute of Contemporary Arts Portfolio*. (1963, published 1964). Screenprint, printed in color. Waddington 54.
Interior (initial state). 1964. Screenprint, printed in color. Waddington 56.
My Marilyn. 1966. Screenprint, printed in color. Waddington 59.

The Solomon R. Guggenheim. (1965). Screenprint, printed in color. Waddington 60.
I'm Dreaming of a White Christmas. (1967). Screenprint, printed in color. Waddington 63.
Swingeing London 67—poster. (1968). Photolithograph, printed in color. Waddington 67.
Swingeing London 67—etching. (1968). Etching and aquatint, printed in color. Waddington 68.
A Postal Card—for Mother from the periodical *S. M. S.*, no. 1 (February 1968). New York: The Letter Edged in Black Press, 1968. Photolithograph, printed in color, and fold-out collage. Not in Waddington.
La Scala Milano. (1968). Photoetching and screenprint, printed in color. Waddington 69.
Kent State. (1970). Screenprint, printed in color. Waddington 75.
A Portrait of the Artist by Francis Bacon. (1970–71). Screenprint and collotype, printed in color. Waddington 76.
I'm Dreaming of a Black Christmas. (1971). Screenprint. Waddington 80.
Picasso's Meninas from the portfolio *Hommage à Picasso*, Volume 2. (1973). Etching and soft ground etching, aquatint and lift ground aquatint, engraving, and drypoint. Waddington 88.

David Hockney

Born in Bradford, England in 1937. Lives in Los Angeles. Attracted early attention with his naïve, childlike drawing style of figures in interiors or landscapes. Often incorporated images of graffiti and packaging in early work. In mid-late 1960s made numerous depictions of glamorous Los Angeles lifestyle that were often characterized as Pop in their celebration of contemporary urban life. After two student lithographs in the 1950s, began a prolific printmaking career with a group of etchings in 1961. Completed 174 printed works by 1975, the overwhelming majority in etching, which showcased his facile draftsmanship, but including approximately fifty lithographs. Collaborated with intaglio printer Maurice Payne on two important illustrated books and several single prints of the period. Major publishers have included Editions Alecto, London, for important early works; Tamarind Lithography Workshop, Los Angeles, briefly in 1964; numerous etchings with Petersburg Press, London; and the majority of lithographs with Gemini G.E.L., Los Angeles. Continues to actively pursue printmaking and experiment with new mediums. Has also designed stage sets for several operas as well as numerous posters.

Biblio.: Brighton, Andrew. *David Hockney Prints 1954–77*. London: The Midland Group and the Scottish Arts Council in association with Petersburg Press, 1979. See also nos. 67, 77, 85, 86, 92, 96, 115.

Myself and My Heroes. 1961. Etching and aquatint. Brighton 4.
Kaisarion with All His Beauty. 1961. Etching, aquatint, and soft ground etching, printed in color. Brighton 8.
The Marriage. 1962 (Published 1968). Etching and aquatint. Brighton 14.
The Hypnotist. (1963). Etching and aquatint, printed in color. Brighton 16.
A Rake's Progress by David Hockney. London: Editions Alecto in association with The Royal College of Art, 1963. (Prints executed 1961–63). Illustrated book with sixteen etching, soft ground etching, and aquatints (one with lift ground aquatint), printed in color. Brighton 17–32.
Jungle Boy. 1964. Etching and aquatint, printed in color. Brighton 33.

Jungle Boy. 1964. Etching and aquatint (proof). Brighton 33.
Edward Lear. 1964. Etching and aquatint. Brighton 34.
Pacific Mutual Life. 1964. Lithograph. Brighton 36.
Figure by a Curtain. 1964 (Published 1965). Lithograph, printed in color, with impasto additions. Brighton 37.
Water Pouring into a Swimming Pool, Santa Monica. 1964 (Published 1965). Lithograph, printed in color. Brighton 38.
Cleanliness is Next to Godliness from *The Institute of Contemporary Arts Portfolio*. 1964 (Brighton 1965). Screenprint, printed in color. Brighton 39.
A Hollywood Collection. 1965. Series of six lithographs and two photolithographs (title page and table of contents), printed in color. Brighton 41–46.
Fourteen Poems by C. P. Cavafy. London: Editions Alecto, 1967. (Prints executed 1966). Illustrated book with twelve etchings (eight with aquatint), and supplementary etching and aquatint. Brighton 47–59.
Henry and Christopher in the Chateau Marmont Hotel, Hollywood. 1967. Lithograph, printed in dark gray, with watercolor and felt pen additions. Brighton 60.
Six Fairy Tales by the Brothers Grimm. London: Petersburg Press in association with the Kasmin Gallery, 1970. (Prints executed 1969). Illustrated book with thirty-nine etchings (most with aquatint, lift ground aquatint, soft ground etching, and/or drypoint), and six unbound duplicates. Brighton 70–108.
Panama Hat from the portfolio *Prints for Phoenix House*. 1972. Etching and aquatint. Brighton 127.
Study of Lightning. 1973. Lithograph. Brighton 133.
Celia Smoking. 1973. Lithograph. Brighton 146.
The Student from the portfolio *Hommage à Picasso*, Volume 2. 1973. Aquatint and etching. Brighton 153.

Robert Indiana

Born Robert Clark in New Castle, Indiana in 1928. Lives in Vinalhaven, Maine. Renowned Pop artist recognized for his heraldic images of words and numbers, often with pointed social and political overtones. Made assemblage sculpture of found objects that first placed him in the Pop circle. After working in lithography, intaglio, and relief processes in the early 1950s at the School of The Art Institute of Chicago, restricted himself almost exclusively to screenprint until the mid-1970s and made over ninety prints by 1975. Made first published print for Arturo Schwarz's 1964 book *International Anthology of Contemporary Engraving: The International Avant-Garde; America Discovered*. Publishers included Edition Domberger in Stuttgart, Multiples, Inc., in New York, as well as several museums. Has contributed numerous benefit prints, posters, and banners to various causes. U.S. eight-cent postage stamp with *Love* image printed in 1973.

Biblio.: Sheehan, Susan, Poppy Gandler Orchier, and Catherine Mennenga. *Robert Indiana Prints: A Catalogue Raisonné 1951–1991*. New York: Susan Sheehan Gallery, 1991. With introduction and interview by Orchier. See also nos. 67, 70, 79, 93, 96, 100, 104, 115.

Err, plate 9 from the illustrated book *International Anthology of Contemporary Engraving: The International Avant-Garde. America Discovered*, Volume 5 by Billy Klüver. Milan: Galleria Schwarz, 1964. (Print executed 1963). Photogravure and etching. Sheehan 29.
Plate (page 52) from the illustrated book *1¢ Life* by Walasse Ting. Bern: E. W. Kornfeld, 1964. Lithograph, printed in color. Sheehan 31.

The Four Winds, double-page tailpiece (pages 140, 141) from the illustrated book *1¢ Life* by Walasse Ting. Bern: E. W. Kornfeld, 1964. Lithograph, printed in color. Sheehan 32.

Eternal Hexagon from the portfolio *X + X (Ten Works by Ten Painters)*. (1964). Screenprint, printed in color. Sheehan 33.

Pelvic and Bright, plate 5 from the illustrated book *Stamped Indelibly*. New York: Indianakatz, 1967. Rubber stamp, printed in color. Sheehan 37.

55555, plate 11 (folio 10) from the illustrated book *Stamped Indelibly*. New York: Indianakatz, 1967. Rubber stamp, printed in color. Sheehan 38.

Love. 1967. Screenprint, printed in color. Sheehan 39.

Die Deutsche Liebe (The German Love) from the portfolio *Graphik USA*. 1968. Screenprint, printed in color. Sheehan 42.

Numbers by Robert Creeley. Stuttgart: Edition Domberger; Düsseldorf: Schmela, 1968. Illustrated book with ten screenprints, printed in color. Sheehan 46–55.

American Dream. (1971). Screenprint. Sheehan 61.

Decade. 1971. Portfolio of ten screenprints, printed in color. Sheehan 63–72.

Picasso from the portfolio *America's Hommage à Picasso*. 1974 (Published 1975). Screenprint, printed in color. Sheehan 82.

Liberty '76 from the *Kent Bicentennial Portfolio: Spirit of Independence*. (Published 1975). Screenprint, printed in color. Sheehan 84.

Alain Jacquet

Born in Neuilly, France in 1939. Lives in New York and Paris. Inventive French Pop artist whose work focuses on issues of reproduction and originality, beginning with series of camouflage works in 1962 which layered abstract patterns, commercial logos, and road signs over well-known artworks. In 1964 began making multiple photoscreenprints on canvas with large halftone dot patterns, such as *Le Déjeuner sur l'Herbe* in which he restaged Manet's landmark painting by photographing, enlarging, and printing contemporary figures in a contemporary setting. Active printmaker beginning in mid-1960s through early 1970s, with numerous offsets and screenprints made with commercial printing firms. Worked with Éditions Georges Visat in Paris in 1965 and again in 1969–70, and developed complex intaglio process derived from photoscreenprints. Also experimented with unusual materials, screenprinting on various plastic and embossed paper surfaces. Also published with Galerie Bischofberger in Zurich, Galerie Der Spiegel in Cologne, Galerie Yvon Lambert in Paris, Galerie Bonnier in Geneva, and Documenta Foundation in Kassel. Created cover for *The Paris Review* in 1963 and occasional multiples in mid-1960s, including an inflatable pillow.

Biblio.: Smith, Duncan. *Alain Jacquet*. Paris: Art Press, 1990. See also no. 67.

Three Color Separation from the periodical *S. M. S.*, no. 2 (April 1968). New York: The Letter Edged in Black Press, 1968. Three screenprints, printed in color, on acetate.

Knitting (Tricot). (1969). Screenprint, printed in color.

Portrait de Laure (Portrait of Laure). (1969). Etching and aquatint, printed in color, with embossing.

Jasper Johns

Born in Augusta, Georgia in 1930. Lives in Sharon, Connecticut. Singularly influential artist of the postwar period in American art who overturned prevailing aesthetic concerns to focus on issues of perception through the depiction of commonplace, flat objects such as flags, targets, numbers, and maps in painterly style. Made first print in 1960 with Universal Limited Art Editions (ULAE), West Islip, N. Y., and completed over two hundred by 1975. First known for intricate explorations of properties of lithography. Turned to etching in 1967 at ULAE and further explored it with master printer Aldo Crommelynck in Paris in the mid-1970s. Pioneered use of offset press at ULAE in 1971. Also mastered screenprint in a small but exemplary body of work with printer Hiroshi Kawanishi of Simca Print Artists, New York, in the early 1970s. Collaborated often with Gemini G.E.L., Los Angeles, on several series of technically complex lithographs, as well as lead reliefs, in late 1960s and early 1970s. Has also designed several original posters for museum exhibitions.

Biblio.: *The Prints of Jasper Johns 1960–1993: A Catalogue Raisonné*. West Islip, N. Y.: Universal Limited Art Editions, 1994. Text by Richard S. Field. See also nos. 64, 65, 67, 70, 71, 76, 86, 95, 100, 106, 115, 118.

Target. 1960. Lithograph. ULAE 1.

Coat Hanger I. 1960. Lithograph. ULAE 2.

0 through 9. 1960. Lithograph. ULAE 3.

Flag I. 1960. Lithograph. ULAE 4.

Flag II. 1960. Lithograph, printed in color. ULAE 5.

Flag III. 1960. Lithograph, printed in color. ULAE 7.

Painting with Two Balls I. (1962). Lithograph, printed in color. ULAE 8.

False Start I. 1962. Lithograph, printed in color. ULAE 9.

False Start II. 1962. Lithograph, printed in color. ULAE 10.

Painting with Two Balls II. 1962. Lithograph, printed in color. ULAE 11.

Device. 1962. Lithograph. ULAE 12.

Alphabets. (1962). Lithograph. ULAE S1.

Alphabets (trial proof). 1962. Lithograph. Not in ULAE.

Alphabets (trial proof). 1962. Lithograph. Not in ULAE.

Figure 1. 1963. Lithograph. ULAE 13.

Red, Yellow, Blue. 1963. Lithograph, printed in color. ULAE 14.

Hatteras. 1963. Lithograph. ULAE 15.

Hand. 1963. Lithograph. ULAE 16.

0–9. (1960–63, published 1963). Portfolio of ten lithographs. ULAE 17.

0–9. (1960–63, published 1963). Portfolio of ten lithographs, printed in color. ULAE 18.

0–9. (1960–63, published 1963). Portfolio of ten lithographs, printed in color. ULAE 19.

Ale Cans. 1964. Lithograph, printed in color. ULAE 20.

Working proof for *Ale Cans*. 1964. Lithograph with crayon additions. Not in ULAE.

Working proof for *Ale Cans*. 1964. Lithograph with paint additions. Not in ULAE.

Working proof for *Ale Cans*. 1964. Lithograph, printed in color, with chalk and crayon additions. Not in ULAE.

Working proof for *Ale Cans*. 1964. Lithograph, printed in color, with ink and crayon additions. Not in ULAE.

Working proof for *Ale Cans*. 1964. Lithograph, printed in color, with crayon additions. Not in ULAE.

Skin with O'Hara Poem. 1965. Lithograph. ULAE 21.

Recent Still Life. 1965. Lithograph, printed in color. ULAE 22.

Two Maps I. 1966. Lithograph, printed in color. ULAE 23.

Light Bulb. 1966. Lithograph, printed in color. ULAE 24.

The Critic Smiles. 1966. Lithograph with powdered metal additions. ULAE 25.

Two Maps II. 1966. Lithograph. ULAE 26.

Pinion. 1966. Lithograph, printed in color. ULAE 27.

Ruler. 1966. Lithograph, printed in color. ULAE 28.

Passage I. 1966. Lithograph, printed in color. ULAE 29.

Passage II. 1966. Lithograph, printed in color. ULAE 30.

Voice. 1966–67. Lithograph, printed in color. ULAE 31.

Watchman. 1967. Lithograph, printed in color. ULAE 32.

Numbers. 1967. Lithograph, printed in color. ULAE 33.

0 Through 9. 1967. Lithograph, printed in color. ULAE 34.

Target. 1967. Lithograph, printed in color. ULAE 35.

Light Bulb. 1967. Etching. ULAE 36.

Figure 4. 1967. Etching. ULAE 37.

Target I. 1967. Etching. ULAE 38.

The Critic Sees from the portfolio *Ten from Leo Castelli*. 1967. Screenprint on clear acetate, set into embossed paper and mounted. ULAE 39.

Double-page plate (folios 49 verso and 50) from the book *In Memory of My Feelings* by Frank O'Hara. New York: The Museum of Modern Art, 1967. Photolithograph. Not in ULAE.

Tailpiece (folio 53 verso) from the book *In Memory of My Feelings* by Frank O'Hara. New York: The Museum of Modern Art, 1967. Photolithograph, printed in color. Not in ULAE.

Summer Critic (unbound double-folio plate) from the illustrated book *To and From Rrose Sélavy*. Tokyo: Rrose Sélavy, 1968. (Print executed 1966). Screenprint, printed in color, set into embossed paper. ULAE 40.

Targets. 1968. Lithograph, printed in color, with varnish additions ULAE 41.

Flags. 1968. Lithograph, printed in color. ULAE 42.

1st Etchings. 1967. Portfolio of seven etchings, six with photoengraving. ULAE 43.

Black Numerals. 1968. Series of ten lithographs, printed in color. ULAE 44–53.

White Target. 1968. Lithograph, printed in white. ULAE 54.

Target with Four Faces. 1968. Screenprint, printed in color. ULAE 55.

Gray Alphabets. 1968. Lithograph, printed in color. ULAE 57.

1st Etchings—2nd State. 1967–69. Portfolio of thirteen etchings, some with photoengraving, aquatint, and roulette. ULAE 58.

Color Numerals. 1969. Series of ten lithographs, printed in color. ULAE 59–68.

Alphabet. 1969. Embossing. ULAE 70.

No. 1969. Lithograph, printed in color, with embossing and lead collage. ULAE 71.

Light Bulb. 1969. Lead relief. ULAE 75.

Untitled. 1969. Etching. ULAE 77.

Untitled. 1969. Etching. ULAE 78.

Untitled, second state. 1969. Etching and aquatint, printed in color. ULAE 79.

Untitled, second state. 1969. Etching and aquatint. ULAE 80.

Target II. 1969. Etching and aquatint. ULAE 81.

Souvenir. 1970. Lithograph, printed in color. ULAE 82.

Light Bulb. 1970. Lithograph and rubber stamp, printed in color. ULAE 83.

Scott Fagan Record. 1970. Lithograph, printed in color, with die-cut. ULAE 85.

Flags II. 1970. Lithograph, printed in color. ULAE 86.

Target. (1971). Lithograph and rubber stamp, printed in color, and watercolor pads and paint brush collage. ULAE 89.

Fragment—According To What—Hinged Canvas from the series *Fragments—According To What*. 1971. Lithograph, printed in color. ULAE 93.

Decoy. 1971. Lithograph, printed in color, with die-cut. ULAE 98.

Color separations and proofs for *Decoy*. 1971. Thirty-seven

lithographs, nineteen printed in color. Not in ULAE.

Progressive proofs for *Decoy*. 1971. Nineteen lithographs, printed in color. Not in ULAE.

Untitled. 1971. Lithograph, printed in color. ULAE 100.

Good Time Charley. 1972. Lithograph, printed in color. ULAE 103.

Zone. 1972. Lithograph, printed in color. ULAE 105.

Device. 1972. Lithograph, printed in color. ULAE 107.

Fool's House. 1972. Lithograph, printed in color. ULAE 109.

Souvenir I. 1972. Lithograph, printed in color. ULAE 111.

"M." 1972. Lithograph, printed in color. ULAE 113.

Evian. 1972. Lithograph, printed in color. ULAE 115.

Viola. 1972. Lithograph, printed in color. ULAE 117.

Two Flags (Gray). 1970–72. Lithograph, printed in color. ULAE 120.

Two Flags. 1970–72. Lithograph. ULAE 121.

Cups 4 Picasso. 1972. Lithograph, printed in color. ULAE 122.

Cup 2 Picasso. 1973. Lithograph, printed in color. ULAE 123.

Painting with a Ball. 1972–73. Lithograph. ULAE 124.

Decoy II. 1971–73. Lithograph, printed in color. ULAE 125.

Color separations for *Decoy II*. 1973. Fourteen lithographs, seven printed in color. Not in ULAE.

Target from the portfolio *For Meyer Schapiro*. 1973 (Published 1974). Screenprint, printed in color. ULAE 126.

Sketch from Untitled I from the series *Casts from Untitled*. 1974. Lithograph, printed in color. ULAE 130.

Handfootsockfloor from the series *Casts from Untitled*. 1974. Lithograph, printed in color. ULAE 134.

Handfootsockfloor (Black State) from the series *Casts from Untitled*. 1974. Lithograph. ULAE 135.

M.D. from the portfolio *Merce Cunningham*. 1974 (Published 1975). Die-cut. ULAE 148.

Four Panels from Untitled 1972. (1973–74). Lithograph, printed in color, with embossing, on four sheets. ULAE 149.

Four Panels from Untitled 1972 (Grays and Black). 1973–75. Lithograph, printed in color, with embossing, on four sheets. ULAE 150.

Allen Jones

Born in Southampton, England in 1937. Lives in London. Member of the younger generation of Royal College of Art students which included Boshier, Hockney, and Phillips. Developed his mature Pop style while living in New York in 1964–65. Became known for his *Bus* images on shaped canvases in the early 1960s, but gained most notoriety for his fetishistic images of women in provocative poses and outfits, in particular, black stiletto shoes. Made several lithographs while teaching lithography in early 1960s. First professionally published prints appeared in 1964 with Editions Alecto, London, which remained his most important publisher throughout the 1960s. Completed seventy prints by 1975, nearly all lithographs with a few additional screenprint projects. Also worked occasionally with Petersburg Press and Marlborough Graphics, London, during this period. Made two important series at Tamarind Lithography Workshop, Los Angeles, in 1965. Primarily worked with printer E. Matthieu in Zurich. Produced billboard *Legs* for Welsh Art Council in 1967. Designed a lamp for commercial production and costumes for *O Calcutta!* in London in 1970, as well as several posters, magazine covers, and exhibition announcements.

Biblio.: Lloyd, Richard. *Allen Jones Prints*. Munich and New York: Prestel-Verlag, 1995. Introduction by Marco Livingstone. See also nos. 67, 77, 80, 85, 92, 100, 115.

Red and Green Baby. 1962. Lithograph, printed in color. Lloyd 15.

Fast Car. 1962. Lithograph, printed in color. Lloyd 16.

Concerning Marriages 1. 1964. Lithograph, printed in color. Lloyd 24a.

Concerning Marriages 4. 1964. Lithograph, printed in color. Lloyd 24d.

Concerning Marriages 5. 1964. Lithograph, printed in color. Lloyd 24e.

Poster. 1964. Screenprint and photolithograph, printed in color. Lloyd 26.

Dream T-Shirt from *The Institute of Contemporary Arts Portfolio*. 1964. Screenprint, printed in color. Lloyd 27.

Self from the portfolio *New York International*. 1965 (Published 1966). Screenprint, printed in color. Lloyd 28.

Miss America from the portfolio *11 Pop Artists*, Volume I. 1965 (Published 1966). Lithograph, printed in color. Lloyd 29.

Pour les Lèvres from the portfolio *11 Pop Artists*, Volume II. 1965 (Published 1966). Screenprint, printed in color. Lloyd 30.

Janet Is Wearing. . . from the portfolio *11 Pop Artists*, Volume III. 1965 (Published 1966). Lithograph. Lloyd 31.

Daisy, Daisy. 1965. Lithograph. Lloyd 34.

Man Woman. 1965. Lithograph. Lloyd 35.

A New Perspective on Floors. 1966. Series of six lithographs, printed in color. Lloyd 36a–f.

A Fleet of Buses. 1966. Series of five lithographs, printed in color. Lloyd 37a–e.

Large Bus. 1966. Lithograph, printed in color. Lloyd 38a–b.

Subtle Siren. 1966. Lithograph. Lloyd 39.

Plate 8 (folio 7) from the illustrated book *Stamped Indelibly*. New York: Indianakatz, 1967. Rubber stamp, printed in color. Lloyd 43.

French Cooking from the portfolio *Hommage à Picasso*, Volume 4. 1973. Screenprint and stencil, printed in color. Lloyd 66.

Gerald Laing

Born in Newcastle-upon-Tyne in 1936. Lives in Scotland and New York. His Pop paintings of 1962–65 were composed from painted simulations of half-tone dots and flat color areas. Focused on images of race cars and bikini-clad women before he moved into an increasingly abstract style. Made first prints in Los Angeles at Tamarind Lithography Workshop in 1965, where he worked again in 1971. Participated in Original Editions's portfolios *11 Pop Artists* in 1966. Other prints of this period are screenprints printed and published by the artist. Completed an illustrated book with Edition Domberger in Stuttgart in 1969. Printed ephemera includes paper plates made for Bert Stern's multiples store, On 1st, and a poster for City Center Light Opera, New York. Also made two important multiples, one of which, *Hybrid*, was a collaborative project with Peter Phillips that involved conducting public interviews to develop a prototype of ideal artwork. A limited edition of small replicas was constructed.

Biblio.: *Gerald Laing 1963–1993: A Retrospective*. Edinburgh: The Fruitmarket Gallery, 1993. Texts by Ian Carr and David Alan Mellor. Interview with the artist by Giles Auty. See also no. 67.

Pile. 1965. Lithograph, printed in color.

Compact from the portfolio *11 Pop Artists*, Volume I. 1965 (Published 1966). Screenprint, printed in color, and silver paper collage.

Slide from the portfolio *11 Pop Artists*, Volume II. 1965 (Published 1966). Screenprint, printed in color, and silver paper collage.

Triple from the portfolio *11 Pop Artists*, Volume III. 1965

(Published 1966). Screenprint, printed in color.

Baby Baby Wild Things. 1968. Portfolio of six screenprints, printed in color.

Dragsters. 1968. Portfolio of five screenprints, printed in color.

Parachutes. 1968. Portfolio of seven screenprints (including title page), printed in color.

Witness by Gerald Laing. 1968. Illustrated book with ten screenprints, printed in color, and collage.

DMT 42 by G. V. Golikova. Stuttgart: Edition Domberger, 1969. Illustrated book with twenty-six screenprints (including title page, wrapper front, and duplicate of wrapper front on slipcase), printed in color.

Roy Lichtenstein

Born in New York in 1923. Died in New York in 1997. Established vocabulary of Pop art movement with paintings of comic strip imagery in bold, primary colors and simplified forms. Developed motif of benday dot pattern that emulated mechanical reproduction and gave uniform flatness to his manipulations of stylistic stereotypes of modern art. Prolific and experimental printmaker, beginning in graduate school in late 1940s. Often printed on unorthodox materials such as acetate and textured plastics. First published print was an etching in 1962 for Arturo Schwarz's book *International Anthology of Contemporary Engraving: The International Avant-Garde; America Discovered*, and he went on to complete over 135 prints through 1975. Worked in all mediums, focusing on screenprint in 1960s. Began working actively in lithography in 1969 with Gemini G.E.L. in Los Angeles, which remained his most important publisher. Other publishers included Gabriele Mazzotta Editore in Milan, Leo Castelli Gallery, and Multiples, Inc., in New York. Also completed numerous multiples including felt banners, an enamel plaque, and ceramic dishes, as well as printed ephemera such as wrapping paper, wallpaper, paper plates, and several posters and magazine covers.

Biblio.: Corlett, Mary Lee. *The Prints of Roy Lichtenstein: A Catalogue Raisonné, 1948–1993*. New York and Washington: Hudson Hills Press in association with the National Gallery of Art, 1994. Introduction by Ruth E. Fine. See also nos. 67, 70, 76, 86, 96, 106, 115.

Castelli Handshake Poster. (1962). Photolithograph, printed in color. Corlett App. 1.

On, plate 11 from the illustrated book *International Anthology of Contemporary Engraving: The International Avant Garde. America Discovered*, Volume 5 by Billy Klüver. Milan: Galleria Schwarz, 1964. (Print executed 1962). Etching. Corlett 32.

Girl, double-page headpiece (pages 118 and 119) from the illustrated book *1¢ Life* by Walasse Ting. Bern: E. W. Kornfeld, 1964. (Print executed 1963). Lithograph, printed in color. Corlett 33.

Foot Medication. (1963). Photolithograph. Corlett App. 3.

Crak. 1963–64. Photolithograph, printed in color. Corlett II.2.

Temple. 1964. Photolithograph, printed in color. Corlett II.3.

Temple. 1964. Folded photolithographed announcement, printed in color. Corlett II.3.

Foot and Hand. 1964. Photolithograph, printed in color. Corlett II.4.

Sandwich and Soda from the portfolio *X + X (Ten Works by Ten Painters)*. (1964). Screenprint, printed in color, on clear plastic. Corlett 35.

Turkey Shopping Bag. (1964). Screenprint, printed in color, on shopping bag with handles. Corlett App. 4.

Seascape I from the portfolio *New York 10*. 1964 (Published 1965). Screenprint, printed in color. Corlett 36.

Brushstroke. (1965). Screenprint, printed in color. Corlett II.5.

Moonscape from the portfolio *11 Pop Artists*, Volume I. 1965 (Published 1966). Screenprint, printed in color. Corlett 37.

Reverie from the portfolio *11 Pop Artists*, Volume II. 1965 (Published 1966). Screenprint, printed in color. Corlett 38.

Sweet Dreams, Baby! from the portfolio *11 Pop Artists*, Volume III. 1965 (Published 1966). Screenprint, printed in color. Corlett 39.

Sunrise from the multiples portfolio *7 Objects in a Box.* (1965, published 1966). Enamel on steel. Not in Corlett.

Dishes. (1966). Six-piece setting of glazed ceramics. Not in Corlett.

Modern Art Poster. (1967). Screenprint, printed in color. Corlett II.8.

Brushstrokes. (1967). Screenprint, printed in color. Corlett 45.

Plate (folio 23 verso) from the book *In Memory of My Feelings* by Frank O'Hara. New York: The Museum of Modern Art, 1967. Photolithograph. Corlett 47.

Tailpiece (folio 25 verso) from the book *In Memory of My Feelings* by Frank O'Hara. New York: The Museum of Modern Art, 1967. Photolithograph. Corlett 48.

Explosion from the portfolio *9.* 1967. Lithograph, printed in color. Corlett 49.

Fish and Sky from the portfolio *Ten from Leo Castelli.* (1967). Screenprint, printed in color, over two photographs. Corlett 50.

Ten Landscapes. 1967. Portfolio of nine screenprints, eight printed in color, some with photographs, some on Rowlux, and one collage. Corlett 51–60.

Salute to Aviation. 1968. Screenprint, printed in color. Corlett 63.

Folded Hat from the periodical *S. M. S.*, no. 4 (August 1968). New York: The Letter Edged in Black Press, 1968. Photolithograph, printed in color. Corlett III.9.

Wrapping Paper. (1968). Screenprint, printed in color. Corlett III.44.

Still Life from the portfolio *The Metropolitan Scene.* 1968. Screenprint, printed in color. Corlett 64.

Haystack #7 from the *Haystack Series.* 1969. Relief print. Corlett 74.

Cathedral Series. 1969. Series of five lithographs and one screenprint and lithograph, printed in color. Corlett 75–80.

Modern Head #3 from the Modern Head Series. 1970. Line-cut with embossing. Corlett 93.

Peace Through Chemistry I. 1970. Lithograph and screenprint, printed in color. Corlett 96.

Modern Print. 1971. Lithograph and screenprint, printed in color. Corlett 103.

The Adventures of Mao on The Long March by Frederic Tuten. New York: The Citadel Press, 1971. Illustrated book with one lithograph (unbound plate), printed in color, and two photolithographic reproductions (covers). Corlett 104.

Mirror #8 from the *Mirror Series.* 1972. Lithograph and screenprint, printed in color. Corlett 113.

Bull Profile Series. 1973. Series of six line blocks, some with screenprint and lithograph, printed in color. Corlett 116–21.

Finger Pointing from the portfolio *The New York Collection for Stockholm.* 1973. Screenprint, printed in color. Corlett 126.

Still Life with Picasso from the portfolio *Hommage à Picasso*, Volume 4. 1973. Screenprint, printed in color. Corlett 127.

Untitled (*Still Life with Lemon and Glass*) from the portfolio *For Meyer Shapiro.* 1974. Lithograph, screenprint, and embossing, printed in color. Corlett 134.

Bicentennial Print from the portfolio *America: The Third Century.* 1976. Lithograph and screenprint, printed in color. Corlett 136.

Marisol (Marisol Escobar)

Born in Paris to Venezuelan parents in 1930. Lives in New York. Pop sculptor who became known for her assemblage and painted wooden figurative constructions, often depicting popular subjects from Hollywood movies to political leaders, such as Lyndon B. Johnson, Mao Tse-Tung, and the Kennedy family. Referred frequently to social and political issues. Also made numerous self-portraits, or more accurately, various figures on which she placed a cast of her own face. Began printmaking in 1961 with three self-published photolithographs. In 1964 began working at Universal Limited Art Editions (ULAE), West Islip, N. Y., and worked mostly in lithography. Images often focused on hands, feet, and faces. After year in Asia, returned to ULAE in 1970 and began making etchings. Worked primarily in black and white, completing over twenty-five prints, most with ULAE, before 1975. Also made a multiple screenprint on silk, as well as occasional posters and magazine covers, most notably a screenprint for the cover of *The Paris Review* in 1969.

Biblio.: *Marisol: Prints 1961–1973.* New York: New York Cultural Center in association with Fairleigh Dickinson University, 1973. Text by John Loring.
See also nos. 67, 95, 115.

Furshoe. 1964. Lithograph. Loring 4.

Shoe and Hand. 1964. Lithograph. Loring 5.

Pappagallo. 1965. Lithograph, printed in color. Loring 6.

Hand and Purse. 1965. Lithograph. Loring 8.

The Kiss. 1965. Lithograph, printed in color. Loring 9.

Double-page plate (folios 15 verso and 16) from the book *In Memory of My Feelings* by Frank O'Hara. New York: The Museum of Modern Art, 1967. Photolithograph, printed in color. Not in Loring.

Hand and Flower, plate 4 (folio 4 verso) from the illustrated book *Stamped Indelibly.* New York: Indianakatz, 1967. Rubber stamp, printed in color. Loring 11.

French Curve. 1970. Etching, printed in color. Loring 13.

Pnom Penh, One. 1970. Etching. Loring 14.

Pnom Penh, Two. 1970. Etching. Loring 15.

Kalimpong 1. 1970. Etching, printed in color. Loring 16.

Kalimpong 2. 1970. Etching. Loring 17.

Five Hands and One Finger. 1971. Lithograph. Loring 18.

Diptych. 1971. Lithograph, printed in color. Loring 19.

The Death of Head and Leg. (1969–73, dated 1973). Etching. Loring 21.

The Spoon. (1970–73, dated 1973). Etching and aquatint, printed in color. Loring 22.

Self-Portrait. (1970–73, dated 1973). Etching. Loring 23.

Catalpa Maiden About to Touch Herself. 1973. Lithograph, printed in color. Loring 24.

Hand in Leaf. 1973. Lithograph. Loring 25.

I Hate You. 1973. Etching. Loring 28.

Forest. 1973. Lithograph: Loring 29.

Cultural Head. 1973. Lithograph, printed in color. Loring 32.

Women's Equality from the *Kent Bicentennial Portfolio: Spirit of Independence.* 1975. Lithograph, printed in color. Not in Loring.

Claes Oldenburg

Born in 1929 in Stockholm. Moved to Chicago in 1936. Lives in New York. Leading Pop sculptor and seminal figure in development of Happenings, along with Jim Dine and Allan Kaprow. Focused on everyday images such as food, clothing, and household products in oversize sculptures, often made of soft materials. Also became known for colossal site-specific outdoor projects. Became prolific printmaker interested in issues of reproduction and mass circulation. Made first editioned print in 1960, the photolithographic poster *New Forms—New Media* for Martha Jackson Gallery exhibition, and completed over 135 printed works through 1975. Worked primarily in lithography but also made numerous printed ephemeral works, such as posters and exhibition announcements. Collaborated with numerous workshops including Gemini G.E.L., Los Angeles; Tanglewood Press, Multiples, Inc., New York; Petersburg Press, London; and Landfall Press, Chicago. Was also instrumental in development of multiples, making his first published example, *Baked Potato*, in 1966 for the multiples portfolio *7 Objects in a Box*, and completing sixteen during this period. Has also written extensively on art, including an artist's book *Store Days*, published in 1967.

Biblio.: Axsom, Richard H., and David Platzker. *Printed Stuff: Prints, Posters, and Ephemera by Claes Oldenburg: A Catalogue Raisonné 1958–1996.* New York and Madison, Wis.: Hudson Hills Press in association with Madison Art Center, 1997–98.
Platzker, David. *Claes Oldenburg Multiples in Retrospect 1964–1990.* New York: Rizzoli International Publications, 1991. Texts by Claes Oldenburg, Thomas Lawson, and Arthur Solway.
See also nos. 64, 65, 67, 70, 76, 93, 95, 96, 106, 114, 115.

New Media—New Forms in Painting and Sculpture. 1960. Photolithograph. Axsom & Platzker 8.

Orpheum Sign, plate 13 from the illustrated book *International Anthology Of Contemporary Engraving: The International Avant-Garde. America Discovered*, Volume 5 by Billy Klüver. Milan: Galleria Schwarz, 1964. (Print executed 1962). Etching and aquatint. A & P 14.1.

Store Poster. 1961. Lithograph with watercolor additions. A & P 16.

Table Top with Objects. 1961. Lithograph. A & P 17.

Double-page headpiece (pages 136–37) from the illustrated book *1¢ Life* by Walasse Ting. Bern: E. W. Kornfeld, 1964. Lithograph, printed in color. A & P 28.1–2.

Double-page plate (pages 172–73) from the illustrated book *1¢ Life* by Walasse Ting. Bern: E. W. Kornfeld, 1964. Lithograph, printed in color. A & P 28.3.

Flying Pizza from the portfolio *New York 10.* (1964, published 1965). Lithograph, printed in color. A & P 33.

Flying Pizza for the portfolio *New York 10.* (1964). Lithograph, printed in color. A & P 33.1.

Teabag from the series *Four on Plexiglas.* (1965, published 1966). Screenprint, printed in color on felt, clear plexiglass, and white plastic, with felt bag and rayon cord encased on laminated plexiglass. A & P 36.

Baked Potato from the multiples portfolio *7 Objects in a Box.* (1966). Cast resin with acrylic paint and porcelain plate. Platzker 3.

Double-page plate (folios 77 verso and 78) from the book *In Memory of My Feelings* by Frank O'Hara. New York: The Museum of Modern Art, 1967. Photolithograph, printed in color. A & P 41.

Plate 12 (folio 10 verso) from the illustrated book *Stamped Indelibly.* New York: Indianakatz, 1967. Rubber stamp, printed in color. A & P 46.

Boom, plate 13 (folio 11) from the book *Stamped Indelibly.* New York: Indianakatz, 1967. Rubber stamp, printed in color. A & P 46.

Scissors as Monument from the portfolio *National Collection of Fine Arts.* (1967, published 1968). Lithograph, printed in color. A & P 49.

Scissors to Cut Out from the portfolio *National Collection of Fine Arts*. (1967, published 1968). Lithograph, printed in color. A & P 50.

London Knees 1966. (Published 1968). Multiple of polyurethaned latex "knees," acrylic base, and twelve photolithographs in various formats. A & P 51.

Nose Handkerchief. 1968. Screenprint on fabric. A & P 53.

Notes by Claes Oldenburg. Los Angeles: Gemini G.E.L., 1968. Illustrated book with twelve lithograph and photolithographs, printed in color (four with embossing and / or varnish additions). A & P 55.

Unattendable Lunches from the periodical *S. M. S.*, no. 6 (December 1968). New York: The Letter Edged in Black Press, 1968. Booklet of photolithographic reproductions of letters, one in envelope. A & P 56.

Profile Airflow (experimental proof). 1968. Molded polyurethane relief over lithograph, printed in color. Not in A & P or Platzker.

Profile Airflow. 1969. Molded polyurethane relief over lithograph, printed in color. A & P 59.

Lipstick (Ascending) on Caterpillar Track. (1969). Double-sided photolithograph. Not in A & P. or Platzker.

Double-Nose / Purse / Punching Bag / Ashtray. 1969 (Published 1970). Bronze and leather object in wood box, with leather covered booklet. Platzker 13.

The Letter Q as Beach House, with Sailboat. (1972). Lithograph, printed in color. A & P 96.

M. Mouse (With) 1 Ear (Equals) Tea Bag Blackboard Version from the portfolio *The New York Collection for Stockholm.* (1965, published 1973). Screenprint, printed in color. A & P 109.

The Office. A Typewriter Print, unbound folded plate from *Raw Notes* by Claes Oldenburg. Halifax: The Press of the Nova Scotia College of Art and Design, 1973. (Print executed 1974). Lithograph, printed in color. A & P 116.

Picasso Cufflink from the portfolio *America's Hommage à Picasso.* 1974 (Published 1975). Lithograph, printed in color. A & P 113.

Three Hats from the portfolio *For Meyer Schapiro.* (1974). Lithograph, printed in color. A & P 115.

Landscape with Noses. 1975. Etching and aquatint, printed in color. A & P 126.

Smoke and Reflections. 1975. Aquatint, printed in color. A & P 127.

Tea Pot. 1975. Lithograph. A & P 129.

Bat Spinning at the Speed of Light (state II). (1975). Lithograph, printed in color. A & P 133.

Eduardo Paolozzi

Born in Edinburgh in 1924. Lives in London. Known primarily as a sculptor, became seminal figure in the development of Pop ideology. In 1952 launched International Group based at London's Institute of Contemporary Arts, along with Lawrence Alloway, Reyner Banham, and Alison and Peter Smithson. Obsessively collected vast quantities of printed ephemera, including images from science fiction and American popular magazines, and introduced British artists to such commercial imagery. Published first print in 1950 and also began experimenting with screenprint, incorporating printed elements into his collages. Revolutionized the medium with Chris Prater of Kelpra Studio in London beginning in 1962, creating numerous photomechanical screenprints from collages of found printed material. Completed nearly two hundred prints through 1975, in etching, lithography, woodcut, and screenprint, including four illustrated books. Also printed frequently with Chris Betambeau of Advanced Graphics in London. Published extensively with Editions Alecto and also collaborated with Petersburg

Press, Marlborough Graphics, and Bernard Jacobson, London. Designed wallpaper, fabrics, and ceramics, and made original magazine cover for *Studio International* as well as several posters.

Biblio.: Miles, Rosemary. *The Complete Prints of Eduardo Paolozzi: Prints, Drawings, Collages 1944–77.* London: The Victoria & Albert Museum, 1977. See also nos. 67, 77.

Plate 11 from the illustrated book *International Anthology of Contemporary Engraving: The International Avant-Garde*, Volume 3 by Franco Russoli. Milan: Galleria Schwarz, 1962. Etching. Not in Miles.

Metafisikal Translations by E. L. Paolozzi. London: the artist, 1962. Illustrated book with thirty screenprints. Miles 13.

Four Images from Film. (1962). Screenprint, printed in color. Miles 14.

Conjectures to Identity. (1963). Screenprint, printed in color. Miles 18.

As Is When by Eduardo Paolozzi. London: Editions Alecto, 1965. Illustrated book with thirteen screenprints, printed in color. Miles 23–35.

Moonstrips Empire News by Eduardo Paolozzi. London: Editions Alecto, 1967. Illustrated book with 101 screenprints, seventy-eight printed in color. Miles 37.

General Dynamic F. U. N.: Volume II of Moonstrips Empire News. 1965–70 (Published 1970). Portfolio of thirty-two photolithographs, fourteen screenprints, and four mixed media prints, printed in color. Miles 54.

The Conditional Probability Machine by Diane Kirkpatrick. London: Editions Alecto, 1970. Illustrated book with twenty-five photogravures and one cancelled copper plate. Miles 63–86.

Hommage to Picasso from the portfolio *Hommage à Picasso*, Volume 1. (1973). Lithograph, printed in color. Miles 160.

Peter Phillips

Born in Birmingham, England in 1939. Lives in Mallorca, Spain. Member of the second generation of British Pop artists, many of whom came out of London's Royal College of Art, including Boshier, Caulfield, Hockney, and Jones. Work characterized by fragmented collage format of images such as pin-ball machines, game boards, and pin-up models. Made first print in 1964 for *The Institute of Contemporary Arts Portfolio.* Continued to work almost exclusively in screenprint, often incorporating photographic elements, which paralleled the effects of his airbrushed, glossy paintings. Completed approximately thirty prints in this period. In 1965–66, collaborated with Laing on *Hybrid*, a multiples project involving public interviews to develop prototype of ideal artwork. Major publishers are Waddington Graphics, London, and Edition Bischofberger in Zurich. Has worked primarily with printers at Kelpra Studio in London and Lichtdruck AG in Zurich.

Biblio.: *retroVision: Peter Phillips Paintings 1960–1982.* Liverpool: Walker Art Gallery, 1982. Text by Marco Livingstone. See also nos. 67, 77.

Custom Print #1. 1965. Lithograph.

Custom Print I from the portfolio *11 Pop Artists*, Volume I. 1965 (Published 1966). Screenprint, printed in color.

Custom Print II from the portfolio *11 Pop Artists*, Volume II. 1965 (Published 1966). Screenprint, printed in color.

Custom Print III from the portfolio *11 Pop Artists*, Volume III. 1965 (Published 1966). Screenprint, printed in color.

Sigmar Polke

Born in Oels, Germany in 1941. Lives in Cologne. Seminal figure in postwar European art who, in 1963, co-founded, with Gerhard Richter and Konrad Lueg, Capitalist Realism, known for its emphasis on Germany's commodity culture and media-saturated society. Like his American counterparts, embraced mediated imagery in his ironic, often cryptic art. Simulated photographic effects in his handmade paintings, but turned to photographic techniques for his prints in 1967. Made prints sporadically during this period, often in large editions, almost all using photolithography and inexpensive papers to resemble effects of commercial media. Paralleling earlier paintings, experimented with preprinted papers and textures overprinted with photographic imagery in early to mid-1970s. Also made posters and several original inserts for books, catalogues, and periodicals. Collaborated primarily with publishers Edition René Block in Berlin, Edition Griffelkunst in Hamburg, and Edition Staeck in Heidelberg, as well as numerous museum publishing ventures.

Biblio.: Block, René. *Grafik des Kapitalistischen Realismus.* Berlin: Edition René Block, 1971.

———. *K.P. Brehmer, K.H. Hödicke, Sigmar Polke, Gerhard Richter, Wolf Vostell: Werkverzeichnisse der Druckgrafik. Band II. September 1971 bis Mai 1976.* Berlin: Edition René Block, 1976.

Polke, Sigmar, and Achim Duchow. *Mu Nieltnam Netorruprup.* Kiel: Kunsthalle and Schleswig-Holsteinischer Kunstverein, 1975. Text by Eberhard Freitag. See also nos. 64, 67, 96.

Freundinnen (Girlfriends). 1967. Photolithograph. Kiel 1.

Wochenendhaus (Weekend House) from the portfolio *Grafik des Kapitalistischen Realismus* (Graphics of Capitalist Realism). 1967. Screenprint, printed in color. Kiel 2.

... Höhere Wesen Befehlen (... Higher Beings Command). 1968. Portfolio of fourteen photolithographs. Kiel 4a–n.

Selbstbildnis (Self-Portrait), fourth supplementary plate from the book *Grafik des Kapitalistischen Realismus* (Graphics of Capitalist Realism). Berlin: Edition René Block, 1971. Photolithograph with varnish additions. Kiel 7.

Fernsehbild (Kicker) (Television Picture [Kicker]). 1971. Photolithograph. Kiel 8c.

Weekend I from the portfolio *Weekend.* 1971 (Published 1972). Photolithograph. Kiel 11.

Weekend II from the portfolio *Weekend.* 1971 (Published 1972). Photolithograph, printed in color. Kiel 12.

Weekend III from the portfolio *Weekend.* 1972. Photolithograph, printed in color. Kiel 13.

Kölner Bettler I–IV (Cologne Beggars I–IV). (1972). Series of four photolithographs. Kiel 15–18.

Fernsehbild Eishockey (Rauwolfiaalkaloide) (Television Picture, Ice Hockey [Rauwolfiaalkaloide]). (1973). Photolithograph. Kiel 19.

Obelisk (Hieroglyphen) (Obelisk [Hieroglyphs]). (1973). Photolithograph, printed in color. Kiel 20.

Hände (Die Vermittlung zwischen dem oberren und dem unteren) (Hands [the adjustment between the upper and the lower]). 1973. Photolithograph. Kiel 21a.

Hauserfront (Wer hier nichts erkennen kann, muß selber pendeln) (Housefronts [He Who Cannot Recognize This, Must Swing Himself To and Fro]). (1973). Photolithograph, printed in color. Kiel 22.

In der Oper (At the Opera). (1973) Photolithograph on flocked paper. Kiel 23.

Figur mit Hand (Es schwindelt) (Figure with Hand [Is Swindling]). (1973) Photolithograph on imitation lizard skin paper. Kiel 24a.

Hallo Shiva. . . (Hello Shiva. . .). (1974). Photolithograph, printed in color. Kiel 29.

Mu Nieltnam Netorruprup. (1975). Photolithograph, printed in color. Kiel 31.

Mel Ramos

Born in Sacramento, California in 1935. Lives in Oakland, California. His depictions of comic-strip heroes, notably Batman, in garish colors against solid backgrounds brought him into the orbit of California Pop. By 1965 had developed theme of pin-up nudes taken from magazines, juxtaposed with brand-name consumer products. Self-published several screenprints and lithographs with Wayne Thiebaud in late 1950s and early 1960s at the California State Fair in Sacramento and at the San Jose State College workshop. First professionally published print was in the illustrated book *1¢ Life* by Walasse Ting in 1964. Continued to work in lithography and screenprint with publishers Tanglewood Press in New York, Collectors Press in San Francisco, Graphicstudio in Tampa, Edition Bischofberger in Zurich, and Tony Mathews in London. Also collaborated with printers at Mourlot's Bank Street workshop in New York and Lichtdruck AG in Zurich.

Biblio.: Obler, Geri, and Heiner Schepers. *Mel Ramos: The Prints*. Vienna: Edition Ernst Hilger, 1998. See also no. 67.

Señorita Rio, double-page plate (pages 152 and 153) from the illustrated book *1¢ Life* by Walasse Ting. Bern: E. W. Kornfeld, 1964. Lithograph, printed in color.

Plate (page 159) from the illustrated book *1¢ Life* by Walasse Ting. Bern: E. W. Kornfeld, 1964. (Plate dated 1963). Lithograph, printed in color.

Chic from the portfolio *11 Pop Artists*, Volume I. 1965 (Published 1966). Screenprint, printed in color.

Tobacco Rose from the portfolio *11 Pop Artists*, Volume II. 1965 (Published 1966). Screenprint, printed in color.

Miss Comfort Creme from the portfolio *11 Pop Artists*, Volume III. 1965 (Published 1966). Screenprint, printed in color.

Candy from the periodical *S. M. S.*, no. 5 (October 1968). New York: The Letter Edged in Black Press, 1968. Photolithograph, printed in color.

Rhinoceros. 1970. Lithograph, printed in color.

Bernard Rancillac

Born in Paris in 1931. Lives in Malakoff, France. Emerged in 1963 as a painter of surrealistic Disney comic characters. Helped to establish the French movement known as Nouvelle Figuration, with critic Gérald Gassiot-Talabot, inspired in part by the Pop paintings of expatriate American painter Peter Saul. By 1966 abandoned comic style in favor of photographically derived graphic compositions based on areas of social and political conflict around the world, including Vietnam, Cuba, Communist China, and the Middle East. Studied printmaking at Stanley William Hayter's Paris workshop, Atelier 17, from 1959 to 1962. Made lithographs in mid-1960s. Became active in screenprint, in particular, in the late 1960s and early 1970s. Also experimented with screenprint on plexiglass. Made numerous protest posters with striking students at L'Atelier Populaire at the École des Beaux Arts, Paris, in May 1968. Published with several galleries in Paris, most often Mathias Fels.

Biblio.: Fauchereau, Serge. *Bernard Rancillac*. Paris: Cercle d'Art, 1991.

Dr. Barnard. (1969). Screenprint, printed in color.

Robert Rauschenberg

Born in Port Arthur, Texas in 1925. Lives in Captiva, Florida. Pioneered the use of everyday objects and printed media sources in postwar art, creating first "combine" assemblage in 1954. Collaborated on numerous innovative performance, dance, and theater projects, designing sets and costumes for choreographers Merce Cunningham and Paul Taylor, among others. Experimented with photographs, reduction woodcuts, transfer rubbings, and photograms at Black Mountain College, North Carolina, in late 1940s and early 1950s. Completed hundreds of prints and multiples from 1960 to 1975. Began vital and prolific printmaking career in 1962 with lithography at Universal Limited Art Editions, West Islip, N.Y., and also began screenprinting on canvas that year. Mastered numerous photographic-based techniques in his appropriation of media imagery. Co-founded E.A.T. (Experiments in Art and Technology) in 1966 to promote collaborations between artists and engineers. Began working extensively in 1967 with Gemini G.E.L., Los Angeles, and Styria Studio, New York, in 1970. Founded own workshop, Untitled Press, Inc., in 1971 in Captiva, and began collaborating with Graphicstudio in 1972 at the University of South Florida, Tampa. Broadened the physical capabilities of printed art by translating his experimental use of materials into editions that incorporated fabric, handmade paper, cardboard, clay, and collage, among other materials. Politically active throughout his career, releasing numerous benefit prints and posters for various organizations and causes.

Biblio.: Foster, Edward A. *Robert Rauschenberg: Prints 1948/1970*. Minneapolis: Institute of Arts, 1970. See also nos. 64, 65, 67, 70, 76, 86, 95, 96, 104, 106, 115.

Abby's Bird. 1962. Lithograph, printed in color. Foster 4.

Merger. 1962. Lithograph. Foster 5.

Urban. 1962. Lithograph. Foster 6.

Suburban. 1962. Lithograph. Foster 7.

License. 1962. Lithograph, printed in color. Foster 8.

Stunt Man I. 1962. Lithograph, printed in color. Foster 9.

Stunt Man II. 1962. Lithograph, printed in color. Foster 10.

Stunt Man III. 1962. Lithograph, printed in color. Foster 11.

Accident. 1963. Lithograph, printed in color. Foster 12.

Rival. 1963. Lithograph. Foster 13.

Untitled. 1963. Photolithograph, printed in color. Not in Foster.

Plank from the book *XXXIV Drawings for Dante's Inferno*. 1964. Lithograph. Foster 15.

Mark from the book *XXXIV Drawings for Dante's Inferno*. 1964. Lithograph. Foster 16.

Sink from the book *XXXIV Drawings for Dante's Inferno*. 1964. Lithograph. Foster 17.

Ark from the book *XXXIV Drawings for Dante's Inferno*. 1964. Lithograph. Foster 18.

Kar from the book *XXXIV Drawings for Dante's Inferno*. 1964. Lithograph. Foster 19.

Rank from the book *XXXIV Drawings for Dante's Inferno*. 1964. Lithograph. Foster 20.

Prize from the book *XXXIV Drawings for Dante's Inferno*. 1964. Lithograph. Foster 21.

Shades. 1964. Multiple of six lithographs on plexiglass panels, aluminum frame, and flashing light bulb. Foster 22.

Kip-Up. 1964. Lithograph. Foster 23.

Spot. 1964. Lithograph. Foster 24.

Front Roll. 1964. Lithograph, printed in color. Foster 25.

Breakthrough I. 1964. Lithograph. Foster 26.

Double-page plate (pages 114 and 115) from the illustrated book

1¢ Life by Walasse Ting. Bern, Switzerland: E.W. Kornfeld, 1964. Lithograph, printed in color.

Breakthrough II. 1965. Lithograph, printed in color. Foster 27.

Post Rally. 1965. Lithograph. Foster 28.

Visitation I. 1965. Lithograph, printed in color. Foster 29.

Visitation II. 1965. Lithograph. Foster 30.

Lawn. 1965. Lithograph, printed in color. Foster 31.

Homage to Frederick Kiesler. 1966. Lithograph, printed in color. Foster 38.

Passport from the portfolio *Ten from Leo Castelli*. 1967. Screenprint, printed in color. Foster 39.

Test Stone #1 (Marilyn Monroe) from the series *Booster and 7 Studies*. 1967. Lithograph. Foster 40.

Test Stone #2 (Lindbergh) from the series *Booster and 7 Studies*. 1967. Lithograph. Foster 41.

Test Stone #3 (Red with Dante Man) from the series *Booster and 7 Studies*. 1967. Lithograph, printed in color. Foster 42.

Test Stone #4 from the series *Booster and 7 Studies*. 1967. Lithograph. Foster 43.

Test Stone 5A (Green Drills) from the series *Booster and 7 Studies*. 1967. Lithograph, printed in color. Foster 44A.

Test Stone #6 (Blue Cloud) from the series *Booster and 7 Studies*. 1967. Lithograph, printed in color. Foster 45.

Test Stone #7 (Torso) from the series *Booster and 7 Studies*. 1967. Lithograph. Foster 46.

Booster from the series *Booster and 7 Studies*. 1967. Lithograph and screenprint, printed in color. Foster 47.

Double-page plate (folios 55 verso and 56) from the book *In Memory of My Feelings* by Frank O'Hara. New York: The Museum of Modern Art, 1967. Photolithograph, printed in color. Not in Foster.

Plate (folio 57 verso) from the book *In Memory of My Feelings* by Frank O'Hara. New York: The Museum of Modern Art, 1967. Photolithograph, printed in color. Not in Foster.

Drizzle. 1968. Lithograph with embossing, printed in color. Foster 48.

Gamble. 1968. Lithograph with embossing, printed in color. Foster 49.

Water Stop. 1968. Lithograph with embossing, printed in color. Foster 50.

Reels (B + C). 1968. Series of six lithographs, printed in color. Foster 52-57.

Guardian. 1968. Lithograph with embossing, printed in color. Foster 58.

Preface (double page plate, folios 6 verso and 7) from *Wordswordswords* by Edwin Schlossberg. West Islip, N.Y.: Universal Limited Art Editions, 1968. Etching, printed without ink, and embossing. Not in Foster.

Landmark. 1968. Lithograph, printed in color. Foster 59.

Autobiography. 1968. Lithograph, printed in color, on three sheets. Foster 60.

Pledge. 1968. Lithograph, printed in color. Foster 64.

Promise. 1968. Lithograph, printed in color. Foster 65.

Tides. 1969. Lithograph, printed in color. Foster 68.

Drifts. 1969. Lithograph, printed in color. Foster 69.

Gulf. 1969. Lithograph, printed in color. Foster 70.

Horn from the *Stoned Moon Series*. 1969. Lithograph. Foster 72.

Sky Garden from the *Stoned Moon Series*. 1969. Lithograph and screenprint, printed in color. Foster 74.

Banner from the *Stoned Moon Series*. 1969. Lithograph. Foster 77.

Sack from the *Stoned Moon Series*. 1969. Lithograph, printed in color. Foster 82.

Air Pocket from the *Stoned Moon Series*. 1970. Lithograph. Foster 93.

Tracks from the *Stoned Moon Series*. 1970. Lithograph, printed in color. Foster 100.

Unit (Buffalo). 1969. Lithograph, printed in color. Foster 105.

Unit (Turtle). 1970. Lithograph, printed in color. Foster 106.

Unit (Hydrant). 1970. Lithograph, printed in color. Foster 107.

Surface Series 47 from the portfolio *Currents*. 1970. Screenprint. Foster 118.

Revolver from the portfolio *Artists and Photographs*. (Published 1970). Screenprint, printed in color.

Composition for Peace Portfolio Part I. (1970). Photolithograph.

Signs. (1970). Screenprint.

Cardbird Door from the *Cardbird Series*. 1971. Corrugated cardboard, Kraft paper, tape, wood, and metal with photolithograph and screenprint.

Cardbird VI from the *Cardbird Series*. 1971. Corrugated cardboard, and tape collage with photolithograph and screenprint.

Untitled from the portfolio *The New York Collection for Stockholm*. 1973. Lithograph, printed in color.

Hommage à Picasso from the portfolio *Hommage à Picasso*, Volume 1. 1973. Screenprint, printed in color.

Peanuts from the *Crops Suite*. 1973. Screenprint and solvent transfer.

Watermelon from the *Crops Suite*. 1973. Screenprint and solvent transfer.

Noname (Elephant) from the portfolio *For Meyer Schapiro*. 1973 (Published 1974). Solvent transfer, gesso, collage, and embossing.

Tanya. 1974. Lithograph, printed in color.

Veils, 1. 1974. Lithograph, printed in color.

Veils, 2. 1974. Lithograph, printed in color.

Veils, 3. 1974. Lithograph, printed in color.

Veils, 4. 1974. Lithograph, printed in color.

Link from the series *Fuses*. 1974. Screenprint, printed in color, on Japanese tissue paper laminated onto handmade paper, floating in clear plexiglass drawer.

Roan from the series *Fuses*. 1974. Screenprint, printed in color, on Japanese tissue paper laminated onto handmade paper, floating in a clear plexiglass drawer.

Treaty. 1974. Lithograph, printed in color.

Kitty Hawk. 1974. Lithograph, printed in color.

Scent from the series *Hoarfrost Editions*. 1974. Lithograph, newsprint, and screenprint transfers, and fabric and paper collage on fabric.

Preview from the series *Hoarfrost Editions*. Lithograph, newsprint, and screenprint transfers, and fabric and paper collage on fabric.

Cunningham Relief from the portfolio *Merce Cunningham*. 1974 (Published 1975). Embossing and stencil, printed in color, with hand-rubbed additions.

Killdevil Hill. 1975. Lithograph, printed in color.

Deposit from the portfolio *America: The Third Century*. 1975. Screenprint, printed in color, with stencil additions.

Snake Eyes from the series *Bones & Unions*. 1975. Bamboo strips, fabric, and paper.

Martial Raysse

Born in Golfe-Juan, France in 1936. Lives in Bergerac, France. Co-founded in 1960 Paris-based Nouveau Réalisme with Yves Klein, Jean Tinguely, Arman, and others. Made assemblage works of mass-produced, primarily plastic, supermarket items in a series known as *Hygiène de la Vision*. From early 1960s, worked extensively with photographic enlargements from fashion and film magazines, primarily of heavily made-up models, to explore issues of consumer excess and artificial beauty in contemporary society. Focused on schematic rendering of female heads by mid-1960s. In early 1960s, also began using neon over his garishly colored compositions to heighten the layers of artifice. By mid-1970s abandoned Pop style in favor of more traditional studies of nature. Worked sporadically in prints, usually with photographic processes. Completed important series of screenprints, *Six Images Calmes*, in 1972, based on earlier installation. Made several films, and in 1966 with Tinguely and Niki de Saint Phalle, designed costumes and sets for ballet. In 1970 made an insert for New York's *The Village Voice* of schematic outline of female head. Also worked in artist's books and posters. Collaborated with publishers Sergio Tosi in Milan, HofhausPresse in Düsseldorf, and Alexander Iolas in Paris, Milan, and New York.

Biblio.: Semin, Didier. *Martial Raysse*. Paris: Galerie nationale du Jeu de Paume; Nîmes. Carré d'art, Musée d'Art Contemporain, 1992. See also nos. 67, 115.

Untitled from the illustrated book *Das Grosze Buch* by various authors. Düsseldorf: HofhausPresse, 1964 (Plate executed 1963). Screenprint, printed in color, and powder puff collage, mounted on board.

Untitled book by Martial Raysse. Paris, New York, Geneva, Milan, Rome, and Madrid: Alexander Iolas Gallery, c. 1968–70. Photolithographed type and typescript, eight photolithographic reproductions after drawings (one with collage) or photographs, one collage, and one inset photographic negative.

Gerhard Richter

Born in Dresden in 1932. Lives in Cologne. Leading figure in postwar European art who intentionally defies stylistic categorization, working in both abstract and figurative modes. Co-founded Capitalist Realism in Düsseldorf in 1963 with Sigmar Polke and Konrad Lueg, considered German exponent of Pop art, which focused on Germany's media-saturated consumer society. Began making paintings based on photographs in 1962, many taken from newspapers and magazines. Began making prints after photographs in 1965, manipulating the photographic processes to address issues of illusion. Preferred photolithography because of its inexpensive and commercial nature. Completed over seventy prints, many in large editions, before 1975. Published with large variety of galleries and publishers including HofhausPresse in Düsseldorf, edition h in Hannover, Galerie Rottloff in Karlsruhe, Galerie Heiner Friedrich in Munich, and Edition René Block in Berlin, as well as numerous regional museums.

Biblio.: Butin, Hubertus. *Gerhard Richter Editionen 1965–1993*. Munich: Verlag Fred Jahn, 1993. See also nos. 64, 67, 115.

Flugzeug I (Airplane I). 1966. Screenprint, printed in color. Butin 4a.

Elisabeth II. 1966. Photolithograph, printed in color. Butin 5b.

Bahnhof (Hannover) (Railroad Station [Hannover]). 1967. Photolithograph, printed in color. Butin 7.

Hotel Diana from the portfolio *Grafik des Kapitalistischen Realismus* (Graphics of Capitalist Realism). 1967. Screenprint, printed in color. Butin 9.

Mao. 1968. Collotype, printed in color. Butin 10.

Umwandlung (Metamorphosis). 1968. Photolithograph. Butin 11.

Atelier. 1968. Photolithograph. Butin 12.

Schattenbild II (Shadow Picture II or Silhouette II). 1968. Photolithograph, printed in color. Butin 14b.

Neun Objekte (Nine Objects). 1969. Portfolio of nine photolithographs. Butin 20

Seelandschaft (Sea Landscape). (1971). Photoengraving, printed in color. Butin 28.

Selbstbildnis (Self-Portrait), fifth supplementary plate from the book *Grafik des Kapitalistischen Realismus* (Graphics of Capitalist Realism). Berlin: Edition René Block, 1971. Photolithograph with varnish additions. Butin 29.

Wolke (Cloud). (1971). Photolithograph. Butin 30.

Kanarische Landschaften I (Canary Islands Landscapes I). (1971). Portfolio of six photogravure and aquatints, printed in color. Butin 32.

Farbfelder: 6 Anordnungen von 1260 Farben (Color Charts: 6 Arrangements of 1260 Colors). 1974. Portfolio of six photolithographs, printed in color. Butin 42a–f.

Larry Rivers

Born in New York in 1923. Lives in New York. Developed a gestural figurative style in the early 1950s with stylistic affinities to Abstract Expressionism but depicted narrative images often based on masterpieces of art history. Along with Johns and Rauschenberg, foreshadowed the increasing influence of everyday imagery and consumer culture as a valid subject for art. Became prolific printmaker, making first prints, for the groundbreaking illustrated book *Stones* by Frank O'Hara, with Universal Limited Art Editions (ULAE), West Islip, N.Y., in 1957, which was also the publisher's first project. Completed over sixty prints during this period, working primarily in lithography at ULAE. Also published with Marlborough Graphics, Edition Schellmann, and Multiples, Inc., in New York. Expressed his passion for poetry in major illustrated books, including *Stones* and *The Donkey and the Darling* by Terry Southern. Made numerous posters and magazine covers as well as several multiples including a banner for the Betsy Ross Flag and Banner Company, New York. Also did billboard for 1963 New York Film Festival.

Biblio.: Hunter, Sam. *Larry Rivers*. New York: Rizzoli International Publications, 1989. See also nos. 65, 67, 95, 115.

Jack of Spades. 1960. Lithograph, printed in color.

Face of Clarice I. 1961. Lithograph.

Face of Clarice II. 1961. Lithograph.

Ford Chassis I. 1961. Lithograph.

Ford Chassis II. 1961. Lithograph.

Last Civil War Veteran I. 1961. Lithograph.

Last Civil War Veteran II. 1961. Lithograph, printed in color.

Lucky Strike in the Mirror (Lucky Strike I). 1961. Lithograph, printed in color.

Lucky Strike II. 1960–63. Lithograph, printed in color.

French Money. 1963. Lithograph, printed in color.

Purim. 1963. Lithograph, printed in color, with pencil and crayon additions.

Nine French Bank Notes I. 1963–64. Lithograph, printed in color.

Gwynne. 1964. Lithograph, printed in color, with oil and pencil additions on paper, cut and mounted on thick gray cardboard.

Nine French Bank Notes II. 1963–65. Lithograph, printed in color.

15 Years. 1965. Lithograph, printed in color.

French Money from the series *Four on Plexiglas*. 1965. Screenprint, printed in color, on board with plexiglass overlay and plexiglass collage.

Don't Fall. 1966. Lithograph, printed in color.

Don't Fall. 1966. Lithograph, printed in color, and rubber collage.

Drawing Announcement. (1966). Lithograph with stencil additions.

Fraser. 1966. Screenprint, printed in color.

Map with Fraser. 1966. Screenprint, printed in color.

Stravinsky I. 1966. Lithograph, printed in color.

Stravinsky II. (1966). Lithograph, printed in color.

Underground with Fraser. 1966. Screenprint, printed in color, and screenprint collage.

Underground with Two Frasers. 1966. Screenprint, printed in color, and collage.

Stravinsky III. 1966-67. Lithograph, printed in color.

O'Hara Reading. 1967. Lithograph, printed in color.

Cigar Box. (1967). Multiple of hinged wood box with painted, screenprinted, photolithographed, and collaged wood, board, canvas, paper, and plexiglass.

Double-page plate (folios 101 verso and 102) from the book *In Memory of My Feelings* by Frank O'Hara. New York: The Museum of Modern Art, 1967. Photolithograph, printed in color.

Double-page plate (folios 103 verso and 104) from book *In Memory of My Feelings* by Frank O'Hara. New York: The Museum of Modern Art, 1967. Photolithograph, printed in color.

Plate (folio 106) from book *In Memory of My Feelings* by Frank O'Hara. New York: The Museum of Modern Art, 1967. Photolithograph, printed in color.

Downtown Lion. 1967. Etching, printed in color.

Dutch Masters. 1964–68 (Published 1968). Lithograph, printed in color.

Enter Emma. 1966–69. Etching and aquatint, printed in color, with pencil additions.

Once More Paul Revere I. 1967–69. Lithograph, printed in color.

For the Pleasures of Fashion (Summer Unit). 1967–70. Etching, soft ground etching and aquatint on cut plates, printed in color.

Untitled from the portfolio *National Collection of Fine Arts.* (1968). Lithograph, printed in color, and lithograph collage, mounted on pink paper.

Once More Paul Revere II. 1968–70. Lithograph, printed in color.

Diane Raised I. 1970. Lithograph, printed in color.

Diane Raised II (Black Diane). 1970–71. Lithograph, printed in color.

Diane Raised III. 1970–71. Lithograph, printed in color, and paper collage.

For Adults Only. 1971. Lithograph, printed in color.

Untitled from the portfolio *The New York Collection for Stockholm.* 1973. Lithograph and screenprint, printed in color.

Diane Raised IV (Polish Vocabulary). 1970–74. Lithograph, printed in color, and paper collage.

Diana with Poem. (1970–74). Folded lithograph and lithograph collage with letterpress poem by Kenneth Koch.

Untitled from the portfolio *America's Hommage à Picasso.* 1974 (Published 1975). Screenprint, printed in color.

Bread and Butter. 1974. Etching and screenprint, printed in color, with varnish additions.

Emma II—Mixed Emotion. 1967–75. Etching, aquatint, and open bite, printed in color, and paper collage.

An Outline of History from the *Kent Bicentennial Portfolio: Spirit of Independence.* 1975. Lithograph and screenprint, printed in color.

James Rosenquist

Born in Grand Forks, North Dakota in 1933. Lives in New York and Aripeka, Florida. Trained as a billboard painter, became one of the defining proponents of the Pop aesthetic in the United States with a vocabulary of oversized, boldly colored fragments of common-place items such as food, cars, machines, heads, and hands, juxtaposed in disjointed, startling combinations. Frequently incorporated brand-name commercial products inspired by magazine illustrations. Prolific printmaker, beginning in 1962 with etching contribution to Arturo Schwarz's book *International Anthology of Contemporary Engraving: The International Avant-Garde; America Discovered,* but began seriously working in lithography at Universal Limited Art Editions (ULAE), West Islip, N. Y., in 1965. Completed over seventy-five prints by 1975, working with a number of publishers including Richard Feigen Graphics, Castelli Graphics, Hollanders Workshop, Multiples, Inc., New York, Graphicstudio, Tampa, Fla., and Petersburg Press, London.

Biblio.: Glenn, Constance W. *Time Dust: James Rosenquist Complete Graphics 1962–1992.* New York: Rizzoli International Publications, 1993. Catalogue by Kirsten M. Schmidt and Carolyn G. Anderson, with Michael Harrigan. See also nos. 65, 67, 76, 86, 93, 95, 106, 115.

Certificate, plate 14 from the illustrated book *International Anthology of Contemporary Engraving: The International Avant-Garde. America Discovered,* Volume 5 by Billy Klüver. Milan: Galleria Schwarz, 1964. (Print executed 1962). Photogravure, etching, and soft ground etching. Glenn 1.

New Oxy, double-page plate (pages 20, 21) from the illustrated book *1¢ Life* by Walasse Ting. Bern: E.W. Kornfeld, 1964. Lithograph, printed in color. Glenn 2.

High-Pool. 1964–66. Lithograph, printed in color. Glenn 3.

Campaign. 1965. Lithograph, printed in color. Glenn 4.

Spaghetti and Grass. 1965. Lithograph, printed in color. Glenn 5.

Dusting Off Roses. 1965. Lithograph, printed in color. Glenn 6.

Circles of Confusion I. 1965-66. Lithograph, printed in color. Glenn 8.

Roll Down. 1964–66. Lithograph, printed in color. Glenn 9.

Circles of Confusion from the portfolio *11 Pop Artists,* Volume I. 1965 (Published 1966). Screenprint, printed in color. Glenn 10.

Whipped Butter for Eugen Ruchin from the portfolio *11 Pop Artists,* Volume II. 1965 (Published 1966). Screenprint, printed in color. Glenn 11.

For Love from the portfolio *11 Pop Artists,* Volume III. 1965 (Published 1966). Screenprint, printed in color. Glenn 13.

Somewhere to Light from the portfolio *New York International.* 1966. Screenprint, printed in color. Glenn 16.

Sketch for Forest Ranger from the portfolio *Ten from Leo Castelli.* 1967. Screenprint, printed in color. Not in Glenn.

Expo 67 Mural—Firepole 33' X 17'. 1967. Lithograph, printed in color. Glenn 17.

Cold Spaghetti Postcard. 1968. Lithograph, printed in color. Glenn 18.

Horse Blinders. 1968. Lithograph, printed in color. Glenn 19.

Forehead I. 1968. Lithograph, printed in color. Glenn 20.

Forehead II. 1968. Lithograph, printed in color. Glenn 21.

See-Saw, Class Systems. 1968. Lithograph, printed in color. Glenn 22.

Horse Blinders Flash Card. 1969. Lithograph, printed in color. Glenn 23.

Night Smoke. 1969–70. Lithograph, printed in color. Glenn 25.

Night Smoke II. 1969–72. Lithograph, printed in color. Glenn 26.

Bunraku. 1970. Lithograph. Glenn 33.

Cold Light. 1971. Lithograph, printed in color. Glenn 40.

Mastaba. 1971. Lithograph, printed in color. Glenn 44.

Spinning Faces in Space. 1972. Lithograph, printed in color. Glenn 46.

Pushbutton. 1972. Lithograph, printed in color. Glenn 51.

Flower Garden. 1972. Lithograph, printed in color. Glenn 52.

Zone. 1972. Lithograph. Glenn 53.

The Light That Won't Fail I. (1973, dated 1972). Lithograph, printed in color. Glenn 54.

My Mind is a Glass of Water from the portfolio *Prints for Phoenix House.* 1972. Lithograph, printed in color. Glenn 58.

15 Years Magnified through a Drop of Water. 1972-73. Lithograph, printed in color. Glenn 63.

First. 1973. Lithograph, printed in color, with acrylic spray additions. Glenn 64.

Flame Out for Picasso from the portfolio *America's Hommage à Picasso.* 1973 (Published 1975). Lithograph, printed in color. Glenn 65.

Flamingo Capsule. 1973. Lithograph and screenprint, printed in color. Glenn 66.

Untitled from the portfolio *The New York Collection for Stockholm.* 1973. Screenprint, printed in color. Glenn 68.

Off the Continental Divide. 1973–74. Lithograph, printed in color. Glenn 69.

Marilyn. 1974. Lithograph, printed in color. Glenn 70.

Paper Clip. 1974. Lithograph, printed in color. Glenn 71.

F-111 (South, West, North, East). 1974. Lithograph and screenprint, printed in color, on four sheets. Glenn 73.

Time Flowers from the series *Nail.* 1974. Screenprint, printed in color. Glenn 77.

1/2 Sunglass, Landing Net, Triangle from the series *Nail.* 1974. Etching and aquatint. Glenn 80.

Tampa—New York 1188. (1975, dated 1974). Lithograph, printed in color. Glenn 81.

Miles from the portfolio *America: The Third Century.* 1976. Screenprint, printed in color. Glenn 88.

Slip Stream. 1975. Collagraph, printed in color. Glenn 91.

Mimmo Rotella

Born in Catanzaro, Italy in 1918. Lives in Milan. Recognized as leading proponent of *affichistes* movement, a group of artists, working mainly in France, whose art was composed of torn-down street posters. Known as *décollages,* these found objects represented the integration of art with the everyday, urban environment, characteristic of the Nouveaux Réalistes group, which Rotella joined in 1961. Developed Mec Art (Mechanical Art), with Alain Jacquet, in early 1960s, which was based on direct appropriation of photo-mechanical imagery and resulted in numerous unique photo-based works on canvas. Also in the 1960s made several three-dimensional works, known as "Rotellised" objects, mostly unique found objects, but occasionally multiples. Made numerous prints beginning with abstract lithographs in the 1950s. Also made lithographic versions of *décollages* of Marilyn Monroe, Elvis Presley, and other film subjects, in small editions in 1970. Published with Galleria Schwarz, Studio Marconi in Milan, and Galleria Faby Basaglia in Rimini, among others. Also wrote phonetic tonal poetry.

Biblio.: Trini, Tommaso. *Rotella.* Milan: Giampaolo Prearo Editore, 1974.

Petit Monument à Rotella (Little Monument to Rotella). (1962). Multiple of found Shell oil can on painted wood pedestal with engraved and painted brass plate.

Plate 16 from the illustrated book *International Anthology of Contemporary Engraving: The International Avant-Garde,* Volume 3 by Franco Russoli. Milan: Galleria Schwarz, 1962. Etching.

6 Prison Poems from the periodical *S. M. S.,* no. 4 (August 1968). New York: The Letter Edged in Black Press, 1968. Photolithograph, printed in color.

Untitled from the portfolio *Les Nouveaux Réalistes* (The New Realists). (Published 1973). Photolithograph, printed in color, mounted in mat, with stencil additions and mylar collage.

Dieter Roth

Born in Hannover in 1930. Died in Basel in 1998. Singularly creative and reclusive Swiss painter, sculptor, printmaker, book artist, filmmaker, and poet. Work evolved through several styles, encompassing Op, Pop, Fluxus, and Conceptual art movements, with consistently inventive use of materials, including cut paper, food, excrement, etc. Worked as graphic designer and textile designer in 1950s. Began printmaking as a teenager and was extremely prolific, completing over eighty books and 300 prints by 1975, many in very small editions. Defied the traditional approaches to the mediums, executing "pressings" and "squashings" with organic materials. Began working in linoleum cut and etching in late 1940s, lithography in 1950, and screenprint in 1957. Published first book in 1954. Collaborated on books with Spoerri beginning in late 1950s. In 1968 began collaborating with Hamilton on prints, in 1970 with Stefan Wewerka, and in 1972 with Arnulf Rainer. Self-published many of his prints. Beginning in 1969, also published numerous prints with Petersburg Press in London, as well as with Edition Griffelkunst in Hamburg, Edition Tangente in Heidelberg, and Rainer Verlag in Berlin. Often printed with H. Kaminski in Düsseldorf, who was experimental collaborator with several artist friends. Also contributed prints to numerous periodicals, and occasionally made posters and special edition prints for exhibition catalogues. After mid-1960s, published most books with Edition Hansjörg Mayer in Stuttgart. Also made multiples sporadically throughout the period, including with Spoerri's Édition MAT in Cologne.

Biblio.: *Dieter Rot Collected Works; Volume 20: Books and Graphics (part 1) from 1947 until 1971*. Stuttgart and London: Edition Hansjörg Mayer, 1972).
Dieter Roth Collected Works; Volume 40: Books and Graphics (part 2) and other stuff from 1971 until 1979. Stuttgart and London: Edition Hansjörg Mayer, 1979. See also nos. 64, 67, 90, 96.

Book AC 1958–64. New Haven, Conn.: Ives-Sillman, 1964. (Multiples executed 1958–1964). Artist's book with twenty-four die-cuts. Rot Book 19.
My Eye is a Mouth. 1966. Etching. Rot 66.
Cards Intended to Accompany Chocolate Bar from the periodical *S.M.S.*, no. 6 (December 1968). New York: The Letter Edged in Black Press, 1968. Photolithograph, printed in color. Not in Rot.
96 Piccadillies by Dieter Roth. London: Eaton House Publishers, Ltd.; Stuttgart: Edition Hansjörg Mayer, 1977. (Reproduced drawing executed 1968). Artist's book with one black crayon drawing (*Self-Portrait as Piccadilly—Eros*, unbound double-page plate), and photolithographic reproductions after drawings. Roth Book 87.
6 Piccadillies. (1969–70, published 1970). Portfolio of six double-sided screenprints over photolithographs, one with iron filings, mounted on board, and one photolithograph (on portfolio box), all printed in color. Rot 117–23.
Big Kümmeling. 1970. Screenprint, printed in color. Rot 223.
Containers. 1972. Portfolio of ten etchings, three engravings, two screenprints, fourteen photolithographs, three relief prints, and one transfer print. Rot 276.1–33.

Edward Ruscha

Born in Omaha, Nebraska in 1937. Lives in Venice, California. Moved from Oklahoma to California before the age of twenty and helped to define the West Coast Pop movement with his often ironic glorification of commonplace objects and landscapes of vernacular architecture. His graphic design background and strong interest in comic books and billboards contributed to his stark, vibrant style combining text and image. Often incorporated words from consumer goods packaging and road signs. Began printmaking in 1962 with landmark series of self-published artist's books in large editions, beginning with *Twentysix Gasoline Stations*, which launched the development and appreciation of the medium. Became prolific printmaker working in screenprint and lithography, completing nearly ninety prints and fifteen artist books before 1975. Also made two films in mid-1970s. Focused on printmaking, rather than painting, from late 1960s to early 1970s, working extensively with Tamarind Lithography Workshop, Los Angeles, in the late 1960s. Also worked with Cirrus Editions and Gemini G.E.L. in Los Angeles, Editions Alecto in London, Graphicstudio in Tampa, Florida, and Multiples, Inc. in New York. Often experimented with organic substances as printing inks, culminating in 1970 installation *Chocolate Room* for the Venice Biennale, which consisted of 360 sheets of paper screenprinted with chocolate.

Biblio.: Bogle, Andrew. *Graphic Works by Edward Ruscha*. Auckland, New Zealand: Auckland City Art Gallery, 1978.
Foster, Edward A. *Edward Ruscha*. Minneapolis: The Minneapolis Institute of Arts, 1972. See also nos. 65, 67, 96, 100, 115.

Standard Station. 1966. Screenprint, printed in color. Foster P4.
1984. 1967. Lithograph with watercolor additions. Foster P5.
Hollywood. Screenprint, printed in color. Foster P6.
Mint. 1969. Lithograph, printed in color. Foster P8.
Carp. 1969. Lithograph, printed in color. Foster P9.
Carp with Shadow and Fly. 1969. Lithograph, printed in color. Foster P10.
Eye. 1969. Lithograph, printed in color. Foster P11.
Annie. 1969. Lithograph, printed in color. Foster P12.
Rodeo. 1969. Lithograph, printed in color. Foster P13.
Hollywood and Observatory. 1969. Lithograph, printed in color. Foster P14.
Long Hollywood. 1969. Lithograph, printed in color. Foster P15.
Hollywood in the Rain. 1969. Lithograph, printed in color. Foster P16.
Short Hollywood. 1969. Lithograph, printed in color. Foster P17.
City. 1969. Lithograph, printed in color. Foster P18.
Air. 1969. Lithograph, printed in color. Foster P19.
Adios. 1969. Lithograph, printed in color. Foster P20.
Sin. 1969. Lithograph, printed in color. Foster P21.
Zoo. 1969. Lithograph. Foster P22.
Ooo. 1969. Lithograph. Foster P23.
Olive and Screw. 1969. Lithograph, printed in color. Foster P24.
Olive and Marble. 1969. Lithograph, printed in color. Foster P25.
Boiling Blood, Fly. 1969. Lithograph, printed in color. Foster P26.
Hey. 1969. Lithograph, printed in color. Foster P27.
Anchovy. 1969. Lithograph, printed in color. Foster P28.
Stains. (1969). Portfolio of seventy-six stains (including inside front cover). Foster B10.
Lisp. 1970. Lithograph, printed in color. Foster P42.
Babycakes. Artist's book with twenty-two lithographs, printed from the portfolio *Artists and Photographs*. (Published 1970). Foster B11.
Cockroaches from the portfolio *Insects*. (1972). Screenprint,

printed in color. Foster P62.
Domestic Tranquility. 1974. Series of four lithographs, printed in color.
America Her Best Product from the *Kent Bicentennial Portfolio: Spirit of Independence*. 1974 (Published 1975). Lithograph, printed in color.
America Whistles from the portfolio *America: The Third Century*. 1975. Lithograph, printed in color.

George Segal

Born in New York in 1924. Lives in North Brunswick, New Jersey. Throughout the 1960s made sculpture and environments from life-size plaster bodies and real objects to evoke everyday situations. In the 1970s began exploring socially and politically charged issues, including the Kent State shootings and gay rights. Produced editioned work sporadically during this period. After early etching for Arturo Schwarz's 1964 illustrated book *International Anthology of Contemporary Engraving: The International Avant-Garde; America Discovered*, worked primarily in screenprint and contributed to several group portfolios including two released by Tanglewood Press, New York. Also worked in multiples, producing an early work for Tanglewood Press, and others for Sidney Janis Gallery and Pace Editions, New York; Galerie Der Spiegel, Cologne; and Editions Alecto, London in the early 1970s. In 1975 printed the innovative *Blue Jean Series* of eleven etchings with 2RC Editions, Rome, in which figures were inked and imprinted on the plate.

Biblio.: Kelder, Diane. *George Segal: Bluejean Series 1975*. Rome: 2RC Editions, 1975. See also nos. 70, 106.

Plate 15 from *International Anthology Of Contemporary Engraving: The International Avant-Garde. America Discovered*, Volume 5 by Billy Klüver. Milan: Galleria Schwarz, 1964. (Print executed 1962). Soft ground etching.
Woman Brushing Her Hair from the portfolio *New York 10*. 1964 (Published 1965). Screenprint, printed in color.
Chicken from *7 Objects in a Box*. (1966). Cast acrylic and fiberglass.
Girl in a Chair from the portfolio *The Metropolitan Scene*. 1968. Screenprint, printed in color.
Untitled from the portfolio *The New York Collection for Stockholm*. (1973). Screenprint on folder containing phonograph record with photolithographed label, printed in color.
Three Figures in Red Shirts: Two Front, One Back from the *Blue Jean Series*. 1975. Etching and aquatint, printed in color.
Girl in Blue Jeans: Back View from the *Blue Jean Series*. 1975. Etching and aquatint, printed in color.
Man in Solferino Shirt: Front View from the *Blue Jean Series*. 1975. Etching and aquatint, printed in color.
Two Figures: One Front, One Back from the *Blue Jean Series*. 1975. Etching and aquatint, printed in color.

Colin Self

Born in Norwich, England in 1941. Lives in Norwich. Important figure in early British Pop circles whose work often resonated with strong political overtones. Prolific and experimental printmaker. Studied etching at Slade School of Art in 1961–62, and created meticulous images in several small editions. Interested in detached and detailed recording of reality showing no personal style of the artist. Eschewing the artist's handmade mark, in 1962–63 devised a multi-plate etching technique using found industrial metal objects, which he arranged into compositions before inking and printing. Explored photo-based mediums in late

1960s. Continued to experiment with etchings without calligraphic gesture in 1971 series *Prelude to 1,000 Temporary Objects Of Our Time*, and in *Nude*, in which objects or figures were inked and pressed on the plate to create an image. Has worked extensively in etching and screenprint, publishing the majority of his prints with Editions Alecto in London.

Biblio.: Spencer, Charles ed. *A Decade of Printmaking*. London: Academy Editions; New York: St. Martin's Press, 1973.

Woman in Fur Coat 6. (1964). Blueprint.
Nuclear Bomber No. 2. (1964). Relief print with embossing and decal collage.
Hot Dog Plans 13. (1965). Blueprint.
Hot Dog Plans 14. (1965). Blueprint.
Hot Dog Plans 16. 1965. Blueprint.
Power and Beauty. (1968). Series of five screenprints, printed in color, and one etching.
Untitled (variant of *Power and Beauty No. 3*) from the series Power and Beauty. (1968). Screenprint, printed in color.
Untitled (variant of *Power and Beauty No. 6*) from the series Power and Beauty. (1968). Screenprint, printed in color.

Richard Smith

Born in Letchworth, England in 1931. Lives in New York. Part of generation of British artists from London's Royal College of Art that responded to the growing infusion of popular imagery. Unique work focused on Pop images of commodities from consumer culture, including several images of cigarette packs. By mid-1960s, began working in an abstract mode with shaped canvas and three-dimensional constructions, while still alluding to issues of packaging and advertising. Active printmaker who became known for cut and folded, three-dimensional prints. After early screenprints, favored lithography and collaborated with numerous publishers including Editions Alecto, Bernard Jacobson, Petersburg Press, and Waddington Graphics in London, and Richard Feigen Graphics in New York. Experimented with printing on plastic and screenprinting on metal objects for multiples. Also made several printed ephemera items including posters and exhibition announcements.

Biblio.: *Cut, Folded and Tied: Drawings and Prints by Richard Smith 1966–1975*. London: The Arts Council of Great Britain, 1975. Introduction by Lynda Morris. See also nos. 67, 77, 80, 92.

PM Zoom from *The Institute of Contemporary Arts Portfolio*. 1963 (Published 1964). Screenprint, printed in color.
Proscenium I. 1971. Etching and aquatint.
C. Grey. (1971). Screenprint, printed in color, on vacuum formed plastic.
Untitled from the *Lawson Set*. (1973). Lithograph, printed in color.
Diary. 1975. Screenprint, printed in color, in seven parts, and pole.

Daniel Spoerri (Daniel Isaac Feinstein)

Born in 1930 in Galatz, Romania. Lives in Seggiano, Italy. Original member of Paris-based Nouveau Réalisme, organized around critic Pierre Restany in 1960, with Yves Klein, Arman, Raysse, Jean Tinguely, and others. Known for his tableau-pièges, or "snare pictures," assemblages made by gluing down leftover objects on a table after a meal and hanging tables on the wall. Performance-based events often accompanied the creation of the snare pictures. Opened Restaurant Spoerri and adjacent Eat-Art Gallery in Düsseldorf in 1968 and 1970 respectively, to further showcase his food art themes, cooking, "snaring," and food-based art. Papered walls of restaurant with correspondence of previous fifteen years. From 1957–59, published *material*, seminal journal of concrete poetry. In Paris in 1959 founded Édition MAT (Multiplication d'Art Transformable), pioneering venture for publishing multiples. Made several artist's books during this period, but only worked occasionally in prints. Completed two multiples for Édition MAT in 1964 and 1965. Made additional multiples sporadically for Edition Tangente in Heidelberg and Seriaal in Amsterdam. Associated with Fluxus in the 1970s. Made posters and printed menus in mid-1970s.

Biblio.: Hahn, Otto. *Daniel Spoerri*. Paris: Flammarion, 1990. See also nos. 88, 90, 96, 103, 106.

Untitled. 1970. Screenprint, printed in color, on canvas.
Untitled from the portfolio *Les Nouveaux Réalistes* (The New Realists). (1973). Pop-up photolithograph, printed in color, and matchstick collage mounted on board.

Wayne Thiebaud

Born in Mesa, Arizona in 1920. Lives in Sacramento, California. Realist painter whose expressionist still lifes of everyday food and toys in serial formats brought him into the orbit of Pop during the early 1960s. Expanded vocabulary to include figures and landscapes in the mid-1960s. After working as an illustrator and cartoonist, began making prints in the late 1940s. Worked at the California State Fair in Sacramento and San Jose State College print workshop in the 1950s with Mel Ramos, primarily making screenprints. Collaborated with fellow painter Patrick Dullanty on screenprints during this period. Produced an educational film on lithography, *Color on a Stone*, with Dullanty, in 1954. Began long collaboration with Crown Point Press, Berkeley, Calif., in 1963, producing numerous etchings and drypoints. Also worked in woodcut, linoleum cut, and lithography, publishing primarily with Parasol Press, New York. Also made lithographs with Gemini G.E.L., Los Angeles, in 1968 and printer Michael Knigin in 1971, and linoleum cuts with Imprimerie Arnera in Vallauris, France in 1970. Completed over fifty published prints in all mediums between 1960 and 1975, many in small editions.

Biblio.: *Wayne Thiebaud: Graphics, 1964–1971*. New York: Parasol Press, 1971. See also nos. 70, 96, 115.

Untitled. (c. 1963). Etching.
Plate 17 from *International Anthology of Contemporary Engraving: The International Avant-Garde. America Discovered*, Volume 5 by Billy Klüver. Milan: Galleria Schwarz, 1964. Etching.
Pies from the portfolio *Delights*. 1964 (Published 1965). Etching and aquatint.
Boston Cremes from the portfolio *Seven Still Lifes and a Silver Landscape*. 1970 (Published 1971). Linoleum cut, printed in color.
Triangle Thins from the portfolio *Seven Still Lifes and a Silver Landscape*. 1971. Aquatint and soft ground etching, printed in color.

Joe Tilson

Born in 1928 in London. Lives in Wiltshire, England. An object maker more than a painter, Tilson explored complex combinations of mediums in Pop constructions combining text, symbols, and mass media images. Work often focused on political issues of the period, including cult heroes such as Ho Chi Minh, Che Guevara, and Malcolm X. Completed his first screenprint in 1963 as part of *The Institute of Contemporary Arts Portfolio* which launched an extensive and close-working relationship with printer Chris Prater of Kelpra Studio, London. Exceedingly inventive as a printmaker, has worked almost exclusively in screenprint, completing nearly forty prints during this period. Often used screenprint in his unique work. Pioneered the development of three-dimensional prints, often attaching various objects to the printed surface and printing on metallic acetates, vacuum-formed plastics and mirror foils. Major publisher during this period was Marlborough Graphics, London. Also published sporadically with Sergio Tosi in Milan and Waddington Graphics in London. Still actively making prints, primarily etchings.

Biblio.: Gilmour, Pat. *Joe Tilson Graphics*. Vancouver: The Vancouver Art Gallery, 1979. See also nos. 67, 77, 78, 85, 92, 96, 115.

Lufberry and Rickenbacker from *The Institute of Contemporary Arts Portfolio*. 1963 (Published 1964). Screenprint, printed in color.
The 1/2 Ziggurat. (1965). Screenprint, printed in color.
P. C. from N. Y. C. 1965. Screenprint, printed in color.
Rainbow Grill. 1965. Screenprint, printed in color, on board and vacuum-filled polystyrene.
T-Shot, Dart, Ziggurat 3, Ziggurat 4, Freeway 2, Trio. (1965). Screenprint, printed in color, in six sections.
Ziggurat 5. 1966. Screenprint, printed in color.
Transparency, Clip-O-Matic Lips. 1967. Screenprint, printed in color, on acetate film over color diapositive mounted on metallized acetate film, mounted on paper.
Transparency, Empire State Building. 1967. Screenprint, printed in color, on acetate film over color diapositive mounted on metallized acetate film, mounted on paper.
Sky 3. (1967). Screenprint, printed in color, and polyethylene bag containing three acrylic letters.
Cut Out and Send. (1968). Screenprint, printed in color, and screenprinted paper collage.
The Software Chart. (1968). Screenprint, printed in color, on lumaline, over astrofoil mounted on paper.
Is This Che Guevara? 1969. Screenprint, printed in color, paper and grommet collage, and paper-clipped photograph.
Earth Ritual, (p. 103) from the portfolio *Hommage à Picasso*, Volume 4. (1973). Screenprint, printed in color.

Wolf Vostell

Born in Leverkusen, Germany in 1932. Lives in Berlin. Influenced by Joseph Beuys, focused on art as a vehicle for social and political expression. Worked in a wide range of mediums encompassing Happenings, film, performance, video, painting, printmaking, photography, multiples, and artist's books, incorporating images of contemporary technology from newspapers and magazines. Co-founded Fluxus movement in Cologne in 1962 and contributed to various Fluxus events, publications, and exhibitions throughout the 1960s. Began publishing conceptual journal *dé-coll/age* in 1962. Became prolific printmaker, beginning in 1960, concentrating on screenprint because of its ease at reproducing photographic images, completing nearly fifty through 1975. Collaborated mostly with publisher Galerie Inge Baecker in Cologne, but also worked with Edition René Block in Berlin, and Edition Tangente in Heidelberg. Completed over thirty-five multiples in this period as well, working with a range of galleries and publishers including Block, Edition Hossmann in Hamburg, and

Edition Howeg in Zurich. Also made numerous artist's books, posters, and wallpaper.

Biblio.: Woimant, Françoise, and Anne Moeglin-Delcroix. *Wolf Vostell: Estampes et Affiches*. Paris: Bibliothèque Nationale, 1982. See also nos. 67, 90, 106.

Starfighter from the portfolio *Grafik des Kapitalistischen Realismus* (Graphics of Capitalist Realism). (1967). Screenprint, printed in color, and glitter collage. Block V14.
TV-Ochsen 2 (TV-Oxen 2) from the portfolio *Weekend*. (1971, published 1972). Screenprint, printed in color. Block V43.
Neujahrsansprache 1 (New Year's Address 1) from the portfolio *Weekend*. (1971, published 1972). Screenprint, printed in color, and glitter collage. Block V44.
Neujahrsansprache 2 (New Year's Address 2) from the portfolio *Weekend*. (1971) Screenprint, printed in color, and glitter collage. Block V45.
Selbstbildnis (Self-Portrait), sixth supplementary plate from the book *Grafik des Kapitalistischen Realismus* (Graphics of Capitalist Realism). Berlin: Edition René Block, 1971. Screenprint with varnish additions. Block 51.

Andy Warhol

Born in McKeesport, Pennsylvania in 1927. Died in New York in 1987. Painter, sculptor, filmmaker, printmaker, and editor who became synonymous with the Pop art movement with his enlargements of well-known consumer products such as Coca-Cola bottles and Campbell's soup cans, and repeated photographic depictions of media celebrities including Marilyn Monroe, Elizabeth Taylor, and Elvis Presley. Began screenprinting on canvas in 1962 with images of Troy Donahue and Warren Beatty. Made first editioned print on paper, a photoengraving, in 1962 for Arturo Schwarz's book *International Anthology of Contemporary Engraving: The International Avant-Garde; America Discovered*, published in 1964. Collaborated with Billy Klüver on first screenprint, a record cover in 1963, but commited seriously to the medium in 1967, beginning a series of thematic portfolios of ten images each, *Marilyn Monroe (Marilyn)*, *Campbell's Soup I* and *II*, *Flowers*, *Electric Chairs* and *Mao*. Completed over 150 multiple prints, almost all screenprints, during this period. Also executed numerous multiples, artist's books, posters, wallpaper images, and exhibition mailers and announcements. Was largely responsible for the reevaluation of issues of originality with his repeated borrowings of photographic images and unsigned, often, unlimited printed ephemera. Published with Castelli Graphics, Multiples, Inc., as well as his own Factory Additions, and used a variety of screenprinters including Aetna Silkscreen Products, Alexander Heinrici, and Styria Studio, all in New York.

Biblio.: Feldman, Frayda, and Jörg Schellmann. *Andy Warhol Prints: A Catalogue Raisonné 1962–1987*. New York: D.A.P./Distributed Art Publishers in association with Ronald Feldman Fine Arts, Inc., 1997. See also nos 64, 67, 70, 86, 90, 93, 100, 104, 106, 114, 115.

Cooking Pot, plate 18 from the illustrated book *International Anthology of Contemporary Engraving: The International Avant-Garde. America Discovered*, Volume 5 by Billy Klüver. Milan: Galleria Schwarz, 1964. (Print executed 1962). Relief halftone. Feldman & Schellmann 1.
Birmingham Race Riot from the portfolio *X + X (Ten Works by Ten Painters)*. (1964). Screenprint. F & S 3.
Campbell's Soup Can on Shopping Bag. 1964. Screenprint, printed in color, on shopping bag with handles. F & S 4.
Campbell's Soup Can on Shopping Bag. 1966. Screenprint, printed in color, on shopping bag with handles. F & S 4A.
Marilyn Monroe I Love Your Kiss Forever Forever, double-page headpiece (pages 112 , 113) from the illustrated book *1¢ Life* by Walasse Ting. Bern: E. W. Kornfeld, 1964. Lithograph, printed in color. F & S 5.
Flowers. 1964. Photolithograph, printed in color. F & S 6.
Cagney. (1964). Screenprint. F & S Appendix I/B.
Kiss from the multiples portfolio *7 Objects in a Box*. (1966). Screenprint on plexiglass. F & S 8.
S&H Green Stamps. (1965). Photolithograph, printed in color. F & S 9.
Cow. (1966). Screenprint, printed in color. F & S 11.
Cow. (1971, dated 1973). Screenprint, printed in color. F & S 12.
Jackie I from the portfolio *11 Pop Artists*, Volume I. (1966). Screenprint, printed in color. F & S 13.
Jackie II from the portfolio *11 Pop Artists*, Volume II. (1966). Screenprint, printed in color. F & S 14.
Jackie III from the portfolio *11 Pop Artists*, Volume III. (1966). Screenprint, printed in color. F & S 15.
Self-Portrait. (1967, dated 1966). Screenprint. F & S 16.
Portraits of the Artists from the portfolio *Ten from Leo Castelli*. (1967). Screenprint, on one hundred, two-part, colored styrene boxes. F & S 17.
Marilyn Monroe (Marilyn). (1967). Screenprint, printed in color. F & S 21.
Marilyn Monroe (Marilyn). 1967. Portfolio of ten screenprints, printed in color. F & S 22–31.
Andy Warhol's Index (Book) by various authors. New York: A Black Star Book/Random House, 1967. Photolithographic reproduction of type and photographs (one printed in color), seven with pop-ups, fold-out, or collage. Not in F & S.
Plate 9 (folio 8) from the illustrated book *Stamped Indelibly*. New York: Indianakatz, 1967. Rubber stamp, printed in color. Not in F & S.
Flash—November 22, 1963 by Phillip Greer. Briarcliff Manor, N.Y.: Racolin Press, (1968). Illustrated book with twelve screenprints (including cover), printed in color. F & S 32–42 and page 44.
Campbell's Soup I. (1968). Portfolio of ten screenprints, printed in color. F & S 44–53.
Campbell's Soup II. (1969). Portfolio of ten screenprints, printed in color. F & S 54–63.
Flowers. (1970). Portfolio of ten screenprints, printed in color. F & S 64–73.
Portraits from the portfolio *Artists and Photographs*. (Published 1970). Photolithograph, printed in color and in black. Not in F & S.
Electric Chair. 1971. Portfolio of ten screenprints, printed in color. F & S 74–83.
Vote McGovern. (1972). Screenprint, printed in color. F & S 84.
Mao from the portfolio *The New York Collection for Stockholm*. (1973). Xerox. F & S 89.
Mao Tse-Tung. (1972). Portfolio of ten screenprints, printed in color. F & S 90–99.
Flowers (Hand Colored). (1974). Portfolio of ten screenprints with watercolor additions. F & S 110–19.
Untitled 12 from the portfolio *For Meyer Schapiro*. 1974. Screenprint, printed in color. F & S 120.
Paloma Picasso from the portfolio *America's Hommage à Picasso*. 1975. Screenprint, printed in color. F & S 121.

Merce Cunningham I from the portfolio *Merce Cunningham*. 1974 (Published 1975). Screenprint. F & S 124.
Mick Jagger from the portfolio *Mick Jagger*. (1975). Screenprint, printed in color. F & S 143.
Mick Jagger from the portfolio *Mick Jagger*. (1975). Screenprint, printed in color. F & S 144.

Tom Wesselmann

Born in Cincinnati, Ohio in 1931. Lives in New York. Leading Pop artist who became widely known for his work on two major series: the Great American Nude, begun in 1961 and the Great American Still Life, begun in 1962. Depicted each in flat, vibrant color and streamlined, abstracted forms. Developed collagelike style of painting in which three-dimensional household objects were cleverly juxtaposed with painted imagery. Often incorporated printed billboards, store display signs, and magazine advertisements into his work. Sporadic but inventive printmaker throughout 1960s and 1970s, who favored screenprint but also worked in unconventional formats, such as blind embossings. Completed several vacuum-formed plastic multiples during this period, as well as five banners and a tapestry edition. Also made unlimited editions of several hand-colored prints.

Biblio.: Fairbrother, Trevor. *Tom Wesselmann: Graphics 1964–1977*. Boston: Institute of Contemporary Art, 1978. See also nos. 67, 106, 115.

Double-page plate (pages 64, 65) from the illustrated book *1¢ Life* by Walasse Ting. Bern: E. W. Kornfeld, 1964. Lithograph, printed in color. Not in Fairbrother.
Double-page headpiece (pages 72, 73) from the illustrated book *1¢ Life* by Walasse Ting. Bern: E. W. Kornfeld, 1964. Lithograph, printed in color. Not in Fairbrother.
Cut Out Nude from the portfolio *11 Pop Artists*, Volume I. (1965, published 1966). Screenprint, printed in color. Fairbrother 4.
Little Nude from the multiples portfolio *7 Objects in a Box*. 1966. Spray-painted vacuum-formed plexiglass with foam backing. Fairbrother 6.
Still Life from the portfolio *New York 10*. 1965. Embossing with pencil additions. Fairbrother 8.
Nude from the portfolio *11 Pop Artists*, Volume II. (1965, published 1966). Screenprint, printed in color. Fairbrother 9.
TV Still Life from the portfolio *11 Pop Artists*, Volume III. (1965, published 1966). Screenprint, printed in color. Fairbrother 10.
Embossed Nude #1. (1965, dated 1967). Embossing with pencil and paint additions. Fairbrother 11.
Embossed Nude #1. (1965, dated 1967). Embossing with pencil and paint additions. Fairbrother 11.
Plate 2 (folio 3) from the illustrated book *Stamped Indelibly*. New York: Indianakatz, 1967. Rubber stamp, printed in color. Not in Fairbrother.
Seascape (Tit) from the portfolio *Graphik USA*. 1967 (Published 1968). Screenprint, printed in color. Fairbrother 13.
Seascape (Foot) from the portfolio *Edition 68*. 1968. Screenprint, printed in color. Fairbrother 14.
Nude (For Sedfre). 1969. Screenprint, printed in color. Fairbrother 17.

Notes on the Publishers

Compiled by Judith Hecker

Information on the publishers focuses on their collaborations with artists in this catalogue during the years 1960 to 1975. Each publisher entry is cross-referenced with works illustrated in the plate section. A bibliographic reference is cited if available.

Edizione dell'Aldina, Rome

Founded in 1969, along with Galleria Aldina, to promote the work of mid-career Italian artists, including abstract, realist, neo-romantic, and figurative painters Arnoldo Ciarrocchi, Fabrizio Clerici, Carlo Mattioli, Giovanni Omiccioli, Enrico Paulucci, Orfeo Tamburi, and Renzo Vespignani. Frequently exhibited and published prints by gallery artists, many produced at Edizione dell'Aldina's own workshop. Printed and released sixteen prints by Arroyo in 1970, mainly etchings and lithographs. Gallery closed and discontinued publishing and printmaking in 1975–76.

See plate entry, p. 86.

Editions Alecto, London

Founded in 1960 by Cambridge University undergraduates Paul Cornwall-Jones and Michael Deakin to publish topographical prints of neighboring schools and colleges. In 1962 relocated to London, was joined by directors Mark Glazebrook, John Guinness, Anthony Longland, and Joe Studholme, and began publishing editions by British artists. Worked extensively with screenprint workshop Kelpra Studio, London, during this period. Collaborated with Robert Erskine's St. George's Gallery in 1963 to form the Print Centre, an exhibition space for new editions. In 1964 Alecto relocated and established intalgio facilities and, within the next few years, lithography and screenprinting facilities. Became leading publisher of Pop prints and multiples in London, releasing landmark projects including Hockney's *A Rake's Progress* (1963), Paolozzi's *As Is When* (1965), Dine's *A Tool Box* (1966), and Oldenburg's *London Knees 1966* (1968). Also published works with Caulfield, Hamilton, Jones, and Ruscha. From 1967 until the early 1970s ran Alecto Gallery, an independent space for exhibiting and selling their publications. From 1967 to 1975 ran branch office in New York. Relocated in the 1980s and closed workshop. Actively publishes under the direction of Studholme.

Biblio.: Spencer, Charles, ed. *A Decade of Printmaking.* London: Academy Editions; New York: St. Martin's Press, 1973.

See plate entries, pp. 40, 42, 43, 50, 66, 74, 82, 106.

Ars Viva, Zurich

Founded in 1971 by film producers Peter Schamoni, Martin Hellstern, and Peter Hellstern to publish prints in large editions (ranging from 3,000 to 10,000) by artist Friedensreich Hundertwasser, with whom they worked on a film. Met Attilio Codognato in Venice and together released the 1973 portfolio *Les Nouveaux Réalistes* (The New Realists), which included works by Spoerri and Christo, among others. Ars Viva ceased publishing in 1975, but Schamoni and the Hellstern brothers continue to co-produce and distribute films. (See also Attilio Codognato entry.)

See plate entry, p. 30.

Bianchini Gallery, New York

Founded in 1958 by Paul Bianchini to exhibit work mainly by European painters and sculptors new to the United States. In the early 1960s began showcasing Pop art and representing Billy Apple, Geoffrey Hendricks, Ramos, Robert Stanley, and Robert Watts, among others. Held historic 1964 *American Supermarket* exhibition, organized by artist Ben Birillo with Paul Bianchini and Dorothy Herzka (who later married Roy Lichtenstein). Published and sold Warhol's *Campbell's Soup Can on Shopping Bag* and Lichtenstein's *Turkey Shopping Bag* to accompany the exhibition. Relocated in 1965 and opened a prints and drawings room in 1966. Displayed works on paper ranging from modern masters to contemporary artists including Dine, Johns, Lichtenstein, Ramos, Rauschenberg, Warhol, and Wesselmann. Gallery closed in 1967. Through the late 1960s and early 1970s Bianchini published lithographs with Oldenburg and produced limited edition deluxe books with original lithographs by Oldenburg and Lichtenstein (released with Publications I.R.L., Lausanne, Switzerland). Since 1992 Bianchini has directed the Galerie Toner in Paris, a non-profit organization promoting contemporary works made with new technologies.

See plate entries, pp. 56, 72.

Biblio.: Whiting, Cécile. *A Taste for Pop: Pop Art, Gender and Consumer Culture.* Cambridge and New York: Cambridge University Press, 1997.

Edition René Block, Berlin

Founded in 1964 by René Block, along with his Galerie René Block, to exhibit work and publish prints by German Pop and Conceptual artists. First exhibition, held in room above gallery prior to its opening, showcased Brehmer's first prints. Inaugural gallery exhibition was *Neodada, Pop, Décollage, Kapitalistischen Realismus.* In 1966 began publishing multiples by Joseph Beuys and Hamilton. In 1967 coordinated for Stolpe Verlag the publication of the portfolio *Grafik des Kapitalistischen Realismus* (Graphics of Capitalist Realism), which included work by Brehmer, K. H. Hödicke, Konrad Lueg, Polke, Richter, and Vostell. Continued to publish extensively with these artists. Organized exhibitions on print techniques in 1972 and on the history of the multiple in 1974. From 1974 to 1977 operated gallery in New York, predominantly exhibiting Beuys and Fluxus artists. Berlin gallery closed in 1979. From 1982–1992 Block headed exhibition and artist-in-residence programs at daad Galerie, an exhibition space supported by the federal DAAD (Deutscher Akademischer Austauschdienst) program which sponsors international composers and artists to work in Berlin. Block is currently an independent curator. (See also Stolpe Verlag entry.)

See plate entries, pp. 47, 84, 100.

Biblio.: "René Block." *Kunstforum International* 104 (November–December 1989): 254–64.

Leo Castelli Gallery, New York

Founded in 1957 by Leo Castelli, the first dealer to promote and exhibit works by American artists Johns, Lichtenstein, and Rauschenberg. In the 1960s published prints by Warhol and Lichtenstein, many of which were produced as folded mailers, posters, and signed editions to announce gallery exhibitions. In 1969 Toiny Castelli, the dealer's second wife, established Castelli Graphics to formalize print publishing and exhibition program for Castelli's stable of artists. Released prints by Johns, Lichtenstein, Oldenburg, Rauschenberg, Rosenquist, Ruscha, and Warhol, often in association with publishers such as Multiples, Inc., Brooke Alexander Editions, New York, and Petersburg Press, London. Also actively distributed editions by these and other artists, published by Universal Limited Art Editions, West Islip, N.Y.; Gemini G.E.L., Los Angeles; Factory Additions, New York; Styria Studio, Glendale, Calif. and New York; and Tamarind Lithography Workshop, Albuquerque, N.M. In 1977 Castelli Graphics expanded focus to include photography and artists outside the gallery's stable. Castelli Graphics closed in 1997. Leo Castelli Gallery is still active.

See plate entry, p. 46.

Biblio.: *Castelli Graphics: 1969–1988.* New York: Castelli Graphics, 1988. Text by Pat Marie Caporaso.

Attilio Codognato, Venice

Founded Galleria del Leone in Venice in 1962. Began publishing prints in 1973, a year after gallery closed, and published sporadically throughout the 1970s. Major works included the portfolio *Antologia della Grafica Surrealista* (published 1975) containing prints by Max Ernst, Man Ray, and André Masson, among others. Conceived and coordinated with publisher Ars Viva, Zurich, the production of the portfolio *Les Nouveaux Realistes* (The New Realists) in 1973. Included works by Christo, Rotella, Spoerri, and Jacques de la Villeglé, among others, many of whom exhibited at Galleria del Leone. Also published prints by Arman, César, Rotella, and other Europeans for Japanese market. Worked with a variety of printers and fabricators in Europe and Japan. Discontinued publishing in 1975. (See also Ars Viva entry.)

See plate entry, p. 30.

Dodo Designs, London

Founded by Robin Farrow in 1965 as company specializing in the design and reproduction of antique objects, enameled signs, and memorabilia. Idea grew from wife Liz Farrow's shop, Dodo Antiques, which sold items such as Union Jack clocks and original enameled advertisement signs which were displayed throughout London and in Underground stations. In 1967 commissioned Peter Blake to create a painting for reproduction as a sign in an edition of 10,000, the only commission of its kind by Dodo Designs. Also created numerous novelty and character products. Dodo Designs closed in 1987. Dodo Antiques is still active.

See plate entry, p. 99.

Edition Domberger, Stuttgart / Filderstadt

Founded in 1948 by Luitpold Domberger in Stuttgart as workshop and publisher specializing in screenprints. Domberger, a self-taught screenprinter, began publishing with artist Willi Baumeister, whose first prints were produced there. Expanded operations in 1961 after relocating to Filderstadt / Bonlanden near Stuttgart. Continued to focus on screenprinting, but expanded facilities to also produce collotype, etching, lithography, and multiples. Released multiples with D'Arcangelo and prints with Christo, D'Arcangelo, Fahlström, Hamilton, Indiana, Laing, Polke, Roth, and Smith. Regularly screenprinted with Richard Estes for publisher Parasol Press, New York. Also printed for Propyläen Verlag, Berlin; Galerie Der Spiegel, Cologne; Edition Schellmann, Munich and New York; and Multiples, Inc., New York. Worked extensively as a commercial printer making posters, calenders, and industrial products. Relocated to Filderstadt / Plattenhardt, also near Stuttgart, in

1986. Recent publications include prints by early and mid-career European and American artists. Is active under the leadership of Domberger's son, Michael, who has been director since 1986.

See plate entry, p. 64.

Biblio.: Michael Domberger. *30 Jahre Domberger, 20 Jahre Haas, 15 Jahre Kicherer.* Tübingen, Germany: Kunsthalle Tübingen, 1979. Text by Manfred de la Motte.

Durable Dish Co., Villanova, Pennsylvania

Founded in 1966 by partners Joan Kron, a collector and former costume and interior designer, and Audrey Sabol, a collector and art enthusiast, to produce limited edition ceramic place settings by Lichtenstein. Established as subsidiary of the Beautiful Bag Co., which Kron and Sabol had begun three years earlier to produce limited edition canvas bags printed with stencil designs by Sabol. Partnership led to the production of additional Pop multiples in 1966–67 under other subsidiary companies, including a "Love" ring by Indiana and a self-portrait ring by Marisol (both produced by the Rare Ring Co.) and an electric blinking "Eat" pin by Indiana (produced by the Genuine Electric Co.). Fiberglass luggage printed with stenciled messages (produced by the Lovely Luggage Co.) and unusually shaped stationary and decorative rubber stamps (produced by the Stunning Stationery Co.) were also released. In 1967 Kron and Sabol co-organized *The Museum of Merchandise*, an exhibition of functional multiples by Christo, D'Arcangelo, Rauschenberg, Ruscha, and Warhol, among others. Kron and Sabol discontinued producing multiples in 1967. (See also Audrey Sabol entry.)

See plate entry, p. 73.

Biblio.: Pacini, Marina. "Who but the Arts Council?" *Archives of American Art Journal* 27, no. 4 (1987): 9–23.

Richard Feigen Graphics, New York

Founded in 1968 by Richard Feigen to publish prints predominantly by artists represented by Richard L. Feigen & Co., his gallery founded eleven years earlier in Chicago and subsequently in New York. Under direction of Jacqueline Chambord, ran print gallery at the department store Bonwit Teller in the late 1960s. Published and / or distributed prints and multiples by British and American Pop artists Jones, Laing, Lichtenstein, Oldenburg, Smith, and Rosenquist. Also collaborated with Pop precursors Christo and Ray Johnson. Contracted various print workshops including Mourlot Graphics, New York; Ives-Sillman, New Haven, Conn.; Due Ricci, Rome; and Robert Blackburn, New York. In 1972 Feigen Graphics discontinued publishing. Gallery is still active with two locations in New York, Richard L. Feigen & Co. and Feigen Contemporary.

See plate entry, p. 94.

edition h, Hannover

Founded by Herbert August Haseke in 1965 to publish editions predominantly by young conceptual German artists shown at his galerie h, also established in 1965. Began exhibiting Richter and Polke within first year of opening. Published large-edition, photo-based prints in photolithograph and collotype techniques by them. Also released smaller edition screenprints by Antonio Caldera, Gotthard Graubner, Konrad Lueg, and Siegfried Neuenhansen, among others. Published multiples by artists such as Jiri Kolar. Gallery closed and discontinued publishing in 1970.

See plate entries, pp. 80, 102.

HofhausPresse, Düsseldorf

In 1961 Hans Möller established print workshop and publishing house under his own name and a year later assumed the name HofhausPresse. Primarily printed screenprints, but also produced experimental multiples, relief prints, prints on foam and metal, and prints with collage. Published the illustrated book *Das Grosse Buch* in 1964, which included work by Christo, Raysse, Arman, and Roth, among others. Also worked with Richter (releasing his first two prints, 1965–66), Pierre Restany, and many artists from the Zero Group (a kinetic art movement based in Düsseldorf). In 1975 Möller began teaching at the Kunstakademie, Düsseldorf, and collaborated with Konrad Klapheck and again with Richter. Publishing activities decreased after 1975, but were revitalized in 1990–91 by daughter Dominique Möller, who continues screenprinting activities but emphasizes more traditional techniques such as woodcut, etching, and lithography.

See plate entry, p. 96.

Institute of Contemporary Art (ICA), Philadelphia

Founded in 1964 on the campus of the University of Pennsylvania to exhibit and educate the public about contemporary art. Known for featuring work by vanguard artists early in their careers, including Warhol's first solo museum exhibition for which they published his *S&H Green Stamps* (1965). Editions published in the 1960s and early 1970s, including *S&H Green Stamps* and multiples by Christo, Indiana, and Lichtenstein, benefited exhibition program and were given to major patrons. In 1978 formalized annual publishing program by inviting internationally recognized and local emerging artists to create benefit prints, multiples, and photographs in conjunction with exhibitions. In 1979 published a print by Rauschenberg and in the 1980s collaborated again with Lichtenstein and Warhol. In 1991 moved into newly constructed building. Continues to publish benefit prints annually.

See plate entry, p. 60.

Biblio.: *Institute of Contemporary Art: Prints, Posters, and Catalogues.* Philadelphia: Institute of Contemporary Art, 1991.

Institute of Contemporary Arts (ICA), London

Opened in 1947 under the leadership of Herbert Read and Roland Penrose, as part gallery, library, and bar to support contemporary European avant-garde culture. Beginning in 1952 used as a forum for meetings, lectures, and exhibitions of the Independent Group. Held exhibitions which showcased Valerio Adami, Hockney, Jones, Laing, Phillips, Smith, and Tilson in the early 1960s. In 1964 published the seminal *ICA Portfolio*, including twenty-four prints, their only fine art publication from this period other than a benefit print by Picasso produced in the 1950s. In 1967 moved to a larger space and in the early 1970s held solo exhibitions of Dine, Hamilton (*Prints and Process*, 1972), and Roth. Is active as exhibition, performance, theater, and lecture space, and in recent years has been publishing prints and multiples by contemporary artists to benefit exhibition program.

See plate entries, pp. 61, 65, 103.

Biblio.: Robbins, David, ed. *The Independent Group: Postwar Britain and the Aesthetics of Plenty.* Hanover, N. H.: Hood Museum of Art, Dartmouth College; London: Institute of Contemporary Arts; Los Angeles: Museum of Contemporary Art; Berkeley: University Art Museum, University of California; Cambridge, Mass., and London: The MIT Press, 1990.

E. W. Kornfeld, Bern

Founded in 1864 in Stuttgart as H.G. Gutekunst auction house and gallery specializing in master prints and drawings from the fifteenth through eighteenth centuries. Relocated to Bern in 1919 and became Gutekunst and Klipstein. Renamed Klipstein and Kornfeld in 1951 when joined by Eberhard W. Kornfeld, who expanded program to include nineteenth- and twentieth-century master paintings, sculpture, drawings, prints, and illustrated books. Subsequently became Kornfeld and Klipstein, and in the early 1960s published prints with Sam Francis. In 1964 became Galerie Kornfeld, with publishing arm E. W. Kornfeld, and that year released their only major illustrated book publication, *1¢ Life* (edited by Francis, written by Walasse Ting), which included lithographs by several Pop artists. Is active year-round as gallery with focus on prints, and holds a major auction every June.

See plate entry, p. 98.

Biblio.: "Print Auctions Inside & Out: A Discussion." *The Print Collector's Newsletter* XV, no. 3 (July–August 1984): 87–94.

Dorothea Leonhart (Edition München International), Munich

Founded gallery in 1963 to promote the work of young German artists. Sold prints by modern masters to support endeavors with emerging artists. Began publishing in 1968 and produced large, affordable editions including a 1969/70 Friedensreich Hundertwasser print released in an edition of 6,400. Established Edition München International in 1970 and began collaborating on large editions with British artists Hamilton, Paolozzi, and Phillips. Also worked with Swiss artists Roth and André Thomkins. Contracted numerous print workshops in order to complete mass editions. Sold gallery and discontinued publishing in 1974.

See plate entry, p. 88.

Biblio.: Colsman-Freyberge, Heidi and Claus. "The German Print Market." *The Print Collector's Newsletter* III, no. 2 (May–June 1972): 32–34.

Studio Marconi, Milan

Gallery founded in 1965 by Giorgio Marconi to promote the work of young artists. Throughout 1960s and 70s primarily represented Italian artists such as Baj and Emilio Tadini, as well as other Europeans such as Hamilton and Paolozzi. Also held exhibitions of Americans Christo and Wesselmann. In 1966 began publishing prints and multiples, extensively with Valerio Adami, Baj, and Rotella, often in conjunction with exhibitions at the gallery. From 1975–79 produced magazine *Studio Marconi* with articles, reviews, and listings. In 1993 gallery was renamed Giò Marconi, under the direction of Marconi's son. Today primarily exhibits young Italian artists and continues to publish prints, printing with workshops near Milan.

See plate entry, p. 34.

Biblio.: *Studio Marconi Milano.* Milan: Studio Marconi, 1998.

Marlborough Graphics, London and New York

Founded by Barbara Lloyd in 1963–64 in London to publish and distribute editions by British artists represented by Marlborough Fine Art, London, founded in 1946. In 1964 opened print gallery in New York and began publishing internationally. Also distributed editions through Rome gallery in the 1960s. Published numerous

works by British Pop artists Jones, Paolozzi, and Tilson, among others, often collaborating with master screenprinter Chris Prater at Kelpra Studio, London. Published many of Tilson's experimental works and over one hundred works by R.B. Kitaj. Worked with D'Arcangelo and Rivers in New York. Began publishing in 1992 in Madrid with contemporary Spanish artists including Manolo Valdés (formerly of Equipo Crónica). Actively publishes and sells editions in London, New York, and Madrid. Marlborough Fine Art is also still active.

See plate entries, pp. 38, 91.

Biblio.: Locke, John. "Marlborough Prints." *Studio International*, suppl., 172 (884) (December 1966): 1.

Édition MAT (Multiplication d'Art Transformable) / Galerie Der Spiegel, Paris and Cologne

Founded in 1959 by artist Daniel Spoerri to publish series of affordable multiples in editions up to one hundred. MAT's first series, *Collection '59*, often referred to as the first multiples publication, was exhibited at Galerie Edouard Loeb, Paris, and included eight works by Marcel Duchamp, Man Ray, and Roth, among others. Spoerri collaborated in 1964 with artist/designer Karl Gerstner to publish MAT's second series, *Collection '64*, including twelve multiples by Roth and Nouveaux Réalistes Arman, Niki de Saint Phalle, Spoerri, and Jacques de la Villeglé, among others. Collection was hand-produced and exhibited at Galerie Der Spiegel, Cologne, before touring internationally. After *Collection '64*, Hein Stünke, Galerie Der Spiegel director, bought Édition MAT and produced *Collection '65* which included thirteen multiples by Arman, Baj, Christo, Lichtenstein, Roth, and Spoerri, among others. In 1965 Spoerri and Gerstner founded publishing off-shoots Éditions MAT MOT and TAM THEK which produced boxed-sets of multiples with text and objects, respectively. After *Collection '65* Galerie Der Spiegel discontinued producing MAT editions, but throughout the 1960s and 70s published prints with Indiana, Jacquet, and Segal, and represented editions by Editions Alecto, London; Multiples, Inc., New York; and Documenta Foundation, Kassel. Under direction of Werner Hillman since Stünke's death in 1994, Galerie Der Spiegel actively exhibits and sells prints and multiples.

See plate entry, p. 32.

Biblio.: Vatsella, Katerina. *Produkt: Kunst!: Wo bleibt das Original?* Bremen, Germany: Neues Museum Weserburg, 1997. Additional texts by Ina Conzen, Thomas Deecke, Danièle Perrier, et al.

Multiples, Inc., New York

Founded in 1965 by Marian Goodman, Robert Graham, Ursula Kalish, Barbara Kulicke, and Sonny Sloan to publish, exhibit, and sell affordable multiples that utilized new and imaginative materials. Known for experimentation with commercial and industrial processes and nontraditional elements such as metal, light, vacuum-formed plastic, and plexiglass. Worked predominantly with Pop artists Dine, Fählstrom, Indiana, Lichtenstein, Oldenburg, Rivers, Ruscha, Warhol, and Wesselmann. Also sold editions by Arman, Baj, Christo, D'Arcangelo, Marisol, Rauschenberg, Niki de Saint Phalle, Spoerri, and Thiebaud. Represented other publishers such as Édition MAT, Paris and Cologne; Tanglewood Press and Original Editions, New York. Continued publishing banners with the Betsy Ross Flag and Banner Co. In 1973 partnership dissolved, and in 1974 Goodman became sole owner and expanded

publishing activities with European artists. Throughout the 1970s collaborated with more traditional print workshops including Crown Point Press, Oakland, Calif., and Derrière l'Etoile, New York, and co-published with Castelli Graphics, New York. In 1977 established the Marian Goodman Gallery, New York, and since then has published as Multiples, Inc./Marian Goodman Gallery, although today primarily deals in unique work.

See plate entries, pp. 44, 75.

Biblio.: Chevrier, Jean-François. "Art Dealers: Marian Goodman." *Galleries Magazine*, December/January 1992: 97–99, 102, 125–26.

Neuendorf Verlag, Hamburg

Founded in 1964 by Hans Neuendorf as Galerie Neuendorf to represent California artists Billy Al Bengston, Joe Goode, and Robert Graham, and British artists Hamilton, Hockney, and Jones. Expanded stable to include Warhol as well as Europeans Georg Baselitz, Lucio Fontana, and Cy Twombly, among others. Began publishing in 1965 with Dine, Hamilton, Roth, Self, and Oldenburg, releasing the latter's *London Knees 1966* in 1968 with Editions Alecto, London. Co-founded the Cologne art fair in 1967. Relocated gallery to Frankfurt in 1987. Closed in 1994 when Neuendorf increased his involvement with ArtNet, a computer database specializing in the digitization of fine art and art-related internet services for publishers, auction houses, and galleries worldwide. (See also Editions Alecto entry.)

See plate entry, p. 106.

Original Editions, New York

Founded in 1965 by Philip Morris, Inc., in consultation with the public relations firm Ruder Finn, Inc., as a print publishing program that placed prints by British and American Pop artists in museums internationally. In 1966, under the direction of Rosa Esman of Tanglewood Press, New York, produced landmark series of portfolios *11 Pop Artists* (Volumes I, II, and III). Included prints by D'Arcangelo, Dine, Jones, Laing, Lichtenstein, Phillips, Ramos, Rosenquist, Warhol, John Wesley, and Wesselmann. Collaborated with Lichtenstein again in 1967 on *Ten Landscapes* portfolio before discontinuing publishing later that year.

See plate entries, pp. 101, 108, 109.

Petersburg Press, London and New York

Founded in 1967 in London by Paul Cornwall-Jones, formerly of Editions Alecto. Important publisher of innovative Pop portfolios, prints, and illustrated books, working extensively with British and American artists including Caulfield, Dine, Hamilton, Hockney, Johns, Jones, Lichtenstein, Oldenburg, Paolozzi, Rosenquist, Roth, and Smith. Released Roth's inventive portfolio *6 Piccadillies* (1970) and Caulfield's landmark illustrated book *Some Poems of Jules Laforgue* (1973). Worked closely with screenprinter Chris Prater at Kelpra Studio, London, with etchers Maurice Payne, London, and Aldo Crommelynck, Paris, and with numerous other workshops worldwide. Opened New York office in 1972 and established an etching and lithography workshop there in the 1980s. Discontinued publishing and printing in 1991.

See plate entries, pp. 48, 76.

Biblio.: Gilmour, Pat. "Graphics: Petersburg Press, Print Publishers X." *Arts Review* 26, no. 12 (June 1974): 271.

Racolin Press, Briarcliff Manor, New York

Founded in 1965 by Alexander E. Racolin, theater producer, attorney, and supporter of performance and fine art. Produced plays in England and off-Broadway in New York. Began publishing books to collaborate with and encourage the work of emerging artists. Released Warhol's *Flash—November 23, 1963* in 1968 after meeting the artist through Fritzie Miller, Racolin's friend and Warhol's commercial graphics representative. Published the multiple *Opal Gospel* (1972) with Rauschenberg, as well as illustrated books with established artists Giacomo Manzú and David Alfaro Siqueiros. Initiated book projects with Dine, Indiana, and Segal, among others, which were ultimately aborted. Racolin discontinued publishing after 1972.

See plate entry, p. 92.

Edition Rottloff / Edition Kaufhof, Karlsruhe, Germany

Founded in 1961 by Helgard Rottloff, along with Galerie Rottloff, to promote the work of young German artists. Also established print workshop to produce posters and invitations for exhibitions. Later in 1961 began publishing screenprints made at their workshop and etchings printed elsewhere. Worked with Markus Prachensky, Arnulf Rainer, and many Zero Group artists (a kinetic art movement based in Düsseldorf) new to printmaking, including Heinz Mack, Georg-Karl Pfahler, Otto Piene, Lothar Quinte, and Günther Uecker, who also exhibited at the gallery. In 1965 established Edition Kaufhof for one year to produce thirty-two prints with new group of artists, including Horst Antes, Gerhard Hoeme, and Bernard Schultze, for distribution in Kaufhof department stores in Cologne, Munich, and Düsseldorf. Published Richter's *Airplane* I for Kaufhof stores and *Airplane II* for Edition Rottloff, both in 1965. Worked with Richter again in 1966 completing a third print and an object for a series of multiples by Rottloff artists. In 1977 added etching facilities to workshop. Discontinued printing and publishing in 1985, but Galerie Rottloff continues to exhibit the work of young German artists.

See plate entry, p. 87.

Biblio.: Rößling, Wilfried, ed. *Vorbilder: Kunst in Karlsruhe 1950–1988.* Karlsruhe: W. Rössling im Auftrag des Badischen Kunstvereins Karlsruhe, 1988.

Audrey Sabol, Villanova, Pennsylvania

Philadelphia collector and art enthusiast who was introduced to the work of Dine, Fahlström, Johns, Oldenburg, and Rauschenberg in the early 1960s by engineer and artist collaborator Billy Klüver. Active as Fine Arts Committee member of the Philadelphia Arts Council, sponsored by the Young Men's/Young Women's Hebrew Association, which brought work by contemporary New York-based artists and performers to Philadelphia. Organized 1962 exhibition *Art 1963—A New Vocabulary* with Klüver and fellow committee member Joan Kron, among others, which featured work by Dine, Johns, Lichtenstein, Oldenburg, Rauschenberg, Rosenquist, Segal, and several Fluxus artists. In 1963 Sabol and Kron established the Beautiful Bag Co., which spawned numerous small multiples companies including the Durable Dish Co. Her interest in the activities of contemporary West coast artists led Sabol to independently publish Ruscha's *Standard Station* (1966), her only solo print publishing venture. That year Sabol organized the exhibition *A Wild West Show or How the West Was Done* for the Philadelphia Arts Council, which included work by Thiebaud and Ruscha, among other California artists. (See also Durable Dish Co. entry.)

See plate entries, pp. 62, 73.

Biblio.: Pacini, Marina. "Who but the Arts Council?" *Archives of American Art Journal* 27, no. 4 (1987): 9–23.

Galleria Schwarz, Milan

Founded in 1954 by Arturo Schwarz, a poet, collector, and scholar, as gallery specializing in Dada and Surrealist art. Began publishing illustrated books with contemporary Italian artists in 1954, including Baj. Throughout the 1960s published historic prints and multiples by Marcel Duchamp and Man Ray, as well as prints, illustrated books, and multiples by American and European artists Arman, Konrad Klapheck, Raysse, Rotella, Spoerri, and Thiebaud, many released in conjunction with exhibitions at the gallery. In 1962 began work on the seven volume illustrated book *Anthology of Contemporary Engraving*, which included editions by Baj, Paolozzi, and Rotella. Volume 5, subtitled *America Discovered* and co-published (under the pen name Tristan Sauvage) with Billy Klüver, introduced printmaking to many American artists. Gallery closed and discontinued fine art publishing in 1975. In 1998 Schwarz reissued an extensive, updated edition of his Duchamp catalogue raisonné (first published in 1969).

See plate entries, pp. 35, 78.

Biblio.: Schwarz, Arturo, ed. *1954–1964: Ten Years of Numbered Editions*. Milan: Galleria Schwarz, 1964.

Stolpe Verlag, Berlin

Founded around 1965 by Rosemarie Haas to publish editions predominantly by young German artists. Released prints and multiples by abstract, constructivist, conceptual, and kinetic artists including Rupprecht Geiger, Wolfgang Ludwig, Günther Uecker, and Timm Ulrichs. With coordination of René Block, released historic 1967 portfolio *Grafik des Kapitalistischen Realismus* (Graphics of Capitalist Realism), including prints by Brehmer, K.H. Hödicke, Konrad Lueg, Polke, Richter, and Vostell. Discontinued publishing in 1969. (See also Edition René Block entry.)

See plate entries, pp. 47, 84, 100.

Tanglewood Press, New York

Founded in 1964 by Rosa Esman with backing of partners Doris Friedman and Hans J. Kleinschmidt to produce affordable Pop editions, primarily in portfolios and boxed-sets. Published numerous groundbreaking portfolios of the period including *New York Ten* (1965) and *New York International* (1966). Was leading producer of Pop multiples in America, with several innovative group projects including *7 Objects in a Box* (1966) and *Ten from Leo Castelli* (1967). From 1970–72 Esman ran Abrams Original Editions for book publisher Harry N. Abrams, producing prints and multiples by Red Grooms, Marisol, Saul Steinberg, and Wesselmann, among others. In 1972 Esman established Rosa Esman Gallery and broadened scope to showcase avant-garde movements in both unique and multiple formats. Closed gallery in 1993 and one year later founded Ubu Gallery with partners Jack Banning and Adam Boxer, located in former Bianchini Gallery space. Esman continues to co-direct Ubu Gallery and publish under the Tanglewood Press name.

See plate entries, pp. 36, 52, 68.

Biblio.: Glenn, Constance W. *The Great American Pop Art Store: Multiples of the Sixties*. Long Beach: University Art Museum, California State University; Santa Monica: Smart Art Press,

1997. Additional texts by Linda Albright-Tomb, Dorothy Lichtenstein, and Karen L. Kleinfelder.

Universal Limited Art Editions (ULAE), West Islip, New York

Founded by Tatyana Grosman as Limited Art Editions in the early 1950s to sell fine art reproductions printed by her husband Maurice Grosman. Renamed Universal Limited Art Editions in 1956, and a year later Grosman redirected efforts to publish original prints. With legendary attention to quality and detail, led revival of stone-based lithography in America. Introduced Rivers to printmaking in 1957, Johns in 1960, and Rauschenberg to lithography in 1962, remaining their most important workshop during this period. Also collaborated extensively with Dine, Marisol, and Rosenquist. Developed important experimental techniques with limestone, including better photosensitivity, which was particularly important for Rauschenberg. Added etching facilities in 1966, offset lithography press in 1971, photographic workshop in 1973, and woodcut printing facilities in 1974 (which remained for one year and returned in 1981). William Goldston, ULAE printer since 1969, began running workshop in 1976 and became director in 1982. Actively publishes with many artists of the Pop generation.

See plate entries, pp. 26, 28, 58, 77.

Biblio.: *Universal Limited Art Editions: A History and Catalogue: The First Twenty-Five Years*. Chicago: The Art Institute of Chicago; New York: Harry N. Abrams, Inc., 1989. Texts by Esther Sparks and Amei Wallach.

Éditions Georges Visat, Paris

In 1937 master etcher Georges Visat established a print workshop, and from 1947 to 1954 produced etchings from paintings by Georges Braque, Marc Chagall, Fernand Léger, and Joan Miró for Galerie Maeght, Paris. In 1961, with support of artist Max Ernst, founded Éditions Georges Visat to print and publish original etchings and illustrated books predominantly by Pierre Alechinsky, Hans Bellmer, Ernst, René Magritte, and Matta. Began working with younger generation of French artists including César, Jacquet, and Peter Klasen, occasionally making screenprints as well. Also published lithographs printed at other workshops. In 1969 opened gallery for exhibiting editions by young artists. In 1970 produced portfolio *Hommage à Christophe Colomb et à Marcel Duchamp*, which included works by American and European artists Arman, Christo, Johns, Oldenburg, Rauschenberg, and Richter. Also collaborated with Lichtenstein during this period. Devoted to popularizing etching while maintaining small edition sizes in order to preserve notions of quality and rarity. Discontinued publishing and printing in 1977.

See plate entry, p. 105.

Biblio.: Adhémar, Jean. *Georges Visat: Éditeur d'Art*. Paris: À Saint-Germain-des-Prés, n.d.

Waddington Galleries, London

Founded by Leslie Waddington in 1966 to exhibit work by European and American modern masters and contemporary artists. Began publishing editions with British artists in 1967 as Waddington Graphics. In 1973 Alan Cristea, formerly of Marlborough Graphics, London, became director of Waddington Graphics and expanded operations by publishing with artists outside the gallery's stable. Also began dealing in modern and contemporary prints. Published numerous works with British Pop

artists including Blake, Hamilton, Jones, Smith, Tilson, and Caulfield, including the latter's illustrated book, *Some Poems of Jules Laforgue* (1973), published in association with Petersburg Press. Worked with printers Kelpra Studio, London; Aldo Crommelynck, Paris; and Grafica Uno, Milan; among others. Waddington Graphics became Alan Cristea Gallery in 1995; continues to publish with contemporary artists and sell modern prints. Waddington Galleries is active with three locations in London. (See also Petersburg Press entry.)

See plate entry, p. 76.

Biblio.: Gilmour, Pat. "Print Publishers II: Waddington." *Arts Review* 26, no. 3 (1974): 59.

The Wadsworth Atheneum, Hartford, Connecticut

Founded in 1844 by Daniel Wadsworth, it is the oldest American public art museum. In 1964, under paintings curator Samuel Wagstaff, Jr., released first publication, *X + X (Ten Works by Ten Painters)*, which benefited the museum and was among the earliest portfolios to feature Pop prints. Worked with print workshop Sirocco Screenprinters, North Haven, Conn., supervised by Ives-Sillman, New Haven, Conn. Collaborated again with Sirocco to publish portfolio by Ad Reinhardt in 1966. Co-published several portfolios and prints by Sol Lewitt with Parasol Press, New York, in 1971. Throughout 1970s organized solo exhibitions of American artists including Christo, Johns, Ruscha, and Warhol. Discontinued publishing editions after 1971; museum is still operating.

See plate entries, pp. 70, 90.

Biblio.: Ayres, Linda, ed. *"The Spirit of Genius": Art at the Wadsworth Atheneum*. Hartford, Conn.: The Wadsworth Atheneum; New York: Hudson Hills Press, 1992.

Selected Bibliography

Bibliographic entries from sections II and III are cross-referenced by number with "Notes on the Artists and Works in the Collection" beginning on page 114.

I. General Pop

1 Alloway, Lawrence. *American Pop Art*. New York: Whitney Museum of American Art; New York: Collier Books, Macmillan Publishing Co., 1974.

2 ———, Allan Kaprow, and Martha Jackson. *New Forms— New Media I*. New York: Martha Jackson Gallery, 1960.

3 ———. *This is Tomorrow*. London: The Whitechapel Art Gallery, 1956.

4 Amaya, Mario. *Pop Art…And After*. New York: The Viking Press, 1972. First published as *Pop as Art*. London: Studio Vista Limited, 1966.

5 *Art Since Mid-Century: The New Internationalism; Volume 2, Figurative Art*. Greenwich, Conn.: New York Graphic Society, 1971. Texts by Mario Amaya, Pierre Restany, Gérald Gassiot-Talabot, et al.

6 *The Art of Things*. Toronto: Jerrold Morris International Gallery, 1963.

7 Ashbery, John, and Pierre Restany. *International Exhibition of the New Realists*. New York: Sidney Janis Gallery, 1962.

8 Ayres, Anne. *L.A. Pop in the Sixties*. Newport Beach, Calif.: Newport Harbor Art Museum, 1989. Additional texts by Jay Belloli, Judi Freeman, Karen Tsujimoto, et. al.

9 Bailey, Elizabeth. *Small Colour Book 13*. London: The Victoria & Albert Museum, 1976.

10 *Bande Dessinée et Figuration Narrative*. Paris: Musée des Arts Decoratifs, Palais du Louvre, 1967. Texts by Pierre Couperie, Proto Destefanis, Gérald Gassiot-Talabot, et al.

11 Becker, Wolfgang, and Enrico Pedrini. *Pop Art America Europa: dalla Collezione Ludwig*. Florence: Centro Mostre di Firenze; Milan: Electa Spa, 1987. Additional text by Sergio Salvi.

12 Born, Richard A. *From Blast to Pop: Aspects of Modern British Art, 1915–1965*. Chicago: The David and Alfred Smart Museum of Art, The University of Chicago, 1997. Additional text by Keith Hartley.

13 *Breakthroughs: Avant-Garde Artists in Europe and America, 1950–1990*. Columbus: Wexner Center for the Arts, The Ohio State University; New York: Rizzoli International Publications, 1991. Texts by Dore Ashton, David Bourdon, Sarah Rogers-Lafferty, et al.

14 Calas, Nicolas, and Elena Calas. *Icons and Images of the Sixties*. New York: E.P. Dutton & Co., 1971.

15 Clair, Jean. *Art en France: Une nouvelle génération*. Paris: Sté Nouvelle des Éditions du Chêne, 1972.

16 Compton, Michael. *Pop Art*. London, New York, Sydney, and Toronto: The Hamlyn Publishing Group Limited, 1970.

17 Contensou, Bernadette. *1960 Les Nouveaux Réalistes*. Paris: Musée d'Art Moderne de la Ville de Paris, 1986. Additional texts by Aude Bodet, Sylvain Lecombre, and Pierre Restany.

18 Crispolti, Enrico. *La Pop Art*. Milan: Fratelli Fabbri Editori, 1966.

19 Crow, Thomas. *The Rise of the Sixties: American and European Art in the Era of Dissent*. New York: Harry N. Abrams, 1996.

20 Ferguson, Russell, ed. *Hand-Painted Pop: American Art in Transition, 1955–62*. Los Angeles: The Museum of Contemporary Art, 1992. Texts by Stephen C. Foster, Donna de Salvo, Paul Schimmel, et al.

21 Finch, Christopher. *Image as Language: Aspects of British Art 1950–1968*. London: Penguin Books, 1969.

22 ———. *Pop Art: Object and Image*. London: Studio Vista Limited.; New York: E.P. Dutton & Co., 1968.

23 Fineberg, Jonathan. *Art Since 1940: Strategies of Being*. New York: Harry N. Abrams, 1995.

24 Frith, Simon, and Howard Horne. *Art into Pop*. London and New York: Methuen and Co., 1987.

25 Gassiot-Talabot, Gérald. *La Figuration Narrative dans l'Art Contemporain*. Paris: Galerie Europe and Galerie Creuze, 1965.

26 ———. *Mythologies Quotidiennes*. Paris: Musée d'Art Moderne de la Ville de Paris, 1964.

27 Geldzahler, Henry. *Making It New: Essays, Interviews, and Talks*. Chappaqua, N.Y.: Turtle Point Press, 1994.

28 ———. *Pop Art 1955–70*. New York: The International Council of The Museum of Modern Art, with the International Cultural Corporation of Australia Limited, 1985.

29 Haskell, Barbara. *Blam! The Explosion of Pop, Minimalism, and Performance, 1958–64*. New York: Whitney Museum of American Art in association with W.W. Norton & Co., 1984. Additional text by John G. Hanhardt.

30 Kirby, Michael. *Happenings: An Illustrated Anthology*. New York: E.P. Dutton & Co., 1965.

31 ———. *Pop Art*. New York and Washington, D. C.: Frederick A. Praeger, 1966.

32 Lane, Hilary, and Isobel Johnstone. *Ready, Steady, Go: Painting of the Sixties from the Arts Council Collection*. London: The South Bank Centre, 1992. Additional text by Alan Sinfield.

33 Lippard, Lucy R. *Pop Art*. New York: Thames and Hudson, 1985 (reprinted 1996). Additional texts by Lawrence Alloway, Nancy Marmer, and Nicolas Calas.

34 Livingstone, Marco, ed. *Pop Art*. London: Royal Academy of Arts and Weidenfeld & Nicolson, 1991. Additional texts by Constance W. Glenn, Alfred Pacquement, Evelyn Weiss, et al.

35 ———. *Pop Art: A Continuing History*. New York: Harry N. Abrams, 1990.

36 ———, ed. *The Pop '60s: Travessia Transatlântica/ Transatlantic Crossing*. Lisbon: Centro Cultural de Belém, 1997. Additional texts by Constance W. Glenn and Alexandre Melo.

37 *London: The New Scene*. Minneapolis, Minn.: Walker Art Center with the Calouste Gulbenkian Foundation, 1965. Texts by Martin Friedman, Alan Bowness, and Jasia Reichardt.

38 Madoff, Steven Henry, ed. *Pop Art: A Critical History*. Berkeley and London: University of California Press, 1997.

39 Mahsun, Carol Anne. *Pop Art and the Critics*. Ann Arbor, Mich., and London: UMI Research Press, 1987.

40 ———, ed. *Pop Art: The Critical Dialogue*. Ann Arbor, Mich., and London: UMI Research Press, 1989.

41 Mamiya, Christin J. *Pop Art and Consumer Culture: American Super Market*. Austin: University of Texas Press, 1992.

42 Mellor, David. *The Sixties Art Scene in London*. London: Barbican Art Gallery, 1993.

43 ———, and Laurent Gervereau, eds., with Sarah Wilson and Laurence Bertrand Dorléac. *The Sixties: Britain and France, 1960–1973—The Utopian Years*. London: Philip Wilson Publishers, 1997.

44 Millet, Catherine. *L'Art Contemporain en France*. Paris: Flammarion, 1987.

45 *Modern Dreams: The Rise and Fall and Rise of Pop*. New York: The Institute for Contemporary Art, The Clocktower Gallery; Cambridge, Mass., and London: The MIT Press, 1988. Texts by Judith Barry, Thomas Lawson, Brian Wallis, et al.

46 Osterworld, Tilman. *Pop Art*. Cologne and New York: Taschen, 1991.

47 *11 Pop Artists: The New Image*. Bern: Kunsthalle Bern, 1966.

48 *Popular Art: Artistic Projections of Common American Symbols*. Kansas City, Mo.: William Rockhill Nelson Gallery of Art and Mary Atkins Museum of Fine Arts, 1963.

49 Restany, Pierre. *Les Nouveaux Réalistes: Un manifeste de la nouvelle peinture*. Paris: Éditions Planète, 1968.

50 ———. *60/90: Trente ans de Nouveau Réalisme*. Paris: La Différence, 1990.

51 Robbins, David, ed. *The Independent Group: Postwar Britain and the Aesthetics of Plenty*. Cambridge, Mass., and London: The MIT Press, 1990. Additional texts by Lawrence Alloway, Diane Kirkpatrick, and Alison and Peter Smithson, et al.

52 Rublowsky, John. *Pop Art*. New York: Basic Books, 1965.

53 Russell, John, and Suzi Gablik. *Pop Art Redefined*. New York and Washington, D.C.: Frederick A. Praeger, 1969.

54 Sandler, Irving. *American Art of the 1960s*. New York: Harper and Row; Toronto: Fitzhenry & Whiteside, 1988.

55 Schneede, Uwe M., and Frank Whitford. *Pop Art in England: Beginnings of a New Figuration, 1947–63*. Hamburg: Kunstverein, 1976.

56 Stich, Sidra. *Made in U.S.A.: An Americanization in Modern Art, the '50s & '60s*. Berkeley and London: University of California Press, 1987.

57 Taylor, Paul. *Post-Pop Art*. Cambridge, Mass., and London: The MIT Press, 1989. Additional texts by Roland Barthes, Jean Baudrillard, and Andreas Huyssen, et al.

58 Umland, Anne. *Pop Art: Selections from The Museum of Modern Art*. New York: The Museum of Modern Art, for High Museum of Art, Atlanta, 1998. Additional texts by Leslie Jones, Laura Hoptman, and Beth Handler.

59 Varnedoe, Kirk, and Adam Gopnik. *High and Low: Modern Art and Popular Culture*. New York: The Museum of Modern Art, 1991.

60 ———, eds. *Modern Art and Popular Culture: Readings in High & Low*. Additional texts by Robert Rosenblum, Robert Storr, and Jeffrey S. Weiss, et al. New York: The Museum of Modern Art and Harry N. Abrams, 1990.

61 Walker, John A. *Cross-Overs: Art into Pop/Pop into Art*. New York and London: Methuen & Co., 1987.

62 Wallis, Brian, and Thomas Finkelpearl. *This is Tomorrow Today: The Independent Group and British Pop Art*. New York: The Institute for Art and Urban Resources for The Clocktower Gallery, 1987. Additional texts by Judith Barry, Dick Hebdige, Thomas Lawson, et al.

63 Whiting, Cécile. *A Taste for Pop: Pop Art, Gender, and Consumer Culture*. Cambridge, Eng.: Cambridge University Press, 1997.

II. Contemporary Prints and Multiples

64 Ackley, Clifford S. *PhotoImage: Printmaking 60s to 90s*. Boston: Museum of Fine Arts, 1998.

65 Armstrong, Elizabeth, and Sheila McGuire. *First Impressions: Early Prints by Forty-Six Contemporary Artists*. Minneapolis:

Walker Art Center; New York: Hudson Hill Press, 1989.

66 *Ars Multiplicata: Vervielfältigte Kunst seit 1945.* Cologne: Wallraff-Richartz-Museum, 1968.

67 Bachler, Karl. *Serigraphie: Geschichte des Künstler-Siebdrucks.* Lübeck: Verlag Der Siebdruck, Graphische Werkstätten, 1977.

68 Block, René, and Ursula Block. *Multiples: Ein Versuch die Entwicklung des Auflagenobjektes darzustellen / Multiples: An Attempt to Present the Development of the Object Edition.* Berlin: Neuer Berliner Kunstverein, 1974.

69 Buchholz, Daniel, and Gregorio Magnani, eds. *International Index of Multiples: From Duchamp to the Present.* Tokyo: Spiral / Wacoal Art Center; Cologne: Verlag der Buchhandlung Walther König, 1993.

70 Castleman, Riva. *American Impressions: Prints Since Pollock.* New York: Alfred A. Knopf, 1985.

71 ———. *Printed Art: A View of Two Decades.* New York: The Museum of Modern Art, 1980.

72 Dückers, Alexander. *Druckgraphik der Gegenwart, 1960–1975: im Berliner Kupferstichkabinett.* Berlin: Kupferstichkabinett, Staatliche Museen, Preußischer Kulturbesitz, 1975.

73 ———. *Druckgraphik: Wandlungen eines Mediums seit 1945.* Berlin: Kupferstichkabinett, Staatliche Museen, Preußischer Kulturbesitz, 1981.

74 Dyckes, William, ed. *Contemporary Spanish Art.* New York: The Art Digest, 1975

75 Felix, Zdenek, Stefan Germer, Claus Pias, and Katerina Vatsella. *Das Jahrhundert des Multiple: Von Duchamp bis zur Gegenwart.* Hamburg: Deichtorhallen; Oktagon Verlag, 1994.

76 Fine, Ruth E. *Gemini G.E.L.: Art and Collaboration.* Washington, D.C.: National Gallery of Art; New York: Abbeville Press, 1984.

77 Gilmour, Pat. *Hockney to Hodgkin: British Master Prints 1960–1980.* New Orleans: New Orleans Museum of Art, 1997.

78 ———. *Kelpra Studio: Artists' Prints 1961–1980, An Exhibition to Commemorate the Rose and Chris Prater Gift.* London: The Tate Gallery, 1980.

79 ———. *The Mechanised Image: An Historical Perspective on 20th Century Prints.* London: Arts Council of Great Britain, 1978.

80 ———. *Modern Prints.* London: Studio Vista and E. P. Dutton & Co., 1970.

81 ———. *Understanding Prints: A Contemporary Guide.* London: Waddington Galleries, 1979.

82 Giménez, Carmen, and Everett Rice. *Contemporary Spanish Prints.* Madrid: Grupo Quince, 1979.

83 *Graphik der Welt; Internationale Druckgraphik der letzten 25 Jahre.* Saint Gallen, Switzerland: Erker—Verlag, 1971.

84 Hansen, Trudy V., David Mickenberg, Joann Moser, and Barry Walker. *Printmaking in America: Collaborative Prints and Presses, 1960–1990.* Evanston, Ill.: Mary and Leigh Block Gallery, Northwestern University; New York: Harry N. Abrams, 1995.

85 Hogben, Carol, and Rowan Watson, eds. *From Manet to Hockney: Modern Artists' Illustrated Books.* London: The Victoria & Albert Museum, 1985.

86 Hults, Linda C. "Printmaking in Europe and America after World War II." Chapter 13 in *The Print in the Western World: An Introductory History.* Madison: The University of Wisconsin Press, 1996.

87 Knigin, Michael, and Murray Zimiles. *The Contemporary Lithographic Workshop Around the World.* New York: Van Nostrand Reinhold Company, 1970.

88 Lane, Hilary, and Andrew Patrizio, with Isobel Johnstone, Paul Martin, and Nicolà White. *Art Unlimited: Multiples of the 1960s and 1990s from the Arts Council Collection.* London: The South Bank Centre, 1994.

89 McKenna, George L. *Repeated Exposure: Photographic Imagery in the Print Media.* Kansas City, Mo.: William Rockhill Nelson Gallery of Art and Mary Atkins Museum of Fine Arts, 1982.

90 Mœglin-Delcroix, Anne. *Esthétique du livre d'artiste: 1960–1980.* Paris: Éditions Jean-Michel Place / Bibliothèque Nationale de France, 1997.

91 Newton, Charles. *Photography in Printmaking.* London: The Victoria & Albert Museum and Pitman Publishing; Wiltshire: The Compton Press, 1979.

92 Riley, Richard. *Out of Print: British Printmaking, 1946–1976.* London: The British Council, 1994.

93 Robinson, Franklin W., ed. *Untitled: Twentieth Century Prints from the Dartmouth College Collection.* Hanover, N.H.: Dartmouth College Department of Art, 1972.

94 Ruhé, Harry. *Multiples, et cetera.* Amsterdam: Galerie A and Tuja Books, 1991.

95 Sparks, Esther. *Universal Limited Art Editions: A History and Catalogue, The First Twenty-Five Years.* Chicago: The Art Institute of Chicago; New York: Harry N. Abrams, 1989.

96 Tallman, Susan. *The Contemporary Print: From Pre-Pop to Postmodern.* New York: Thames and Hudson, 1996.

97 Tancock, John L. *Multiples: The First Decade.* Philadelphia: Philadelphia Museum of Art, 1971.

98 *The Tate Gallery 1982–84: Illustrated Catalogue of Acquisitions.* London: Tate Gallery Publications, 1986.

99 *The Tate Gallery 1984–86: Illustrated Catalogue of Acquisitions.* London: Tate Gallery Publications, 1988.

100 Thiem, Gunther, ed. *Amerikanische und Englische Graphik der Gegenwart: aus der Graphischen Sammlung der Staatsgalerie Stuttgart.* Stuttgart: Staatsgalerie, 1974.

101 *3–∞: New Multiple Art.* London: Arts Council of Great Britain for the Whitechapel Art Gallery, 1971. Texts by Reyner Banham, Janet Daley, Karl Gerstner, et al.

102 *Tradition and Conflict: Images of a Turbulent Decade, 1963–1973.* New York: The Studio Museum in Harlem, 1985. Texts by Benny Andrews, Mary Schmidt Campbell, Vincent Harding, et al.

103 Vatsella, Katerina. *Produkt, Kunst!: Wo bleibt das Original?* Bremen, Germany: Neues Museum Weserburg, 1997. Additional texts by Ina Conzen, Thomas Deecke, Danièle Perrier, et al.

104 Wye, Deborah. *Committed to Print: Social and Political Themes in Recent American Printed Art.* New York: The Museum of Modern Art, 1988.

III. Pop Prints and Multiples

105 *American Prints from the Sixties.* New York: Susan Sheehan Gallery, 1989.

106 Becker, Jürgen, and Wolf Vostell. *Happenings: Fluxus, Pop Art, Nouveau Réalisme.* Hamburg: Rowohlt Verlag, 1965.

107 Blanchebarbe, Ursula. *Pop-Art und Realismus: Werke aus der Graphischen Sammlung der Kunsthalle Bielefeld.* Bielefeld, Germany: Kunsthalle Bielefeld, 1988.

108 Block, René. *Grafik des Kapitalistischen Realismus.* Berlin: Edition René Block, 1971.

109 Bond, Anthony, and Kay Vernon. *British Prints of the 1960s and 1970s: From the Collection of Tony Reichardt.* Sydney: Art Gallery of New South Wales, 1990.

110 Butin, Hubertus. *Grafik des Kapitalistischen Realismus / Graphics of Capitalist Realism.* Frankfurt: Galerie Bernd Slutzky, 1992.

111 Casimiro, José Gandía. *Estampa Popular.* Exhibition organized by Teresa Millet. Valencia, Spain: Instituto Valenciano de Arte Moderno (IVAM) Centre Julio González, 1996.

112 Fleming, Marie L. *Pop Art: Prints & Multiples.* Ontario: The Art Gallery of Ontario, 1982.

113 Gall, Ulrike, and Roland Scotti. *Pop: Kunst der 60er Jahre, Druckgraphik und Tassen Sammlung Beck.* Ludwigshafen am Rhein: Wilhelm-Hack-Museum, 1991.

114 Glenn, Constance W. *The Great American Pop Art Store: Multiples of the Sixties.* Long Beach: University Art Museum, California State University; Santa Monica: Smart Art Press, 1997. Additional texts by Linda Albright-Tomb, Dorothy Lichtenstein, and Karen L. Kleinfelder.

115 Goldman, Judith. *The Pop Image: Prints and Multiples.* New York: Marlborough Graphics, 1994. Additional texts by Ronny Cohen, Mignon Nixon, Hubertus Raben, and Christopher Sweet.

116 Kozloff, Max. *Pop Prints.* London: Arts Council of Great Britain, 1964.

117 Livingstone, Marco. *Pop Prints.* London: The South Bank Centre, 1993.

118 *The Pop Art Print.* Fort Worth, Tex.: The Fort Worth Art Museum, 1984.

119 *Pop-Sammlung Beck.* Düsseldorf: Rheinland-Verlag, 1970.

120 Primus, Zdenek, ed. *Much Pop More Art: Kunst der 60er Jahre in Grafiken, Multiples und Publikationen / Art of the 60s in Graphic Works, Multiples, and Publications.* Stuttgart: Amerika Haus and Mercedes-Benz AG, 1992. Additional text by Manfred Kratz.

121 Richmond, Susan, and Joan Young. *The New Spirit: Pop Prints and Their Legacy.* Ed. Jonathan Bober. Austin: Archer M. Huntington Art Gallery, College of Fine Arts, University of Texas, 1996.

122 *S.M.S.* Paris: Didier Lecointre and Denis Ozanne, 1989.

123 Spencer, Charles, ed. *A Decade of Printmaking.* London: Academy Editions; New York: St. Martin's Press, 1973. Additional texts by Robert Erskine, Eduardo Paolozzi, Joe Studholme, et al. Interview by Richard Bellamy with George Segal.

124 Stemmler, Dierk. *Pop Art und Umfeld: Druckgraphik aus der Sammlung Etzold.* Mönchengladbach, Germany: Städtisches Museum Abteiberg Mönchengladbach, 1989.

125 Taylor, Sue. *POP! Prints from the Milwaukee Art Museum.* Milwaukee: Miwaukee Art Museum, 1993.

Index

Abstract Expressionism: 9, 28, 75, 77, 98
Adami, Valerio: 9
Aetna Silkscreen Products: 13, 92
affichistes: 35, 84
Airplane I (Flugzeug I): *87*, 87
Edizione dell'Aldina: 86, 128
Editions Alecto: 11, 40, 42, 43, 50, 66, 74, 82, 106, 128
Alloway, Lawrence: 18
Alpino: *53*, 53
American Supermarket: 16, 56, 72
Arcay, Wilfredo: 11
Arman (Armand P. Arman): 10, 13, 17, 18, 23, 24, 26, 28, 32, 36, 96, 114
Arroyo, Eduardo: 21, 86, 114
Ars Viva: 30, 128
As Is When: *10*, 10, *42*, 42
J. & P. Atchinson: 24, 109
L'Atelier Populaire: 12, 23, 54
Babe Rainbow: *99*, 99
Baby Baby Wild Things: *104*, 104
Baj at Marconi's: *34*, 34
Baj, Enrico: 18, 23, 34, 114
Baked Potato: 17, 32, 68, *69*
Barutti, Giorgio: 30
Basanow, Dawa: 17, 24, 68
Beaudet, Maurice: 98
Beautiful Bag Co.: 73
Betsy Ross Flag and Banner Company: 16, 24, 44, 56
Beuys, Joseph: 47, 80
Bianchini Gallery: 16, 56, 72, 128
Birillo, Ben: 56, 72
Birkle & Thomer & Co.: 12, 47, 84, 100
Birmingham Race Riot: 20, *90*, 90
Edizioni Il Bisonte: 86
Blackburn, Robert: 26
Blake, Peter: 38, 61, 65, 99, 114
Block, René (Edition René Block): 12, 16, 23, 47, 84, 100, 128
Boom-Boom: *36*, 36
Boshier, Derek: 23, 38, 65, 103, 114
Brehmer, K.P. (Klaus Peter Brehmer): 12, 21, 23, 100, 115
de Broutelles, Jean-Jacques: 11, 54
Cage, John: 28, 52
Cagney: 13, 18, *41*, 41
Campaign: 58, *59*
Campbell's Soup Can on Shopping Bag: 56, *57*
Capitalist Realism: 9, 12, 16, 47, 80, 100
Leo Castelli Gallery: 13, 46, 73, 128
Caulfield, Patrick: 11, 23, 76, 115
Caza, Michel: 11, 12, 23
Chiron Press: 12, 24, 75, 101
Christo (Christo Javacheff): 10, 12, 17, 18, 23, 24, 26, 32, 96, 115
Cigar Box: 16, 19, 32, *75*, 75
Cleanliness is Next to Godliness: *103*, 103
Codognato, Attilio: 30, 128
Crown Point Press: 78
Custom Print I: *101*, 101
D'Arcangelo, Allan: 12, 13, 19, 64, 68, 74, 115
décollage: 35, 84
Le Déjeuner sur l'Herbe: 10, *11*, 11, 105

Dietz Offizin: 88
Dine, Jim: 11, 13, 17, 23, 24, 28, 35, 68, 74, 82, 116
Dishes: *73*, 73
Dodo Designs: 99, 128
Domberger, Luitpold (Edition Domberger): 12, 23, 64, 128
Drag—Johnson and Mao: *82*, 82
Dr. Barnard: *54*, 54
Duchamp, Marcel: 10, 16, 17, 18, 22, 24, 30, 34, 50
Durable Dish Co.: 73, 129
Düsseldorf Kunstakademie: 47, 102
École des Beaux Arts: 12, 54
Eddie (Sylvie's Brother) in the Desert: 19, *52*, 52
11 Pop Artists: 13, 24, 42, 74, 82, *101*, 101, *108*, 108, *109*, 109
Elisabeth II: 21
Equipo Crónica: 9, 53, 116
Erró: 9, 23
Esman, Rosa: 13, 17, 24, 36, 52, 68, 108, 109
Estampa Popular: 53
Factory Additions: 13, 24
Fahlström, Öyvind: 9, 12, 19, 21, 52, 116
Richard Feigen Graphics: 94, 129
Feldman, Eugene: 60
Flag 1: 26, *27*
Flash—November 22, 1963: 20, 92, *93*
Fluxus: 16, 23, 24, 84
Foldes, Peter: 54
Foot and Hand: 19, *46*, 46
Freimann and Fuchs: 102
Gassiot-Talabot, Gérald: 9, 54
Giménez, Lola Garcia: 53
Girard, Georges: 98
Girlfriends (Freundinnen): 21, *102*, 102
Goodman, Marian: 16, 17, 24, 44
Grafiche Gaiani: 78
Grafik des Kapitalistischen Realismus (Graphics of Capitalist Realism): 12, 42, *47*, 47, *84*, 84, *100*, 100
Greer, Phillip: 20, 92
Grosman, Tatyana: 12, 17, 26, 28, 58, 77
Das Grosze Buch: *96*, 96
edition h (Herbert A. Haseke): 12, 21, 80, 102, 129
Haas, Hans Peter: 12, 23, 48
Hains, Raymond: 24, 35, 84
Hamilton, Richard: 9, 10, 11, 12, 16, 18, 19, 20, 23, 40, 43, 48, 61, 65, 76, 88, 117
Hatfields Radiation Research: 106
Hockney, David: 11, 12, 65, 66, 76, 103, 117
Hödicke, K.H.: 23
HofhausPresse: 12, 23, 80, 96, 129
Ibero-Suiza: 53
Independent Group: 9, 11, 18, 43, 50, 88
Indiana, Robert: 12, 16, 20, 23, 24, 44, 64, 104, 117
Institute of Contemporary Art (Philadelphia): 20, 60, 129
Institute of Contemporary Arts (London): 11, 18, 61, 65, 103, 129
The Institute of Contemporary Arts Portfolio: 11, 23, *61*, 61, *65*, 65, 76, 103
Interior: 18, *43*, 43
International Anthology of Contemporary Engraving: The International Avant-Garde; America Discovered: 23, 70, *78*, 78
Is This Che Guevara?: *91*, 91
Ives-Sillman: 12, 70, 90
Jackson China Co.: 73

Jacquet, Alain: 9, 10, 11, 16, 105, 118
Johns, Jasper: 9, 12, 16, 17, 18, 23, 26, 28, 30, 52, 58, 72, 77, 118
Jones, Allen: 10, 11, 12, 13, 21, 24, 65, 76, 103, 109, 119
June Moon: *64*, 64
Editions K.A.K.: 12, 23
Kelpra Studio: 11, 12, *14*, 38, 40, 42, 43, 50, 61, 65, 74, 76, 88, 91, 101, 103
Kent State: 20, 88, *89*
Kicherer, Frank: 12, 23, 76
Kitaj, R. B.: 11
Klasen, Peter: 9, 11, 23
Klein, Yves: 24, 96
Klüver, Billy: 78
Knickerbocker Machine and Foundry: 13, 17, 24, 68, 108
Kornfeld, E.W.: 23, 98, 129
Art Krebs Screen Studio: 62
Kron, Joan: 73
KWY: 12, 23, 96
Laing, Gerald: 10, 12, 20, 23, 104, 119
Lautrec Litho: 106
M. H. Lavore Co.: 52
Leblanc, Georges: 78
Legs: 22
Leonhart, Dorothea (Edition München International): 12, 88, 129
License: 28, *29*
Lichtenstein, Roy: 9, 12, 13, 16, 19, 20, 24, 46, 47, 56, 68, 70, 72, 73, 74, 78, 80, 87, 104, 119
Little Monument to Rotella (Petit Monument á Rotella): 18, *35*, 35
London Knees—1966: 17, 32, 106, *107*
Love: 12, 44, *45*
Löw Siebdrück: 87
Lueg, Konrad: 23, 47, 80, 102
Mao: 80, *81*
Studio Marconi: 34, 129
Marilyn Monroe (Marilyn): *13*, 13, 24, 92
Marisol (Marisol Escobar): 23, 77, 120
Marlborough Graphics: 11, 38, 91, 129
Marquet, Jacques: 11
Mass Originals: 44
Édition MAT / Galerie Der Spiegel: 16, 18, 30, 32, 35, 130
Metal Box Co.: 99
Möller, Hans: 12, 23, 96
Moonstrips Empire News: 18, 50, *51*
Mourlot Graphics: 94
Multiples, Inc.: 12, 16, 24, 44, 73, 75, 130
My Marilyn: 18, *40*, 40
Neuendorf Verlag: 106, 130
New York International: 13, 24, 36, *52*, 52
New York 10: 13, 24, 36, 68
Notes from Guernica (Notas para Guernica): *86*, 86
Nouveau Réalisme: 9, 10, 12, 16, 17, 18, 23, 24, 26, 28, 32, 35, 36, 48, 52, 54, 84, 96, 105
Les Nouveaux Réalistes: 30, *31*
Nouvelle Figuration: 9, 52, 54, 86
Nude: 17, *108*, 108
Oldenburg, Claes: 9, 13, 16, 17, 18, 20, 23, 24, 32, 68, 78, 80, 106, 120
1¢ Life: 23, 98
On 1st: 72, 73
Original Editions: 13, 101, 108, 109, 130
Paolozzi, Eduardo: 9, 11, 12, 18, 23, 42, 43, 50, 74, 121
Pappagallo: *77*, 77

Payne, Maurice: 82

P.C. from N.Y.C.: 38, *39*

Petersburg Press: 11, 48, 76, 130

Phillips, Peter: 10, 12, 13, 20, 21, 24, 66, 101, 103, 121

Pin-Up 25. The Feeling Between Fingertips… (Aufsteller 25. Das Gefühl zwischen Fingerkuppen…): 21, *100*, 100

PM Zoom: 19, *61*, 61

Poleskie, Steve: 12, 13, 24, 101

Polke, Sigmar: 10, 12, 21, 23, 47, 80, 102, 121

Portrait of Laure (Portrait de Laure): *105*, 105

Pour les Levrés: *109*, 109

Power and Beauty No. 3: 20, *66*, 66

Prater, Christopher: 11, 23, 38, 42, 50, 61, 65, 74, 76, 91

Racolin Press: 92, 130

Ramos, Mel: 21, 98, 122

F. & J. Randall: 106

Rancillac, Bernard: 9, 11, 16, 21, 52, 54, 122

Rauschenberg, Robert: 9, 10, 12, 17, 23, 28, 30, 35, 52, 74, 77, 84, 122

Raysse, Martial: 9, 10, 11, 12, 17, 21, 23, 24, 32, 96, 123

Restany, Pierre: 17, 23, 35, 105

Richter, Gerhard: 12, 20, 21, 22, 23, 47, 80, 87, 102, 123

Rivers, Larry: 12, 16, 18, 19, 28, 32, 75, 123

Rosenquist, James: 9, 11, 19, 58, 74, 94, 124

Rotella, Mimmo: 18, 23, 24, 28, 35, 124

Roth, Dieter: 11, 12, 23, 48, 96, 125

Edition Rottloff / Edition Kaufhof: 12, 87, 130

Royal College of Art: 9, 38, 61, 65, 66, 76, 99, 101, 103

Ruscha, Edward: 12, 19, 23, 62, 64, 125

S&H Green Stamps: 19, *20*, *60*, 60

Sabol, Audrey: 62, 73, 130

de Saint Phalle, Niki: 10, 11, 17, 23, 24

Sandwich and Soda: 20, 70, *71*

Schwarz, Arturo (Galleria Schwarz): 16, 23, 35, 70, 78, 131

See-Saw, Class Systems: 94, 94

Segal, George: 24, 68, 125

Self, Colin: 11, 20, 24, 69, 125

Señorita Rio: 21, *98*, 98

7 Objects in a Box: 17, *68*, 68

Sirocco Screenprinters: 12, 13, 24, 44, 70, 90

6 Piccadillies: 11, 23, 48, *49*

69: *64*, 64

Smith, Richard: 10, 19, 38, 61, 104, 126

Solbes, Rafael: 53

Some Poems of Jules Laforgue: 11, *76*, 76

Sonnabend, Ileana (Sonnabend Gallery): 9, 23, 87

Spoerri, Daniel: 16, 17, 18, 23, 24, 28, 30, 32, 48, 126

Stacy: *104*, 104

Staib & Mayer: 48

Stämpfli, Peter: 9

Standard Station: *62*, 62

Starfighter: 12, 84, *85*

St. George's Gallery: 10, 11

Stolpe Verlag: 47, 84, 100, 131

The Store: 18, *18*, 24, 106

Studio L'Ariete: 30

Surrealism: 30, 50, 52, 54

Swingeing London 67—poster: 18, *19*

Tamarind Lithography Workshop: 12, 23

Tanglewood Press: 13, 17, 36, 52, 68, 131

Télémaque, Hervé: 9, 11, 23, 52, 54

X + X (Ten Works by Ten Painters): 12, 70, *71*, *90*, 90

Thiebaud, Wayne: 78, 98, 126

This is Tomorrow: 43

Tilson, Joe: 10, 11, 21, 38, 91, 126

Tinguely, Jean: 9, 10, 23, 24, 96

Toledo, Juan Antonio: 53

A Tool Box: *74*, 74, 82

Tortured Life: *42*, 42

Townsend, George: 20, 24, 90

Turkey Shopping Bag: 20, 56, *72*, 72

Universal Limited Art Editions: 12, 17, 26, 28, 58, 68, 74, 77, 131

Untitled (Derek Boshier): *65*, 65

Untitled (Martial Raysse): cover, 96, *97*

Untitled (Daniel Spoerri): 30, *31*

Valdés, Manolo: 53

de la Villeglé, Jacques: 24, 35, 84

Éditions Georges Visat: 23, 105, 131

Vostell, Wolf: 12, 20, 23, 84, 100, 126

Waddington Galleries: 76, 131

The Wadsworth Atheneum: 12, 70, 90, 131

Warhol, Andy: 9, 10, 12, 13, 16, 17, 18, 19, 20, 22, 24, 32, 41, 42, 47, 56, 60, 68, 72, 77, 80, 90, 92, 127

J. Watson and Co.: 106

Weekend House (Wochenendhaus): *47*, 47

Wesley, John: 12

Wesselmann, Tom: 12, 16, 17, 21, 24, 68, 74, 108, 127

Wittenborn and Company: 17, 24

Wrapped Look Magazine (Look Magazine Empaqueté): 18, 32, *33*

Photograph Credits and Copyrights

Individual works of art appearing herein may be protected by copyright in the United States of America or elsewhere, and may thus not be reproduced in any form without the permission of the copyright owners. The following copyright and / or other photograph credits appear at the request of the artists and / or their heirs or representatives.